DIVINING
CHAOS

DIVINING CHAOS

The Autobiography of an Idea

Aviva Rahmani

New Village Press • New York

Published in the United States by New Village Press
bookorders@newvillagepress.net
www.newvillagepress.org
New Village Press is a public-benefit, nonprofit publisher
Distributed by NYU Press
Publication Date: June 2022
First Edition

Library of Congress Cataloging-in-Publication Data

Names: Rahmani, Aviva, 1945- author.
Title: Divining chaos : the autobiography of an idea / Aviva Rahmani.
Description: First edition. | New York : New Village Press, 2022. |
 Includes bibliographical references and index. | Summary: " An
 autobiographical memoir of artist, feminist, and environmental activist
 Aviva Rahmani includes her personal life and eco-art projects Ghost Nets,
 restoring a town dump in coastal Maine to wetlands, and The Blued Trees
 Symphony, an artistic and legal opposition to natural gas pipelines.
 Rahmani also presents her trigger point theory, a thesis to predict and
 confront outcomes to ecological challenges." —Provided by publisher.
Identifiers: LCCN 2021060919 | ISBN 9781613321669 (paperback) |
 ISBN 9781613321683 (ebook) | ISBN 9781613321690 (ebook other)
Subjects: LCSH: Rahmani, Aviva, 1945- | Artists—United States—Biography.
 | Women artists—United States—Biography. | Ecology in art.
Classification: LCN N6537.R233 A2 2022 | DDC 700.92—dc23/eng/20211231
LC record available at https://lccn.loc.gov/2021060919

Cover design: Lynne Elizabeth
Cover image: Aviva Rahmani
Interior design and composition: Leigh McLellan Design

Contents

Hoping for a New Landscape of Hope

Lucy R. Lippard

When the brilliant artist/scholar/activist Aviva Rahmani reads physics, she hears "the poetry of the universe." For an artist, she reads a lot of physics, and those viewers lucky enough to keep up with her get to listen to the universe too. Over the years, as described in this book, she has moved from painting to conceptual and feminist performance, to an invaluable technological expertise, to modeling new concepts of environmental or ecoart, with many equally compelling side trips. You can read this account simply as an unblinking first-person art history, with walk-on parts by Herbert Marcuse, Angela Davis, Newton Harrison, Allan Kaprow, Morton Subotnick, Judy Chicago, Suzanne Lacy, Bread & Puppet, Wangari Maathai, among others, and an equally stellar group of scientists, led by long-time collaborator Jim White, paleoecologist and Dean of Arts and Sciences at the University of Colorado at Boulder.

But there's a lot more to it. Today Rahmani is a leading visionary in crucial current debates around climate change and environmental innovation. She sees artists as Cultural First Responders, or Black Swans.[1] *Divining Chaos* innovatively fuses a brave and admittedly somewhat neurotic

1. She explains that "Nassim Taleb coined the economic term *black swan* to describe a disruptive event that changes fundamental perceptions, such as the pandemic." (p. 18)

woman's memoir with a complex analysis of eco-art's (and eco-feminism's) role in saving the planet. Her mission is to open up relationships to "wider global biogeographic systems," to tell "the big story of the future."

The "Pandemic Diary" opens the book with an ongoing autobiographical thread bringing gusts of fresh air to the often stuffy halls of scientific theory. Rahmani appropriates Boolean physics,[2] CAS (Complex Adaptive Systems), and the roles of algorithms. Along the way, she has formulated her "trigger point theory" (which I don't dare try to encapsulate). Her varied artwork is based on transparency and empathy for humans, animals, trees, and everything else living on the planet, fed by her endless curiosity and appetite for learning and change, which includes moments of clairvoyance and insightful dreams, as well as serious studies of outlying fields, from music theory to graphology. She has traveled widely, beginning with attending an Arab wedding during a family visit to Israel, where she reluctantly comes to understand the tragedy of Palestine. After participating in a conference in Beijing, she went to Inner Mongolia, where she "rode a horse with no name through the desert."

We are led through a life made fascinating by a strong moral compass dedicated to learning and applying the lessons to her art, as well as a level of PTSD beginning, but not ending, with family dynamics, the fates of her forebears in the Holocaust, from a privileged if contentious girlhood to the precarious life of an artist ahead of her time, which involves bowing out of, or beyond, the commercial artworld in favor of a stubborn belief in her contributions. She persists, despite obstacles—rape, a serious head

2. George Boole first published the premises of Boolean logic in 1841. They persist as constructs for software design and became critical to the fields of electronics, data mining and as a model for information theory. Information theory plays with a few simple conditions—if, then, and, yes, no—to identify rules to find answers to complex questions. A Boolean analysis algebraically defines knowledge by asking simple conjunctive, disjunctive, and negative questions: true/false; AND, OR, NOT. The if of any given interaction can reveal how, why, when. Trigger point theory defines Boolean conjunctions and prepositions between agents. OR, AND, NOT establish true/false logical conclusions. Prepositions designate spatial and temporal relationships to qualify a noun. These conjunctions, disjunctions, and negations in Boolean theory are basic to information theory, have a role in game theory, are applied to warfare but also to strategizing solutions for peacetime problems. (p. 25)

injury, Chronic Fatigue Syndrome, two bouts with breast cancer, and a tumultuous love life. Her battle with ecocide, with its roots in white supremacy and fascism, continues. So, of course does patriarchy, which she defines as a social, not just a gendered system.

Rahmani describes ecoart as a hybrid form birthed by people like her who can't accept silos. Where the mostly male land artists use sculptural techniques to monumentalize their own philosophies, ecoartists are driven by the need to heal rather than make (literal) impressions. She focuses on the preposition *with*, which, "is what distinguishes compassion from empathy. *With* is the analog of the Boolean *And* and the trigger point I'm trying to find for hope." One of her many concentrations is the burgeoning concept of the Rights of Nature, and the contingent "idea that the heart of a system depends on its periphery." In our age of climate change, she says, "unless we intervene in fragmentation, nothing will be left to mitigate the disaster of maximum warming."(p. 126) Her own extensive aesthetic interventions—*Ghost Nets, Gulf to Gulf, Hunt for the Lost,* and *Cities and Oceans of If*—demonstrate a panoply of possibilities for wholeness.

The project that has finally brought attention from a broader constituency to Rahmani's collaborations with serious scientists, is her ongoing *The Blued Trees Symphony.* She conceptualizes landscape with music, "in patterns that correspond not only to scoring but also to historical events." Rules of harmony, counterpoint, and dissonance were "semiotic inspirations related to abstract emotional events in time." (p. 242) *Blued Trees* is not just an aesthetic event. It incorporates startling challenges to fossil fuel pipelines, providing "a test case to adjudicate between copyright law and the law of eminent domain, which has allowed corporations to seize land." (p. 18) Following the example of Canadian sculptor Peter von Tiesenhausen,[3] she places art in the path of corporate greed. With biodegradable,

3. Canadian sculptor Peter von Tiesenhausen copyrighted the surface rights to his land in Western Canada, occupied by a natural gas hot spot, and fended off the prowling "land men" working for soulless corporations by demanding $500 per hour to talk. In 2020, the artist Eliza Evans launched *All the Way to Hell,* giving away mineral rights on her land to protect it from fracking.

buttermilk-based ultramarine blue paint and a horde of supporters, she marks the paths of pipelines, blocking them from barging through the land to destroy habitats, water, and forests. Challenging copyright and eminent domain in favor of the rights of nature, she offers "new legal boundaries between ownership and place, legal manifestations of ecotone adaptation. "

Following up on her childhood obsession with trees, Rahmani "designated a series of GPS-located trees (tree-notes) in habitat corridors where natural gas pipelines were proposed, creating a score from biogeography, conceived to protect forest contiguity, an essential agent for preserving watersheds and water quality and reducing habitat fragmentation at large landscape scale. Research indicates that trees function in relationship to one another as complex communities, not only as habitat for other creatures but as interdependent social webs with other critical abiotic systems, such as watersheds."[4]

On June 18, 2018, slightly more than three years after the project launch, copyright lawyer Gale Elston choreographed and organized a mock trial for *The Blued Trees Symphony* at the Cardozo School of Law in New York City. [5] "This project suggests replacing arbitrary boundaries and rules with a *Blued Trees* CAM in which our vulnerability and interdependence with other life, such as trees, is protected. A transdisciplinary, synesthetic vantage may better equip us to counteract ecosuicide," writes Rahmani (p. 267). The judge ruled for an injunction to protect the trees.

Rahmani cites a parable she learned from Nobel Laureate Wangari Maathai, creator of the Green Belt reforestation movement in Kenya in 1977. During a great forest fire, as all the big animals fled, one tiny hum-

4. "We know now that plants 'scream' ultrasonically and release pheromones when they are cut down. Distinct sounds have been recorded when trees were drought-stricken or attacked by pine beetles. The composer Bernie Krause has assembled serious sonic archives of habitats before and after human extractions." (p. 126) See also Suzanne Simard, *Finding the Mother Tree: Discovering the Wisdom of the Forest*, New York: Penguin Random House, 2021.

5. Elston and her colleagues structured the trial, prepared arguments, wrote and coordinated scripted briefs, and recruited Judge April Newbauer of the Bronx Supreme Court to adjudicate; the attorneys performed pro bono.

mingbird flew back toward the fire with a drop of water in her beak. When the other animals laughed at her and asked her what she hoped to accomplish with one drop of water, she replied, "It's all I can do."

A devoted idealist, convinced that her innovations are crucial, Rahmani is deeply disappointed when her ideas are ignored or rejected. Yet in the long run, which is the subject of this book, she is becoming an influential model for a sensual and intellectual art that escapes expectations and hopes to heal the planet.

Introduction

My life changed forever one fall day in 1962. That was when I first divined a path out of chaos.

It happened at the Château de Chillon, in Switzerland, where in the sixteenth century a monk had been imprisoned in its dungeon.

"Go paint a vista. Then come back," my art teacher had said. It was for my art school portfolio.

Shortly afterward, I returned crestfallen by feelings of failure. "The trees confused me," I confessed. "I couldn't start."

"Go back and find the story."

The next afternoon, I found a shallow sloped path before the remains of the old drawbridge at the entrance to the eleventh-century fort. Sitting down on a convenient rock in a grove of trees, I inhaled the fragrance of green living things and fresh water, found the story at the edge of the sunlit lake, and began a watercolor painting. If I had known about the monk, his story might have shadowed and darkened mine that day.

Almost sixty years later, I was living in lockdown in New York City. In the evenings, I often walked on the path in the nearby Joan of Arc Park, where I always looked up to admire the early-twentieth-century equestrian statue of Joan of Arc by Anna Vaughn Hyatt Huntington (1876–1973).

Joan always inspired me, but I had to wonder: How did she accept her premonitions of hope and calamity? Was it really pure faith? Did the monk at Chillon question his convictions any more than she had?

I was often alone on the path and could drop my mask below my nose for the sweet spring scents. When I encountered someone mask-less—usually a large young white man with a belligerent expression who commandeered the walkway—I quelled panic.

Sometimes on my walk, my view of the city dissolves. I see what Manhattan Island might be like if we ignore environmental warnings. Other times, I see how it might have looked before Europeans arrived, when Manhattan was the ancestral home of the powerful Lenni Lenape. Some of the Lenni Lenape still live here, but they are no longer powerful.

Lenni Lenape translates as "pure" or "authentic" people. Their culture was matrilineal, which meant that the mother's clan determined social standing and leadership roles. They had no concept of land ownership, although farming plots were managed by the women and allocated according to need. They were familiar with and practiced companion planting and caught fish with the aid of ground chestnut meat, which seemed to make the fish drunk and, like all drunkards, easily caught.

At Chillon, I was working in an ecotone. Ecotones are the subtle transitions from one nuance of habitat to another, as rich in subtlety as human relationships. Environmental scientists have identified rules for how species interact that are grounded in physics, as in *The Theory of Island Biogeography,* by E. O. Wilson and Robert MacArthur.

Physics investigates chaos and complexity algebraically and, to a lesser extent, by trigonometry. Humans have always tried to divine chaos and complexity. I am no different. When I read physics, I hear the poetry of the universe. The laws of physics describe how life functions and changes. Art's task is to break immutable rules and make games of relationships and boundaries between ideas to make the invisible visible.

Many art writers—John Berger, for example—have explored spatial ideas in art. Transdisciplinary theorists such as the physicist Basarab Nicolescu identifies the space "in between" as where rules bend in the world to promise new solutions to problems. *Ghost Nets* (1990–2000),

my ecoart project in Maine, restored a degraded ecosystem. I worked in the space between science and art.

At Chillon, I still had a lot to learn about boundaries. Now, I understand that a line defines boundaries, but boundaries can be blurred in many ways.

The complexities of the landscapes I study most carefully now are often shadowed in the edges by conflict. Instead of a gentle path to serene waters, the view ahead is often dangerous and confusing because critical habitat destruction seems inextricable from the problem of human overpopulation. Both seem enmired in intransigent politics. As I consider our common landscape now, I see a kaleidoscope of disparate countries, environments, communities, mixed with the grief and joy of time and place hovering like ghosts from our past, whispering of our future.

Today I know something about edges, ecotones, and even how humans interact in those spaces. Ecotones can be webs of protection from the unfamiliar viruses of other species. The protective relationships in ecotones fray and vanish as humans and animals come in ever-closer contact with the increasingly corralled remaining wildlife across the planet, making space for a viral thoroughfare. I believe the COVID-19 virus emerged as a consequence of the contact between one species and another, from wild species to their new human neighbors: zoonosis. For most people, COVID-19 was a "black swan": something out of the blue, previously unimagined and today's red flag.

COVID-19 is a pathogen that represents what I call a trigger point, the site where disparate agents come together and precipitate a tipping point, starting endless cascades of change. Colloquially, that cascade is "the butterfly effect," when the flap of a butterfly's wings can effect change at scale. The former, a trigger point, is about location. The latter, a tipping point, is about time.

Humans have been generating tipping points, chipping away with impunity for a long time at the integrity of ecotones and habitats, fragmenting systems that might once have buffered relationships between humans and other species. Classical writers confirm my opinions in writings that describe how the hills of Greece and Italy were once clothed in complex forest systems, until trees were cut down to build cities, leaving scant

vegetation to knit together and hold soil in place, resulting in erosion and leading to torrential floods. Human expansionism, entitlement, and extractive behaviors are ancient patterns. Arguably, many Indigenous cultures seems less ecologically voracious.

This is also the breathless moment of promise in chaos, a moment for us all to find answers to old questions, such as "How do we all get along?" Our answers may help us all survive a desperate world that often scares me to death. This is when the big story of the future emerges.

Excerpts from a Pandemic Journal

March 10, 2020

Today is the fourth day of lockdown. I recall a phrase from Sappho: "For every surge of heart, there is a pinch of ashes." The summer I turned twenty-one, I was living on the Upper East Side of Manhattan, a block from Gracie Mansion. My thinking about everything then was steeped in poetry. I calligraphed Sappho's fragment in dense black paint eight inches high on the white wall above a hallway alcove in my apartment. I have felt bad ever since about how difficult it probably was for the super to have my flight of poetic fancy erased when I left. In that case, the landlord cleaned up my pinch of ashes. Today, most people bear responsibility for more than a pinch of ashes.

May 12, 2020

It is almost two months since New York City declared the pandemic lockdown. I just returned from a twenty-minute walk in the Joan of Arc Park near my apartment on the Upper West Side of Manhattan. The park is about eighty blocks from the hospital where I was born. That fact gives me the transient illusion that in my entire life, little has changed. Despite detours in my history, until now, I walked along a relatively stable path from one security to the next. Nothing is stable or secure now. I have felt

terrorized by maskless people, but today, to my great relief, everyone was wearing a mask for the first time since I've been taking these walks.

The columbines in the park are in full, almost summer bloom, nodding a bit on their stalks in the warm twilight, mixed up with a riot of red azalea blooms, one pastel tulip, and a plethora of leaf textures from hundreds of plants and low shrubs.

Despite depressing realities, the walk felt good. Just before I left my apartment, I got off the phone with the composer Eve Beglarian, one of my collaborators for my new project, *Blued Trees Black Skies*. We've just gotten our grant from the MAP Fund and are trying to retool a vision we've worked on for almost two years to adjust to the lockdown.

The pandemic changed all our plans. I've been thinking about using an old image I recently reworked, of praying hands, modeled on those of a devout ex-lover to represent aspirations.

I imagine each of us has had their own forms of instant spiritual conversion since lockdown, making an inchoate babble of devout prayers for deliverance.

Eve suggested iPhone apps to let the audience project images during performance. I realized later that they could be projected onto any environment from a live stream.

Instead of pursuing that idea right away, I created the *Hunt for the Lost*. I call it a morality scavenger hunt. It is a series of installations and social media events to continue until the 2020 presidential election. I created a mock campaign of yard signs for Governors Island that could catalyze reflection and discourse. The project will launch with links to a website with an online board game of alternate realities for the "found." The text will be prompts for each hunt. In addition to a prompt for *Morality*, I wrote prompts for everything I could think of that has been and will continue to be lost during this time out of time when we have lost our way, such as *Hope, Kindness, Forests, Heart, a Missing Song, Joy, Species, Snow, Thoughts, Empathy, Courage, Freedom, Birds, Memories of Love, Forests,* and *Marriage*.

I have written thirty prompts. A new set of prompts will be loaded weekly until the election.

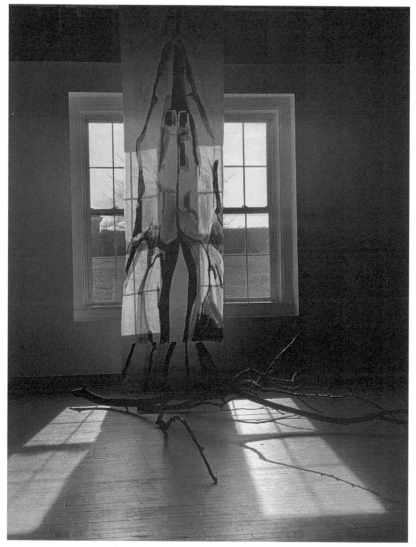

Praying Hands, realized in installation for *Blued Trees Black Skies,*
staging for a dance work sketch with Aviva Rahmani and André Zachary,
LMCC, Aviva Rahmani, 2020. Photograph by Aviva Rahmani.

I was thinking about production options for *Blued Trees Black Skies*
while I walked through the park. Before lockdown, we planned to launch
in late August 2020. The setting was going to be a large grove of trees on
Governors Island, here in Manhattan. Ordinarily, that would be a time of

peak random holiday-mood traffic on the island: reputedly fifteen thousand visitors a day! The content that has remained the same for me from before lockdown are empathy, ecocide, the deliberate destruction of habitat for economic advantage, and the contiguity of forest systems.

My original plan for the installation would have included suspending a series of thirty-foot-long translucent banners of symbolic imagery and text from the trees, including the images of praying hands. Several large clusters of thirty-foot-long branches painted with a nontoxic ultramarine blue casein I used for earlier public projects would have been assembled on the lawn. I had been completing plans until my last day in the studio. Dancers choreographed by Yoshiko Chuma would have moved between the trees, the banners, and the branches, appearing and disappearing at twilight, weaving themselves through the random crowd. Eve had planned her composition with Robert Black, to be played live from twenty-four acoustic basses distributed in the installation within the grove. I imagined it would be both joyous and challenging.

Before the lockdown, our plan was already running into technical problems. I couldn't use monofilament wire to suspend the banners I was working on, which would have made them float in the air like ghosts. Instead, I would need to use very wide, visible, straps. Suspending the banners would require blanketing the grass in the grove with sheets of plywood and driving a forklift over the plywood to attach the banners, not just long ladders. It began to seem that the production process would cancel our message. Then came COVID-19. The prospect of doing anything with a large crowd this summer melted away faster than the glaciers.

Yesterday, I tried to think this through in a phone call with Madeleine Cutrona, director of the Fiscal Sponsorship program that I am part of at the New York Foundation for the Arts (NYFA) and that sponsored my MAP Fund grant. Our conversation identified several ideas about the work I'm doing now that I want to build on. First, I don't want to do work for a passively seated audience, especially now, when so many of us have been reduced to passively sitting in front of our computers, an even more sensorially alienated relationship to art than the traditional relationship of a seated audience to active performers. Second, I wanted the masks and the social distancing to be our starting point, not what

we ignore. Is accepting catastrophe the only sane path forward to work in this pandemic reality?

I told Eve, "Maybe the images I wanted to suspend could just be projected, and we could interface it with some new media solutions."

I feel hopeful and open about our collaborative process: Ideas are flowing. They fall or lead. I'm looking for points where small ideas can leverage large ones, an approach fundamental to my rules-based theory about art and change. The rule I was applying from my theory was that play can teach.

I write a prompt for *Lost Forest*:

Lost Forest

An entire forest has gone missing.
More things than we can list are missing with the missing forests.
The missing list of lost things is very important to know.
The forest went missing because we forgot the list.
Hard work and time will help us find the missing forests.
If you find a missing forest,
You must hide it from other people.
Keep the secret of the found forest.
You can celebrate finding the missing forest.

May 21, 2020

I still have no assurance about when I can access my studio again. Today we learned that late action alone on COVID-19 cost thirty-six thousand lives. The helplessness I feel in the face of misery is far more excruciating than the sequestration. I obsess about children forced into a worse sequestration. I can't stop imagining the horrific experiences of immigrant children trapped in cages. Can any of those children understand the forces destroying their lives now? What will they tell us of their torture in another twenty years?

When I was a child myself, I couldn't have understood the global drivers of our present crisis, but I did intuit what my parents had survived. Today, it's hard to imagine a sufficiently timely response to the present. But imagining a coherent response to horror now seems to be the task.

During lockdown, my most consistent response to reality has been depression, as it was in childhood in response to events I couldn't change or control. If I cast about now for what to defy as I once defied my father, I am flummoxed. The one thing I am certain of now is that depression is a realistic response to the pandemic.

Recently, it has occurred to me that I can't go on like this. Wearing myself down with rage isn't resilience. It's just hysteria. There are reasons to take care of myself, rest, smell the roses in the midst of this pandemic. Those reasons include wanting to last a little longer, complete more work. That thought is paradoxical. No matter how urgent reality may seem, I assure myself, time always allows change. I argue with myself. The pandemic makes everything urgent even though time has halted.

May 30, 2020

Protests across the county since the murders of George Floyd, Tony McDade, Ahmaud Arbery, and Breonna Taylor. I fear many things will get far worse long before this book is published. Last night I cried for hours for my country.

And yet the pandemic continues to teach valuable lessons. Though carbon emissions did not reduce as much as many people had hoped for, the world was treated to an experience of sudden and significant, if temporary, carbon emission reductions of up to 17 percent. Apparently, the motivator was the ephemeral carrot of self-preservation mixed with empathy for those who might be affected and the stick of possible personal death from the virus. In weeks, a paradigm about pollution dramatically changed. That proved dramatic change could happen fast. COVID-19 had emerged as the consequence of a disruption in sensitive conditions in relationships between human and nonhuman animals. Its emergence triggered multiple international lockdowns, the crash of economic systems, and the vanishment of cherished assumptions for many, such as that democratic governments always care about the people they govern. Overnight, anchoring social outposts that had been taken for granted especially in urban areas, including restaurants, nail salons, performance venues, fashion, schools, and sports events vanished. But the longing for human

companionship is unquenchable. For the virtually privileged, it simply spilled into back-to-back Zooms.

As the lockdown continues, those of us who had been flying across geographies are staying home and finding new ways to talk to each other. Besides human qualities shyly emergent in these exchanges, such as empathy for the other, there are new practical options for communication. Restoring habitat contiguity and edge integrity, providing family planning, and eliminating extractive industries might be outcomes. More support for art as a "cultural glue" would be useful as we struggle to adapt to the world we have created. Access for all those whom the pandemic has muted because they aren't Zooming is probably a priority.

Could the daily 7:00 P.M. cheering be a black swan? Could it be that simple? The clapping reminds me of the Zen parable of the sound of one hand clapping. Could we consider that sound a mystic intellectual rune for the individual among the many celebrating the commons? Is each pair of clapping hands one sound among many demographics and species? Are all our clapping hands like infinite refractions of my image of praying hands? Is the clapping a small, playful entry into chaos at a point of sensitive conditions that could triage the world's hurts?

While these evening events last, they will continue to celebrate courage and empathy. Despite all the elements of disruption and chaos, this spontaneous and ubiquitous expression is completely inclusive. Aesthetic skill is appreciated but not required. There is no distinction between audience and performer. The sound affirms health and hope. As it occurs internationally, it asserts a complex contiguity with all life. It implicitly demands justice, validation, and protection. Could that signify a way forward at scale? Could the sound of one hand clapping include the sounds of paws and fins and leaves joining the orchestra? Of course, as usual, it won't be that simple.

June 22, 2020

I'm taking time to mourn an old loss. My mother died on this day in 2003 at the age of ninety-five and a half in her bed at her home in White Plains, New York, surrounded by family and with a nurse who administered a

last morphine shot. I was absent. I was in Geneva, Switzerland, at a class reunion for the Collège du Léman with Earl, a man I thought was the love of my life. I had been apprehensive about leaving my mother. We talked about it before I left.

"I'm afraid you won't be here when I come back."

"You are going with a man you love. That is a good thing to do."

She gave me her favorite string of pearls, and I boarded the plane.

A few days later, my sister called. Hours later, we boarded another plane to return to New York City. The last event of the reunion was planned to take place at the school, where I might have confronted the former director about his abusive behavior while I was a student there. Instead, that day I was sobbing out my grief for my mother during the entire flight back to New York.

We were seated on the left side of a middle row. A man from across the aisle, in the seat nearest to Earl, leaned across the aisle to ask, "Why is she crying?"

"Her mother just died."

"Tell her there is heaven."

Unconsoled, I continued sobbing.

In life, my mother had rarely been validated any more than I had been, even by her. Her marriage had become increasingly difficult. We had conversations about divorce. Once she speculated out loud that perhaps she could get a job cooking soup in a department store to support herself. At the time, in addition to her housekeeping skills and talents, she had been co-managing my parents' internationally successful family business for decades. She spoke five languages fluently.

Mother had created a world with my father and couldn't imagine her world without him until he died.

Then she made a new world for herself.

After Father was committed to a nursing home when he developed dementia in his late eighties, she not only saved herself from bankruptcy at the age of eighty but also accumulated millions of dollars in wealth from the sale of properties that remained in their White Plains business. I got a sense of her challenges when I helped her review the real estate contracts after Father was committed.

Mother's obituary in the *Journal News* referenced her philanthropy. In her will, she left substantial sums of money to the Children's Zoo in Jerusalem, to White Plains Hospital, and to establish a firing range in Tel Aviv in honor of my father, a one-time Haganah sharpshooter.

June 30, 2021

This morning, my scale alarmed me. I have gained weight. No surprise.

In the media, someone referred to the ubiquitous fifteen pounds of COVID-19 weight gain and chuckled. Others have reported stepping up their regular drinking or a rise in domestic violence or increased sexual harassment of workers or more murders. I work incessantly and lose track of how many hours I work, night and day. Time is like taffy, stretching and compressing. If I don't work, there's nothing I want to do. Even online opera, which normally gives me joy, often wears thin. I know that signs of depression include losing interest in things that previously gave pleasure and expressing anger or despair.

I long for a loving or just kind human touch. I haunt Facebook, where my nose presses to the window of friends who escaped the city and express delight in the great outdoors. I have long passed hate in my responses to the person I call a "fat orange in the White House" and don't want to talk to loved ones who still support him. I am amazed by everything, and none of the amazement is joyful except the 7:00 P.M. citywide celebration of service every night. It all just *is*. I know. I'm not alone, but I am relentlessly alone.

July 5, 2020

I don't hear the clapping very often anymore. But today the news gave me joy. Laws are another way to organize discursive experience and track change. Today law effected change. Natural gas pipelines have been halted in several states, including the area where the people involved with my project *The Blued Trees Symphony* had painted and copyrighted hundreds of trees in the path of natural gas lines. We were leveraging laws about ownership in order to avert ecocide. Dominion Energy and Duke Energy canceled the Atlantic Coast pipelines that would have gone through North Carolina as well as Virginia and West Virginia, where the *Blued*

Trees were located. In addition, a district court ruled that the Dakota Access pipeline, valiantly resisted by Native American Water Protectors led by the Standing Rock Sioux tribe, despite great persecutions, must shut down by August 5. Water and habitat preserved will include lands around the Standing Rock reservation in North Dakota. The natural gas corporations finally retreated due to the costs incurred by lawsuits. As it has turned out, the outcomes set a precedent that would arrest the installation of more natural gas pipelines. The Supreme Court reached a final legal decision right on time, inadvertently adjudicating for Earth rights.

Life defied my routine dystopia and astonished me again, as it has throughout my life, even more often than it has delivered painful reality checks and near-death experiences. The victories let me glimpse the alternative world I believe we need, a world that defies ecosuicide and cleaves to environmental justice.

One hand clapped.

During COVID-19, at times our choices going forward have never seemed more stark, more dauntingly complicated, or more darkly shadowed by political difficulties. The gas-line victory didn't let me forget the darker lesson from our government during the pandemic: unless we are filthy rich, we must accept helplessness. However, I choose to believe that despite dark clouds, this time looks like an opportunity to playfully collaborate with life in sensitive initial conditions. Or at least imagine a world of *if* and *with*. As many of us face how high the stakes are, how dire the prognostications, I am heartened that justice prevailed over some pipelines, *with* the work of others. The work of *with* is a time-dependent process no matter how driven by urgency or colored by grief over collateral damage. Justice requires patience as well as persistence to work with the rules of legal precedents, with judges and lawyers and mainstream opinions about public (economic) and common (community) good.

The Blued Trees Symphony had inspired the beginnings of a composition playing across the planet: nature's unfinished opera. During the pandemic, I have imagined life collaborating with me to complete something. This gas-line judgment isn't another disheartening lesson in helplessness.

July 29, 2020

In early 2020, the emergence of COVID-19 was a critical disruption in many already-dysfunctional aspects of the human status quo, from class entitlements versus disenfranchisements to sudden appearances of wild animals in urban settings. Writing this evening after we learned that riots were incited by white supremacists in Minneapolis, I feel that I am in the eye of yet another life storm as rage over injustice and cruelty has exploded across the country and in my city, stoked and contaminated by fascists, as Hermann Göring once burned the Reichstag to blame Communists and effect Nazi control of the government.

August 31, 2020

I was tested again for breast cancer today. I am clean. Despite the pandemic, the rise of fascism, the acceleration of ecocide, economic insecurity in the world, and the pressure to complete work on Governors Island under impossible circumstances, something may have changed in me for the good. If stress might cause breast cancer, then all the stress of the present is somehow mysteriously less than I felt before the 2016 election, when I got breast cancer the second time. I didn't look a gift horse in the mouth when I got the news and bought myself flowers on the way home from the hospital.

September 12, 2020

Everyone is acting crazy. Me, too. I took a deep dive into chocolate this past week, with little regret. Politics combined with the pandemic feels toxic. I believe the current response of the present United States government to white supremacy in the midst of the pandemic joins genocide more deeply to ecocide, patriarchy to fascism—proof that the relationship of the current administration of the United States to the rest of the world is ecosuicidal.

September 29, 2020

Over one million people have died of COVID-19. Over two hundred thousand of those deaths have occurred in the United States.

October 26, 2020

I went back to the installation of *Lost Forest, Found* with Yoshiko Chuma today. It includes an assemblage of painted branches on the Lavender Field. The Governors Island grounds people are letting the grass grow under the painted branches I had installed, so it is slowly disappearing into the green even as the blued limbs appear to emerge from the earth. The branches have attracted flocks of life, particularly hermit thrushes and butterflies. They flit about at lightning speed as they seem to be feasting on the buttermilk in the nontoxic casein paint. After the election, the blue art will become mulch, an abstraction of a cycle of life and hope.

Two visitors stopped to photograph the branches while we sat at a picnic bench above the Lavender Field. Yoshiko called them over. They asked me questions about the installation, especially one bone-white branch I had left unpainted. I told them that the piece is about many things, including racism, that I left just one branch pale to consider how it would be if white people were just one more color, not any more special than any other skin tone.

The visitors asked me, "Why blue?"

I replied, "These are dead trees. We are killing many trees. Living trees preserve water. When these dead branches are mulched, they will create new vegetative life to protect water. The blue is for the water they will preserve in that cycle."

November 1, 2020

The election is in days. Whatever the outcome, I will take down the signs for *The Hunt for the Lost* ten days later.

1

A Path

It is August 2020 on Governors Island, and my studio is beautiful. Big windows overlook the river and a magnificent view of the Manhattan skyline. This is my first time back since lockdown five months ago.

My first response to my new studio in 2019 was to make friends with Marisa DeDominicis, executive director of Earth Matter, a major recycling and research facility on the island. Together, Marisa and I carefully studied the trees in her purview. She cut down and gave me a forty-foot-long branch and helped me elegantly trim its shape, carrying it on the roof of her car to my studio as grounds people laughed at the sight. Alone in my studio, I painted it ultramarine blue.

The branch splits my studio space, creating a trigger point. Any visitor becomes a performer negotiating a relationship to a dead piece of a living tree, requiring them to physically connect with the branch and respect its limits as long as they are in the studio. The branch choreographs its audience.

The art world has had a long-standing argument about whether art can effect change. Physics tells us how change occurs. The lens of physics can reveal black swans, anomalies that can dramatically change the trajectory of events.

At one time in Britain, when something was a certainty, people would call it "just as certain as swans are white." The discovery of black swans in Australia ended that symbol of certainty. Nassim Taleb coined the economic term *black swan* to describe a disruptive event that changes fundamental perceptions, such as the pandemic.

Physics addresses the nature of life through rules and processes independent of human agency.

Many forms of art require rules humans invent but the best art is always a black swan, a surprising event. I have speculated that my rules for trigger point theory could be applied to agents in any chaotic system to divine where to find black swans.

When lockdown was imminent, I hoarded my few last days of freedom. Before the pandemic, I was sure that *Blued Trees Black Skies* would be a spectacular success. My topics were the interdependent themes of ecocide, environmental justice, and racism.

In *The Blued Trees Symphony*, I had designated a series of GPS-located trees (tree-notes) to be marked with ultramarine-blue casein in habitat corridors where natural gas pipelines were proposed. The tree-notes created an aerial musical composition, a score. It was a test case to adjudicate between copyright law and the law of eminent domain, which has allowed corporations to seize land.

Patrick Reilly, a copyright lawyer, had said, "Win this case in the court of public opinion before you enter the courtroom."

I understood that the righteousness of my activism wasn't at stake, as that isn't protected by copyright law. He meant for me to communicate the idea that art that is not only site-specific but integrated into the habitat redefines rules about land ownership.

Before the pandemic, I had been considering returning to my home in Maine, where I knew I could be very happy to live in beauty. While I kept working in my studio those last few days before lockdown, the window in time to travel between New York and Maine closed. I yearned, helplessly, to escape.

My residency with the Lower Manhattan Cultural Council (LMCC) was time-limited to just after the November presidential election. My

frustration with the government and politics grew as the administration swung wildly from one inept response to another.

In those days before lockdown, most of us were not yet wearing masks. I was usually alone in the studio, but the commute to Governors Island meant anxious hours on the subway and possible infection, gambling on luck.

In May and again in July, friends died of COVID-19. I was relieved to learn that despite my early lockdown gamble, I had tested negative.

The international death toll mounted. Lonely and afraid, I surrendered to what felt like suspended animation. I took daily breaks for grief. Seemingly with the whole world, I foraged for toilet paper. The collaborative team I had painstakingly assembled and found funding for to launch *Blued Trees Black Skies* fell apart. As spring advanced, everyone was clamoring for a return to "normal," a "before" of routines that began to seem like faded fairy tales.

A few years ago, when I had cancer for the second time, I studied the so-called cytokine storm phenomenon, an immune system gone haywire in response to threat. As lockdown ground on, it became clear that we were all living in a cytokine storm.

I raged and yearned and sulked in vain. My living expenses were coming out of the 2018 sale of a Manhattan co-op I had loved. I had bought low in 2005 with my share of proceeds from selling my mother's house after her death, in 2003. I was stranded in a small and exorbitantly expensive rented apartment for five months, alone in the eye of the viral storm, with no means of generating income but high expenses dissipating my nest egg.

But for me, the months wouldn't be aimless.

In the first weeks of the lockdown, I attended at least one Zoom meeting a day with colleagues as I gathered my thoughts. I hosted a Zoom for my webcast series, *Gulf to Gulf,* with my two longtime collaborators, the scientists Dr. James White and Dr. R. Eugene Turner, Jim and Gene, respectively, in this story. I called the episode "Stumbling Forward," describing how art and science might navigate our common future. At night, when I wasn't feeling too depressed, I often watched streaming performances from the Metropolitan Opera while musing on what kinds of productions would be the norm on the other side of this historical divide.

Before bed, I read a few pages of science fiction about female heroines in impossible worlds to inspire me to overcome surreal realities.

COVID-19's mark on society was first evident on the frail elderly, the poor, poorly paid first responders, people of color—most of whom were already suffering the handicap of a legacy as the descendants of slaves—or Native peoples on reservations. The price of inequity not only was reflected in human lives but also was the occasion of great reckonings for anyone who cared to pay attention. The most obvious reckoning was over race and class.

What many people came to call the "Great Pause" of the pandemic was also a great distraction from a disaster even more overwhelming than human deaths or economic hardships.

Because science has been part of my work for most of my career, I had known that this pandemic was coming as a leading edge of environmental collapse. I hadn't expected to see the United States fail so many defenseless citizens so miserably. Humanity was past due a deadline to reckon with challenges that our own species had created. The pandemic was another facet of our accelerating international ecological crises, from apocalyptic fires to annual one-hundred-year floods. COVID-19 was different only because it engulfed all the peoples of the entire planet at the same time.

I had thought we might have had the grace of another two to three years to get our act together. The grace period I'd hoped for vanished faster than I anticipated, but not by much.

The ecological writing on the wall was obvious in 1990, when I began *Ghost Nets*. *Ghost Nets* had combined elements of performance, science, and studio art. It had inspired trigger point theory, my ideas about how to effect greater environmental restoration with art. I had imagined that the compelling narrative and model I expected to create might contribute to stopping destruction. When the project was complete, in 2000, it was clear that I needed a greater effort to help stop the rendezvous with disaster. In 2012, Jim commented that we had been in the slow phase of climate change. Now he anticipated a geometric acceleration of impacts as we entered the fast phase.

Storms and I are old friends.

In 1994, a serious spring nor'easter washed ocean waves under the floor of my Maine studio, on the made-land southernmost toe of the *Ghost Nets* site, which protruded into deep water. The building stands on low piers, but high enough that the interior wasn't flooded. My first response was to rush down the hill from my home and splash through the waves in heavy winds to fling open the front door of my studio, with my heart thumping. I had been trying to capture in paint the experience of being inside a breaking wave crashing against rocks, a metaphor for change in time. I cast myself in the great tradition of J. M. W. Turner, the nineteenth-century English Romantic painter who lashed himself to a masthead in a fierce storm to engrave that impression on his mind before he rendered it in paint.

Turner's most famous painting of a storm at sea is *The Slave Ship,* shown for the first time in 1840. It is based on the true story of the *Zong,* whose captain deliberately threw 133 slaves overboard to collect insurance. The *Zong* presaged the future when it sacrificed 133 souls to a balance sheet. Turner expressed his outrage by accompanying his painting with an excerpt from an unfinished poem he was writing, which included the lines,

> Yon angry setting sun and fierce-edged clouds
> Declare the Typhon's coming.
> Before it sweeps your decks, throw overboard
> The dead and dying—ne'er heed their chains
> Hope, Hope, fallacious Hope!
> Where is thy market now?

Spring 2020, in New York, I foresaw that the greater storm would come from the same capitalistic greed that motivated the captain of the *Zong.*

In the last century, my family was tortured, was murdered, and committed suicide under fascism. As a philosophy, fascism prioritizes money above humanity, it privileges one color of people, and it renders common good expendable. Common good is defined here as what benefits an

entire community—for example, all inhabitants of a country. Empathy is jettisoned for the sake of the status quo market that the state depends on for stability.

The consequence of the pandemic for almost everyone was profound and chaotic dislocation from most space and time tethers. If arguments advanced by ecofeminists such as the historian Carolyn Merchant are correct, one reason we came to this dislocated crisis is because art, like gender and nature, was separated from science during the Age of Enlightenment, leaving an empathy gap. As doctors, nurses, and firefighters tended to endangered humans, artists were cultural first responders. But we were all vulnerable, and things were fraying at the edges.

The personal is political; the local is global. Many of our problems are as much about how we behave in our most private and intimate settings as in our policy decisions. My experiences provoke more questions: Is empathy essential to how living systems adapt to change? Can we be both generous and brave? Is the feeling state as critical to strategies of change as political actions and legislated policy change?

Thinkers have long tried to understand why empathy is so often in short supply. Pragmatists say that altruism serves human survival, whether by accepting sustainability limits to human populations or by recognizing the interdependence among species. Love for the other has been at the heart of most religious philosophies. From the Ten Commandments to governmental regulations, civilizations have tried to impose a measure of restraint on unfettered entitlement. Growing up, I needed a coherent story that connected empathy with my environment.

Consider these three words: *pity, compassion,* and *empathy.*

Pity has its roots in a religious experience of *withness* as a communion with divine mercy. Hundreds of years ago, *pity* and *piety* were synonymous and conflated with *obedience.* It is provocative to consider that obedience to the sacred coexisted so intimately with great class disparities, aggressive colonization, and subjugation of the nonwhite world. We think of pity as a close cousin of compassion, the capacity to completely feel another's suffering, perhaps because in our souls we recognize the sacred potential of bestowing mercy on another. Yet people often resent

feeling pitied. The implication is that pity is not the same as truly feeling the suffering of another.

Compassion might be more enlightened than pity. It implies the drive to do something about the source of suffering. Etymologically, the word might be broken down into *com-passion*, "with passion."

Empathy, however, goes one step further, understanding the other's experience on the other's terms. That requires us to relinquish the security and control of our own frame of reference or confirmation bias, the assumption that we know what we know, and do the work of living in the edges between ourselves and the other.

Empathy has attracted endless research and millennia of philosophical and creative attention. Quite a number of recent writings have singled out failures of empathy throughout public systems, particularly in the United States.

Jamil Zaki argues in *The War for Kindness: Building Empathy in a Fractured World* that empathy is an acquired skill whose acquisition profoundly changes us. If ever we needed to practice empathy for one another and ourselves in the heat of passion, now is that time.

We face two dangerous risks as we try to project humanity's future. One is patterns of learned helplessness. The other is a longing for fairy-tale happy endings, in this case, an imagined previous normal of a status quo. The term *learned helplessness* refers to all the ways we are trained to internalize and accept despair over impossible conflicts. I define fairy tales as all the ways we are lulled into searching for evanescent rainbows instead of negotiating with complexity. Fairy tales seem to reify a patriarchal worldview where dashing, rich princes rescue passive, threatened, but beautiful princesses.

On the other hand, some people find denial useful.

I have no quarrel with a legal and loving commitment between two equals. In fact, the aspiration to build a life partnership with another can be the height of human fulfillment. My quarrel is with how marriage can embody sexism and support patriarchies.

Patriarchy, defined here, is not about gender, although it does privilege gender. As it is used in this text, the term refers to a social system ruled

by powerful men that tends to prioritize property ownership and rigid masculine roles and can lead to totalitarianism. Patriarchy is the common denominator linking some conventional marriages to learned helplessness, fairy tales, fascism, and ecocide for everyone. Feminist writers have pointed out since the 1970s that romantic fairy tales can glamorize sexist abuse, including marital rape and child marriage. In real life, fairy tales can give only shallow, simplistic answers to daunting problems, such as parenting, joint property, and intimacy. But fairy tales are seductive.

Three men ignited the passion of my mature heart at different stages of my life. Each love was distinct. Each time I hoped for a lifelong partnership. I married the first one. The second man was a bright flame—handsome, colorful, pretty crazy, and ultimately unfaithful—but for a long time I thought he was the love of my life. "Love of my life" is an evocative phrase that plucks at heartstrings for most of us. Sadly, he developed dementia and died of COVID-19 in a nursing home while I was editing this book. The third man was much younger and wholly unsuitable but the sweetest of the three. When he found a true love to marry, I wished them well with a sincere joy in the happiness they had found. Any phenomenon, from love to violence, from water to energy, can be viewed as a system. Physics observes systemic patterns of order and disorder, terms that include degrees of symmetry and correlation. In chaos, a simple system can suddenly change because of anomalistic conditions. In complexity, a new order emerges from interactions among many agents. Algorithms can identify the smallest variables in wind patterns that become a major storm.

The significance of sensitivity to initial conditions is a fundamental assumption in chaos theory about tracking outcomes when many disparate agents closely interact. Sensitive initial conditions seem to attract the interest of artists like meadows of wildflowers attract bumblebees. Sensitive initial conditions are where I look for trigger points.

Complex systems describe the apparently random interactive situations that aren't random at all. A complex adaptive system (CAS) is a snapshot of how various agents continuously adapt to these highly variable interactions.

A complex adaptive model (CAM) establishes and applies rules to observe data in a CAS. Those observations can predict probable outcomes

from interactive relationships. Whether a CAM succeeds depends on two variables: data and rules. Data is the raw material. Rules establish parameters to observe predictive relationships in the data. Observing a conventional CAS relies on a set of simple algebraic rules for interaction usually based on Boolean theory—if, then, or—common in computer algorithms.

George Boole first published the premises of Boolean logic in 1841. They persist as constructs for software design and became critical to the fields of electronics and data mining and as a model for information theory. Information theory plays with a few simple conditions—if, then, and, yes, no—to identify rules to find answers to complex questions. A Boolean analysis algebraically defines knowledge by asking simple conjunctive, disjunctive, and negative questions: true/false; AND, OR, NOT. The if of any given interaction can reveal how, why, when. Trigger point theory defines Boolean conjunctions and prepositions between agents. OR, AND, NOT establish true/false logical conclusions. Prepositions designate spatial and temporal relationships to qualify a noun. These conjunctions, disjunctions, and negations in Boolean theory are basic to information theory, have a role in game theory, and are applied to warfare but also to strategizing solutions for peacetime problems.

The best rules reveal simple patterns, such as in animal behavior. Biological swarms are classic examples of simple rules: if a bird flies too close in migratory flight, then it must move to avoid a collision.

The CAS I have been observing is our present chaotic mess.

My core premise in trigger point theory is that the butterfly point of emergence that precipitates a tipping point can be identified as much by "embodied" or "tacit" knowledge from an art practice as by mathematics, shaping the outcomes of a CAM as an artwork. Embodied or tacit knowledge is not unique to artists. Indigenous people often believe it is conveyed in dreams and ceremonies. In the last century, the scientist and philosopher Michael Polanyi described how we internalize knowledge simply from being alive and sentient; making these processes conscious amplifies their power.

Any of us can find ourselves at any time at a point of sensitive conditions, where a small opportunity might intervene and establish a new order. But can we notice it?

Both physics and art might be considered reality checks on confirmation bias. Like scientists, artists are trained to observe life with dispassionate empiricism, which can be established by training, particularly in how students are trained to observe and record what they see, rather than what they expect to see.

As in physics, order, disorder, and symmetry are familiar in every aspect of the arts. Music has harmony. The visual arts have the golden mean, which posits recognizing and following ideal proportions in every aspect of nature. However, the verification of value in art is much less absolute than anything algebra can deliver. Enduring value generally follows centuries of subjective judgments. But we can't wait.

What caught my imagination most powerfully during my serious research into the physics of change was Maxwell's demon, an idea model posited in 1867 by the mathematical physicist James Clerk Maxwell. He proposed the hypothetical conditions of a closed system in which a "demon" might sort hot and cold molecules. The demon's behavior apparently imposed order on entropy and initially seemed to contradict the second law of thermodynamics. Physicists later understood that the work of sorting to impose order increased entropy. This insight is interdependent with Boolean thinking. The idea that reorganizing existing data to create new relationships could completely change a system fascinated me.

My dissertation identified six rules to apply trigger point theory to a complex adaptive model. Each rule for trigger point theory drew from other disciplines in addition to physics as much as from my personal experiences. The power emerges when they are considered in tandem, in relationship and cyclically. This is *how* I propose art can help find the *where* of black swans.

Each rule for my CAM emerged from both my research as much as from my personal experiences.

1. *There will always be a small point of entry into any chaotic system.* This idea is at the heart of chaos theory, a mathematical discipline that identifies emergence, the point where systems will change. I propose that the process of aesthetic analysis, often rapid and instinctive, dependent on tacit knowledge, can also identify points where systems change. Identi-

fying those points can have profound impacts on culture and, eventually, policy. In art as in science, attention to critical details and small points of entry is important.

2. *There will be critical disruptions in sensitive initial conditions.* This idea from complexity theory is that interactions between agents as points or nodes in any system are what determine the emergence of new systems. The observations of those interactions can predict futures. I argue that art functions with and observes anomalies in those sensitive states of interaction. Any set of sensitive conditions is vulnerable to disruption. Chaos and complexity are both theories that project into the nonlinear world of nodes in systems.

3. *The paradox of time and urgency is that there is time to change.* Even when there's urgency, we have time. Newtonian physics presumed that time is linear and immutable. Einstein proved it isn't that simple. Physicists are still grappling with the relationship between time and space. In the context of trigger point theory, time takes on complexity based not only on the physics but also on the perception of experience as we struggle to scale up solutions and make wise choices for long-term sustainability. Even in times of urgency such as ours, strategic planning has to take many variables into account.

4. *Layering information will test perception.* This idea is borrowed from the work of the late Ian McHarg, the father of landscape architecture, and from how geographic information system (GIS) layers statistical data about reality to identify points of logical convergence and probable prediction. McHarg drew topographic and demographic elements onto tracing paper. He used the resulting composites for his landscape analyses. The military was already using this process of layering to determine war strategies based on statistical information. The power of visualizing data this way is routinely illustrated when the *New York Times* creates GIS maps of voter distributions and behavior.

5. *Metaphors are idea models.* The work of George Lakoff and Mark Johnson showed that metaphor is crucial to many forms of human thought and very important in political narratives. My personal experience of

rape would embody the most visceral metaphorical idea model life gave me. It was a fulcrum connecting my personal story to what became an ecofeminist political analysis as the CAS we need to reorganize the agents that result in ecocide.

6. *Play will teach.* The philosopher John Dewey asserted this principle in his writings about art and education as a means to provoke imagination and original thinking. Game theory echoes this assumption. This may be the most important of the six rules for bringing traditional ideas about artmaking into culture.

Collectively, these rules identify how art can observe emergent transformation in systems and triage interventions. Because building a CAM is one way to consider relationships between disparate factors, the result is sometimes called a "knowledge space." I am suggesting that trigger point theory creates a different kind of knowledge space.

In 2012–2013, I applied the rules I was developing for trigger point theory to how interactions between agents might work to restore finfish populations in the Gulf of Maine. I used GIS mapping to compare data collected by a friend of mine, the late ecologist Dr. Michele Dionne, former director of the Wells National Estuarine Research Reserve in Wells, Maine, just before she died, about an invasive species, European green crabs (*Carcinus maenus*), and finfish abundance. Fishermen I knew in Maine told me there was a significant relationship between intact ocean eelgrass (*Zostera marina*) habitat and finfish. The fishermen knew that these beds are critical offshore habitat for baby fish. The green crabs, described as "voracious predators," eat fish larvae, and their movements disrupt eel grass beds.

I combined Michele's data with eel grass habitat mapping I collected from public sources and further correlated the presence of mercury from carbon emissions and runoff from cars in a coastal parking lot. A small intervention might have been to put in a vegetative buffer as a filtration system in the landscape between the parking lot and the shore to reduce mercury poisoning, which also impacts eel grass. Another trigger point emerged from my research: dumping ship ballast farther out to sea could mitigate the migration of invasive species such as European green crabs into estuaries before they even reached eel grass. Although my analysis

wasn't conclusive, the data didn't disprove my hunch about how reorganizing habitat data might identify trigger points for the restoration of finfish populations.

If we can reorganize data to effect change in open biogeographic systems, I wondered, could applying trigger point theory also change environmental policies? *The Blued Tree Symphony* applied the rules of trigger point theory to laws about ownership and Earth rights. The legal theory that emerged connected the originalist definition of art in copyright law and the terminology of the "sacred" home in eminent domain law.

As lockdown crept forward, in June 2020, it became very evident that finding our path forward to common good was a stonier landscape problem, in the broad sense of landscape as a complex system in continual states of adaptation, than the one I once studied at Chillon.

At Chillon, I had started with blank white paper.

I have other memories of white.

White page. White canvas. White snow. White clothes. White clouds and sea foam. White reflects a full spectrum of light, which makes it the sum of all possible wavelengths. Art often starts as a white surface but manifests in many colors and forms. Symbolically to me, that makes white a space of ultimate uncertainty, possibility, and the future.

Black is different. It is the absence of light. It can exist in nature without light. As spectral color in physics, white functions like black. Both are invisible.

Both extremes of the spectrum of light represent a kind of certainty. In human history, certainty, stability, security, and equilibrium often equate with periods of peace and prosperity. On the other hand, a judicious soupçon of uncertainty, unpredictability, and disruption can prompt emergent creative adaptation when stress is encountered.

Logic tells me that stability is a consequence of time. Social science lends depth to how the physics of change in time applies to human behavior. I need only common sense to tell me that equilibrium is a fairy tale these days. Still, common sense never stopped me from yearning for fairy tales.

"Begin at the beginning and go on till you come to the end: then stop," said the King to Alice in a topsy-turvy world. Lewis Carroll, the pen name for Charles Lutwidge Dodgson, led his readers through the phantasmagoric world of his young heroine, where conventional rules were relinquished. He wrote *Alice's Adventures in Wonderland* eighty years before I was born.

During the first days of emergency self-isolating for the pandemic, Brian Droitcour of *Art in America* interviewed me for an article by Eleanor Heartney on the ecofeminist roots of current ecoart thinking, featuring *The Blued Trees Symphony*. In those early days of the lockdown, I was still philosophical and sardonic about our internment and the long dance we had commenced.

We were talking about the pandemic. I told Brian, "If we imagine Mother Nature is real and sentient, then she has designed the best installation performance event ever: lock up all the humans and make them hysterically forage for toilet paper." That reflected my thinking about art and life—not art about life or imitating life but that art could be determined by life, as the branch in my studio had choreographed a dance between people and space.

If we agree that great art must affect a great audience, what greater audience could there be right now? Life could not have designed better art. Mother Nature created a performance score that forced us all to negotiate with radical uncertainty together, like a monstrously scaled-up version of my studio branch. Each agent of life we depend on was dramatically disrupted.

But could this be where art would manifest as a first responder to leverage anomalies in sensitive conditions to create a trigger point? *Art in America* published this excerpt from my conversation with Brian:

> Delacroix expressed the spirit of art when he painted the spirit of the second French Revolution in 1830. In 2020, painting the spirit of resisting this fascist state is not enough, not by a long shot! Any artist goes through this spiritual process of internalizing the times and regurgitating something that makes sense. But it's very hard to see how most pictures on a wall could express the zeitgeist now. For

me, it has everything to do with our relationships to wider global biogeographic systems. We need to learn how to understand our relationships with the elements of nature we depend on, like trees. I'm not reactively turning nature into art. I'm making art from my relationships with nature. I identify as an ecoartist, a genre that emerged from working with nature. That is quite distinct from environmental art, on or from nature. This is not the same as working with nature, which is what we really must do if we're going to survive as a species. We have to figure this out.

What I considered most important in my answer was the preposition *with*. *With* is what distinguishes compassion from empathy. *With* is the analog of the Boolean AND and the trigger point I'm trying to find for hope.

If the task now is to live sustainably *with* other life to preserve our own lives as agents in a complex and interdependent ecosystem, then we must first consider our relationships.

What Brian understood better than I was that most people need to know they have an anchor on board before they set out for a long journey in uncharted waters.

In *The Blued Trees Symphony,* the trigger point in the legal system was where current ownership laws defeat environmental justice and common good for most people, or the planet, versus creating a model for different relationships.

Lewis Carroll knew something about unfamiliar worlds and unpredictable outcomes. It's been more than 150 years since he wrote his delightful allegories that are so prescient for our miserable ecological present. His walrus was a study in rearranging data:

> "The time has come," the Walrus said,
> "To talk of many things:
> Of shoes—and ships—and sealing wax—
> Of cabbages—and kings—
> And why the sea is boiling hot—
> And whether pigs have wings."

As the pandemic wound on, I was rearranging what I thought I knew to make sense of how U.S. racism supported ecocide, how the nineteenth and twentieth centuries had galloped through the American Civil War, suffrage for women, the civil rights movement, a plethora of uncertainties, to bring us to the Pandora's box of horrors revealed by the pandemic. In Carroll's time, as today, the relative beginnings and ends of disruption left many people flailing in pathetic uncertainty and hurtling toward death. The antecedents of my future trailed behind me in my parents' lives.

I was negotiating around the dead and the living.

"Begin at the beginning," the King told Alice at her trial, "and go on till you come to the end: then stop."

My own beginnings were complicated.

2

At the Beginning

I was conceived in winter. It was the end of World War II, a time of sensitive conditions in the world. The Allies had liberated the concentration camps in Europe, and the world learned the extent of Nazi perfidy.

August 1, 1945, an agreement was declared in Potsdam, on the river Havel, near Berlin, between the United Kingdom, the United States, and the Soviet Union that effectively ended World War II in Europe. On August 22, 1945, I became a firstborn American in the French Hospital in Manhattan. Being born a girl was the first time I disappointed Father, who had expected a son to build an empire.

Mother said I was born with the dawn, a sign of new hope. But she may have been unreliable. My birth certificate says I was born at 8:30 P.M. My timing had to have been close to when Mother learned her parents' fate. Perhaps my birth came at a trigger point in her life.

Growing up, I heard Mother say I was an ugly baby. Then she countered that by saying I grew up beautiful, like an ugly duckling becoming a swan. What was ugly were the events that took Mother's parents.

My parents had fairy tales. Their marriage defied the gulf between their parallel hopes for a peaceful life in Palestine.

Both my parents told me stories about their previous lives in Eastern Europe, recounting how before emigration their entire communities had saved money to buy land from Arab overlords in Palestine. Father's conflict was between Zionist ideals and the growing conflicts his Arab friends might have experienced with Jewish communities over land. He always managed to charm enemies and make bridges between powerful people from all backgrounds but couldn't create reliable common ground between Arabs and Jews.

As refugees early in the last century, my parents had both joined relatives in Palestine. Besides my mother's parents left behind in Poland, my father's older brother, Uncle Efrain, was left behind in Russia. Both families had been established in Palestine at least from the nineteenth century. But their respective experiences of Zionism were very different, with different implications. Father's vision was contingent on risk. Mother experienced Palestine as a safe harbor after losing most of her family to the Nazis. She yearned for stability, often quoting from Jane Austen's idealized portraits of domestic bliss in a far more stable world than Europe, Palestine, or her own marriage could offer. They each described their love as fundamentally a friendship that endured most of their conflicts for most of their lives.

The name on my birth certificate remained blank for two weeks. My parents finally chose Aviva, a Hebrew word that translates as "spring" in English—the light that comes after darkness, green after ice and snow. "I thought we would move back to Palestine. That's why we named you Aviva. Many children then were named Aviva for girls, Aviv for boys, to celebrate the birth of a new nation, a new era."

In 1948, Ben-Gurion declared independence for the State of Israel. That was also the occasion of what Palestinians call the "Catastrophe," when an estimated 80 percent of the Arab population was expelled. Ever since, the two peoples have battled for ownership of the same land, using different names for it. How conflicted did that leave my father? In the 1970s, he had a serious falling-out with one of his best and oldest Jewish Israeli friends, a man who had escaped the gas chambers by crawling out over dead bodies as a young child. My father was against expanding the settlements; his friend was not. Father's disputations over Arab-Israeli

relations continued for decades, until every leader he had known was dead and he was in failing health.

What's in a name? By the time I was born, my politically adventurous father had long ago changed his original name, Gabin, of Romanian origin, to Rahmani, a common Middle Eastern name, to protect Efraim from Stalin's anti-Semitism. Father imagined that the name change would obscure the trail back to Efraim from Father's Zionist activism.

The middle name on my birth certificate was eventually listed as Alexander, after my father, as if my father were willing me to be the boy he wanted. Later, I started writing it as "Alexandra" whenever an official form requested my middle name. That's how it appears on my passport.

I have always been acutely aware of the implications of naming. Recently I have encountered other Avivas, but for most of my life, I almost always had to spell the name several times for any stranger hearing it for the first time. I often added that it is a palindrome, to put my questioners at ease. The next question was inevitable. "Where are you from?"

For a time, I wanted to be called Juliette, which sounded more American to me in the 1950s. In high school in Switzerland, I called myself Vivienne, reveling in my freedom from the controversial historical narratives that my name saddled me with. Later, I considered legally changing my name to Alexandra Gabin. My older sister, Ilana, liked my middle name so much that she appropriated it for herself as she went through school, nicknaming herself "Sandy" and leaving me even more disassociated from my own identity.

According to Mother, Father had minimal interest in me for the first years of my life. Did she say that only once? I felt blamed for my gender and my father's disappointment. In my mother's family of blonds, Mother had fair skin but black hair. My maternal grandfather, Joshua Zoltoc, had rejected my mother because after her birth my grandmother suffered from epilepsy. He also hated her coloring. He once threw a fork at her forehead, leaving a mark, and cursed her by calling her "Blackie."

When my parents met in Haifa, Father told my mother he was a night watchman. She was relieved to think he had a steady job. They married two weeks later. He left out that he was patrolling Mount Carmel for the Haganah, a paramilitary organization resisting British rule.

By the 1930s, the British had a price on Father's head. My parents became refugees again and fled with my infant sister in 1939. I learned the reason for the price on his head only last year: he had shot and killed a British officer.

My parents' flight across the Negev Desert was life-threatening. My sister was two. She says she still remembers that when they spilled their water, she and my parents were forced to drink their car's radiator water.

The small family continued east, through India and Japan to Canada, passing through Winnipeg, where my mother's brother Harry had settled, then to the United States, where my parents lived for a while in Massachusetts as farmers before moving to New York City, where my father went into the import-export business, which had been his father's occupation as well before his murder.

"We moved from this beautiful farm with a big house to a tiny apartment in New York City," Mother told me.

When I was two years old, we moved again—this time to Tarrytown, in Westchester County. Shortly before the move, I nearly died. I was in the hospital for two weeks with a respiratory illness, probably a complication of rheumatic fever. My therapist tells me my hospitalization would have had a profound effect on my affective relationships. All that remains is an abstract memory of whiteness and a recurrent metaphor of blank canvases.

According to my mother, I didn't talk until I was two. I think that must have been after I was released from the hospital. Perhaps I had been waiting for my father to take an interest in what I might have said or for my mother to declare me beautiful. I imagine that when I survived and left the hospital, I might have decided to give up waiting on approval from either of them before I spoke.

Contemporary standards would consider the treatment of infants and young children in the 1940s as not only misguided but cruel. Children were not to be coddled. Children were meant to grow up as independent, self-reliant little adults from the very beginning. Responding to their emotional needs could only spoil them for the rest of their lives. Could the touch deprivation that many children experienced under stress have

emotionally crippled an entire generation? Can we blame misguided child psychology for confirmation bias or an empathy deficit? This idea about institutionalized deprivation could be another kind of butterfly effect. It is tempting to extrapolate further and speculate about how trust develops in childhood and its role in sociopolitical as well as interpersonal behavior in adulthood.

The white nightmares didn't leave me for a long time. The memory of white, and waking from a white nightmare, has recurred throughout my life. Nor did I ever stop longing for simple answers to complex situations, to know how to avoid catastrophes like those my parents survived—perhaps how to be a blank canvas.

That time may have been even more traumatic for my mother than it was for me. As I was growing up, she told me many times about those two weeks we were separated and how the doctor wouldn't let her see me.

"He was a Nazi!" she said.

I understood how the word *Nazi* evoked horrors for my mother. I wasn't in the habit of questioning my parents' statements, especially anything that might evoke their painful engagements with history. That could only connect me to miserable feelings and confusion: What were my lost family's last moments like? How could people perpetrate such monstrousness? What was the full story behind what had happened to my grandparents? I didn't want to know why she called the doctor a Nazi, and she didn't volunteer her thoughts.

When I was a little older, I looked for answers in my dreams, where dangers were abstracted. Lucid dreaming emerged as an answer to my nightmares. It was an intuitive practice. At night before I drifted off, I schooled myself to systematically solve the problem of threat as I slept. Year by year, I methodically progressed from escaping monsters by flying to outwitting gangs of men with my cleverness to protecting not only myself but others, as well.

Father had intimidated Mother early in their marriage by knocking her down in a jealous rage. When I was in my forties, Mother confided that her parents had asked her to save them. Intimidated, she never asked my father to help them.

Today, instead of being warned off by fears and complex discomforts, I am often relentless about getting answers. As a child, I knew only that the veil of denial was an emotional steel door. As an adult, I know that explicit monsters can lurk in gauzy mysteries.

I wonder whether my mother's references to my doctor as a Nazi were rhetorical or literal? Given that there were a number of Nazi sympathizers in the United States, it is possible to consider that the doctor may indeed have been anti-Semitic. He might have expressed his intolerance by denying empathy to a specific infant. Or he might have been a rigid person who subscribed to the "tough love" approach of Skinner boxes, a steel cage that deprived infants of any sensory stimulation, accepting the cries of all children, as was fashionable then. Or he might simply have been a busy man with numerous patients, too concerned over his own children at home or his hemorrhoids to dally over one baby, one mother. I know how to add layering to my perceptions. But it leaves me emotionally bloody to try to sort out the motives and responsibilities of long-dead adults and the consequences of their decisions.

My sister was fond of reminding me that our mother "let me cry" as evidence of healthy lungs. So, if my mother faulted the doctor, she had a double standard. Or was she still just overcome with grief over the loss and suffering of her own family in the Holocaust? Silence normalized cruelty and denial.

On the other hand, where was my father? If the doctor was unreasonable, surely my father could have intervened. Although he was a short man, my father had a powerful presence, honed by the many traumas he had survived. Was my mother unreasonably angry with the doctor for an indifference the doctor shared with her husband? Did she have the temerity to confront either one? Was my father really indifferent, or did he simply have his own priorities—such as his honor, his empire, or the uncertainty of matters of life and death for his Arab friends in Palestine? Did he know the implications for my mother of his in-laws' fate? Did his troubles preclude worry over his daughter's life? Might my mother have angered my doctor to the point where I was collateral damage in a gender-based power struggle? In 1947, I doubt many male doctors in

a large hospital would have tolerated a woman's strong opinions or needs, even if they were about a dying child. I wish I could go back in time for answers.

I suspect that whatever the details of these relationships, those two weeks changed me. They must have disrupted my equilibrium, although not enough to kill me. Perhaps partly for that reason I have always had a conflicted relationship to equilibrium: yearning for fairy-tale stability while running from the deadly white boredom of security.

What we know from disruptions in biological communities is that short of complete collapse, they often foster creative diversity. Disruption can contribute to resilient systems by triggering adaptations in species or establishing new iterations and edges in ecotones. Perhaps those two weeks somehow even contributed variables that have sustained me as an artist.

Change is only linear in retrospect. Science tells us that in the moment of emergence and self-organization, the best we can do is identify which significant agents might be interacting by what rules of behavior and the probable outcomes based on those rules. The change that concerns me is the point where potential adaptation in sensitive initial conditions can be studied as a complex adaptive system.

The French Hospital closed long before I might have gotten my medical records. Information about those two weeks could be useful. A history of rheumatic fever has implications for heart health, one more risk factor during the pandemic. Mother was a smoker. Could her smoking have contributed to my respiratory illness? Could the stress of my parents' adaptation to unspeakable realities have been a factor?

How much can early experiences determine a life? Can I blame the doctor who saved my life when I was two for any loneliness I feel in lockdown or my health vulnerabilities today?

I think when I was hospitalized at two, I couldn't breathe because history was suffocating me.

I always choose the window seat when I fly. Even on overnight flights, I prefer to spend time glued to the window rather than sleeping. As the

white clouds and variegated terrain scroll past beneath me, I sketch and take photographs. Clouds are hard to draw with black ink, capturing subtle transitions between light and dark. I enjoy the self-discipline of wrestling with an impossible aesthetic task and can spend hours struggling to translate lines on paper into soft shapes as a plane eats up distance across the planet. It is like a puzzle game. But as soon as I land, I am always desperate to escape a claustrophobia that has overcome me.

I have always preferred dead white walls and have often painted how daylight from a window modulates the variations of white on a wall. But during lockdown, my white walls closed in, evoking my early nightmares of hospital white.

Green. I am seven. We are having an early summer thunderstorm. A monster thunderstorm is my favorite weather. It never scares me the way monsters scare me in my dreams. The lightning energizes me, and the thunder thrills me. I breathe in the heady fragrances of ozone, wet leaves, and damp soil. I am surrounded by the pendulous branches of my favorite climbing tree, the weeping beech behind our home. I am the best tree climber in my neighborhood. Mother requires me to always wear a dress and dress shoes, but no matter how high I climb, I always return spotless.

Snapshot of the author as a child. Date and photographer unknown.

Raindrops tapping the leaves make music with a gentle rhythm. I am safe from all worries in my tree shelter. I imagine the tree as a loving grandparent I never had: strong, wide-trunked, easy to climb, and with space to sit in the crotch between two wide branches and look out on the world from a superior position. I love the smooth gray bark of the tree, like the skin of an elephant might feel if an elephant would let me pet it.

If I could see between the dense summer foliage of the trees, I would see all the way to the Hudson River. I can see the river from my bedroom window and often spend hours just staring off to the water before falling asleep. I note how the land changes from the high point of our property as it descends to the water and then ascends again on the far bank of the river to the Palisades.

I kneel on my bed and watch the building of the Tappan Zee Bridge, how the workers' string of lights steadily reaches across the river to the Palisades. Each night, the lights crawl a little farther to the other shore, until the bridge is complete. Those lights teach me how people negotiate a river that cuts through a landscape.

Once I was old enough to have conversations, Father began teaching me about soil, land, and ownership. He had an abiding interest in farming, and we found a context for our relationship in which I could accept his lessons. On summer weekends, we worked together in the modest family vegetable garden behind our house. He showed me how to stake tomatoes and pull weeds. I observed how light, dirt, and water nourish food.

I learned the value of asking good questions from him. At our Passover table, my father sang the text of redemption in his beautiful tenor. As the youngest, I was always tasked to ask the Seder questions. After careful attention to the standard questions and answers, I was encouraged to participate in the discussion that followed about the meanings of the text, such as "What is freedom?" That was when I understood that a sharp intellect could win me adult approval and capture my father's attention.

In addition to lessons from my father, curiosity taught me the fundamentals of ecotones, how layers of habitat permit the transitions from one geographic shape to another that assure ecosystem stability, from soil to tree canopies. On weekend afternoons, my mother and I sometimes

took the train into the city to attend the ballet. We sat by the window on the river side, and I remembered my observations of the river at night. Coming and going to Tchaikovsky's *Swan Lake* or Stravinsky's *The Firebird* on the train, I studied how the currents moved the waters in complex ways and how the levels of the Palisades lifted and then graduated as we approached Grand Central. Those were wordless lessons about land and water.

As I watched the waters of the river swirl scant feet from the tracks, I could feel the life of the river in my own body as intensely as I felt my heart surge when Maria Tallchief defied gravity to leap and spin in *The Firebird*. Later, I would admire the gorgeous whimsies of Chagall's staging and costumes for the ballet and keep them in my mind to inspire a future production of my own. Polanyi's work on tacit knowledge had not yet been published in 1958, but I was absorbing a rich and diverse knowledge base and an understanding of how systems work long before I could articulate what I knew. Ecotones, the ballet world, and swirling river currents were shaping my imagination.

After school, I often walked down the hill to the river. If I turned right before the road continued west toward the railroad tracks, I came to Tarrytown's Warner Library. There, I could bury myself in the children's section. I think I read every book in the room, with particular attention to fairy tales. Later, I graduated to the adult sections of the library and read Russian writers like Dostoevsky. My most prized possession was the complete works of Hans Christian Andersen, a birthday gift from my mother when I turned ten. Later that same year, my mother bought me the *Encyclopedia Britannica,* and I began vacuuming up ideas. From her own library, I read and reread Montaigne and Boccaccio.

In those early years, I was learning empathy for the world around me through the filter of art. When I walked down the hill to the library, I passed brambles and skunk cabbage in each habitat transition, expanding the biological library in my mind as I learned more about ecotones, from hillsides to tributary streams that fed the river. I was building a smooth and durable road to my creative world.

But roads require a firm fill base to be reliable, and the life of the imagination has its own challenges. My rambles were not always happy.

From a very young age, I was prone to profound depression, even attempts at suicide. I deliberately ran in front of cars, hoping to end the sadness and loneliness that filled me. Did my depression begin in those two weeks alone in a hospital when I was two? Was I genetically prone to depression? Had I epigenetically inherited my parents' posttraumatic stress from their experiences of war? Was I, as one therapist suggested decades later, just a bad fit for my family? Seventy years later, the cause matters less than the hard-won insights I wrestled from my battles to survive.

As the lockdown spring went on, encaged in my Manhattan apartment, I ate ice cream and gorged on Zooms, devouring topics.

The biological economist Brian Czech presented his ideas on my *Gulf to Gulf* Zoom during lockdown. He argued that steady-state economics must be grounded in honesty about our social impacts, in basic empathy for species perishing under the burden of so much habitat extraction.

As I reflect on empathy, I consider the two poles of empathy and cruelty—my own and the world's. Isn't either empathy or cruelty just another system that defines power or powerlessness? I can connect dots between economic inequities, such as those that Brian Czech studies; personal behaviors that nurture cruelties, such as leaving a child without her mother for two weeks; disassociations from our experiences, such as my mother's inhibitions and silent frustrations; and the extractive industries that destroy cultures and stable ecosystems. Human babies and young animals display natural empathy. Most adult humans have an instinctively protective response to infants of all species, including our own. So evidently, we need to be taught cruelty to exercise it and can be trained out of empathy. For what purpose? I cannot see rational purpose in caging the young children of immigrants and refugees.

The discomfort of many purchases the comfort of a few? If that's the case, then maybe many of us need reeducation.

How much cruelty did I learn—to practice or accept? Did my early years teach me warring philosophies? Cruelty at war with empathy? Isn't a reasonable relationship to land and landscape rooted in empathy? Isn't cruelty at the heart of ecocide? Many artists have been known to be intensely cruel; yet isn't art itself an expression of empathy?

Over time, my relationship with Father increasingly swung between love, terror, and, eventually, hatred. Over and over, we tried to find common ground and failed. He had been a boxer. He tried to teach me to box. I cried.

There was the day he tried to teach me to fish. In a rowboat with me, he picked up a worm and threaded it onto a hook. I became hysterical at the thought of the pain the worm was experiencing, ending the lesson and leaving my father baffled.

Another time, the entire family was walking up the steps to our front door after a temple service, when I felt something tickle my leg. When I looked down, I saw what seemed like an enormous black beetle and screamed. My father brushed it off me and crushed it, which made me even more upset. It seemed like weeks before weather eventually washed away the beetle's remains. Until it had entirely vanished, I gave the scene of the crime as wide a berth as possible. My responses to animal pain and death, even in insects, were unintelligible to my father. Perhaps that was because what he had endured in his life would be forever so much fresher.

The summer I was seven, Father took me to an Arab wedding in Israel. This must have been in Haifa, the city by the sea where my aunt Tziporah, Father's sister, lived. I adored my aunt, with her bright red lips, musical laugh, and waist-length black hair. She was an actress, and her Hebrew name meant "bird" in English. I thought she was like a beautiful bird, and I wanted to be just like her when I grew up.

Father was on my right, and I leaned into his solidness. Half the pleasure of that afternoon was that it was just He and I. He was laughing and happy. I was terribly excited by all the new sights and sounds and tastes. It was a sunny summer afternoon, and we were with Father's friends, part of a crowd of celebrants seated in a big circle on the ground, surrounding the dancers and musicians. I remember happy voices speaking Arabic. We spoke many languages at home—Russian, Hebrew, Yiddish, English, later Spanish—and I had picked up a few words of Arabic from Tziporah's maid, whom Tziporah called "Honey" (although I think her real name must have been Hana). I don't think I understood the talk around us. I had so many experiences to absorb simultaneously. That day, pure sensation crowded out memories of mundane details like words.

I took in the brilliant swirling skirts of the performers, whose presto motions and lively rhythms remain so vivid almost seven decades later. A wild red burned into my consciousness from the dancers' long dresses, reminding me of the scarlet costumes of *The Firebird*. As the dancers flew by, we ate exotically spiced, delicious food with our fingers. (That is something I would never do in public today without flinching.)

That summer I saw a beautiful red bird across the wide lawn where we were staying. Breathless and motionless, I wondered at the bird's beauty. Suddenly, a cat appeared and pounced on the bird. That memory left me hating cats until I had my own.

I disappointed my father a second time later that year. In addition to the cello, my father played the viola. Ilana, my older sister, was already an accomplished pianist. I began violin lessons with the vague anticipation that one day we might all play chamber music together. But harsh squawking sounds came out of my instrument. After a school concert, another student violinist made a contemptuous remark about my bowing. I felt so discouraged that I begged my parents to let me learn piano instead, the "easier" instrument. I accepted my father's disappointment and continued to study classical piano well into my graduate years. I made it a centerpiece of my master's thesis and then pursued bel canto singing and music theory. Long after my father's instruments had disappeared from my parents' home, song gave me joy.

For the ten years after the Arab wedding, we often returned to Israel in the summers. As my naming had promised, the new nation seemed a place of hope. The summer I was twelve, I remember dancing and singing in the streets of Tel Aviv (which means "hill of spring") in the warmth of the evening—cousins and friends, Arabs and Jews together, as my parents had once presumed would always be Israel's reality. But when I think back, I question whether the young Arabs I remember dancing with were really there.

The adults in my life seemed to believe we would all live together harmoniously even though there had already been violent conflicts between Arabs and Jews. Those conflicts existed when we attended the Arab wedding and while I was dancing in the streets, but perhaps the consequences of Jewish settler belligerence weren't as evident, or minds on both sides

were not as locked up with bitterness, entitlement, and desperation—or I was just too young to know.

When I had my genetic analysis done, 67.9 percent of my code went back at least two thousand years to historical Israel. Does that make me 67.9 percent indigenous to that region? Did I imagine Arab dancers who were ghosts of a common community? Does all war come down to a lethal adult game of who wins power based on presumptions about what we think we know?

"In Russia," my father told me, "Jews couldn't own land, so owning land in Palestine had great symbolic importance." Later, I thought that was one reason why he understood the anguish of his Arab friends. After he left Palestine, he started buying land wherever he went. My mother came to call them his "shopping trips." After he was declared incompetent, she gave up trying to find the deeds or reclaim the properties that weren't in the United States. Instead, she had me help her sort out the contracts for rental properties they still owned and decide which land to sell at what price, until all that was left was her own home in White Plains, New York.

In the beginning, I don't think either of my parents imagined a time when the lands of other people in Palestine might be taken by forcible fiat. At the Arab wedding, I had been safe, a child loved by my father, loving him for giving me those wonderful moments, thrilled by all the vivid sensations and perceptions I was taking in, with no thought that disaster might lurk just around a corner.

During my childhood in Tarrytown, my parents often entertained visitors from Israel. I understood and spoke an indifferent Hebrew but wasn't very interested in their conversations. I was happy to escape the adults and commune with my tree. If I had stayed and paid attention, I might have witnessed history. Our visitors were leaders of the new State of Israel. My father was arguing that they should not have given the money to finance the building of Yad Vashem in Jerusalem, the memorial to Holocaust victims like my mother's family; instead, he believed it should have gone to the Arabs as reparations for land appropriation. I was eight in 1953, when Yad Vashem was built.

Instead of listening, I went to my tree. Later, I realized that even in the midst of those arguments about Israel's future, Father must have been hatching plots to acquire more land.

What I wanted in those days was what I had seen in my best friend's midwestern Presbyterian home. Her family gathered in front of their fireplace. I always wanted my own family to gather the same way. No one in the neighborhood had a television yet. Families gathered to relate to one another in the evening. Our living room was the center of our common activities.

It was rare for all four of us to gather in the living room, but we always had dinner together in the dining room. On the one occasion I insisted after dinner that we gather in front of the fireplace, my sister grumbled— what was the point? By then, she was well into her teens and perhaps had little incentive to convene with her family.

We lived on a high hill with a steep driveway, our house towering over the other homes on Altamont Avenue. The room had a large picture window that looked out on our modest front lawn and beyond to the river.

My father always lived in places with spectacular views and eventually was buried in one such place. That was even true in the nursing home where he lived his last days. If I faced the window in our house in Tarry-town, the fireplace was behind me, with some seating and a polar-bear skin in front of it. To my right was the baby grand, where my sister and I practiced. In front of the window were some chairs and a coffee table, where my parents gathered with guests. The piano had enough room around it that I could pretend I was dancing in *Swan Lake* as my sister played Bach. Sometimes my father stood near her and played his viola.

At other times, my mother and I sat before the fire in the evening, filling in coloring books, she in a chair, while I sprawled on the floor at her feet. Once, I looked over and noticed she was coloring in the shapes very lightly. I was perplexed, even annoyed.

"Why are you coloring so lightly?"

She seemed as puzzled by my question as I was by her pastel hesitancy. I thought coloring lightly was a waste of time and good paper. It

seemed to me that the goal of having a white page defined by black lines was to colonize as much of the surface as possible with bright colors. Red was my favorite color.

I often sat with my father and asked for a story. Alternately, I wanted him to scratch my back, and he patiently obliged. He called me his princess and told me stories that always seemed amusing—about fights he'd won, about surviving being shot, escaping from the Bolsheviks, and being rescued by his schoolmates, about a man falling from a building, about someone he shot. Because he laughed, I laughed, too. I was learning that casual cruelty could be entertaining. Violence was normal. Defiance was admirable.

None of Father's stories ever explained why he sometimes cried out the word "fire" in Russian in his sleep. I didn't ask, but his cries from the bedroom next to mine on the first floor of our house echoed as fear in my own nightmares.

There are many anecdotal accounts of people in close relationships sharing similar dreams. I will never know what memories prompted my father's cries of "fire" in the night, any more than I would have asked my mother what she thought had happened to her beautiful Polish relatives. But I wonder if my father might have been reliving fleeing the burning of his home where his father died during the Russian Revolution and whether he felt the same terror of monsters I woke from as a child. Fleeing dangerous monsters seemed to be a refrain in my father's life that has reverberated in mine.

I am sure now that my grandfather died in the fire that haunted Father, murdered by revolutionary violence. Many times, Father recounted the details of how he had fled Odessa as a teenager with his mother, sister, and younger brother. Perhaps he repeated it to find closure. His stories never clarified why they'd left Efraim behind.

My Russian cousin, Efraim's daughter, Ludmilla, said he became an economist. Father said his brother was remarkable. Tziporah said Efraim also became an admiral in the Soviet navy. Stalin still sent him to die in Siberia. Online accounts of the Imperial Russian and Soviet military tell confusing stories of intense anti-Semitism, defied by a handful of Jews who rose with distinction through the ranks anyway.

As a child, sometimes I sleepwalked through the house. We never spoke of that, either. Answers to trauma were casualties of my family history, lost truth drowned in time.

My reluctance to ask serious questions that might have explained my parents' experiences or even how their past histories shaped my own experience was a matter of deliberate disassociation between cause and effect. It seems to be a dangerous skill that war refugees and their children develop and share—dangerous because secrets never die. But I was expected to learn that skill as much as I was expected to master cooking, gardening, ballet, or music.

The most important skill that my mother wanted me to learn was the exercise of courage. It was a limit to test—so I dangled myself over the banister of our porch, above a sheer drop to the driveway twenty feet below, in front of her, knowing full well I was teasing her fear. She said nothing as she watched my acrobatics. A consequence of my bravado was that I never learned appropriate fear. Instead, I internalized posttraumatic stress disorder (PTSD) from both parents.

Inherited PTSD has recently become a topic of epigenetic research, with evidence that a parent's trauma leaves chemical markers on the child's DNA. What are those implications? For me, it has meant a lifetime in therapy, trying to answer impossible questions about why dots didn't connect.

When we first moved to Tarrytown, the big Westchester estates were just beginning to be broken up. Our neighborhood still had rural touches. It had empty lots entangled with brambles and populated by wildlife, where I could play hide-and-seek with my friends, and green suburban lawn vistas punctuated by stately trees and mesmerizing small streams and ponds, where I could watch turtles and frogs.

My father's business was to fill each empty space with a nice well-built house, to be sold at a good price and used to pay our bills. He understood the value of a large tree and took pains to protect as many as he could. But each new home further fragmented the spacious habitat I cherished. I began to resent how he was taking away the enchanting plant communities that surrounded my beloved trees.

It wasn't until I was a little older that I would begin to challenge my father over what he was doing. I wasn't yet ready to connect dots between

the power of his authority, the economic realities that framed our lives, and the violence to habitat that so upset me. It never occurred to me that my relationship with a beloved tree had been bought by selling similar open places for development. As I laughed at Father's stories about dominating others and shrugging off danger or studied my image in the mirrors of the ballet studio, I was oblivious to how the shackles of gender roles were slowly slipping over me or how casual violence was tutoring me.

Ilana has a clear mental image of Father kicking me up our driveway. I don't remember that. Memory is a trickster. Memory loss is a survival strategy, like gaps in a habitat, but I think the steep incline of the hill we lived on would have made her memory impossible.

I have considered the impacts of habitat fragmentation all my life. Habitat fragmentation imposes schisms on nature that preclude resilience. Fragmentation contributes to species extinctions, while contiguous forests mitigate climate change. We know now how trees need what biologists call "nurse vegetation" in order to flourish, how a complex relationship among layers in a forest supports a vast diversity of visible and invisible biological life, and how the ecotones that define transitions from one ecosystem to another work together to knit soil, clean water, and mitigate air pollution.

Thinkers like the ecological economists Herman Daly, Robert Costanza, and Brian Czech have argued that when we factor the production costs of harvesting the natural world, we must also consider the costs of losing clean water, intact forest systems, and other species. Fragmentation is like carpet-bombing our own support systems. It is only possible if people disassociate themselves from the consequences of their own behavior. In those terms, my father was a bit player compared to paper companies that clear-cut whole forests for toilet paper, or African gold miners, or Brazilian ranchers who poison and burn down entire swathes of landscape.

Habitat fragmentation is a consequence of unrestrained sprawl and resource extraction, as well as lazy urban planning and greed in the service of entitlement. It is also the consequence of exploding global human populations yearning for *Lebensraum,* the Nazi term that justified their acquisitions of the property of others. Historians generally agree that acting out *Lebensraum* permitted genocide.

Ecological restoration is often taught and presented as primarily an engineering problem. That was how I first learned it: observe how water flows and wind is filtered. The cost of fragmentation I had come to angst over or the disassociations I came to accept were more intangible, although equally measurable in their effect on my spirits. I marked the value of how small streams and ponds tutored and nourished me. I counted the cost when they vanished. I didn't know how to count erosions of empathy.

Ecofeminists at the end of the last century argued that entitlement to extract natural resources to the point of systems collapse makes extraction like rape. Presumptions of entitlement, they said, reflected what we now call "rape culture." Nancy Princenthal's book *Unspeakable Acts,* which looks at rape content in 1970s art, identifies the real problem as a culture of impunity. The implication is that sustainable ecological restoration might hinge on empathy training and prosecution for ecocide as much as on engineering. Would we perpetrate rape or habitat fragmentation if we felt empathy for all life?

I am ten. We had created a wall-size paper mural about American history, on which I had crayoned an immense running horse for Paul Revere's ride.

I am standing in front of the classroom with some other students.

Mrs. Kelley stops in front of me. "What do you want to be when you grow up?"

I look back at her. Her question is incomprehensible. "A housewife," I reply.

Being a housewife meant that I wanted to be like my mother, an elegant woman who presided over a well-run household, cooked competently, tended lush peonies in our garden, and was married to a respected pillar of our community.

Mrs. Kelley frowns. "Don't you want to be an artist?"

Her question seems foreign.

In childhood, my goal was a placid world. I understood that being a woman artist in 1955 meant embracing some sort of outlaw status. Even at ten, I knew I wanted the stability and happiness that my mother had promised would come from modeling myself after the dignified heroines

in all of Jane Austen's books. I wanted the happily-ever-after endings of my favorite fairy tales. The endings of the stories in *Grimms' Fairy Tales* were rarely happy. I preferred Hans Christian Andersen, even if his stories were sometimes sad. I read Hans Christian Andersen more for his kindness than for modeling. Obviously, I was not, after all, either a mermaid or a little match girl. Some pieces didn't fit: my father's nightmares, my mother's unspoken reflections on vanished relatives, or my own memories of whiteness.

What I wanted was to graduate from working with my father in the garden to sharing his ambitions to design land use. At ten, I didn't see the brick wall I was about to hit. It didn't occur to me to ask anyone whether a housewife could also run a large company. When I was a child, the scale of his vision wasn't yet evident. He seemed content to be a successful builder in Tarrytown. But I vaguely sensed that we shared a desire to unfurl our wings and fly over large landscapes with expansive possibilities. I associated my father with excitement, competence, and intrigue.

Gradually and bitterly, I would come to understand that gender would clip my spreading wings. I knew and accepted that I was being groomed to accept the inevitability of marriage and childbearing. That was nothing I looked forward to, but I thought I still had time.

Many years later, I co-opted the word *housekeeper*, a term that had once felt like a sentence to eternal bondage, culture jamming it into roles of caretaking expressed in the Bible as husbandry. I have described my practice as being a "good housekeeper to the Earth, our sacred common home."

I accepted the limits of my future autonomy. Tziporah, against her will, in an arranged marriage, had been married at seventeen to a wealthy older German man. She had been in love with a boy her own age. But I still imagined a vague in-between time, perhaps in my teens, when I could be part of my father's world. I sensed how he thought about land and watched his face as he studied property or discussed land use with his friends. His facial expressions when he gazed out a car window, passing vacant lots, mutely hinted at complex relationships that only made sense decades later for me between land ownership and environmental policy.

When I walked the limits of my world—east to the Hackley School, north to the Tarrytown library, or west to the train station along the Hudson—I could assemble a mental map of how biogeographic parts fit neatly together around homes and roads. That same mapping couldn't contain the fragmented psychological and historical choreographies of my parents' early geographies.

On the second floor of our house, above the bedrooms for my parents and myself, was a family room with a Ping-Pong table and a record player, where I listened endlessly to Burl Ives narrate Prokofiev's *Peter and the Wolf* and memorized recordings of bird calls. There, too, were my mother's sewing room, my sister's bedroom, and my father's spacious, sunny home office.

The office had dramatic views sweeping down to the river and interesting engineering drawings on the walls. While I waited for a day when we might work together, I liked spending my time drawing on the floor. On days when my father was away, I would spread out blank paper and fill in the whiteness with drawings of animals.

Sometimes I spent time in my mother's sewing room, where interesting fabrics were stored on shelves. Her sewing room was a far smaller room than my father's office and had a much less spectacular view from its small window. It never occurred to me to note the vast discrepancy between the two rooms and their windows on the world, but I sensed that their relative real estate in the house reflected who had power in our family. I liked learning Mother's meticulousness handiwork—embroidery, knitting, and crocheting—and experimented with designing, making patterns for and sewing my own clothing. My sister and I often did these activities together, and I enjoyed her company.

But I understood that my father's office opened up to a world that was as thrilling as a thunderstorm and that I wanted to explore. I wanted to live in a world that was more like my father's office than my mother's sewing room. I wanted space that was huge and beautiful. Mother's sewing room didn't open to a wider world; it closed in on itself with a sense of cozy intimacy.

Mother explained the difference between men and women to me: "Men want to fly to the sky. Women pull them down to earth."

My father's office opened to the sky. My mother's sewing room felt earthbound.

I trusted my mother's honesty about marriage, but although I had told Mrs. Kelly that I expected to be a housewife, theirs was not an appealing future relationship. I couldn't have said it then, but I feared my spirit would die if my aspirations were confined to a little room.

3

Waltzing with My Father

ather and I danced with monsters and discord.

I was in training to defy reality on stony ground. The path I hoped to travel would soon be overgrown, and I would be forced to take a detour. My life changed when I was eleven.

When my father's once-wealthy family fled Odessa for Palestine, their home had been in flames. Tziporah told me their attackers were Bolsheviks. My paternal grandmother, Malka, took her teenaged children, a Fabergé piece, and a silver samovar, leaving behind silk sheets, her husband, and Efraim, her eldest. What were their thoughts? Did my grandfather really die in flames? What happened between flames and flight? Had they already packed all their bags to escape? Were there last words? How do people survive immense tragedies and make new lives? Where does all the sorrow go?

It was Father's first flight from chaos but far from his last. He and Efraim had both been educated in military schools, an unusual privilege for a Jewish family in tsarist Russia, one that would save them both for a while. Father bragged that when he first attended school, even though he was small for his age, he fought off several older boys in an attack, then made them his friends.

Crossing the border, Father was shot in the leg. He crawled to a farmhouse, but the occupants wouldn't let him in. He was captured and brought before a tribunal presided over by the same schoolboys he'd once fought. They greeted him effusively and provided an escort to the border for his refugee family.

In Palestine, Malka opened a small kiosk to sell soup and newspapers to laborers. Father took a job as a cement worker by day and played cello in a touring orchestra by night.

I am very young. My father is angry with me. The set of his shoulders and the fury in his eyes scare me.

I'm screaming, "Go ahead and kill me. I know that's what you want to do!"

Father turns away. I think that I have won.

It isn't our first and will be far from our last violent clash, but it is the first time I seize the power of defiance.

Beneath defiance were sad realities I didn't understand. I was lost in a past I couldn't comprehend but had decided to accept. Defiance required less courage than honesty.

Looking back, I think the helpless fear and grief we shared when he hesitated and turned away were more alarming than his violence. In that moment, I learned the most important lesson he had to teach me: Assess threat, decide, act. Don't look back. Ilana explained it after she read a draft of this book: "You learned to survive by making quick decisions."

The day I stood up to my father, we made a tacit bargain. I would accept his violence and relinquish trust. In return, he acknowledged my courage, and I won his respect. I bet my future on a paradox that the love I needed and the love he understood canceled each other out. His parenting work was done. He wanted me to defy reality. It was, at best, a shaky contract. I would spend much of the rest of my life waltzing to the music of that paradox.

I am ten. Our front lawn is important to my father. Sometimes, on Sunday afternoons in good weather, the entire family deploys to pull the yellow-green crabgrass that mars the orderly blue-green perfection of our small vista. The family lawn must be perfect. Once, I find a four-leaf

clover and show it to my mother. I am sure that discovery means I will be lucky for the rest of my life. I still want the excitement I see in my father's life for myself, with or without his heart, and assume luck will grant my wish.

Father told stories about his life to teach me his values. One of his stories was about attending a hypnotist's show. The hypnotist asked for volunteers, and my father, who was always eager to learn something new, immediately offered to assist him. The hypnotist took a good look at him and turned him down. I don't think the hypnotist gave a reason for his rejection, but I can guess. My father was a stupendously willful man. It showed in his eyes and the set of his jaw.

The story stuck in my mind as a lesson that willfulness is protective. From palmistry, I later learned that a sign of willfulness is a thumb that tends to slant outward at a right angle from the palm. To my satisfaction, I noted that is exactly how my thumb presented. It took many years for me to learn that willfulness isn't always the best response to a challenge.

I am eleven. My sister, Ilana, is nineteen. It is 1956. I am learning what my life as a woman will be. It is confusing. Ilana is having a glamorous wedding in the Plaza Hotel on Fifth Avenue. I like the lobby entrance to the storied hotel. In a flurry of excitement, Mother and I assemble something old, something new, something borrowed, and something blue. Ilana's garter belt is blue. My sister is wearing an extravagant, long, white gown with lots of lace that our mother has sewn with seed pearls. I think the seed pearls represent my parents' devotion to Ilana's future.

When Ilana read the draft of this book, she said, "There never were seed pearls." Our mother died in 2003, so we have no explanation for the discrepancy in our memories. They join a vast collection of ambiguities. Finding the lost seed pearls is like gathering a scattering from an unstrung necklace, like so many other missing pieces of our history.

We agree that I was her maid of honor and wore an ugly pink dress of shiny material we agree our mother had sewn. The *New York Times* ran a notice in the marriage section. The spectacle of the ceremony impressed me, but I felt untouched by the idea of participating in a similar ritual, even though I knew in a few years it would be my future. I had no idea

that some women had already long contradicted my certainties; Simone de Beauvoir's book *The Second Sex* had been published in 1949.

The newlyweds found an apartment in Yonkers. Ilana's husband went to work for Father, and soon they had the first of what would be four children, starting with two sons whose given middle names were Rahmani, in preparation for Father's dynasty. I watched warily as I realized that her husband and their two sons had manifested as the legacy my father had hoped for at my own birth. They were the miraculous redemption of my failure.

The configurations of power in my family shifted. Any ideas I had about joining Father's business and learning about land in exciting ways began to evaporate like the water that had spilled into the sands of the Negev Desert when they fled Palestine.

Ilana, unlike her husband, had no part or interest in the family business. Her life was soon far from the glamour of the Plaza. It seemed circumscribed by housekeeping and childbearing and looked to me like an ending rather than a beginning.

I was watching the implications of introducing an adult male into the family unfold. The probabilities didn't need any algorithms at all. I had missed the lesson embedded in the model I was given. The hidden message precluded a role in a wider world than the one I saw in my mother's sewing room. My brother-in-law was the inelegant black swan in my world. I was bitterly jealous. It hadn't required any work on my brother-in-law's part to win the place I had craved. He was in the right place at the right time. I didn't know the science of complexity yet, but I saw the consequences of how nodes of agents in interaction with my sister's life were bleeding into my own life.

In case I had misunderstood my brother-in-law's role in my family, he made it clear one afternoon as we walked down Tarrytown's Main Street, when in response to some dispute, he picked me up and threw me into an open sidewalk trash can. He laughed as I struggled to extricate myself. I was too small. No one else on the street seemed to notice. He eventually plucked me out. I never forgot.

The Manor, the wealthier part of North Tarrytown on sites closer to the Hudson River, was studded with many old trees. Many of the new

sites circled Fremont Pond, a large, pretty freshwater pond. My father designed around the trees to preserve them. I hadn't seen what he was doing with the new houses in Sleepy Hollow but knew my parents and I would soon move from Altamont Avenue in Tarrytown to a house he was building in the Manor. I wanted to see what he was doing and where we would live.

I had things to look forward to, even if some walls might be slowly closing around me. The new house represented an adventure. Every time someone drove to the site of our new home, I begged to go along, but I hadn't yet found someone to take me.

One Sunday afternoon in late spring, I was playing on the front lawn of our house in Tarrytown. Maybe I was shooting pictures of the grass with my new Brownie camera. I was fascinated by the green complexities of foliage and grasses. My attention was broken when my sister and her husband walked up the steps and asked me if I wanted to go with them to see the site at last.

Here's where it gets weird. I had a moment of inexplicable but absolute clarity. Despite being offered what I had asked for many times, I replied, "No," very firmly.

All these years later, I recall the puzzlement on their faces. Perhaps they even asked, "Why not?" Why not indeed? I wondered as they left. I had no conscious awareness of any danger. But soon after, as they were driving into the gates of Sleepy Hollow, a speeding southbound car struck their car, spinning it around. The backseat, where I would have been sitting, was totaled. Neither my sister nor her husband were seriously hurt.

What I understand now is the significance of "No." I had learned something new: that other people's expectations, logic, and even previous knowledge aren't the only ways to make decisions or protect myself from danger. My intuition could protect me when I was awake as much as my unconscious protected me when I was dreaming. It was a hedge against the vagaries of luck.

We moved to a house on the edge of Fremont Pond, just a few hundred feet from the riverbank. When we moved, Mother hired a landscape architect, Armand Benedict, and had the entire front yard planted with pachysandra, which required no weeding. She had also taken a hand in

designing the new house, which had a large bay window in the living room that dwarfed either the picture window in our Tarrytown living room or the window in my father's office. It looked out on a spectacular view that eclipsed our former restricted view of the river.

My parents gave my sister and her growing family a lot for building their first house; it had a magnificent tulip tree in what would become their backyard and was a short walk from our house.

The three of us—Ilana, Mother, and I—fell into patterns of frequent visits. We sat around a large table in front of the picture windows, on window seats covered with rose velvet bench cushions, and talked as we sipped tea from a silver service and elegant china. I was often bored and restless. My attention would drift to the way the wind moved the leaves in the trees around our property. I could never capture that effect, but I learned how to converse.

Father was traveling frequently and expanding his development business to Venezuela. One day he announced he'd bought a two-thousand-hectare ranch in Maracay, in north-central Venezuela, not far from Lake Valencia, where the Kennedy administration would give him backing a few years later to build a small city with factories, schools, and housing, I was intrigued. It sounded very big. Our life was changing again. Even if we still had a lawn in Sleepy Hollow, we would have had no time to pull crabgrass.

Father said that cannibal tribes lived not far from the borders of the ranch, and he showed me a shrunken head. I looked at the pathetic desiccated head and didn't know what to think. Many years later, I realized it probably came from a small monkey, perhaps a baby. Even though these stories confused me, I wanted to believe the ranch might present new opportunities.

He said, "There are six horses. You could have your own horse."

The horses were much more interesting than Ilana's wedding had been. I imagined a string of them tethered in the dusty afternoon sunlight of the ranch. I had been riding for years by then, and like many young girls, before I became boy crazy, I was horse mad. I had no idea how the ranch might allow me to have a horse, but I desperately wanted my own horse.

I didn't know what an architect was, but I knew that Father made drawings and handed them over to someone else for the Building Department's approval. I had seen and studied the drawings in his office for years. I wanted to do that, too. My father invited me to design a house he would build on the ranch for us all to live in.

This was my opportunity to impress him with my talent and hard work. I spent enthusiastic hours meticulously designing a circular house whose bedrooms opened on a large interior courtyard garden as well as external gardens. Each room opened onto the exterior landscape. He liked my drawings, and I waited eagerly for my design to be built. I imagined a world with the house, lush gardens, and horses. But the next time I asked about horses, he told me the ranch manager had run off with the string.

I stopped asking about the house. No house was ever built. This time, I felt my father had disappointed me. I felt ashamed by his failure.

Mother compared herself to Father. She often hesitated to follow her own dreams, she said, because she was a fearful person. The implication was that he never had such qualms. Once she had wanted to be a fashion designer or an opera singer. I had heard her tonelessly humming to herself. It was a nervous habit. I didn't think she could be a singer.

She often said she was determined to see me live a life without the fears that plagued her. It didn't occur to me that it might be hard to fulfill dreams if you are busy pulling people back to earth when they try to fly.

I was attracted to the thrill of danger. I didn't feel fearful, but I was cautious. I understood the connection between danger, excitement, and complexity. I systematically read through each volume of the *Encyclopedia Britannica* my mother had bought for me, lingering on Spinoza and Descartes.

While I was studying how grass grows and leaves move, becoming a young scholar and watching my dreams of working with my father fade, scientists in many fields were publishing their insights about the physics of quantum mechanics and the mathematical rules that determine outcomes when disparate agents interact. In another decade, those considerations would lead to the creation of models for complex adaptive systems. I'm sure those scientists didn't consider a clash between a child's ambitions

and the expectations of adult men to be an agent in determining outcomes. But Betty Friedan did.

In 1963, the publication of Betty Freidan's *The Feminine Mystique* galvanized what became the second wave of feminist activism, building on de Beauvoir's work. She never labeled her analysis a complex adaptive system, but that's what I think it was. Looking back on the trajectories set in motion in my little world in 1956, it is obvious how easily and casually unintended consequences eliminate expectations, let alone aspirations, or alternately open doors to new possibilities. Between 1956 and 2009, I learned a great deal about danger.

Now, I understand the chaotic and complex unexpected dangers that threaten the entire matrix of ecological systems that support life on Earth, not only my own relationships and aspirations. But long before I conducted my Ph.D. research, I understood that the entire human species was being led over a cliff and into an abyss of uncertainty.

After we moved to the Manor in 1956, I never saw my favorite tree again. Mother often spent the day in the city with her Russian friends. We lived too far away from my former friends to see them easily. When I started classes in Scarborough Country Day School (SCDS), I found it hard to make new friends. Our class was small. It seemed that everyone had been going to dancing school together since they were toddlers. I felt little in common with them. Most of their families belonged to the Scarborough Country Club, which was restricted. Neither Jews nor people of color were welcome. I felt lonely and angry.

But SCDS was situated on beautiful grounds with a pretty brook and had been founded on Montessori principles. Intellectually, I flourished with new teachers and very small classes. My favorites were World Religions, for which we used a college textbook, and the after-school art class I took with Mr. Sullivan, whose nickname was "Sully." The former took me back to Tarrytown's Warner Library, where I systematically devoured as much as I could of the entire adult section on religion. There, I found serious discussions of questions no adult in my world was addressing.

What I didn't find and might have given me pause even at such a young age was a serious discussion that was emerging in theological circles around the interpretation of the word "dominion" in Genesis.

Sully's class was where I began to absorb what it meant to make art, although I didn't yet imagine that could be my life or the connection to a wider world. I had been taking classes at the Museum of Modern Art in New York City, but these were my first serious painting classes. One of my first paintings was of a single tree against a red sky.

Now, instead of playing hide-and-seek with the neighboring children or climbing my favorite tree as I had in Tarrytown, I spent time with my best friend, the family dog, a sweet-natured, smart, pedigreed, and beautiful tricolor collie I named Duke. Duke and I developed a daily ritual of long walks after school in the nearby woods and along the banks of the Hudson near the Philipse Manor Station.

In my English class, we read Henry Wadsworth Longfellow's *The Song of Hiawatha*. The walks with Duke were opportunities for me to practice walking silently across the forest floor of dry leaves and brittle branches. I was diligent but never achieved silence.

As I carefully placed each foot on the dry leaves in my path, even through the soles of my shoes, I thought I could feel the contours of the ground. I held my breath and took the next step, frowning but concentrating as hard as I could on the joyful prospect that my next step would be in concert with my beloved woods and all the life therein.

It had escaped me that besides a lifetime learning woodcraft with mentors, Hiawatha was probably wearing soft moccasins, not hard-soled shoes. I was blind to critiques of Longfellow's racism and sentimentality; an awareness of them would come later. What did not escape me was the evanescent sense of what it might have meant to be Native American and grow up in the culture of those traditions. Throughout my life, I have been drawn to the Native Americans and other Indigenous peoples I have met, have studied when I could with Native teachers, have read their literature and meditated on what I have learned. It would take me a lifetime to learn some basic ideas from those studies, like generosity with and gratitude for

all of the Earth and the simplest and most profound teaching of all, to give back more than we take. Other lessons would be absorbed more easily, such as the practices of companion plantings and honoring the sources of my food. In time, Robin Wall Kimmerer's book *Braiding Sweetgrass* would reach and inspire many more non-Native environmentalists.

Longfellow had a romantic understanding of Indigenous people, tainted by the routine overt white supremacy of his age. Even imperfectly filtered through a historical and cultural divide and my teacher's limits, what would endure for me was how Native cultures live with nature.

My exercise was to walk mindfully through a habitat. The space in which I moved as a child during those walks was densely populated by interdependent, complex life. I was engaging in self-education and absorbing tacit knowledge. In adulthood, such walks are routine parts of my art practice. They are exploratory, performative sketches of the landscape.

What also did not escape me even at eleven was that my father had his eye on the woods that Duke and I loved and planned to build more houses there. I understood on a clenched-gut level that the complexity I was enjoying was at great odds with the systems that supported my father's livelihood. As an adult, I recognize that my anger was a response to ecocide, the decimation of all nonhuman life in the pursuit of human expansion for profit. At eleven, I just mourned.

Far more than the landscape surrounding our home was changing. As in Tarrytown, my parents continued to receive visitors from Israel. Now they included not only friends from Israel but power brokers from the Westchester County government. Someone suggested that Father run for mayor. He wasn't interested.

In the living room, Father taught me to waltz and polka. These two dances represent completely different moods. The waltz is a graceful exercise in 3/4 time, with emphasis on the first beat. The polka is in 2/4 time, more rollicking. Classically, the female partner in the waltz looks coquettishly over her shoulder, away from her partner, as they turn around the floor. In the faster polka, their eyes meet. Both dances emerged in Europe, the first in the eighteenth century and the latter at the beginning of the nineteenth century and marked the first time couples danced together rather than as part of a group of dancers executing formal figures. Father

and I had no music to dance to, but in his lightly distanced, formal embrace, I learned to turn and dip. The accompaniment to our dancing was our laughter, taking pleasure in the dance movements and each other's company.

On the other end of the living room from the picture window was a music room with a baby grand. The floor was raised on a split level, and on the rise between the two rooms was a built-in fireplace.

Every afternoon after my walk with Duke, I practiced the piano for at least an hour, sometimes adding some singing to my classical studies. My favorite song was the sad minor tones of the Russian folk song "Dark Eyes" (Ochi chyornye), a paean to the beguiling eyes of a beloved and the lover's mournful longing. When I was angry, which seemed more and more frequent, I played Sergei Rachmaninoff's Prelude in C-sharp Minor, op. 3, no. 2. It begins with deep chords, which stretched my fingers to their limits; then my hands danced across the keyboard, at times meditative and then manic, soaring to high notes but always grounded in the depths of the lower register. When Father had visitors, he often asked me to play a few pieces on the piano for his guests. I always complied with some short Chopin or Haydn piece—never the soulful passion of Rachmaninoff's prelude.

On weekends, I traveled by train into New York City for ballet and figure-skating lessons. Spine straight, muscles engaged, and limbs leaning into the space beyond my body defined my stance—at home I walked with a book on my head to perfect my posture. During the week, my favorite activity remained riding lessons, learning to become one with the fluid power of the horse I straddled as we turned and crossed the ring in intricate dressage patterns I was learning. My mother asked whether I wanted singing lessons. I said, "No." I was already taking enough lessons. Later, I regretted that Boolean NOT.

In a world of intense cultural wealth, I often felt isolated. The rules I was internalizing gave me scant relief from the incremental gender-based narrowing of my world or my parents' unspoken grief over the horrors that had taken their loved ones. I longed for my lost family. Father and I were fighting every night. I dreaded the impending destruction of "my" woods and felt helpless. I wondered if I was going crazy.

One day in the car on the way to school, I told my mother I thought I needed therapy. She assured me that nothing was wrong with me. I never asked again. Eventually, I realized that what was wrong was entirely out of my control and none of it was my fault.

My sixth-grade teacher, Mrs. Drew, sensed something. She suggested that I participate in the Beechwood Players, an adult theater group, which performed at the school on weekends. I had only a small walk-on part in a play I can't recall, roller-skating in from stage right and exclaiming, "It's midnight!" But I got a lot of applause. It was a lesson in getting adult approval, and I could add performance to my repertoire of cleverness. This was a "Yes" experience, as transformative as my "No" to my sister and brother-in-law had been before their accident. In theater, I could have powerful emotional relationships simultaneously with many people. *I* could be a black swan.

My first response to this introduction to the theater was to begin reading the actor and director Konstantin Stanislavsky's writings on Method acting. I understood that art could filter internalized feelings to move the hearts of perfect strangers. Tziporah and her only daughter, Yael, my cousin, were accomplished performers. I thought this might be something I could do, too. A few years later, I would perform a monologue for my whole school—a girl lamenting the death of her boyfriend. Onstage, I sank to my knees, wailed of loss to the heavens, and got a powerful response.

My teachers' messages in those early years were mixed. On several occasions, I felt ridiculed for my precociousness. I now believe it was intellectual gatekeeping. The same Mrs. Drew who encouraged an interest in drama challenged my use of the word *gist* in response to one of her questions.

"Where did you get that word?" she shouted in front of my whole sixth-grade class, as if I had stolen it and deserved shaming and punishment.

I came away from encounters like that with anger, contempt, and confusion. How, I wondered, could adults be so irrational?

Gatekeeping and gaslighting are routine features of many women's lives, clouding clear thinking as we weigh our options and judge our self-esteem. What I would not credit for many years was how such experi-

ences set me up for more learned helplessness and intellectual self-doubt. My takeaway lesson was that women could deny me entrance to reality as easily as men could. Nothing about power is gender-specific. It would take me far longer to understand all the layers of disenfranchisement that sustain a status quo that leaves out most of the world.

By the time I was twelve, we were spending more time in Venezuela. On holidays, I joined my mother and sister, staying at the Tamanaco Hotel in Caracas as the men worked elsewhere. The Tamanaco Hotel was on a hill above the city and very different from the El Conde, another Caracas hotel. The Tamanaco was like a country club, with a pool, volleyball court, nightclub, and restaurants. In the hotel bookstore, I bought the *Kama Sutra* and began studying the mysteries of sex as assiduously as I'd ever studied Spinoza.

Gazing beyond the wide hotel patio, I could see hills covered with rickety *favela* homes. I would walk to the low wall that encircled the landscaping around the hotel to stare at the view. I was unusually farsighted, so I could discern some details. I tried to imagine the lives of the people who lived in this shantytown, confused by the vast difference between how I lived and how I imagined they lived.

On New Year's Eve 1958, we attended a fancy party under a wide tent on the Tamanaco's lawn, thrown by President Pérez Jiménez. It would be his last celebration before the coup that overthrew him. Between dances with my father, I chattered with my dinner companions at the long banquet tables, enjoying the novelty of eating a variety of potatoes and plantains.

But then jets began to fly over us. In an orderly fashion, the party ended. We returned to our rooms. Early the next morning, we took a cab that raced us through the city to the airport, ducking down in the seats to avoid bullets. Like everything else dramatic I endured or heard about in my childhood, our escape was never discussed. We simply boarded a flight for the four-hour trip back to New York. The next day, I returned to my classes.

My life was beginning to take on the qualities of an existential theater production. In my mind, each vignette had a distinct stage set: Venezuela,

Tarrytown, Sleepy Hollow, New York City, Scarborough, Israel. The play was further divided into the cities where some of my family had lived for generations.

Father's assimilated family had been traders and diamond merchants to the tsar. But another, more spiritual branch of my family had been steeped in Kabbalah in Palestine.

Tziporah told me that when their family fled the Russia Revolution, they appealed for help to their uncle in Safed, who was a high rabbi there. That would have been about 1917. My family's original name, as I mentioned, had been Gabin. I don't know what my great-uncle's name would have been, but a cousin's surname was Silverstein. A rabbi with that name lived in Safed then; I saw his signature on a document.

Despite my predilections for denial, ever since I sat down for the second time at Chillon, I have pursued questions. Questions create parameters and can lead to answers, such as I explored in a series of projects from 1979 to 1987 that questioned violence: If a violent world is a disincentive to having children, what causes and heals violence? Could healing come from simple discourse?

Why didn't I ask Tziporah a thousand questions? When I was fourteen, Ilana gave me a stack of books from her college classes about existentialism, including Martin Buber's *I and Thou*. I read his mystical, metaphorical writings about discourse as inherently a religious experience. It profoundly moved me. My studies were desultory; I read only phrases at a time, then contemplated them for years.

When I was older and encountered Kabbalah, it fascinated me. I traced the philosophical ideas to roots in ancient Assyria. I meditated on the central metaphor of the tree of life diagram linking Earth and heaven and the ten nodes of the diagram, called *sephirot*, which portray how qualities of the divine and reality are disassociated from time and space but originate in pure energy. Depending on the illustration, from seventeen to twenty-two pathways connect the nodal schematic, suggesting an abstract concept of modeling empirical relationships between agents that long predated any algorithmic CAS. Decades later, it would be a relatively short conceptual step from Kabbalah to the mystic physics of complexity theory.

I've heard Safed referred to as "the blue city." It has been a center for Kabbalistic studies for centuries. Morocco has a blue city of its own, Chefchaouen, painted by Jewish refugees from the Holocaust to represent sky, water, and freedom. The idea of faraway blue cities fascinates me. It fascinates me even more to think about mystical and spiritual implications connecting me to long-lost remnants of my family. I like to imagine some genetic predisposition to mysticism that might have explained the conviction of my "No" on the day of my sister's accident or my instinct for lucid dreaming.

When I came to do *Blued Trees,* I remembered the blue cities. Instead of maintaining distinct identities, by then all the places my family touched down in made up a surreal geographic kaleidoscope that I normalized without questions.

When I reassembled the geographic pieces from my childhood mental landscapes, they painted themselves in vivid color with profoundly conflicted messaging. During the pandemic sequestration, I thought I would find the turnkey piece of my puzzle if I wrote the Department of Tourism in Safed to ask why it was called the "blue city" and to try to identify the high rabbi, my great-uncle. Someone named Laurie Rappaport wrote back, referring to Safed as "Tzfat":

> Tzfat is known as the "blue city" because much of the city is painted blue. Blue is a traditional color of kabbalah, Jewish mysticism, and denotes the natural elements of the sky and water. In addition to individuals painting their houses blue, a number of the city synagogues have a lot of blue in their interiors. Also, the city, for tourism reasons, has painted a lot of facades in the Old City area blue to promote that image. Tzfat is known as the City of Kabbalah, due to the immigration of kabbalists who fled the Spanish Inquisition and came to Tzfat in the 1500s to live and develop the study of Jewish mysticism.

As for my uncle? "There wasn't one main rabbi. There would have been several. Also, the Sephardi community would have had their rabbis and the Ashkenazi community would have had their rabbis."

Safed, or Tzfat, is ancient. The historian Josephus identified it as Sepph, a fortified city where ancient fires were once set to celebrate the new moon.

When my father's family reached Palestine, Safed was a town of about eight thousand people, with twice as many Muslims as Jews and a handful of Christians. In 1834, local Muslims had ransacked the Jewish population in the "looting of Safed." In 1917, the Jewish population in Safed appealed to their European relatives for support. Rappaport sent me a JPEG of one of those appeals signed by someone who was probably my relative, identified as "Rabbi Avraham Leib Zilberman, Head of the Beit Din of Safed." In 1929, Safed was the site of an Arab uprising that massacred twenty Jews. But Malka, my paternal grandmother, and her teenaged brood had long since moved on to the seaside city of Haifa, leaving behind few answers for me in Safed.

Objects ground me. Nothing I learn is neutral. Today, I am meditating on courage as I sit at the same faux French vintage wooden desk I chose for my bedroom as a tween. When I chose the desk, I knew my father had met with Haile Selassie to start a project on the east coast of Ethiopia. Growing up, I grasped at straws of casual comments to fill in the details of the invisible world of my family's past. My parents supplied few details about the cities where they grew up, but my mind has fleshed out my father's Odessa, my mother's Białystok, and Bridgewater, Massachusetts, where my family had their farm before I was born. Then there's the mystical world of Safed.

Before Chillon, my imaginary landscapes formed and re-formed, bled back and forth across time swimming in obscure patterns like schools of fish in an ethereal ocean. Dream worlds where monsters and gangs of men pursued me or dazzling whiteness or the later glimpses of blue cities were as real to me as the fairy tales I was consuming.

In summertime in Mother's Poland, her family visited a place with trees taller than any she'd seen when she visited me when I lived in Maine. Grandmother Hannah took Mother to the churches in Białystok to listen to liturgical music. Hannah loved that music, as I always have.

Mother learned fear in Poland, not just from anti-Semitism. Grandfather Joshua had a violent temper and stubbornly refused to leave Poland for Palestine. He complained, "Jewish workers always make trouble. In Palestine, there will be nothing but Jewish workers." So my grandparents

stayed, but Hannah had the prescience to send all four of her children to foreign worlds thousands of miles away. Evidently, her husband didn't stop her, whatever he believed. Like Malka escaping the Russian Revolution, Hannah understood the difference between fight and flight to protect her children under great duress.

While I was waging my campaign for recognition and participation in my father's adventures with land, puberty was kicking in. I was twelve, leaving my childhood behind, developing a curvaceous figure and getting attention from older boys, but unsure if I was ready to be a woman.

Sexuality is power so long as it is withheld, but it is also a double-edged sword. Mother and my aunt Tziporah, who often came to visit from Israel, encouraged me to wear clothing that made me look more like a woman than a girl, which only added to my anxiety. But I still began wearing Fire Engine Red lipstick, like my mother did, while my girlfriends wore Pink Vanilla.

Attention from the boys gave me social status in school, which left me feeling giddy. No one warned me that seduction could be as dangerous to the seducer as to the seduced. I felt powerful and was unkind, lording my newfound status over girls who had ignored me the year before. Within the limits of the times, I flaunted my new awareness of my sexuality. That meant I opened my blouse to two inches below my collarbone and peered out at boys from under a sweep of hair, as I had seen Veronica Lake do.

Looking back, I see a series of bit roles without obvious relationships between events except through my father. His ambitious vision was what tied everything together and encircled the globe.

He was building cities, for God's sake!

Despite intermittently violent conflicts, I still wanted to waltz into the future with Father and away from problematic histories. My desire to master the dance overrode my sensibilities about crumbs of important information, such as his tales of Indigenous people's shrunken heads or the view of the *favela* from the Tamanaco. Important anomalies fell through the cracks. It never occurred to me that fairy tales about royalty might conflict with being my father's right-hand person or becoming

a seductress or even that they were at odds with reality. At eleven and twelve, the reality of my brother-in-law's position in the family business stood firmly in my way.

I remained determined to be valuable to Father's business. I paid attention to accounts of corruption and graft in Venezuela from both my parents. I took note of the positions and powers of his colleagues.

As Father went from building houses to constructing office buildings for IBM in White Plains, I saw the tiny notebooks he filled with short lists of people to call each day and left on his home-office desk as algorithms for success. They were not so different from my own to-do lists today. I tracked where he sited his developments in Westchester and what the terrain was like between Maracay and Caracas in Venezuela. I absorbed something about city planning. I integrated that into what I had seen of ecotones and began building my mental world map of all the places my family was connected to.

I continued to watch how Father looked at property and how he decided one lot could be organized in relation to another lot, to knit geographic and infrastructure features, to fulfill visionary urban functions. I began to visualize how understanding land dynamics is about layering data. I followed business reports on the news and suggested a marketing plan.

Laughing, Father said, "I don't need one. I have as much demand for my buildings as I could ever want."

I had more ideas. I tried to convince Father to buy land in California rather than cut down the trees I loved. I argued that prospects in California were better than continuing to struggle with the byzantine politics of South America.

He dismissed me. His dismissals offended me because I was sure it was good advice, carefully researched. I knew I was right. It didn't occur to me that being a twelve-year-old girl disqualified me.

Instead, my pride fueled our increasingly volatile relationship. I swung from intense interest in his affairs to disgust. At other times, he reached out to me, as when he invited me to sample the sweet, canned juice of an exotic fruit that he was considering developing on the ranch.

As I began to look more like a woman than a child, the tensions between us became more explosive. More and more good parts of my relationship with my father fell away. The violent outbursts and conflicts escalated so dramatically that at times I was convinced one of us might actually kill the other. I didn't make a direct or conscious connection between my budding sexuality and his rage, but his rage often seemed directed at any expression of my sexuality—when I was on the phone with a boy or wearing something that clung too closely to my body. The violence paralleled how my sexuality and intellect were blooming.

One day, Mother came home from an errand and came upon Father beating me on my bed. She recalled blood on my face. I remember squirming away from his blows. I don't remember blood.

Throughout my teens, I continued my independent religious research project, working through Taoism, Hinayana and Mahayana Buddhism, Zen, and all the Christian denominations. I had learned to compartmentalize my experiences. I didn't yet know that spirituality didn't need to be enclosed by religion. Kabbalah was still in my future.

In the spring of 1959, I learned of a summer study program in Montreux, Switzerland, and begged my mother to send me there. I was elated to escape the violence with Father.

In Switzerland, I quickly made friends and avidly studied a range of languages. We were housed in a beautiful old building on the shores of Lake Geneva. Many of my fellow students came from cosmopolitan backgrounds similar to my own, with families who had also fled various tyrannies and made or preserved fortunes elsewhere. For the first time, I was not defensive about my family's lifestyle or background. I felt part of a sympatico community.

That was where I first heard the phrase "scratch a Russian, find a Mongol." I understood that to mean that Russians have a streak of powerful passion, even ruthlessness, and romance, perhaps the qualities of Genghis Khan, all on horseback. Years later, I heard the saying that a Mongol without a horse is like a bird without wings. Those images appealed to me. I thought of myself as more Russian than anything else. I resembled my father's side of the family more than Ilana did. When we visited Moscow

together many years later, after our father's burial in Israel, I was flattered to be taken for a native Russian whenever we stopped someone to ask for directions.

In 2020, entertaining myself during lockdown, I was thrilled to learn from a genetic testing company that 2.1 percent of my DNA came from both southern and northern China, only five generations back, tenuous evidence of my kinship with the horse tribes.

As my dream of working with my father faded, I realized that my only way forward as a woman would be to find a man whose life interested me. In Montreux, I met Alain, from Paris—my first count—and Fernando, a fervent Catholic, my second count, with whom I began a long-term correspondence about religion that lasted long after I went home. From Montreux, I wrote my parents that the culmination of all my research was that I was considering converting to another religion. My parents rarely went to temple, and religion seemed to have faded from their lives. It didn't occur to me that they might care.

They telegrammed me that Father had suffered a heart attack. I was to return immediately.

All my rage at my father became concern. As I sat in class before I left, I dug my nails into my palm so hard that I was surprised I didn't draw blood.

Both my parents met me at La Guardia. Father looked fine.

For the first time in my life, I asked, "What is going on?"

"You needed to come back and learn about reality." That was their only explanation. I was astonished by the irrationality of their thinking.

It was midsummer. The very next day, my father put me to work in his bleak, stuffy, light-deprived office in downtown White Plains, placing me under the supervision of his bookkeeper. She had me copy bookkeeping numbers from an old ledger into a new ledger all day, until she took pity on my misery and left me to spend my days writing to Alain. My exile in my father's office had no relationship to my previous dreams of land and creation. I was there twelve hours a day. The worst part of my reeducation was that I was not allowed to continue my riding lessons.

In September, my parents enrolled me in the local public high school. This, too, was "to teach me about real life." I was more stunned by what

seemed a string of foolish responses than I was by this new disruption. I felt insulted by their dismissal of my serious studies and deep thought. I had previously doubted my parents' intelligence, but now they had certainly lost my intellectual respect. I decided I needed to escape my incompetent family and return to Switzerland.

Meanwhile, at first, I found it hard to adjust to the new school. Soon, however, I reestablished friendships with former neighbors from Tarrytown. I was put in the Advanced Placement classes, including English, taught by Miss Kasberger. With her, I happily picked up my interest in drama and became transfixed by the dreamlike formalism of Japanese Noh theater.

Noh is a traditional dance theater form that was codified in the fourteenth century. A supernatural figure appears as a hero to recount a traditional story enacted by dancers in elegantly stylized masks. Noh has its own body of music and gorgeous costumes. What transfixed my imagination—besides the fantastical myths and images—were the carefully coordinated combinations of sweeping but controlled movements and exotic sounds punctuated by the graphic visuals of the masks and brilliant costumes describing a magical world. It was a means of organizing perception that I would recognize again in Native American cultures.

That year, I became seriously interested in fashion design, creating drawings of form-fitting dresses for ideally healthy bodies. I also began reading the great playwrights who dealt with tragic realism, like Henrik Ibsen and Eugene O'Neill. I was drawn to the power of how they wove symbolic meaning into metaphoric abstraction.

I wrote a play, which I titled "To Love," long since lost, about a biracial girl who passes for white. She falls in love with a white boy, in whom she wants to confide her secret. The main character's jealous sister taunts her over her ambivalence and conflict, preying on the girl's feelings of inadequacy and self-doubt, hounding her to commit suicide by jumping off a cliff. The core of the play was less about the relationship with the boy than the relationship between the sisters, in which shame and racism distorted the basic elements of love, empathy, and trust.

My religious idealism merged with politics. I fell in with a tight, progressive circle that included David Bromberg, whose family had been

friends with my family in Tarrytown and who later became a famous musician. He and others in our group were planning on joining the Freedom Riders to protest segregation in the South. I wanted to go, too, but Mother refused to give her permission.

Father's rage escalated.

Some research has suggested that an experience of childhood abuse can incline a young person to take up religious studies. I ignored the violence and continued my religious research, but in secret, retreating into my own world. I traveled to Brooklyn to meet with a bishop, who gave me a stack of books to read and topics to think deeply about.

My world was not only changing; it was splintering. It continued to splinter throughout my teen years. I was learning to disassociate and compartmentalize my life, disrupting my own ecotones. Depending on how many disruptions bring the system to a new state, the effects can generate either new opportunities or clear-cut future possibilities.

A window of opportunity opened. Toward the end of the school year, it looked like my mother would join my father full-time in Venezuela. He needed her help there. My father had begun commuting weekly to Venezuela, and my brother-in-law was working for him there but chafing under my father's authority. My brother-in-law would soon leave the business to work for someone else. When Father was at home, home was an emotional battleground. His attention was completely focused on what he wanted to accomplish in Venezuela, the political challenges he was encountering there, and my brother-in-law's imminent defection. I was a distraction.

When I was about to turn sixteen, Mother offered me three choices: boarding school in the States, a convent school in Venezuela, or a return to Switzerland. I chose Switzerland.

She didn't ask for my father's permission or for money for the tuition. She had a collection of jewelry he had given her, and she sold her diamonds. She didn't tell me that till many years later. I never questioned how she might have felt about selling her cache of security to save me from my father. Her only comment when she told me was that she had never liked diamonds.

I was sent to the Collège du Léman in Versoix, a suburb of the city of Geneva. On Sundays, I often attended a service in the small local church,

where "Amor" (love) was painted in large bold red letters above the nave, and I joined the congregation in song.

Despite freedom from my father's temper, Switzerland revealed whole new worlds of injustice. The director failed to protect me from sexual abuse and made false sexual accusations. He stood by while older white South African boys taunted the young children of Patrice Lumumba by calling them "sons of goats" until they cried. He forced the boys to stand in the snow in the middle of the night for some imagined infraction. The Lumumbas, tall and elegant, came to rescue their children. I wrote the director a letter demanding better treatment and copied it to my parents, expecting an imminent rescue. I was not rescued. I remained at Léman, becoming suicidally depressed until the next year, when my parents finally allowed me to transfer back to Montreux.

Despite being a successful businessman who worked with world leaders and expected his women to be always well turned out in expensive jewelry and clothing, Father kept his women on a very short financial leash. That winter, he passed through Geneva. We met briefly in the airport. I was more interested in railing at him for sparing me only fifteen minutes than welcoming his interest. Nonetheless, when he presented me with a small, elegant gold watch, I wore it every day.

Shortly after I settled into school in Montreux, Ilana sent me an article from *Glamour* magazine about a new program in fashion design at Parsons School of Design, in New York. She suggested that I apply.

I began assembling my art portfolio under the direction of a British teacher who had studied at the Royal Academy of Arts in London, the same one who sent me to Chillon. He taught me to differently understand landscape than what I had learned from my father. In addition to the artwork I did at Chillon, I learned to paint rings around a moon in a nighttime sky and make meticulously realistic drawings of still lifes like a bowl of eggs, clothed live models, and classical busts, all of which gave me skills to observe my world more carefully. Before I left school, he surprised me when he told me I had been the best student he'd ever taught.

The school director in Montreux was only slightly wiser than what I'd lived with at Léman. One of the girls took a picture of another girl in a bathtub, showing her from the shoulders up and wearing a shower cap.

The merchant in town who developed the photo showed it around to his friends. Despite the innocence of the photo, the school's director blamed all the girls for attracting prurient attention and was outraged enough to initiate a lockdown. He called all the girls into the dining hall and told us we would be confined to the main building for a month except to go directly to our classes and back, and then we would be locked into our bedrooms for the night.

One of the girls found these strictures so impossible that she tried to commit suicide by walking into Lake Geneva, in hopes of drowning. She was rescued and immediately expelled. The rest of us were called to the dining room again, where we were sternly warned, "The next girl who commits suicide will be expelled." All the girls laughed at the absurdity of his statement for days.

The school director wasn't the only irrational adult male at the school abusing authority. When I visited the small school chapel for some reflection, the resident priest began babbling about having watched me, then tried to kiss me.

That spring, I was accepted at Parsons to start in the fall. I had spent every weekday afternoon after my classes preparing my portfolio, but I had no thought of becoming a professional fine artist. (Even less did I imagine becoming an artist interested in ecological restoration and public policy.)

Before I left Switzerland, I spent a month in Madrid with my friend Fernando's family. Francoist Spain was semifascist. Fernando and his family were monarchists and supporters of Franco. This was not an unusual political position among my European friends, and I had come to accept it. Several of my schoolmates were the children of minor nobility from various countries who supported monarchies. The Bourbons were a favorite. Somehow, I didn't think about how far this was from my passion for civil rights only a couple of years earlier or realize I was in the belly of a beast.

By then, I had fallen completely in love with Fernando. He was two years older than I, funny, charming, and smart, and would inherit his family title as Count Cas Viegas. I had been pouring out all my religious feelings and aspirations to him. Perhaps I was as in love with the glamour

of his aristocratic identity and the geographic panorama that seemed laid at my feet as I was with the sweet boy I knew.

We seemed so close and discussed imminent marriage. He described the royal family I would meet before our wedding. My only cause for pause was his mention that I would give birth to our firstborn (a son, of course) in the family's drafty castle north of Madrid.

During that blissfully romantic month, I ate menudo, a traditional tripe stew; took afternoon siestas and had midnight dinners with his family in their formal dining room; and uncritically learned about bull-fighting. Fernando explained how he practiced bullfighting on the family estate. It sounded benign and exciting. Watching bullfights on the small black-and-white television in their living room as Fernando expostulated on the bullfighter's courage and skill, I couldn't see the red blood or any pain or confusion in the animal's defiant eyes.

My Spanish fairy tale didn't, couldn't, last. Mother appeared at the end of my idyll and whisked me away from what she considered the pernicious Catholic influence of my erstwhile fiancé's family. It would have caused an irreparable break between me and my family if we had married.

Fernando soon vanished and never wrote to explain why. That summer, a mutual friend sent me a postcard explaining that Fernando had anticipated a conflict with his religiosity because he was overcome with lust. I didn't doubt that. Despite all our religious talk, I had been, too. Perhaps he became a priest. I was seriously crushed but buried my disappointment in the *Larousse Gastronomique* encyclopedia and worked myself through as many of the twenty-five hundred recipes as I could before school started.

Along with fairy-tale dreams, my innocent respect for authority and authoritarian ideas was blowing away like dandelion fluff in gusts of summer wind. I was still trying to waltz with what my father meant to me. The music kept getting more discordant. Understanding this complex adaptive system was becoming rougher. I feared I was dancing alone in a roomful of the same unnamable monsters I thought I had vanquished in my dreams years before. I was learning unwanted lessons. I wearied. But new beginnings were coming.

When I registered at Parsons for my first semester, I met and chatted in line with Donna Karan, who was also signing up for classes. I was impressed to learn that she was supporting herself with fashion illustration and remembered her story later, when I had to support myself.

That first year back in New York, I lived at home and fell into routines that subdued my defiance and mirrored my family's values. Twice a week, I worked with Joseph Pilates, the exercise physiologist whom everyone called "Joe," creating as near to a perfect body as I could, as did my sister, Ilana, and Mother. Joe's work was never about creating the appearance of a perfect body; it was about creating a perfectly functioning body, like a wild animal's. I worked with Joe until he died, in 1967, learning ever more about body movement. I wore elaborate, careful makeup, dieted until I weighed 110 pounds, and kept my eyes open for a likely husband to replace Fernando.

At Parsons, my drawing, painting, and art history classes unexpectedly fired my imagination much more than the tedious dressmaking skills of endless stitching of handmade buttonholes into the wee hours of early morning, which I came to detest. Commuting during my year at Parsons, I disciplined myself to sketch fellow passengers, especially their hands, often with a 9H pencil to create as clean a line as possible. I didn't yet think that I might become a professional artist, but I was becoming more serious about learning artmaking.

4

A Rape

I n August 1964, I turned nineteen. Time had run out. Time was free
dom, but it had an expiration date. I had internalized hard lessons
about my life options. I presumed that marriage was inevitable. Until
then, I could make the most of my time if I protected my chastity well.

Somehow, I didn't credit the fact that my mother had held onto her
freedom until her late twenties, when she finally married my father. She
didn't have me till she was thirty-eight.

Ilana married at the age I was then. Tziporah had been seventeen when
she married. For years, every argument with my father had ended with
me shaking with resentment and fear as he bellowed that he couldn't wait
till I was out of the house, which he announced would be when I was
sixteen. My mother never openly contradicted his forecast. The subtext
seemed to be that the end of my teen years would release my parents from
responsibility for me. My life would be turned over to an acceptable man,
who would own and control my future.

This might be a good time to remind my readers that not all girls
grow up being told they can be anything they want to be or encour-
aged to acquire skills that prepare them to be independent. I was a first-
born American to parents whose views were still firmly planted in the

nineteenth century. I was not yet an old maid, but my task was to choose a husband quickly. As at Chillon, I feared failure, but this time I thought I understood my task.

Before I had a chance to choose, I was raped.

Time and disruption each have their own logic. Disruption can be a determining element in sensitive initial conditions. With time and opportunistic conditions, systems can survive disruption in new relationships. There isn't always time, however.

The conflict I have always struggled with between learned, sometimes actual helplessness and my willingness to understand a way forward is an effort to find equilibrium between urgency and deliberation. In 1964, I didn't understand that sometimes the path forward becomes rhizomatic, as certain French philosophers have described the world, a system where nodes branch out into infinitely deliberate possibilities.

Defiance is not like a Boy Scout Swiss Army pocketknife with infinite possible applications, as I would come to learn. I took many wrong turns. Quick thinking often came too late to rescue me from calamity occasioned by defiance.

Rape may be the ultimate paradigm for learned helplessness, the unwanted penetration of an orifice by another. Semantically, *penetration* and *orifice* can include many ways people feel their will is overcome by the will of another. Insults to habitat ecotones may parallel violations of relational boundaries. Rape is to the person as fragmentation and extraction are to the ecotones that prevent ecocide. The annihilation of safety for the person who has been raped is as destabilizing as the destruction of ecological hot spots in the larger landscape.

The narrative I grew up with was that physical rape, if it is even recognized as rape, was always the victim's fault. A counternarrative has tentatively emerged in recent years with the #MeToo movement, but the effects on the justice system are inconsistent, at best exempting mostly privileged young white women from the depths of shaming and making their perpetrators accountable but ignoring many other rape victims and their offenders.

It has taken me a long time to waltz away from the lessons I learned from my father about entitlement. Meanwhile, my mother taught me another set of lessons about helplessness even while she wanted me to have the courage she thought she lacked.

"God knows what happened to them," Mother would say. She turned her head away as she spoke. She was looking nowhere I could see, but in her mind's eye, I think she saw her aunts and cousins. The hunch of her shoulders and the thin set of her lips warned me off questions. Her body language spoke. The text was like the floral inscriptions on sixteenth-century maps of unexplored oceans: "Here be monsters."

In her silences, I heard, "Trespass not. Advance at your own peril."

The tragedy of rape is an effective weapon of war, whether declared as an international offensive against entire communities or deployed one-on-one for power.

My mother's silent speculations usually came after something evoked a random memory of cousins and aunts. The glimpse of a beautiful hat might be a trigger. Her memories lived in a long-ago vanished Białystok, Poland, that I have never visited.

"They were so beautiful, elegant, and fashionable!" she would say.

This was something I understood. Mother valued beauty, elegance, and fashion at all costs. Father's distribution of approval and disapproval among the women in his life validated her standards.

Mother's favorite story from her youth was about when she arrived in Winnipeg, Canada, as a teenager to live with her brother. She took a waitressing job and spent all the earnings from her first paycheck on pretty earrings rather than a good meal. She told this story often, her smile lingering over the memory of the purchase. I was meant to take her lesson about values and priorities: beauty first. She sometimes followed up her story with this admonishment: "Always buy what you really want."

But beauty and desire can be cruel mistresses.

Cruelty comes in many flavors. Our minds can be cruelly raped without ever engaging our body. Acquiescence to cruelty is a kind of rape. The forced witnessing of cruelty to another is a violation and often a torture. Even as a child, I intuited that what had happened to our beautiful relatives

was something creepy and cruel. Later, I would find more explicit subtext for my intuitions. Historical records reveal what the Nazis often did if they captured a pretty young Jewish woman: she would probably be gang-raped and/or become their personal sex slave before being murdered.

Besides my parents' cautionary warnings, physical rape was foreshadowed by everyday signposts. Danger and shaming were possible at every turn: the assaultive risk of subway molestation or catcalls if I wore a short skirt. At all times, a lady circumscribed her life, for fear of landing at the mercy of violent predators. Al Gore famously said of climate change that it is like slowly boiling a frog to death in what starts as cold water. Losing freedom as a woman in the 1960s was also incremental. At nineteen, married or not, I had been carefully groomed to become one more boiled frog.

The most intimate and honest conversations I had until I was in my twenties, in fact, were with the Black women my mother hired to care for our home. They were kind and seemed interested in me, though none of them lasted very long. I wish I could remember their names, but I remember one conversation in particular.

When I was thirteen, chatting in the kitchen with one of these women, she suddenly said, "You're beautiful and smart. Be very careful what man you choose."

That was more power than my mother ever suggested that I had and more wisdom than she ever conveyed.

Rape is a stick that keeps women and gender-fluid people in line while we reach for the fairy-tale carrots of happily-ever-after romance. I have spent a lot of time thinking about how metaphors could be used in developing the rules of trigger point theory—metaphors to tell a story about behavior and thinking. Arguably, rape is one of the most powerful instructional metaphors in every human culture. Everywhere in the world, young women are familiar with the story of rape. It is a story of social death and, in some societies, a sentence of actual death. Ecofeminists cite rape as a metaphor for the consequences of predatory and extractive behavior that have decimated our planet. Ecological rape has been noted so often and for so long that it has entered a vernacular mainstream as "rape of the environment."

My rape would parallel what I felt when my father cut down beloved trees. Each tree in Sleepy Hollow had been a companion to Duke and me during our daily walks. In the end, Father actually made every effort to preserve trees, but it was never enough for me.

Growing up, my despair at seeing habitat destruction recurred and intensified over and over. In Venezuela, I had watched annual fires consume the land. Later, in Southern California, I watched the steady paving over of layers of blue hills under an onslaught of cheap housing. When I later saw whole biological systems collapse after Katrina in 2005 and in the Gulf of Mexico under the weight of the British Petroleum (BP) oil spill, I felt overcome with grief and helpless frustration. The takeaway lessons seemed to be that fossil fuel corporations, like dictators in Spain, Venezuela, the church, or my family, had absolute power to inflict damage with impunity.

In the spring of 2020, I understood that I was meant to accept helplessness in the omniscient grip of power, fascism, and COVID-19. I had long understood that I was meant to accept that resistance against patriarchy is futile. Hannah Arendt eloquently described that process of acceptance.

My parents had often warned me about those lonely walks, even with Duke. There were "men" out there who might violate my innocence because "boys [or men] only want one thing." I wasn't innocent, but in the early 1960s, I understood that besides possible pain or the psychological repercussions of violation, it would be socially calamitous if I lost my virginity.

Walking with my dog alone in the woods should have been the least of my worries. Statistically, most rapes are ordinary, routine, frequent, and at the hands of someone known to the victim. The United States Justice Department's Bureau of Justice Statistics reported in 1997 that "28% of rapes are committed by an intimate partner, 7% by a relative of the victim. More than 50% of all rapes and sexual assaults take place within one mile of the victim's home or at their home, and four in ten occur in the victim's home."

Current statistics say that one in four women are victims of rape and that one in seven men are. Those are the reported rapes, the ones people feel entitled to call rape. In many cultures, rape is validated only under particularly narrow circumstances, calibrated by external evidence of

trauma. In some cultures, any rape at all is the sole responsibility, liability, and shame of the victim, regardless of age or circumstances. That doesn't make rape any less traumatic or traumatizing, but it does encourage opacity at best, internalized secrecy at worst. Whether or not rape victims have experienced any prior abuse, research has shown that rape victims are often revictimized in many ways. Breaking the taboo of silence is what has made the #MeToo movement so important and powerful.

Statistics show a relationship between experiencing victimization as a minor and subsequent victimization. Women who reported that they were raped before the age of eighteen were twice as likely to report being raped as an adult. Women who reported that they were physically assaulted as a child by an adult caregiver were twice as likely to report being physically assaulted as an adult. Women who reported that they were stalked before the age of eighteen were seven times more likely to report being stalked as an adult.

When I lost my virginity, it was an ordinary rape in an ordinary place on an ordinary evening. It transformed my life in as extraordinary ways I could not have anticipated, as my brother-in-law's appearance in my life once had. Rape disconnected me from how I experienced my body. No amount of Pilates work would repair that disconnect. For years afterward, rape was the first line of the private story I wrote in my head about my adult life. Rape explained every subsequent poor choice or failure. But rape also marked a critical turning point that made me into an artist willing to take unconventional risks. It forced me to abandon the certitude that my life would be like the lives of all the other women in my family: sheltered and placid but painfully constrained.

In my new state, I would embrace a reckless commitment to nonconformism. I took ownership of my new status, just as an ecological system has to find a new equilibrium when collapse demands adaptation to a new state.

His name was Kenny. I had known him since I was twelve and he was thirteen. He lived next door to Ilana. We started as friends. In the winter, we went ice-skating together on Fremont Pond. My friends and I could walk down from the snowy gardens of my family's backyard to the small dock, put on our skates, and glide onto the surface. On the afternoons

when I was alone, I practiced figure skating after school in Duke's company. Sometimes I had skating parties for my classmates and led lines of crack the whip, racing across the ice. After skating, when Kenny and I were alone, we went back up to the house and sat in front of the fireplace in the music room to warm up. When there was no ice, I sometimes had parties in our basement, where I had painted a large mural of a provocatively dressed, sexy woman walking down a street toward a man leaning against a wall with a bottle in his hand.

Kenny was the first boy who kissed me. I thought that meant we would marry.

At twelve, I was interested in sex but scared of sexual aggression. I had encountered terrifying sexual aggression from strangers on the streets of Caracas. Father kept rooms at the El Conde Hotel in the business center of the city and commuted from there to his project in Maracay. He had been developing his ranch since 1961 as part of President Kennedy's newly conceived Alliance for Progress. Sometimes the family stayed at the El Conde with him. But it was a drab, ugly business place, and there was little for me to do.

One afternoon, my mother and I took a walk from the hotel past gardenias and bougainvillea to the plaza in the center of town. It was unforgettable for all the wrong reasons. In Caracas and other Latin American cities I later visited, the aggression was physically threatening. Men swarmed women and girls with propositions. I remember nothing else of the walk, whether we got to the plaza or how we returned.

I'd also experienced sexual street aggression in New York City when I commuted in for ballet lessons just north of Hell's Kitchen in midtown Manhattan or figure-skating lessons at Rockefeller Center. I had to walk a gauntlet of catcalling men to reach my destination. After a while, I stopped attending ballet classes in New York unless I could spend lunch money on a taxi directly from Grand Central Station to the studio, thereby avoiding the men. I never discussed with my mother how scary these experiences were. The threat of rape or the ubiquity of abuse was too normal for any woman to demand attention to personal details.

It was clear to me that sex and the threat of rape were completely separate experiences. But it had also been made clear to me that sex before

marriage wasn't an option in my conservative family. In my family, a woman who lost her chastity before marriage was contemptible. Outcast status was the price of sex before marriage. Still, I kept the *Kama Sutra* by my bedside, memorized all the positions it described, and eagerly but patiently anticipated a time when I could practice them all. The sexual pleasure it promised would have to wait for marriage. Sex, with the risk of pregnancy was too big a risk to gamble for mere pleasure, no matter how intriguing the *Kama Sutra* was.

My first kiss felt so charged that it detoured the trajectory of my universe with a promise of sensual bliss for years to come even without sex. After Kenny kissed me, I thought I loved him. I thought he was handsome, carried his picture in my wallet, and showed it to my girlfriends. I called him my boyfriend. He remained my intermittent boyfriend throughout my teen years.

That first kiss, however, also initiated long, tedious bouts of wrestling to restrain Kenny's sexual aggression. But unless a real prince came along to sweep me away—or as would happen in my case, a count—Kenny was it.

Over the seven years that followed that first kiss, there were times I struggled more and times I struggled less. It wasn't that I wasn't tempted to surrender, but the stress of the power struggle usually overwhelmed any pleasure. My family and my culture had made it clear that "accidental" sex before marriage would be an unforgivable social failure, far more serious than giving up the violin. Any man who could not respect that boundary was not only disrespecting my limits but endangering my future. But it was presumed that any boy would continually test those boundaries. Father proclaimed his warnings with a smirk and a knowing chuckle or a somber manner.

My family and schoolmates referred to women who divorced with as much contempt as women who had lost their virginity. It was evidently very easy for a woman to fall into disrepute, and, like a biological collapse in nature, often impossible to recover the former state. A woman had to be constantly vigilant to, even obsessed with, that danger. This was never overtly discussed. Innuendo was sufficient education.

Despite all that, Kenny and I were left alone for long hours to watch TV in the downstairs den and eventually get into sexual mischief. The rape occurred just before I started at NYU, after transferring from Parsons.

While studying fashion at eighteen, I often wandered the midtown department stores. Across from Bergdorf Goodman was the Plaza Hotel, where Ilana had been married and where I had always assumed I would someday be married, as well. Sometimes I would stop at the Pulitzer Fountain in front of the hotel and sit on the lip to draw passersby or create a study of the Karl Bitter statue of Pomona, goddess of abundance.

One day a man came by and struck up a conversation. The fountain was a regular stop for me, and he came by several times to talk about art. One day he gave me a book. It was a series of short essays about women whose lives as powerful, independent people were launched after they lost their virginity outside marriage. If that was a courtship offering, I didn't recognize it. Eventually, I went on to other haunts and never saw him again—but the book's premise stuck in my mind.

My expectations for myself were still very small. I expected a life like my sister's. Father was commuting weekly to Venezuela, but Mother was spending more time at home in Sleepy Hollow again. Kenny's parents had divorced, and he left Sleepy Hollow to live with his father in a genteel neighborhood on the edge of the Village, on Fifth Avenue at Tenth or Twelfth Street, near Washington Square Park and NYU.

I decided to let Kenny marry me.

Early one summer evening, we had dinner with his father and his father's girlfriend. After dinner, his father and the girlfriend retired to the father's bedroom and closed the door. Kenny led me down the hall that faced the bathroom and into his bedroom, across the hall from his father's bedroom. He closed the door behind us as his father had closed his own bedroom door. It was a small room. I don't recall a window.

We sat on the bed and began to neck. I enjoyed necking. But then we began our usual wrestling match. Thanks to years of dance and horseback riding, I wasn't a weakling. But he was stronger than I was and determined. He pinned me down under him.

Being pinned down may have triggered another memory of violence, the time when my father pinned me down on my bed for a beating when I was fourteen because I had spent too much time on the phone with a boy. Perhaps that's why I could never recall details of the actual rape afterward. The details of my subjugation differed, but the lesson was the same. I could not defend myself from harm.

I do remember that I was afraid to shame myself that night by screaming. Screaming would have announced to his father and his father's girlfriend—just across the hall—that I had already compromised myself. I was alone in Kenny's bedroom. Screaming would be redundant.

Except for the minutes when my clothing must have been torn away and my body penetrated, I can recall each detail of that evening as vividly as I recall my most recent meal. I was wearing a sleeveless brown patterned silk dress with a high-cut neckline and a short hem. Afterward, I took a bath as Kenny sat on the edge of the tub in the bathroom.

That was when I remembered the book of stories about "fallen women." I identified as a fallen woman, but with that, I also took ownership of my future. It wasn't the ideal narrative, but it was the only one I had.

I dressed, left the apartment, and took a taxi to Grand Central. I felt shame when I boarded and exited the train to return to my parents' house. I was sure my walk broadcast my newly discounted status. I was sure that losing my precious virginity was obvious to the audience of my fellow passengers, who probably barely noticed me. A ravine gaped between my legs. Getting in and off the train, I felt like I was compensating for the ravine by waddling down the aisle. When the train stopped in Philipse Manor, I left the train, got in my mother's car, which I'd parked there earlier in the evening, drove home, and went to bed.

It never occurred to me to report to anyone in my family what had happened. After all, I was a fallen woman. I could no longer claim any voice or place in their society.

If a rape came to light in the 1960s, a man's culpability was rarely at issue unless it was a stranger and there was clear evidence of violence. That is still often true. It was normal for men to "misbehave." If a man

misbehaved with a woman and she was a foolish casualty of his bad behavior, it was always the fault of some failure in the woman—she was too provocative, too confrontational, too reckless. Violence without rape was tolerated, but I understood that losing my virginity before marriage would destroy my life. Nothing in my experience before my rape contradicted that assumption.

I knew Kenny had raped me but knowing isn't the same as psychological ownership. That would have required accepting an alternate, uncertain future life while mourning the life I had irredeemably lost.

The next day, I told a close friend that I had been raped the night before. I was met with a blank look and silence. I had encountered the same experience before, at fourteen, when I told a different best friend that my father had beaten me. Beatings and rape were equally items for the trash bin of secrecy. If secrecy means rape never happened, doesn't exist, no response to the news is required.

In 1964, we had no word for "date rape." Being on a date disqualified a victim from claiming rape. If you knew your attacker, if you were in the wrong place at the wrong time, dressed the wrong way, then the rape was your fault. There was no formal container or outlet for shame or grief if the victim was guilty of any of those transgressions. Despair, anger, disgust, guilt, or fear because of rape was always the secret responsibility of the victim. The feelings could only be internalized. Any feelings expressed publicly were discredited by the social consequences.

The term *gaslighting* (from Thorold Dickinson's 1940 film, reprised by the director George Cukor in 1944, in which a cruel husband tries to drive his wife crazy to distract her from his own crimes) has entered our culture to describe sweeping realities like rape under a plush carpet of secrets. Rape was, and often still is, accompanied by an experience of gaslighting at the cultural scale. It distracts victims of sexual violence from the crimes of patriarchal entitlement.

For the rest of my life, rape left me craving an elusive wholeness as solid as the rigid social systems I had accepted until then. My boundaries had been blasted to smithereens from the inside out. My recklessness included years of sexual promiscuity, validated in my mind by the erotic

writings of Anaïs Nin all through the height of the "sexual revolution," leaving me even more psychologically bruised and confused by the time I reached middle age.

Sharing my experiences of violence created secondary problems. A woman raped had to rise above the trauma or pretend it had never happened. Even today many rape victims, especially in traditional cultures, must endure a lifetime of reality-denying lies. Rape victims tolerate the insanity of denial or social excommunication. After that one attempt to tell a friend, I didn't repeat the report until I began therapy. I had recognized pity in my friend's blank, silent expression.

We now know that men, too, are often raped. I have met several men as damaged by experiences of rape as any woman. Men and women experience the same shame, confusion, and social destruction. Rape cannot be defined narrowly as a sexual experience. It is a power play. There is a trajectory of kindness from pity to compassion to empathy absent from the dynamics of power. Pity is the least of what we owe a victim.

Ecofeminists have said that rape is a pitiless colonization of the other as property, an exercise of power possible only in the absence of empathy. It is an unspeakable exercise in the taking of control of one person by another, one who has an arbitrary measure of greater power, analogous to how humans routinely act as one species dominating another to extract "value."

The dynamics of power are always about a denial of empathy for the other. Empathy makes any witness as vulnerable as any victim. Empathy is the opposite of pity. Pity condescends to the other from a place of safe separation and steals what remains of self-respect. Pity for a victim of rape simply extends that theft of power and buries the theft under shame. Such pity enhances the power of the rapist and insulates any witness who has not been raped. In the natural world, corporate exploitation and despoliation of entire habitats decimate whole cultures to enrich a few. Whole populations are left shamed by their misfortune at the hands of their colonizers and extractors. It is the same dynamic.

What is required is more than compassion, as well. The 1960s offered no guidelines for compassion for rape victims. Compassion connects us to the vulnerability of others and ourselves. Compassion for the pain of

others shatters our comfort zone as much as rape shatters a victim's world. Even more, empathy cannot coexist with exploitation.

Immediately after my rape, I still thought I would marry Kenny. I couldn't yet imagine an alternative path forward. I accepted that my loss of personal agency was a normal part of marriage. Although Kenny and I were behaving as though we expected to marry, I understood something new and distinct after I was raped. Life as I had known it—a safe place in the society I had known, the traditional future I presumed and imagined for myself, despite its limitations and liabilities—was lost forever whether I married Kenny or not.

Virginity had been the singular price of my security. I had squandered that future by my own failure: too short a skirt, being alone in a room with a man. Incidentally, that traditional future looked pretty grim. In 1964, at the age of nineteen, I had no forum to discuss any of my thoughts or questions. I had never met a woman who credibly modeled an alternative life to the one I knew.

When Kenny and I argued about something besides the rape two weeks later, he knocked me down. That finally gave me the courage to defy my own expectations and walk out and away into what seemed like a precarious future.

Denial was still my crutch, helping me carry on. I showed up for classes. My routines didn't waver. I didn't understand yet that it wasn't just rape that had changed my life. It was everything that had led up to rape. Rape had just put a cap on it.

Is it obvious that denial or accepting reality without complaint isn't the same as happiness? So many aphorisms and colloquial metaphors remind us that denial comes back to bite us—those about sweeping problems under carpets, burying your head in the sand, whistling Dixie, elephants in rooms, the emperor who has no clothes. A psychiatrist once commented in passing that if you are kicked in the stomach, you feel kicked in the stomach. Why is denial such a persistently seductive solution? In 1964, rape was only the tip of an iceberg of learned helplessness. In 2020, I have learned to own, recycle, and make rape my informant.

I can't say I was a happy young woman before the rape. Growing up, I saw a lot that suggested denial was an imperfect life strategy. The choices

I initially saw for myself after the rape didn't make me happy, either, but they allowed me to survive despite a new loneliness. Denial would continue to be a desperate lifestyle until I encountered the women's movement in the late 1960s.

In the natural landscape, a place where water can collect or be shaded by a fallen tree branch might be all that's necessary for new life. Feminism combined with therapy provided the emotional sustenance and shelter that I needed to survive.

It wasn't until the 1990s that I came across the feminist social scientists of the last century, who pointed out a continuum between child abuse, rape, and domestic violence. They argued that these assaults are training models to conform to a white-supremacist society.

Gendered violence teaches men and women (especially) to normalize gender privilege. It prepares everyone to adapt to a hierarchy of white cisgendered male patriarchal control. The education of young women to conform to that system advances as a progression of impacts from all sides. In some cultures, male rage and vindictiveness are endemic, and women often function as gatekeepers to protect the men by reinforcing standards of behavior, such as prescribed appearance or submission to male control with shaming. Today's feminists call these normalized systems of violent repression "rape culture."

At the end of the 1980s, after I had already created decades of work about violence between people—not only rape but child abuse and domestic violence, violence between men, and animals victimized by people, always trying to understand the link between human behavior and environmental disaster—I heard a sociologist on the radio say, "It is amazing how much pain you can inflict if you don't feel your own." Perpetrators of rape or ecocide might be people who have disassociated from the ecotones of their own vulnerability and dependency on others, human or not—people afraid to feel either empathy or their own pain and choosing to inflict pain instead. The perpetrator might be as much a captive of helplessness as the person victimized. If we are ever to end cycles of destruction, one of the tasks ahead is to normalize greater mercy.

Just as rape may be a form of spiritual murder, the removal of keystone elements of a habitat threatens the heart of the entire system, leav-

ing it chaotic and unreliable. When Anglos decimated the herds of buffalo that the Plains Indians depended on, that was precisely what happened. They destroyed the Plains Indians' spirits as much as their livelihoods. To seal the deal, they built railroad lines in the path of buffalo migration corridors.

Native Americans have been persecuted from the birth of this nation. They called George Washington "the town destroyer" because he burned forty Native settlements to ashes when the Iroquois resisted becoming assimilated farmers; in his writings, he was explicit about his intention to destroy their spirit along with their habitat.

Deforestation as a weapon of war has a long history. The United States deployed Agent Orange, defoliating swathes of land in Vietnam. Ancient Romans broke the resistance of the fabled Druids of the British Isles by destroying their old-growth forests, reducing them to the fields of colorful heath so familiar to tourists ever since.

Habitat loss occurs for many reasons, including some that aren't anthropogenic—for example, when a wetland becomes a meadow and then a forest. Wholesale destruction is typical of wars, but landscapes can disappear in the absence of war when humans steadily encroach on an intact system to gather firewood, hunt indiscriminately, build roads, or gather timber, incrementally endangering the integrity of the whole. Trees are cut to build houses and warm people. Oceans are overfished to feed them. Livestock are set loose to graze on saplings before those animals also become a meal.

The forests and waters of the world deserve the same empathy and restraint we might have for other victims of human violence. If we felt our fear of losing water, a habitable climate, or pollinators as our own loss, not only the loss of peace and beauty, might we then hesitate before cutting down another hectare of Amazon forest? Instead, the ecosystem and social ecotones that might protect a habitat or a sexual assault victim are steadily eroded for profit.

Besides breaking lethal silence, the genius of the #MeToo movement has been to tear apart the prison of isolation inherent in rape culture. That is a restoration process. A similar process takes place in the environment when ordinary people become aware of the value of planting

indigenous species or take measures to conserve the large tracts of forested land that sustain a habitable Earth by providing contiguity and new edge areas.

Whether destroying land to win a war or leaving plastic in the oceans or clear-cutting forests, the damage is as irreversible as rape. The consequences of ecocide earn inadequate empathy or restraint.

In the mid-1960s, none of this was clear to me, not the missing love or the inexorable ecocide devouring the Earth. What *was* clear was my instinctive need to live in another system. Like so many young people in the 1960s, I heard a clarion call for change. Few of us understood a relationship between change and empathy as a practical strategy. I certainly did not.

The year of my rape, after I transferred from Parsons and enrolled full-time at NYU, I was also accepted into the Cooper Union School of Art and Architecture, where I began my education in earnest as a young artist with a social conscience by taking evening classes.

I was determined to make a mark on the world. It was a time of promise. Success was the obviously accessible American dream. Ideals were ubiquitous. Boundaries were dissolving like tissue paper in a hard rain. That was when I began to think like a cross-disciplinary artist, looking from music to dance to sculpture. We had no word yet for interdisciplinarity, or even less transdisciplinarity, the elusive space between science and art. But artists were testing and dissolving boundaries in revolutionary ways. I wanted to be part of that revolution. I had replaced my hopes of engaging in my father's land adventures with another kind of exploration.

My drive to understand new forms was as visceral as my search for spiritual meaning had been when I was younger. I needed an alternate understanding of myself as a woman. The art world of the 1960s was where I glimpsed an exciting future for the first time since my childhood dreams of working with my father or my dream of romance with Fernando.

I wasn't the only person searching for new paradigms. By 1966, an exuberant instinct to transform and mend the world was ubiquitous from Paris to New York to points east.

My experience of rape unraveled a false set of convictions in my personal life and uncovered a whole new set of connections to a wider world.

In the mid-1960s, I was like a blind mole, reading random scientific texts and tunneling through the new ideas I found. That autodidactic process took decades to coalesce. When it did, it would serve me as I formulated trigger point theory. My experiences were encouraging me to layer as many disparate forms of data as possible, like reinforcing the redundancy factor of ecotones. Layering is required to fully analyze and find solutions to environmental degradation.

Over my life, as I watched habitats I loved succumb to destruction, my feelings paralleled my responses to rape. In both ecocide and rape, the dramatic destruction of the world produces cascades that invite further assaults. In childhood, I connected the dots my mother had laid out between genocide and rape when she spoke of lost relatives. Much later, I would see how those connections were the warm-up to ecocide.

Rape was a small but critical disruption of the sensitive conditions of my life. I was lucky that I didn't get pregnant in an era when abortion was illegal and potentially fatal. If I had gotten pregnant, this book might never have been born or at least not been born from this story. Instead, surviving rape scarred me, but my survival strengthened me.

Ecological restorationists can begin the regeneration of habitat that has been decimated. My previous self-image had died, but I found a new life. I would bear no progeny, but I was not hopelessly and completely destroyed. I found the wherewithal eventually to adapt in the ecotones of my life. I had saved the bare bones of an entire ecosystem in which I was at the center. As I had in lucid dreaming as a child when faced with multiple assailants, I saved myself. I was free. In time, I would imagine myself protecting not only myself but also a wider community of trees, other plants and animals, sheltering water, and climate for many more.

At nineteen, that was all still very far away.

5

Connections and Transgressions

M y first step away from the man who raped me in 1964 left behind lingering fairy tales about my future. Between that incident and April 4, 1968, the date of Martin Luther King Jr.'s assassination, the world I knew began reorganizing itself. The very air in New York City in those years was electrified with creativity, charged with urgency, hope, and danger. Small rituals around a woman's traditional role began falling away, replaced by new ideas about freedom. I was ready to make up for years of restriction.

Psychologically unmoored from my family's safe harbor by my rape, I embarked on a career as an artist, embracing every new concept I encountered as fervently as I had once embraced religion. I had found my black swan, immersed myself in a 24/7 round of art classes in several different schools, and initiated a studio practice. Somehow, I knew it would be a long haul, but I had found my lodestone.

In addition to my classes at NYU and The Cooper Union, I attended daytime and weekend classes at the Art Students League and the School of Visual Arts. Some classes and teachers had lasting influences. Robert Beverly Hale's anatomy classes at the Art Students League launched my lifelong research on how the physiology of human bodies determines

our perceptions, building on the work I had done in dance class and with Joseph Pilates.

That meticulous study was at odds with growing ferment in my personal life, mirrored in the streets around me. By the end of the 1970s, I would be in California, where I would see creativity clash with violence.

Early in the 1960s, I had come under the spell of Anaïs Nin's luxuriant prose about her sexual freedom. I realized that sex disrupted all the systems I resented. Sex as power unmoored from marriage was a new idea. Many men felt entitled to sample it as a phantasmagoric free banquet with delicious impunity. Indiscriminate sampling often ignored impacts on partners. I didn't know about that yet. What I did know was that flaunting my sexuality unnerved men, and I relished that power. I embraced the sexual revolution.

Although I was flying high on ideas, I still wanted life anchors. While my family had been traveling, Duke was boarded. I thought that he, like me, must be lonely and confused. I asked my mother to let me have him. I was being wildly unrealistic and selfish; I was barely up to caring for myself, let alone a large aging dog. She said, "No. He's mine." Not long afterward, he left one snowy winter and never returned. His time had run out.

I was living on the Lower East Side of Manhattan.

I had boundless energy to go dancing to the music of the Velvet Underground at the Electric Circus, where I first experienced the composer Mort Subotnick's *Silver Apples of the Moon* and its accompanying sound-light show. I hung out at Slug's, a jazz club, to hear and sketch Yusef Lateef, Sun Ra, and other legendary musicians. I was oblivious to the drug dealers and muggers who frequented Slug's and made the area a no-man's-land for taxicabs. They were just part of the landscape, as ubiquitous and puzzling to me as the *favela* in Caracas.

Two doors west of the Electric Circus, a block from Cooper Union, I often looked in on the new clothing by the Black designer Khadejha McCall. Khadejha was a tall, striking, warm woman. I admired her style and vision. Besides a personal connection, we shared a real love for beautiful clothing.

In the 1960s, clothing was as much a part of street performance as music. I wore Day-Glo chartreuse-green tights embroidered with Mylar

diamonds and a tiny miniskirt and sometimes wore a platinum-blond waist-length wig that made me feel kinship with Nico, lead singer for the Velvet Underground.

One day, Khadejha offered me a job. I became her assistant, hat model, fashion illustrator, and friend. She expressed an elegant and comfortable simplicity in her clothing, clean lines, well constructed, with feminine flourishes. Today I can recognize African silhouettes in my memories of her designs. Khadejha, who had several children by different men, was a strong, independent role model. She was an inspired artist supporting herself and her family.

I was proud to apply Donna Karan's advice about supporting myself with fashion illustration. Khadejha wanted to introduce me to her friends, including Ellen Stewart, another Black woman, founder of the famous La MaMa Experimental Theatre Club. Yet in spite of her talent and strength, Khadejha deferred to her tall, handsome boyfriend and business manager, who was younger than she was. He was adamant that she should fire me and hire a Black person for the same job. I understood his political statement, but I wondered whether it would serve Khadejha's vision to fire me. She told him that I had all the skills she needed, but he won. I learned that even strong women could cede control over their lives to men.

What I didn't understand were all the complex reasons she might have deferred to him or any of the arguments I should have made for how I could support my friend in her work. Instead, Khadejha disappeared. It is only now, as the pandemic has torn a scab off racial and class injustice, that I can better comprehend what happened then and what opportunity was lost.

Being fired might have been the first time that I found myself in a complex adaptive system, in which disparate agents in interaction determined outcomes. Even in my teenaged study of the *favelas* in Caracas, my response had been more about the abstract cognitive dissonance of what I was seeing than an experience of my own complex relationship to caste, race, or class. Equally, I saw no avenue forward for me to effect justice. I saw no alternative except to swallow my confusion.

In my relationship with Khadejha then, I understood that her relationship with her boyfriend, the racial/political issues, and the structure

of the fashion world were not impossible for me to unravel but that I was somehow implicated in those tangled relationships despite my frustration. Unlike the *favela*, the personal entanglements were rooted in profound complexities I wanted to understand but could not fathom.

During the summer of the 2020 pandemic, I finally tracked Khadejha down. She was eighty-seven and living in Atlanta. She had earned a master's degree, had pursued a successful career in fashion, had long since moved into printmaking based on African motifs, and was chronicled in a book by Ada Calhoun, *St. Marks Is Dead: The Many Lives of America's Hippest Street.* Calhoun quotes Khadejha as complaining that the members of the Velvet Underground would visit her store but only wore jeans. I was thrilled and moved to learn that she had kept one of my fashion drawings.

Two women, one Black, one white, will not come to the end of their lives with the same rewards for their talents, let alone what a white man might walk away with. The late film director Joel Schumacher—tall, handsome, white—was also in my cohort at Parsons. In a conversation we had at the California Institute of the Arts (CIA; CalArts) years later, he said, "In every class, someone is singled out by powerful people to be given advantages and promoted to success. I was that person." Evidently, it never occurred to him to question his entitlement. I recall only one Black person at Parsons, a young man from Harlem whom I have never heard of since.

In the spring semester, I moved with my boyfriend, Payson—"Pays" to me—into a loft building on the Bowery inhabited by artists who would become famous. Pays was the first man I'd met who promised a friendship of equals. He matched my intellectual, creative, and sexual passion. But my new sexual autonomy did not free me from family censure. When Pays and I visited my mother and sister in Sleepy Hollow, Ilana and I got into an argument upstairs in my former bedroom.

"Go back to New York and have sex in a room!" she yelled.

"You are the emotional whore!" I yelled back.

Ilana knocked me down hard.

I hit my head against the wall and began screaming hysterically. Somehow, I was on my bed and still screaming.

Mother came upstairs and slapped me hard.

I stopped screaming.

As I lay alone on the bed, Pays, Ilana, and Mother convened downstairs. They agreed that I needed therapy. Mother paid for my therapy twice a week for years, and I integrated it into my schedule with workouts with Joe and my classes.

In the city, Pays and I ate at Ratner's, at 111 Second Avenue, where the waiters let us order a bowl of soup and eat the entire contents of the bread basket that came with it. Sometimes, they even replaced it. Leaving our loft, I stepped over drunks sleeping in the doorway and on the street.

Over the next few years, I cycled through several B jobs: salesgirl, Head Start teacher, freelance sign painter, hostess at a wine-tasting event at the New York World's Fair, greeter at the Metropolitan Museum of Art. My last job in New York was retouching type on old manuscripts for reprint. Painting in the very thin lines that age had faded in each letter required meticulous attention to detail. I was good at it and enjoyed the meditative task, but my job with Khadejha remains my favorite job ever.

My job at the Met seemed the most surreal of them all. In those days, the first floor of the museum had a gracious restaurant with sculptures by Carl Milles for the large *Fountain of the Muses,* situated in a shallow reflecting pool. My job was to look well put together and stand at the entrance with a clicker, tracking everyone who passed inside while cheerily saying "Good morning" or "Good afternoon," making eye contact with a big smile for every single visitor. I made that smiling contact with hundreds of people a day, no matter how deformed their bodies or how cool their demeanors. This was a small exercise in generosity.

The restaurant was staffed mostly by actors and Latinos. I occasionally worked the cash register while someone went on break or helped the kitchen staff set out the food. I was perfect for the job because my whole life had taught me to present a placid, pretty appearance without any personal identity beyond a gracious welcome to all comers. By the end of the day, I found it impossible to smile at anything.

My circle of personal friends included poets and other artists who taught me as much as any of the classes I was taking. We were all studying

The Tibetan Book of the Dead together, solemnly sharing our understanding of the Bardos between life and death and speculating on whether hallucinogens might be the fast track to enlightenment.

Drugs were an aesthetic choice, and their effects began to inflect and bleed into normal life and our artmaking. On one occasion, I took some drug before leaving for work at the Met. When I was supposed to be greeting people, the manager found me staring into the reflecting pool, studying the water.

"Is anything wrong?" he asked.

Although I had alarmed myself, I had long since become practiced at swallowing how I felt.

"No."

I pulled myself together and returned to my station. That incident was the first indication that something might be unraveling inside me.

One summer afternoon, I was sitting in the kitchen of a poet friend who had become a drug dealer. He told me he was scared because he thought the Mafia was watching him for recruitment or death. While I was there as a friend, not to buy anything, he offered me a hit of N-dimethyltryptamine (DMT), a quick-acting, powerful hallucinogen that lasts only twenty minutes.

Suddenly, I heard the most amazing, complex symphonic sound I had ever encountered. I turned to my friend to ask, "What's that music?" I was not only high; I was drunk on sound. Later, I began to sort out what I had heard. The music had been made up of all the ordinary sounds of the city: traffic, people talking, the clanging of trash cans. It was a revelatory, exciting moment. I had experienced how drugs could color ordinary life and, more important, how ordinary life could be transformed into moving art. My twenty-minute epiphany told me what kind of artist I wanted to be: someone who could make magic out of the ordinary elements of life we take for granted.

It was the right time in my life to encounter that vision of sound. Eventually, the memory of acoustic transformation knit with what I would learn about the physiology of perception and the integration of disciplines in a creative world without arbitrary boundaries.

This was something slightly different from what I was seeing in the Fluxus artists who had captured my attention. But the Fluxus aesthetic was as conceptually lush and formally dense as my DMT experience.

This was the heyday of the Fluxus art movement, when Allan Kaprow was doing Happenings and Jill Johnston was writing brilliant monologues for the *Village Voice* about the minimalist dance performances of the Judson Memorial Church artists, all realizing something besides monumental spectacle. Another window was opening up about what art could be.

In my 3-D class at Cooper Union, we were told to carry an object with us everywhere we went for a week and then make a report about the experience. I don't recall what I chose or what my report was, but I never forgot the idea that my relationship to an object might be the actual experience instead of the object itself.

One fall afternoon in 1966, as I was getting off work from my job at the Met, an attractive young man struck up a conversation with me at the bus stop in front of the museum. I was taking a break from my relationship with Pays and felt free to start a new romance. My new boyfriend, Billy, took me to "9 Evenings: Theatre and Engineering"—later known as Experiments in Art and Technology (E.A.T.)—show at the Armory.

That night we became part of Robert Rauschenberg's crowd scene for his Tennis Court piece, part of his performance work *Open Score*. Rauschenberg, whom I later got to know as Bob, said the technological problems had made it a failure. Despite the technological glitches, I was thunderstruck. His work left a trail of conceptual bread crumbs leading me to the kind of work I wanted to do. I could feel the creative tension of engaging a large group of ordinary people in performing ordinary actions while transposing us from one context to an entirely different one.

On another night, I was mesmerized by watching Yvonne Rainer walk slowly across the floor as a performance, embodying at a new pitch of awareness what I had learned from Joseph Pilates. The works I saw were on a scale I'd never witnessed before. They also combined the same kinds of simple actions that had excited me about Fluxus works. The intimacy of Fluxus seemed diametrically opposite to E.A.T., which had added an entirely new technological element.

I was dazzled. Rauschenberg was already my idol. I was elated to be in his work and experience it firsthand from the inside. I decided that I wanted to combine both ends of the spectrum, from intimacy to spectacle.

Billy's easy proximity to art power impressed me. His father was a collector of Rauschenberg's work, and Billy had recently had an internship with the artist James Rosenquist. Billy took me to meet Stan Lee and Jack Kirby, of Marvel Comics fame. They were experimenting with plastic lithographic plates for fine art printing and invited me to take a few and make images for them. As with so much in my life then, I was too naïve to realize what special opportunities they were offering. I was already laser-focused on my own vision for the art I wanted to make and often oblivious to what others might have taught me.

Billy eventually joined me in therapy. It looked like we were headed for marriage. He was a suitable boy, and I loved him. But he decided to join the Peace Corps to avoid Vietnam. They sent him to Bahia, Brazil. We corresponded. But my attention drifted, my patience flagged, and we began to lose touch.

The truth was that even three years after my rape, despite the sexual freedom I had been exploring, my romantic relationships were still very dysfunctional. I couldn't wait for him. When he left for Brazil, I felt abandoned.

I wanted to pursue what I had seen in the Armory show. I followed up my interest in E.A.T. in a series of meetings held for artists. It looked like there might be opportunities for artists to develop projects with the Bell Telephone engineers who were behind E.A.T. I submitted a proposal for a project with high hopes. When I didn't receive an enthusiastic response, I kept trying to find someone at E.A.T. to connect and collaborate with. It didn't occur to me that a bright, pretty, privileged young woman would not have equal entry with the men. What I intuited even then and can clearly see in hindsight was that the most necessary element I missed was a relationship with a man who would be acceptable to the community I needed to enter. In the late 1960s, I was consumed with my own creative priorities, which were to learn everything I could about art as fast as possible.

It seemed easy to meet other artists and become part of their events in downtown New York. The entire city seemed like a stage set for per-

formance art. Besides Fluxus's performances, I saw films by Stan Brakhage and Stan VanDerBeek, whom I would later work with at CalArts in 1971. The images I was internalizing washed over me like a creative waterfall.

At one of the E.A.T. meetings, I ran into Pays, and we resumed a passionate relationship. We moved into another loft, this time in the Meatpacking District, where beef carcasses lined the narrow cobblestoned streets. Walking home from school at night, I had to thread my way between the skinned bodies of dead cattle suspended above the sidewalks.

Our loft was part of a group of low buildings that surrounded a small courtyard, where Andy Warhol's crew sometimes came to revel among fermenting barrels of pickles in the night, wine and pig grease staining clothes of satin and silk, normalizing another layer of abandon. Warhol's people and the dead animals became a collage of impressions that blurred into all the sensual extravagance of the times. The individual artworks and events were less important than the continuity of crowd expression. My takeaways were fleeting images and enduring ideas.

Pays was working with Peter Schumann's Bread and Puppet Theater, and I joined, too. Once more I was stunned by monumental effects created with simple means. When Peter shared homemade bread with us all, I was charmed. I performed with his theater as part of a puppet-headed procession of simply clad performers in Judson Memorial Church. He had choreographed us so that our moving figures cast enormous shadows on the walls of the church as we passed in front of the audience. Those shadows that our flashlights cast in the context of a religious allegory made a powerful impression on me. Their simplicity contrasted dramatically with the elaborate means of the E.A.T. events, as had the Fluxus strategies. They seemed closer to my DMT-inspired impression of how life could be transformed and activated in ways inaccessible through conventional painting and sculpture.

This potential for transformation felt particularly relevant during the anti–Vietnam War demonstrations. How could I lock myself in a studio alone when collective righteousness on the streets was remaking the whole world? But the vision we were all yearning for still seemed vague and abstract to me.

All the works I was seeing contrasted dramatically with the extravagant operas I saw in the cheap seats at the Metropolitan Opera House or my memories of Stravinsky's *The Firebird*. I was most drawn to the democracy of Fluxus, Kaprow, and Peter Schumann's means; they showed how an artist might design a work that anyone could participate in and that could have profound impacts on an audience. I hadn't yet internalized my longing to combine the sensual aesthetic terms that might take form in my own artwork with these simple structures, nor did I understand how I might express that in original ways.

What I found most exciting was the sensual reimagining of the world in the artworks I was seeing, imaginings that could model another future. In the spring of 1965, I came out of the *Responsive Eye* exhibition at the Museum of Modern Art seeing moiré and fractal patterns everywhere. Even without the help of hallucinogens, I was transfixed by the patterns suddenly obvious in the sidewalk grates and stone facades of buildings.

I was seeing how art can do the work of reorganizing perception to change society in a flash. I was absorbing what I would eventually understand to be art's embodiment of the principle behind Maxwell's demon. This was equally true on the micro and macro levels. I was seeing art all around me that didn't look like that of the painters of the Renaissance I had studied so carefully. The art that surrounded me drew on the materials of everyday life: cars, various technologies, the movements of crowds, street trash, and political actions. Behind these choices, deliberately or intuitively, were responses to the horrors of World War II. No longer did the intelligentsia assume that if we simply reversed the tropes, trappings, and presumptions of the past, humankind would steadily march to an ever-better future of goodwill and universal plenty. Like a house of cards, that assumption had collapsed. Culture was rooting around in the detritus for meaning.

By 1967, I was being surprised by art that was not only reimagining the world but reshaping it. Abbie Hoffman's action of raining dollar bills on the traders on Wall Street and watching them scramble, to reveal their financial greed, went viral. Hoffman's prank seemed like a quantum leap from Allan Kaprow's Happenings. I was discovering new ways not only

to conceive of space but also to imagine the relationships between that space and innovative relationships to an audience.

Before I met Billy, Mother had thrown Pays and me a gracious party to introduce him to family friends. I refused to announce that we were engaged, although that was everyone's expectation. My defiance was a reversal of what he and I had tried to do at nineteen, when we headed to the New York City Marriage Bureau for a license. But that required his mother's permission, and Pays had a fraught relationship with his mother; she was a cold woman, a renowned oral surgeon and talented artist, comfortable in circles that included Jean-Paul Sartre and other luminaries of the times.

When Pays and I got back together and I weighed him against Billy, I was also weighing their mothers. Billy's mother was kind and gentle. But I thought the brilliant success of Pays's mother, despite her issues, might make it easier for him to accept and support my own ambitions. It never occurred to me that anything about his mother might have left Pays with some ambivalence about powerful women.

Even though Pays had lived away from his mother for several years, supporting himself as he worked on premed studies at NYU since his midteens, she refused to give her permission, and we could not marry on that first try. His mother attended the party my mother finally threw for us. At the party, I positioned myself on the opposite side of our parents' expectations.

Eventually, Pays and I married in the winter of 1967, over the objections of my psychiatrist, who foresaw trouble. I dreamed of hands strangling me. My psychiatrist pointed out that the Spanish word for hand, *mano,* might imply something about how I experienced men. He feared that Pays would be controlling. He didn't say it, but I think he disapproved of how I had abandoned Billy.

When Pays was accepted to do graduate study at the Scripps Institution of Oceanography and we were about to leave for San Diego, my psychiatrist advised me to marry first, not withstanding his misgivings, lest I be unprotected in California. Despite my record of defying authority, I cautiously accepted his advice. I was as ambivalent as my psychiatrist

because I thought I was also still in love with Billy. But I had seen that Billy thought about politics in more conservative ways than I, and I had already given up on finding common ground with conservative values.

I anticipated more freedom with Pays than I thought I would have with Billy. But defiance was still the only way I knew to negotiate conflict, and the targets of my defiance kept moving. My resistance to patriarchy would have consequences.

There was no wedding at the Plaza for me. We wrote our own vows and married in our loft with our mothers and our two best friends in attendance. Afterward, we all went out to dinner at our favorite restaurant in Chinatown and tucked into a feast. Wondering whether I'd just made a terrible mistake, I got drunk.

Pays and I became activists in the antiwar movement. We went to the demonstrations at Columbia that spring, where police on horseback chased us all down the side streets. Many of our fellow activists were brutally beaten and arrested, but we escaped unscathed.

The next two years were bloody:

April 4, 1968—Martin Luther King Jr. was assassinated.

June 6, 1968—Bobby Kennedy was assassinated.

May 15, 1969—Jimmy Rector, a gardening activist in People's Park, was shot by Berkeley police, who had been called in by Ronald Reagan. He died four days later.

May 4, 1970—The Ohio National Guard murdered activist students at Kent State.

May 11, 1970—A student self-immolated at the University of California at San Diego to protest the war.

John F. Kennedy's 1963 assassination had been shocking. Parsons canceled classes that day. I went to the nearest church to collect my thoughts. The shocks of assassinations and death over the next seven years progressively reinforced bitter new lessons in political helplessness and control. Violence teaches submission. The conservative forces in power in the United States had no intention of accepting any new models of visions for the future.

Pays and I left for California in the spring of 1968. My mother bought us a green VW van, which I named Boris. We rescued from the local

pound a medium-size black Lab, whom I called Natasha. We stuffed our car with dried bags of delicacies from Chinatown and set off.

It was an ill-fated trip from the beginning. The back door of the van flew open when we hit the highway, and the road was strewn with cloud ear fungus and pistachio nuts. I had been driving since my early teens, while Pays, who had just gotten his driver's license, insisted on doing all the driving. He was a horrible driver, accelerating terrifyingly into hairpin turns as we drove north to Canada and across the continent before heading south from Montana and then west through Las Vegas to San Diego.

Our first night on the road, we huddled in a pup tent with Natasha in a fierce rainstorm. After that, I refused to camp out and insisted we stay in motels each night for the two weeks of our trip. Pays was so worried about the cost that he routinely drove twelve hours a day. I sat in the passenger seat with Natasha on my lap and tears streaming down my face as I stared silently out the window.

In San Diego, we were adrift from family and friends back east. Pays was working at the Salk Institute and began a daunting course of study at Scripps with the great oceanographer Roger Revelle as his mentor. Revelle was one of the first scientists to work on global warming and marine regulation, and, through Pays, I learned a lot about that work. I was not yet ready to research those ideas for myself, but I would spend years thinking about them until I was ready.

When we left New York, I had promised myself that I would take the bones and sinew of everything I had learned and make a new form of art. The elements I was assembling included what I learned from Joseph Pilates; the monumental simplicity of movement I had watched in Yvonne Rainer's and Peter Schumann's work; Rauschenberg's technological fireworks in E.A.T.; the confrontational tropes from Abbie Hoffman and other artist activists; and the spatial and perceptual lessons from my classes.

After a summer in a bleak navy suburb of San Diego, we moved to Del Mar, where we had a small organic vegetable garden and settled into a new lifestyle. We were soon part of a social circle that included some of the greatest scientific minds of those times, from Jonas Salk to Francis Crick. I was so used to the circles of power my father inhabited

that, just as when I worked for Khadejha, I had no idea what privilege I was experiencing.

Instead of paying attention to the luminaries around us, I threw myself into developing an experimental performance practice. I initiated the American Ritual Theatre (A.R.T.)—inspired by the work of Jerzy Grotowski, whom I'd read about in the *Drama Review*—and began performing throughout the San Diego area with a troupe of students I recruited from the University of California at San Diego (UCSD). I was often gone all day and into the night.

Our first public performance was in the Synanon Center in downtown San Diego. I called it an "anti-performance" and in a press release described my intention to direct a "sad circus." During the performance, I called out movement directives to the troupe. Announcing arbitrary directives of control in live events was meant to mirror the rising turmoil of political conflicts overcoming the country, so evident in San Diego as the home of many military outposts.

The concepts I was evolving with A.R.T. produced a number of works that set me on the path of my practice for the rest of my life. My first works were improvisational, using spatial structures, based on my dance training and what I had learned in New York. We performed in various settings indoors, in commercial settings, and in nature. The events were often simple walking pieces, incorporating improvisational interactions with ambient sound, sometimes in costume, as when I sewed silver-tinseled miniskirts to wear with silver-dyed T-shirts and painted the women with silver stage makeup to stroll through downtown San Diego.

I was interested in combining the intimate positioning and interaction, closer to what I had seen from Fluxus combined with the monumental effects I had participated in with E.A.T. and in Peter Schumann's work.

One of my favorite informal performance venues was the open space of the Salk Institute, part of Louis I. Kahn's design, where every movement was dramatically framed by the plaza, the ocean vista flanked by imposing towers. Another of my favorite works took place on the crest of a high hill in then sparsely populated East County. We had driven far into the countryside, and from the base of the incline at the bottom of

a hill, I watched my performers drift slowly amid a stand of eucalyptus trees, appearing and disappearing between the trunks.

We were performing primarily for ourselves, with scant documentation. We often ended the evening at a favorite Mexican restaurant, dancing deep into the night.

What I was absorbing from the people we knew, from the stories Pays told me from his classes, and from my own performative experiments was another way of looking at culture. This was more sophisticated research than observing the effect of op art on perception—radically different from what I had known in New York City but not so different from what I'd observed from my father. It was one more lesson that I could not have named then but was grounded in complexity and systems theory. The world of art and politics in 1960s New York City had primed me to have an open mind. Once again, as I had as a child with the *Encyclopedia Britannica* or at Tarrytown's Warner Library, I was vacuuming up ideas, this time by osmosis, from the great environmental ideas and initiatives around me.

By then, I was avidly tracking what Pays was learning about oceanography as closely as I'd once tracked my father. The thinkers at the Salk Institute, including Jonas Salk himself, at the university, and at Scripps were already inculcated, consciously or not, by Marshall McLuhan's ideas about media and information—which had been predated by the work of the Austrian biologist Ludwig von Bertalanffy, a founder of modern general systems theory (GST). Since the 1940s, von Bertalanffy had been contesting the notion that systems trend toward equilibrium.

Despite the intellectual excitement that Pays and I shared, our marriage was suffering. Pays went on a research cruise and announced that this would be our future life together: him on cruises and me tending home, hearth, and cradle. I struggled to come to terms with those implications. It seemed worse than giving birth in a drafty castle. Meanwhile, I was following Adele Davis's book on nutrition and packing homemade soy burgers for Pays's lunch, while his schoolmates ate hamburger, to his chagrin. I was also taking hallucinogens more often.

Pays wanted to participate in my performances, but he reacted badly to my direction. After a performance he had insisted on being part of

at San Diego State, he chased me through our home until he caught me in the back entryway, behind the kitchen, and knocked me down against the wall. What I recall most vividly was how close his hand was to the knife rack. From then on, I feared my husband, as Mother had felt fear since early in her own marriage to Father.

Conflicts over the Vietnam War were erupting at the University of California at San Diego in La Jolla, where I was regularly performing with A.R.T. and becoming increasingly obsessed with the work I was creating. In the late 1960s, San Diego County was a small, strange community of military outposts and the John Birch Society, of encounter groups and surfers, of brilliant academic intellectuals and avocado farmers. The administration at research institutions like Scripps reflected the same mélange.

Pays and I had both been auditing classes at UCSD with the immensely popular philosopher Herbert Marcuse, where we become acquainted with Angela Davis, Martha Rosler, and other students who were profoundly committed to social change. My new friends included Angela's sister, Fania, and Fania's husband, Sam. Marcuse's lectures showed me that art could apply a Marxist analysis to organizing the process that results in production.

My performers and I began meeting with Marcuse to argue over what a revolutionary art might look like and whether performance art might provide the best vehicle for political change. Marcuse was devoted to the Surrealist core of the artist Max Ernst's work. In the book *Eros and Civilization,* first published in 1955, Marcuse argued that Ernst had fully realized Sigmund Freud's notion of the polymorphous perverse. He believed that contemplating Ernst's images would effect the great revolution of democratic entitlement that was Marx's ideal goal. My takeaway from our conversations with Marcuse was an ideal of total immersion in joyful interactions with our environment. I believed that the potential interactions in street-theater performance art could effect social change far more immediately than any static image on an immovable surface, passively viewed.

Total creative immersion didn't translate well into traditional expectations of how a wife should behave in the 1960s. I had only vague ideas

about asking Pays to share household duties and no examples of successfully sharing domestic responsibilities that protected freedoms for both partners. Pays's temper erupted unpredictably and scared me. In a short time, politics exploded whatever stability we had been establishing and plunged us both into the turmoil of Ronald Reagan's California.

Meanwhile, several UCSD faculty members in the music and art departments with whom I had developed friendships, including the composer Pauline Oliveros and the artists Eleanor Antin and Newton Harrison, asked me to assemble a proposal for a dance department, which I completed in the spring of 1969, based on the performance premises I had been developing with A.R.T.—for example, to include vernacular dance forms in the curriculum. As I was developing these ideas, Pays became entangled in academic politics. He invited Marcuse to speak at Scripps about the social responsibility of science and scientists.

Pays's mentor, Revelle, had opposed McCarthyism without repercussions, but Marcuse's presence provoked the conservative administrative forces at Scripps to initiate retaliations against activists. That had serious academic consequences for faculty and students alike, and the conflicts contributed to Marcuse's premature retirement.

The Women's Liberation movement would become the basis for a new political narrative about disenfranchisement and gender justice. Eleanor Antin and I began a collaborative group with other local artists called Nine Women, which included Ida Applebroog, Faiya Fredman, Judy Nikolaides, Pat Patterson, Martha Rosler, Joyce Cutler Shaw, and Ellen Van Fleet, to meet, collaborate, and experiment with feminist content. Eleanor commandeered a Quonset hut for us in the UCSD art department, and we began a regular routine of working on installations there. Martha assembled the first consciousness-raising group on campus with a number of us. Some women from the *San Diego Free Press* launched a feminist newspaper called *Goodbye to All That,* which I worked on intensely for a time and Martha also contributed to. The newspaper got press attention from publications as far away as the *New York Times.* I wrote several articles and created calligraphic headlines. One article was a profile of Khadejha. Another article, "The Worm," was a macabre story of a woman whose life is invaded by horrific shame.

Hoping to save my marriage, I wanted Pays and me to go into couples therapy. Pays was becoming more violent. I sought an injunction. It was impossible to get an injunction without filing for divorce in California then, so I thought I had no choice. I became the first and only person in my family to get a divorce. That summer was a bad time for us all. Pays had a terrible motorcycle accident, ended up in the hospital, and lost his scholarship.

Our dog, Natasha, was cruelly neglected. One day, a neighbor told me she'd seen Natasha killed by a car. I was too obsessed with my own affairs even to retrieve her body, and Pays never asked about her. Since then, I have grieved long and hard for that sweet dog, whom we both so callously neglected. Now, I think Natasha's lonely death reflected how manic and desperate and confusing those years were and how inadequate I was to manage my own affairs. At the time, I didn't spare a heartbeat to change the trajectories of my own obsessions.

Then the University of California at Los Angeles fired Angela Davis for refusing to take a loyalty oath because she was a declared Communist. UCSD provost John Stewart threatened me with arrest if I pursued the dance department plan, due to my making radical speeches at antiwar rallies on campus. Newton Harrison took up my cause among the faculty. He urged me to follow Angela's example and get publicity. He sent me to the Los Angeles art collector Stanley Grinstein to ask for support.

Naïve about media politics and confused about my task, I was a weak advocate for myself. Stanley didn't seem to understand the importance of what I was saying. I returned empty-handed and feeling as defeated as I'd felt that afternoon in Montreux when I tried to make sense of how to paint the landscape around Chillon. This time, there was no pretty watercolor takeaway.

I found myself in the eye of a political storm I was completely unprepared to navigate. The younger circle of UCSD students and the performance community at UCSD gathered around Angela and Marcuse to lend support. When Pays started working with the group around Angela to promote her legal case, I wanted to help, but I couldn't face working with Pays. As in so many divorces in those times, I ceded our friends to him.

Pays and others in our circle secured jobs with CRM, a small educational publishing company being established in Del Mar. As so many political, professional, academic, and personal relationships overlapped, the wonderful qualities of a small intellectual community became something far more complicated. My own relationships with my peers devolved into something extremely muddy, laced with sexual harassment, homophobia, bullying, and professional attacks that completely blocked my advancement and sense of security in San Diego. Gossip got back to me that people I had sexually rejected described me as "crazy" to people who might have hired me. On two occasions, men whose sexual advances I had refused stalked and physically threatened me.

What I had underestimated was the persistence of sexist tropes. My marriage had briefly insulated me from misogyny. The personal issues I might have buried under intellectual prowess had overtaken my dynamics. I felt marooned in a tangle of far more serious complexity and calamity than I had encountered between Khadejha and her boyfriend or around my brother-in-law as a child, with no more idea how to extricate myself.

Angela Davis was able to seize the initiative and battle against Reagan's conservative Communist scaremongering with legal logic. As a philosopher, she made powerful arguments. What she grasped (that eluded me) was that politics and policy making are a narrative process. She expanded on Marcuse's thinking with an understanding of the radical implications of persecutions of members of the Black Panther Party, including in her own family. She relied on an understanding of fundamental principles of justice and racism.

That spring, police beat Angela's brother-in-law, Sam, her sister Fania's darkly handsome husband. While Angela made common cause with Black political prisoners, my own knowledge of the politics of Blackness was still shallow, disconnected, and abstract. It would take until the 2020 pandemic to fix that.

In an interview in the September 2020 issue of *Vanity Fair,* Angela Davis described how her lifetime of passion and consistency had always been sustained by her belief that the world could be changed. In 1969, I

had none of her confident political skills or insights and no clue how to build alliances across political spectrums. The certainties that had anchored my life were disintegrating. The Black women I had known gave me examples of fortitude and of quiet resistance that were very different from the bravado of defiance.

For a time, I was adrift. The provost seemed to have forgotten about me, but the dance department never materialized. I audited classes in the UCSD medical school and toyed with the idea of becoming a doctor. Later, I supported myself for a while by doing medical illustrations. At first, the classes fascinated me, especially dissections. But one day as we were dissecting a human head, the realization that this had once belonged to a person with a whole life overcame me, and I could not continue.

Instead, I haunted the library at UCSD and delved so deeply into mystic studies that I was asked to lecture on Kabbalah, because every time the lecturer who taught a class in mysticism tried to check out a book, I already had it. I didn't recall a blue city and didn't yet know of my great-uncle, but I did memorize the tree of life.

Many years later, I puzzled over the contradictions in Judaism. I see Kabbalah now as a source of wisdom and allegiance to justice that arose out of the Hasidic Orthodox Jewish sects. But members of those same sects were the ones my father argued with in Palestine over the treatment of their Arab neighbors.

I remembered my parents' stories of how their families had scrimped to save money to purchase land back from Arabs, the same strategy I saw in action during a residency at the University of Washington in Bothell—in that case, among the Tulalip Native American tribes buying back ancestral lands. In their offices, I could study GIS maps that showed a painstaking jigsaw puzzle of one plot of land at a time being patiently bought back to reconstruct their homeland. Why did that strategy go so awry in Palestine? My father's opponents in the early and mid-twentieth century advocated for settlements on Arab lands. Did they just abandon the earlier strategy? I haven't done my homework. I don't adequately know the history. According to my genetic ancestry analysis, besides that hypothetical connection to Mongol hordes, almost 70 percent of my DNA is grounded in that part of the world. (On the other hand, four times the

amount of my Asian DNA is Slavic-German.) Does that give me any land entitlement?

I understand the arguments for a return to a past demesne, but I still agree with my father that taking those lands back by force from residents who have lived on them for countless generations is not an answer. Unfortunately, there seems to be evidence that forces with their own agendas, such as those in Iran, have been meddling in Palestine for a long time. During the Israeli-Lebanese conflict in 1984, I made a point of visiting Egypt before meeting my family in Israel because I wanted to hear a different point of view on the conflict. In a Tel Aviv taxicab, the Arab Israeli driver complained to me that Iranian-backed militants were going from door to door in the Palestinian lands, demanding allegiance or promising retribution.

In 1970, with the celebration of the first Earth Day and then the United States withdrawing ground troops from Cambodia a few months later, I thought the new age was obviously upon us. We were just wrapping up the loose threads of the great revolution. I thought that would include the Palestinian territories.

My father might have foreseen the future, but I was blind to the long-term strategic complexities in the Middle East that would lead to so much misery for so many people. I did understand that in my immediate environment, I was not even succeeding in resolving critical human conflicts among my own performers. I discussed my uncertainties with Newton, who advised me to look into encounter groups.

Reading about behaviorism, psychology, and neuroscience, I got a glimmer of understanding about how relationships between people are constantly shifting adaptations to uncertainties, like the ecotones that I had begun to understand in physical landscapes.

In early 1970, based on the principles I had pondered with Marcuse, I started a commune in Del Mar with the performers of A.R.T. I conceived of it as a living sculpture and called the project *Synapse Reality,* for all the points where neurons intersect in the brain. The commune was intended to embody an immersive commitment to performative experimentation. In the discussions that led to forming the commune, we combined that with ideas about sharing household responsibilities equally across genders

and growing our own food. Every aspect of those conversations was grist for new ideas about what my futuristic artmaking might look like.

As the commune struggled in housekeeping meetings, I started noticing how the women I knew, including myself, poured attention and energy into our romantic relationships. I began considering those relationships less as being about intimacy and more as performative art events. I called my ideas about that work *The Relationship as Art Form* and recorded my observations in detailed journals.

After Natasha's death and before my divorce, I had rescued a mature dog I called Shiva. When I found him at the pound, he was huddled in the corner of his cage. Shiva was a magnificent black Belgian shepherd who had been abandoned in Torrey Pines State Natural Reserve. When I brought him home and tried to engage him in play by raising my hand for him to jump to reach a treat, instead of jumping, he cowered in a corner and peed on the floor in terror. Clearly, he had been beaten. My raised hand didn't mean an invitation to fun. It meant imminent pain and rejection.

I took on Shiva's psychological rehabilitation as a relational project. But his fear made him dangerous to other people, and he terrified several of my friends. Others got pleasure from intimidating him further. If he was an exercise in *The Relationship as Art Form*, Shiva was an object lesson in how extended relationships contextualize the primary focus.

As I was sorting that out, I adopted a second dog, a pure white German shepherd I named after Rosa Luxemburg. Shiva and Rosa commenced a love affair as passionate and tender as any I had ever observed among humans, perfectly incarnating *The Relationship as Art Form.*

Synapse Reality and our discussions about relationships there drew many visitors, including faculty from UCSD and visitors from New York, from Ellen Willis to Jill Johnston. But as time went by, the core structure of the project began to dissipate as some people left and others moved in who had never attended Marcuse's lectures or been part of A.R.T. Our collective path to social change became more opaque as state-sanctioned violence grew against activists under Reagan and other conservatives.

Later that spring, I performed in *The Plague* with the Living Theatre when it came to San Diego. The company had begun working more

radically in Brazil since its time in New York. I had looked forward to learning from Judith Malina and Julian Beck, but their sexual aggression toward me and my then-boyfriend repulsed me.

I did not know how to negotiate my boundaries with people who felt sexually entitled. I saw it as my problem, as rape had been. Apparently, when I was single, I was available for colonization, particularly when I was on my own without a male protector. When I was part of a couple, my body was usually inviolate, like any other piece of private property— but not always.

I began working out of a collage aesthetic, mixing things up in my work, reflecting the tumult of the times and my impressions from the *Synapse Reality*, and looking for emergence. I put records of my experiments in notebooks, but I didn't have the foresight to understand the need to document or make much aesthetic analysis.

Synapse Reality looked down from a hill above the Del Mar racetrack. The exception to the lack of documentation of my work with A.R.T. was a film of one of the performances, *Silver Mirrors Walking*, staged in the racetrack's vast, empty winter parking lot.

Silver Mirrors Walking, still from film produced by Lynn Lonidier. Performed by Aviva Rahmani and John White, 1970.

Silver Mirrors was performed by me and John White, with whom I was touring. It was shot by the late poet and filmmaker Lynn Lonidier, who joined our tour. Our measured walking between the white lines of the asphalt expanse, approaching each other without ever meeting, was interspersed with footage of the traffic on I-5 to our east and of the endangered white rhinoceroses from the San Diego Zoo, with whom I was obsessed as a metaphor about loss and time.

Lynn captured the surreality and prescience of that time in my life. In the original work, the soundtrack, now lost, was a casual conversation in a Denny's restaurant across the way from the track, in which the three of us discussed our plans for the tour. Our conversation was interspersed with the clinking sound of china coffee cups on saucers and conversation with our waitress. The film was the most successful outcome of the *Synapse Reality* experiment.

In the fall of 1970, Shiva, Rosa, and I moved out of the commune. I began to look for mentors who could explain the challenges I was encountering and help me grow. From Khadejha and Ellen Stewart, I might have learned a great deal about how a woman manages personal and sexual relationships in a theatrical company. Instead, I made mistakes with consequences. The sexual revolution and the Women's Liberation movement had moved goalposts between expectations and boundaries, and clear rules had not yet emerged for a new world. Perhaps in many sectors, they still have not emerged.

Shortly after my work with Judith and Julian on *The Plague*, I learned that Steve Paxton, whose work I'd seen in the "9 Evenings" show, was coming to Los Angeles to conduct a workshop. I drove up from San Diego County to attend with two of my fellow A.R.T. performers, Claudia Bader and Barbara Zakarian. Steve's workshop attracted many well-known people from the L.A. art community as well as from New York, including Barbara Smith, with whom I became good friends; John White, with whom I would later tour; Alex Hay; and Bob Rauschenberg, who was an occasional drop-in.

It was in Steve's workshop that I developed *TThe Pocketbook Piece.* Claudia, Barbara, and I entered an open space in front of a group, sat down on the floor, and spilled out the contents of our pocketbooks, which were

set in front of us. I had asked my fellow performers not to edit the contents and told them I expected them to free-associate, without censorship, the narrative behind each object as psychodrama. In those days, a pocketbook, usually something slung casually over one's shoulders, was as private as a woman's private parts and was never opened in public. Once opened, the container revealed every detail of a woman's life. Speaking simultaneously, we described each item in intimate but clearly audible tones—for example, "This is the lipstick I wore the night I was raped." When each of us had finished describing her last object, we replaced everything and walked out through the audience in different directions.

Rauschenberg came in at the beginning of the first version of the performance but abruptly left. He was one of the few artists I genuinely admired, and his departure deeply disappointed and hurt me. Alex told me later that Bob couldn't handle personal material. I found that surprising, considering how open his work seemed. In retrospect, it was clear he never let his personal life enter his art—for example, his sexual orientation.

I wish I had discussed that incident with my friend Carolee Schneemann before she passed away; she was a contemporary of Rauschenberg

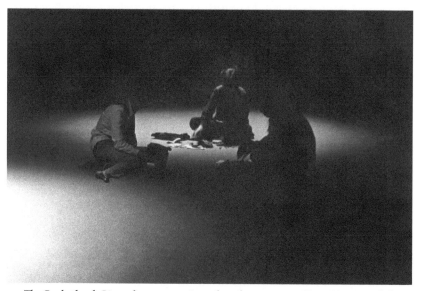

The Pocketbook Piece, documentation of performance in Claus Von Wendel's studio, Del Mar, California. Performed by Claudia Bader, Aviva Rahmani, and Barbara Zakarian, 1970. Photograph by Fred Lonidier.

but had placed her sexual life at the heart of her own work. Her 1964 film *Fuses* was a close-up document of her sexual relationship with her then-husband, the composer Jim Tenney, who later taught at CalArts. *Fuses* continues to be a touchstone for discussions about a woman's sexuality.

I'd first met Carolee in 1967 at her party for street performers. With the Grateful Dead playing behind us, a number of us had gathered around members of the San Francisco Mime Troupe to discuss how best to be activist artists. I don't recall who said it, but the advice was to go to our own communities, even if that meant the suburbs, to effect change.

Alex Hay and Steve Paxton urged me to return to New York and establish myself there. In the midst of seeming chaos, art self-organized as my compass, steadying my course in the storms. When I look back, I don't know whether to weep over my wrong turns and misapprehensions or congratulate myself for surviving my own intuition. I was driven by nothing but blind intuition, letting life write on the blank canvas of my talent. Perhaps it was my very position at the edges of turbulent communities erupting with ideas and conflicts that kept my mind fertile.

A long path lay ahead. I couldn't yet disentangle the defiance I had learned as a child while resisting my father with true courage, but I trusted that the compass of art would guide my passage like Ariadne's golden thread, pulling me along through disruptions, complexities, and conflicts to escape inevitable confrontations and perhaps, as in my childhood dreams, rescue others with me.

Because so much seemed to be breaking down in the late 1960s and early 1970s, I thought everything required more transparency, even my own creative strategies. It seemed that all our challenges then—and perhaps even now—could be reduced to accepting or resisting unfair power. All the answers were apparently in modeling structures for people to live in another world, a world of tolerance and inclusion that I had dreamed of for the *Synapse Reality*.

By 1971, I felt completely at a loss about my future.

Newton advised me again: "You need an institution to support your work. Go see Allan Kaprow at CalArts. Ask him for a teaching job."

6

Collaborations

arly in the fall of 1971, I stuffed my two big dogs into my VW Beetle and drove eighty miles an hour up the coast under a vivid blue sky, past vast blurs of brilliant color, to CalArts. Our trip had a dreamlike quality. Shiva, my neurotic black Belgian shepherd, and Rosa, my white German shepherd, were excited about the heady scents they inhaled through the window. We were passing fields of commercial flower farms, which have long since vanished under housing developments.

I was becoming interested in the ecological idea that the heart of a system depends on its periphery. The biological edges we were passing seemed to parallel contemporaneous discussions about social and psychological boundaries.

Ecologically, vulnerability at the edges is important for several reasons. First, the edges of any habitat are crucial to its integrity. Fragmentation can be dangerous because ecotone microhabitats act as filters and bulwarks to support larger systems. An intact ecotone system is where animals migrate between food sources or for water, shelter, and mating. Edges are also an insurance policy to provide resilience to disruptions. Resilience allows species and peoples to sustain communities in equilibrium.

Finally, ecologists speak of biological redundancy as natural engineering to protect systems. Any edge is, in effect, a pool of many small variations on biological functions in case any species in the core habitat is threatened or weakened. These subtle complexities reinforce ecotones.

Trees appear to function in relationship to one another as complex communities, not only as habitat for other creatures but in ways we can recognize as social and interdependent with other critical abiotic systems, as watersheds. Research indicates that trees routinely phonate, acoustically communicating with one another and sounding alarms across genera and other species through the fungal mycorrhizae that attach to their roots. We know now that plants "scream" ultrasonically and release pheromones when they are cut down. Distinct sounds have been recorded when trees were drought-stricken or attacked by pine beetles. The composer Bernie Krause has assembled serious sonic archives of habitats before and after human extractions.

When a forest is clear-cut, does the soil mourn what was lost before it, too, is lost to errant winds? The deserts of Africa and the Middle East were once flourishing gardens and woodlands. In Maine, vast hardwood forests were cut down in the seventeenth century by the same British who had lost what remained of their own forests after Roman decimation.

That wider impact from the periphery to the heart is the rub. In our age of climate change, unless we intervene in fragmentation, nothing will be left to mitigate the disaster of maximum warming.

That day in 1971, as my dogs and I approached and then left Los Angeles behind, we traversed the futuristic concrete highway complexes that the historian and urban critic Lewis Mumford had identified as the greatest public artworks of the twentieth century. We encountered scant traffic. My destination was a meeting with the artist Allan Kaprow a week before fall classes began at CalArts.

CalArts had just opened its new campus in Valencia. I arrived days before it opened in October 1971. The articles of incorporation had been filed ten years earlier under a mandate from Walt Disney, consolidating prominent performing and visual arts schools in Los Angeles. When Cal-

Arts opened in 1970, it immediately emerged as the premier nexus of cutting-edge creativity in the world.

I had with me a slim black portfolio of typed-up performance scores to show Allan. His work was about what I had been thinking about and discussing with Marcuse about human interdependence with all the elements and ecotones of life. *Synapse Reality* and *The Relationship as Art Form* were the two works that had taken my thinking as far as I could bring it up to that point.

When the dogs and I pulled into the CalArts parking lot, the dogs tumbled out and set off racing over the then-empty hills surrounding the campus until I called them back to my car. My goal as I walked into the large, newly built, shiny, industrial-looking building was to ask for a job.

I never got that far.

I found my way to the office of the School of Art, where Allan was the vice chair. We sat across from each other alongside a desk and exchanged greetings. I handed him my portfolio. He quickly scanned through it. Before I had a chance to ask for a job, Allan turned his head and yelled across the room to the painter Paul Brach, then chair of the School of Art, who was standing not far away.

"I want her as my student!"

Paul smiled slightly, nodded laconically, and just like that, I began to work with Allan. I thought that was better than a teaching job.

Allan became my mentor. He got me a job and a scholarship and made me his assistant the following year, when I started graduate school.

What had inspired my regard for Allan was in his eulogy for the painter Jackson Pollock, "The Legacy of Jackson Pollock," published in *ARTnews*, October 1958. Allan had described Pollock's marks on canvas as a "'dance' of dripping, slashing, squeezing, daubing and whatever else went into a work, [which] placed an almost *absolute value upon a diaristic gesture* [italics mine]." Allan went on to admonish the complacency of his own generation of artists and predict the artist of the future: "Pollock, as I see him, left us at the point where we must become preoccupied with and even dazzled by the space and objects of our everyday life, either our bodies, clothes, rooms, or, if need be, the vastness of Forty-Second

Street. . . . The young artist of today need no longer say 'I am a painter' or 'a poet' or 'a dancer.' He is simply an 'artist.' All of life will be open to him. He will discover out of the ordinary things the meaning of ordinariness. He will not try to make them extraordinary. Only their real meaning will be stated. But out of nothing he will devise the extraordinary and then maybe nothingness as well."

Change was in the air. The first green parties would be established in 1972 in Tasmania, Australia, and New Zealand. Despite my challenges in San Diego, I was sure that new possibilities would emerge from formal ideas based in artmaking about social dynamics, such as I had discussed with Marcuse. As in the artist Joseph Beuys's development of the term *social sculpture,* based in Rudolf Steiner's thinking, ideas about collaborative practices did evolve into current ideas about social practice.

The year before my meeting with Allan was when I had first discussed tensions between the people in A.R.T. and the *Synapse Reality* commune with Newton Harrison. When the personal conflicts baffled me, that was when he had suggested I look into encounter groups. I saw encounter groups as an extension of my performance research.

Allan and other members of the Fluxus movement were working with scores for "simple" events, such as licking jam off a car. I wanted to consider how an activity might be the seed of another system, especially in relationships. What, in fact, did it mean to lick a sugary condiment off a car? How interesting that a collection of words might catalyze such unusual behavior. Allan's classes were experiments in crafting poetic scores and developing sensitivities to the spatial particulars of venues to perform our activities. As in my work with Peter Schumann, my experience of Rauschenberg, or my insights from my father's strategic approaches, I watched how Allan leveraged ordinary people to precipitate extraordinary metaphors and outcomes.

Before my first meeting with Allan, I set myself two tasks. One was to know myself better, a journey that had begun with therapy as a teenager after my rape. The second was to find more effective ways to work with others. In addition to Allan, I looked forward to working with Judy Chicago, who was leading CalArts' Feminist Art Program with Mimi Shapiro.

The founders of CalArts had imagined the school as a continual performance. That was how I experienced it my first year. Allan asserted that CalArts was set up as a community of equals, modeled on the Bauhaus art school of the prewar Weimar Republic.

In Allan's classes, I explored where personal boundaries began and ended in a series of performances for small groups. Several of those experiments were collaborative and systemic; they drew as much from what I had learned from consciousness raising, encounter groups, and skills I had developed with A.R.T. as from formal studies at CalArts.

I did not yet know about advances in physics, such as Edward Lorenz's 1961 work on what would become known as the butterfly effect. In 1971, the Nobel Prize in Physics went to Dennis Gabor for his work in holography. The Santa Fe Institute's work on complexity theory was still almost fifteen years into the future. Increasingly, artists and other intellectuals were gravitating toward systems theory. Partly as an outgrowth of conceptual art, the crossover into visionary insight became as easy as zoonosis, a novel virus transmitted from one source to another.

I had a lifelong fascination with graphology. Long before I saw my first Agnes Martin painting, I was interested in the idea that longhand could be an aesthetic mark, representing a system comparable to Oriental brushwork, the action painting of Jackson Pollock, or a delicate line in representational drawing.

Formally, what interested me were the continual calligraphic effects of my cursive handwriting as "authentic" marks in the journals I kept. I was inspired by and translating Oriental calligraphic ideas about the passion of the scribe's passage, how the trace of handwriting miniaturized an Abstract Expressionist approach to mark making. I elaborately illustrated my journals, regarding them as the documentation of how life was acting on me.

In the three years I spent earning my BFA and MFA at CalArts, I was fiercely driven by my intuition despite self-doubt. The more I could learn about the collaborative process, the more I might get a handle on both human and biological dynamics. I realized that it might take decades.

Ecoart, or ecological art, as a distinct genre has evolved as a hybrid form from people like me who couldn't accept silos. Where land artists

such as Robert Smithson were using sculptural techniques to stamp their own philosophical comments on the Earth, as my father had, ecoartists are driven by the sense that the Earth desperately requires healing much more than stamping.

The technological options at my disposal dazzled me, as did the chance to work with all the amazing artists at the school. Nam June Paik was gone, but we could work with the visual electronic systems he'd left behind. I spent a lot of time with the color video synthesizer he had developed, a precursor to color television. The studio was supervised by Paul Challacombe, who had worked closely with Paik. Paul and I became lovers, conducting our courtship in endless hours alone in the lab, manipulating the abstract visualizations on the screen before us.

While I was completing my master's at CalArts from 1972 to 1974, I managed the sound/light studio for Morton Subotnick, whose *Silver Apples of the Moon* I had danced to at the Electric Circus a few years earlier. In my own electronic music, I created a laser-pulse audio-interface projection for a version of *The Pocketbook Piece,* which had been performed and recorded with Alison Knowles in her *House of Dust* installation on campus.

In 1971, I was as obsessed with all the variations of collaborative processes I could imagine as I was with the topic of rape. Exploring collaboration seemed like an important way to deconstruct dysfunctional relationships. Many progressives were desperate for solutions to the problems we had uncovered and were gravitating toward all kinds of solutions. The messy boundaries between notions of "insanity" or "madness," absurdism and surrealism, drug culture, intuition, and mysticism overlapped and blurred with simple nonconformity as we all questioned the nature of reality before we understood much about neuroscience. Encounter groups seemed like a window into relational change.

I invited several of my new friends to meet and become involved with Connie Russell, an untrained but charismatic leader of weekly encounter groups conducted from her La Jolla home.

Encounter groups opened a Pandora's box, sometimes permitting the abuse and manipulation of vulnerable people's hearts and minds at scale. Too many plunged into murky psychological waters without a life

preserver. I was searching for a holy grail of perfect transparency, but transparency had given permission to say hurtful things just because they were deemed "honest." Confusing honesty and transparency for venting accusations has persisted into our own times, seemingly fueling the political divisions we experience today.

It was in Connie's group that I became first acquainted with and then partnered with a man named Earl. He would drift in and out of my life for thirty-three years, leaving a wake of romantic upheaval with each passing. When we met, he was the handsomest man I had ever seen: a Viking with golden hair and sapphire-blue eyes who drove a big silver car and worked as a professional poker player. What attracted me more than his good looks and dashing demeanor were his quirky thinking and raw insights into art despite his lack of any academic training. He was a born performance artist and the man I once thought was the love of my life.

Years after Earl and I first met, one Halloween night after Pays and I had reunited, the three of us were attending an event at the La Jolla Playhouse. As everyone waited for the curtain to rise, Earl disappeared from the packed audience, then reappeared, climbing the steps to the stage. He shambled across the stage in a faded pink bathrobe and slippers, with his long blond hair wrapped in curlers, then descended the stairs on the other end, passing back through the aisle and out of the auditorium to a roar of audience laughter.

In the early 1970s, political and personal change was about to hit a first brick wall of resistance and backlash. That backlash, fueled by ever more radically conservative think tanks and strident media personalities, would ricochet and accelerate for the next fifty years. I vastly underestimated how the changes my friends and I hoped for might provoke vengeful wrath among those who were determined to defend the status quo and their place in it. The backlash we may have triggered started then and culminated in the populist support for Donald Trump, sweeping him into the White House in 2016 on what seemed to be a tsunami of bitter cruelty.

Conventional politics seemed peripheral to what I wanted to explore. I was designing conceptual models for the new era and in search of role models among powerful older women who could support my goals. I

hoped to learn how a woman might exercise power differently than a man might. I imagined that a woman with any amount of authority would not be sexist. I was mistaken.

Over the years, women sometimes disappointed me as deeply as any man who abused power. Ruthlessly competitive ambition abounded among my feminist colleagues as much as among any of the men I knew or among women who didn't identify as feminist. As time went on, I would be most offended by the ridiculing of accounts not only of patriarchal entitlement but of date rape and the pillorying of victims, as much from women as men. My experiences of encounter groups and collaborative projects in the early 1970s reflected the realities that my entire culture was struggling to come to grips with. I pitied those who drowned in murky waters and noted the persistence of patriarchy.

I had no idea how challenging, complicated, provocative, or contested sociopolitical change would be. But with the culture at large, I kept learning and growing. My evolution came with my evolving understanding of complexity theory, my observations of how microhabitats at my *Ghost Nets* site adapted to stress in biological ecotones, understanding how trigger point theory might support habitat contiguity; as well as the personal analogies I contemplated in therapy and recovery groups, and from my own artwork. Insights about these larger questions were often captured as I created my own artwork.

In 1971, exploring all the variations of collaborative processes I could imagine seemed the solution to everything unjust. I thought understanding collaboration was as important as understanding rape, two poles of justice and injustice.

I still think I was right.

The educator and sociologist Maury Stein chaired the School of Critical Studies at CalArts and had a leading role in planning the school's course of development. Maury had been at Brandeis, a hotbed of radical and creative pedagogy. He and his wife, Phyllis, had been deeply engaged in the cocounseling movement in Boston, and his ideas infused the values of the school. Allan Kaprow applied Stein's principles of discursive investigation in his classes.

I did not work with Maury, but I wish I had. He might have taught me useful techniques to identify what was unhealthy and detach myself from the worst aspects of encounter groups.

I had met Connie while creating *Synapse Reality* and introduced several of my new friends at CalArts to her ideas. But the weaknesses of encounter groups were becoming apparent, as I saw complicated issues uncovered but never resolved in a healthy manner.

Instead of training or accountability, Connie's bona fides were that she was part of the same intellectual circle that included Marcuse and was the daughter of the respected *New York Post* columnist Max Lerner. She and her husband, Dick, had founded a folksinging venue, the Candy Company, so I assumed she was conversant with the language of art. Early members of Connie's group included famous singers and figures from the worlds of theater and performance. She captured my imagination because she was trying to understand how psychological factors might have caused her teenage daughter Nicki's severe autism. Together, we visited Viktor Frankl, a kind man whom I respected for his 1946 book *Man's Search for Meaning*. Through Connie, I also had the opportunity to meet and get to know other luminaries of the time, including Carl Rogers, a founder of the humanistic, client-centered psychology movement; Jane Fonda; and later Gloria Steinem, who reappeared in my life periodically as part of extended communities of feminist thinking. Gloria always impressed me with her intellectual sangfroid.

In the late 1960s, metaphorical thinking preempted biomedical research; autism was labeled mental illness, comparable to schizophrenia, thought to be caused by poor mothering, called "refrigerator mothering" or "refrigerator parenting." In 1970, I had been commissioned to illustrate R. D. Laing's work on schizophrenia, *The Divided Self,* for a textbook, *Psychology Today.* Laing had maintained that insanity embraced a metaphorical diagnosis of representing the creative acting out of core family dynamics. I embraced what I thought Connie's group represented and what I saw of her daughter Nicki's life as metaphorical performance research.

The obsessiveness I saw in Nicki paralleled how many artists think and behave when we become focused intently on something small, ordinary,

even insignificant as a door into another world—a trigger point. At Cal-Arts, I once watched my fellow art student David Salle meticulously videotaping a line on the floor. My childhood obsessions with photographing grass had been little different.

Psychological research has a long, largely debunked history about possible relationships between creativity and mental disorders. Antonin Artaud, an icon of modern theater who battled mental illness from the age of nineteen, reinforced the idea of a connection between creativity and "insanity." His influential 1938 book *The Theatre and Its Double* was a manifesto for a Theatre of Cruelty, prescribing psychological shock value to launch a revolutionary agenda for new thinking. Artaud seemed to advocate complete surrender to the fruitful anarchic guidance of the unconscious. I had been reading his work intently at the inception of A.R.T.

While at CalArts, I rented an apartment in Valencia near the school with a roommate, Marni Farrell Gud, a student in the Women's Design Program, working with the feminist designer Sheila Levrant de Bretteville. The fundamental idea that most feminists agreed on then—which Marni and I endorsed—was to tear the lid off secrets.

My life was in more flux than I could admit to myself. I regarded my dogs, Rosa and Shiva, as what the Native American activist Winona LaDuke has called "relatives in her family," but I sacrificed them to move in with Marni and start work at CalArts.

Rosa went to a fellow student but ran away. I spent weeks scouring the countryside, calling for her, but she was gone. I wasn't thinking logically. It never occurred to me to look for her at an animal shelter.

Shiva was flown to an ex-lover in Canada, who later wrote me that Shiva had joined a wolf pack. If he did join a wolf pack, I hoped he was happy, but too often, wolf packs lure dogs to them, only to kill them. Shiva and Rosa had been deeply in dog love and had had a litter of puppies, which I had given away. Unlike my irresponsible abandonment of Natasha just a couple of years before, I felt acutely that I had betrayed them both at another point of great transition.

Marni and I became close friends and soon began to collaborate. We traded ideas with Allan about how to contextualize conventionally fe-

male ideas about transparency, intimacy, and vulnerability. I drew her into the circle around Connie, which became another opportunity to conceive of ways to frame feminist ideas. Initially, we had modest ideas about an appropriate venue to exhibit our evolving project. We experimented with creating a work that would be viewable on microfiche for a hall area, but Allan suggested the main gallery of the school. He saw that we needed that physically imposing grand podium to boldly assert the power of the intimacy, juxtaposing it with monumentality. In 1972, Marni and I mounted *Two Nice Jewish Girls 9–5* in the main gallery.

We assembled all the detritus of trauma from our personal lives: her parents' death and my divorce.

The walls and steps of the staircase were papered and strewn with the residue of our pain: Letters, photographs, diaries, and other personal documents were exposed to anyone who chose to view the evidence of heartbreak. I shared my personal journals, as though opening my private life to strangers was the most natural thing in the world. We set up a table and some chairs where we could talk with our audience. It was like installing the contents of the pocketbooks of our souls for public view, as in *The Pocketbook Piece,* but in this case, we invited direct interaction.

Alison Knowles contacted Los Angeles art writers who wanted to cover our installation, but they could not arrive before our committed 5:00 P.M. quitting time, as our title had promised. That might have been a missed opportunity. But for us, our punctiliousness was a statement about the performance women give of appearances as much as about the formal boundaries in time for the event.

My interests in collaborative nuance and the topic of rape culminated in *Ablutions,* a collaboration among Judy Chicago, Suzanne Lacy, Sandi Orgel, and me that has gathered considerable notoriety. All of us except Judy were CalArts students; Suzanne and Sandi were both in a class that Judy was teaching and were deeply involved with the Feminist Art Program. I was the only one who had directly experienced rape, and I had the most extensive performance experience. The manner in which we addressed rape was modeled on Women's Liberation consciousness raising. What emerged from our work together on *Ablutions* was a performance that became legendary, described many times in many publications.

In an essay for the book *Blaze,* I wrote about the day I approached a table where the four of us were having lunch in the CalArts cafeteria and suggested we do a performance about rape. I thought the four of us had comparable interests in how relationships might produce work on the topic. When Suzanne had a massive retrospective at the San Francisco Museum of Modern Art in 2019, she included documentation of *Ablutions.* We both tried to find Sandi Orgel to confirm her memories of what we'd each contributed, without success—but Suzanne and I both recall that Judy was teaching a class in the Feminist Art Program in which Sandi developed the image of a woman bathing in eggs, a critical contribution to *Ablutions.*

Judy contributed an image of women bound in gauze.

Besides the concept of doing the performance about rape together and the conversations that confirmed the elements we would assemble, my contributions were drawn from A.R.T., coordinating the choreography and spatial relationships.

My most enduring memory from the work was an argument between Judy and me over the eggs. I had been tasked with buying the eggs for the egg bath. The day before the performance, I drove up the coast from La Jolla on Route 1 to the food co-op in Solana Beach, where I purchased our eggs. They were organic. It would never have occurred to me to purchase ordinary eggs for the event. It was clear to me that every level of the work required absolute authenticity and integrity. When I showed the bill for the eggs to Judy, her pragmatism was outraged.

In *Ablutions,* two nude women of average appearance, echoing the traditional trope of female nakedness as a fit subject for art, entered the open space and began ritually bathing in tubs of milk, egg, and liquified clay. The context drained residual eroticism from their nudity.

While Suzanne walked around the periphery of the space, nailing raw kidneys to the walls, ceiling speakers blasted stories of rape experiences from the corners of the space. The cumulative effect of raw meat, confinement in a crowded space while listening to accounts of rape, the spare object spacing of elements, and the simple performances of the naked women was so powerful that Suzanne recalls some audience members gagging as they exited at the end.

The artists Carolee Schneemann and Hannah Wilke, close friends of mine until their deaths, were known for their beauty and had created sounding boards for my own ideas about the body in performance. They recognized early on the power of an attractive naked woman's body. Their audiences were riveted by the vision, but it wasn't always clear how much introspection was taking place among their viewers. How to redirect attention, to desensitize without desensitizing? It is a paradox.

My commitment was to the vulnerability of the naked female body, more than to audience ambivalence over allure. The unresolved issue is still who takes the power of ownership over perception, the "gaze," and how? This was the issue I tried to address in *The Blued Trees Symphony*, but *Ablutions* was about human bodies, and the *Symphony* is about other species.

In the early 1970s and 1980s, but particularly in *Ablutions*, I was interested in the relationships between culturally shocking narrative content and the assemblage elements of site-specific installation/performance. To think out the spatial relationships as choreography, I made some diagrammatic sketches of the staging. They were like my preparatory work for A.R.T. performances and my project work since. Formally, I have always asked questions that cross sculpture and performance: How can organizing space and time determine perception?

Two Nice Jewish Girls and *Ablutions,* in 1972, gave the melodramatic details of rape, divorce, and death with deadpan delivery. The tempo of movement in space was stately, even liturgical. The metaphorical imagery and movements of performers in a spatial structure were determined by the length of time to perform activities between the distanced objects, such as the tubs, so the action of nailing animal organs to the wall and bathing may have carried emotional power but looked visually understated.

What interested me most that night was seeing the impact on an audience of watching naked women bathe in blood, eggs, and milk while they heard tales of anguish. The cumulative effect of all our efforts was notable.

Interest in *Ablutions* peaked late in 2019, just before the pandemic. It came in the wake of the #MeToo movement and after the publication of

books by Vivien Fryd and Nancy Princenthal on artists who dealt with sexual violence in the 1970s. Some feminist artists criticized those books for inconsistent attribution. The reality was that so many feminist artists have created work around rape and violence that two books couldn't contain it all.

My own correspondence with the writers picked up questions about citation, attribution, and accuracy. I have always thought a methodical exegesis of works and attention to the provenance of ideas enrich the intellectual capital for us all. In the fall of 2019, I had extensive separate conversations with Vivien and Nancy. The simmering discontent from other women who felt as I did—that the writings had shortchanged their own work on rape—revealed how vast the topic remains and how hard to encompass. Early writing about *Ablutions* had often credited only Suzanne and Judy, and sometimes only Judy, based on Judy's published texts. Over and over I have heard from authors that writers look at people's websites or what artists write about themselves instead of cross-checking primary sources. If I have any lingering resentments over attributions, I must equally fault myself for not writing about my own early work, particularly from 1969 through 1973.

In 1972, it never occurred to me to write down my memories of *Ablutions,* any more than I had thought to save detailed documentation about A.R.T. or *Two Nice Jewish Girls 9–5.* As committed as I was to the work, I was equally committed to an aesthetic philosophy of ephemerality, a Zen assertion of the temporality of all existence. It was an idea affirmed in *The Tibetan Book of the Dead* in Zen and in the Fluxus movement that so many of my friends were part of then, distinguishing between spiritual values and capitalist ones. And yet I was shocked, *shocked,* that my own contributions, let alone those of others in the art world, vanished like smoke when we embraced that evanescence.

The role of the art historian, like that of the investigative journalist, is to be a sleuth, to uncover the invisible and retrieve the lost. What I didn't anticipate in the early 1970s was that the collaborative structures I was investigating might have independent value far into the future, whether or not they were attached to particular works. Again, I was naïve, imagining

that the quality of my work would magically speak for itself. Or expecting some writer on a white horse to rescue my thinking from oblivion.

A growing interest had developed before the pandemic in taking a closer look at the feminist work of that period, including a look at which work had been promoted and why. Jennie Klein, writing for *PAJ: A Journal of Performance and Art,* was one of several feminist writers who made an effort at thoroughness. Competitions among various demographics in the art world have been the norm for a long time, mostly with white men coming out on top. As in many sectors of the society to this day, attention privileges prior systems of reward and punishment. The most visible and established maintain a familiar status quo. Power accrues power and excludes the disenfranchised. Sorting this out isn't just intellectually hard work; it has economic implications—for doing it right, doing it wrong.

In a 2019 exchange with Nancy, I said that in an ideal world, we needed a panel moderated by a giant in therapeutic intervention, such as Viktor Frankl, to tease apart all the intellectual connections. In February 2020, Nancy Princenthal moderated a panel at the dieFirma Gallery with Suzanne Lacy, Lynne Hershman Leeson, and me on performances about sexual violence in our work. The panel ended with Nancy's question to the panelists: "What has been left out?"

I replied, "The men." Several men in the audience did reveal their fears then and their indoctrination from youth into a culture of violence that confines men as much as women.

The pandemic revealed secrets that were no secret to the disenfranchised in every sector of society worldwide. Who is entitled to attention and support? This is the work of ownership reparations, which go way beyond the art world. The science historian Thomas Kuhn wrote in *The Structure of Scientific Revolutions* (1962) that in changing a paradigm, you need to reconcile past premises with new knowledge. That reconciliation is as necessary in personal relationships as in biogeographic ecotones or any other agent in a complex adaptive system. It is a catch-22, because people can usually recognize and validate only what they already understand.

Perfumed Milk was the third of my three major works about personal trauma between 1971 and 1972 that came out of trying to live life transparently while I was at CalArts. It was performed at the Woman's Building, in Los Angeles.

The audience for the performance of *Perfumed Milk* was standing room only. On one blank concrete wall was a projection of one version of the *Meat Piece,* by Eileen Griffin. *Meat Piece* was a series of films I had completed two years earlier in collaboration with several artist friends. Each version had a simple score. Hands slowly manipulated a raw cow's heart in close-up framing. The heart took on metaphorical meaning as a woman's vulva. In one version, by Martha Edelheit, it was shot in black and white in a dirt ditch.

On the concrete floor was a linen tablecloth set with a large metal bowl of rosewater that perfumed the air. A small perfume bottle was placed between the bowl and a large sledgehammer. The performers included Madeline Ridley, who had a gamine appearance; Dick Kilgroe; and me. Dick and I entered from different directions, walked through the audience, and commenced a conversation whose content was styled as psychodrama but whose delivery tone was casually conversational. We spoke about our actual experiences with domestic violence. Dick was Barbara Smith's partner at the time; she also performed that night and later wrote a review of the three works for *Artweek,* which included a performance by Vicki Hall.

Dick was a large, handsome man with a shock of brown hair. He performed bare-chested, sweating in the warm air. I was wearing a demure floor-length pink-and-white-checked skirt and white leotard top. When we reached the open space in front of the projection, Madeline and I knelt on either side of the bowl of rosewater, and I silently began to bathe her face with the water. Dick knelt a few feet away alongside us, also silent, and began rhythmically smashing the small perfume bottle with the sledgehammer, releasing the scent into the audience. The only sound was the thud of Dick's powerful blows, to which he brought tremendous intensity.

When the performance was complete, I found myself inarticulately shaken. I flung myself through the press of our audience into what felt like the safety of Paul Challacombe's arms. It was the first time I had de-

signed an artwork that contained more emotion than I had been ready to take ownership of. Even now, more than fifty years later, recalling the performance in this writing evokes PTSD. *Perfumed Milk* culminated and completed the experimental research I was doing on how far I could take psychodrama in live performance.

In studying ocular or acoustic physiology, it is striking how far human vision and hearing diverge from the flattened perception that a screen can deliver. And yet our entire culture promotes systems and technologies that render our world flat and our engagement passive.

I produced a number of works with less intense emotionally personal content while I was at CalArts that continue to inform my thinking now. Each explored relationships between poetic instructions and simple actions, formally influenced by what I was learning from Allan. I modeled the formats on how spare Allan's work had become and how compatible that was with my own ascetic scoring. For example, a typical work by Allan was based on his directions for pairs to make telephone calls and wait a certain number of rings before picking up the receiver. These means came from the Fluxus artists, who had created whimsical "event scores," such as Alison Knowles's *Make a Salad,* in which she made a salad for the audience.

I wrote a brief article for *High Performance* magazine in 1979 that included several of the works I had produced at CalArts. It described *Sunsets,* a work that conflated painting and performance in time. Several of the pieces had explored aspects of moderate psychological danger or discomfort. I hadn't been interested in the physical danger of what Chris Burden had done in *Shoot,* in 1971—having his wife shoot him. I was interested in emotional risk and boundaries.

Smelling was a work I created in Allan Kaprow's class. It was performed outdoors in a field. Two rows of people faced each other. The people in one row slowly moved down the second row blindfolded, smelling each person in turn, and then removed their blindfolds. The line moved again as people tried to identify whom they had smelled. Allan described what he saw as "deer tenderly sniffing each other." I think about this work as exploring each individual performer as a microhabitat, the act of smelling as experiments in making boundaries and ecotones in relationships.

Giving and Taking lined up men and women in rows facing each other. The women were instructed to verbally give something to each man they faced as they moved down the line, and the men were instructed to verbally articulate what they had been given. The line moved and the sequence remained: the women gave, and the men took. Predictably, this angered many of the men. The men felt cast as exploiters and resented being asked to ritualize a transaction that was so explicit.

In *Stealing,* I arranged with the owner of a gift shop to allow us to deliberately steal something and later return it. I was curious about the issues of trust and empathy that tested the owner and the participants, but when we discussed it afterward in class, I felt inexplicably irritable and impatient, as though I couldn't dispassionately discuss the very topics I wanted to explore.

Physical Education was a favorite work of mine from that period that continues to gain an audience. I thought it was both explicit and elegant about how we manage water and the analogy to ecofeminism. Marilyn Emerzian was one of the performers who filled a plastic baggie with tap water, then drove with me to the beach. We stopped several times en route to take out a teaspoon of water and replace it with dirt from where we stopped. Making change only one teaspoon at a time and, in the end, flushing it all away down a toilet.

At the beach, we poured the muddy water into the sand. We refilled the baggie with seawater and laboriously repeated the ritual, driving back to the school, where the remaining muddy, salty water vanished.

As with *Ablutions,* these were works for untrained strangers rather than the small, tight group I had assembled for A.R.T. I had learned from Allan that the poetic delivery of ritualized directions was as important as the activity. Unlike the path I'd found at Chillon but like the solutions in my lucid dreaming as a child, this was a path I made for others.

These were the exact instructions for each performer in *Physical Education*:

1. Take a plastic baggie and a plastic spoon. Go to a water fountain or sink in an institution. Fill the baggie half full of freshwater and seal it. Drive to the ocean. Stop four times en route. At each stop, take a teaspoon of

Physical Education, detail of performance,
California Institute of the Arts, Aviva Rahmani, 1973.

earth and put it in the baggie with the institutional water and leave behind
a teaspoon of the freshwater at each site. Reseal the baggie each time.

2. At the beach, get out of the car and find some very dry sand. Pour out
the earth and water mixture into the dry sand. Walk to the water, refill the
baggie half full with seawater, and seal it. Return to the car. Drive back
to the original institution, stopping four times en route to leave behind a
teaspoon of seawater and gather a teaspoon of earth to replace it.

3. On returning, take the baggie to a toilet. The remaining seawater and
arable soil mixture are then poured down the toilet. Flush the toilet. If
the spoon is plastic, discard it.
Variation: Use a special spoon to transfer the mixtures of earth and water.
Keep the spoon.

Today this work still interests me, both as a study in paying attention
to ecotones and as a subtle political statement. It ritualized the incre-
mental transactions between an institution, a human, and the ecotones
of transition from land to sea and back to built infrastructure. Water

and the ocean were common ecofeminist iconographies. The toilet was likened to a vagina. Flushing the water down the toilet was how I saw us squandering the natural world.

Physical Education was one of the last works I produced at CalArts that equally reflected the whimsy I had experienced just a few years earlier—of an art-world innocence that was being lost to political change—and the hints of the environmental mayhem to come. This was before the international art world became a daunting commercial arena that catered to oligarchs.

As I worked, CalArts was dramatically changing around me. I was changing, too. The Disney family resented funding the school and cut the endowment to one dollar. The World Music Program and its gamelan orchestra disappeared. Allan confided to me that instead of maintaining the Bauhaus model of scholarships for students as accomplished as the teachers, the school began accepting the students who could pay. Interdisciplinary work disappeared.

Judy Chicago took the Feminist Art Program out of the school and into what became the Woman's Building, in downtown Los Angeles. She walked through the main gallery with me before she left and said, "Come with us. This is how we will make future leaders." I gave her invitation a lot of thought, but CalArts had the technology that I thought I needed more than I thought I needed to be groomed for leadership.

When the Feminist Art Program left, the school became a far more hostile and lonelier environment for women artists in general and feminist artists in particular. Allan and I had a falling-out. He suggested that I work with Stephan von Heune, who shared my interests in sound installations, but I couldn't establish a rapport with him. During my last two years at CalArts, I felt confused and isolated.

Over the years, my father and I had reached a détente. In the fall of 1973, he invited me to take a quick trip to Israel with him. While he met with Menachem Begin to discuss politics, an attractive and charming military attaché escorted me to various sites. He took me to see the monumental public artworks made from the twisted debris of bombs. At other sites, we stood before the ruins of fortifications built by the Greeks,

the Romans, the French, and the British, and I contemplated Western history.

We drove to the Golan Heights. As we looked down on the kibbutzim below, a powerful foreboding overtook me, even stronger than the one I'd felt the day I told my sister and brother-in-law that I didn't want to drive with them.

"I smell death here," I kept saying.

My escort looked at me uneasily. Perhaps he knew something I didn't.

As in other clairvoyant experiences I have had, my state of mind bordered on a trance. My perception of the world felt like it was simultaneously widening and losing focus as my awareness sharpened. I had no doubt about the imminent death I was intuiting.

My father and I left Israel that evening. The next day, I learned that the Yom Kippur War had broken out on the Golan Heights. Begin might have told my father of the impending military action. Perhaps my escort had already known about the plan as I stood next to him, repeating "I smell death."

About that experience, I think that iterative science has not yet pierced a thin veil between the parts of our consciousness. That in-between space includes unsettled intuition, a spiritual heart where empathy for the other might live, and the mystic unknown from which all art emerges. All art training brings artists to this precipice of consciousness, whether it simply transgresses the familiar or borders on Laing's interpretation of insanity.

In my last year at CalArts, after rejecting Judy's invitation to join her in Los Angeles, my intuition was to continue my work on the same track I had been pursuing. I threw my energy into a final installation, *Stay Wait Look Listen, My Symphony*. Under the supervision of the pianist Leonid Hambro in the School of Music, I was pursuing a double major in electronic music. I had been intensely studying and playing Beethoven's *Pathétique* Sonata, which he had composed in 1798, when he was twenty-seven.

My Symphony was based on imaginary exchanges between the long-dead Beethoven and me, with analogies between the music, his personal life, and the intimate contents of my journals. It was curated by the artist

Lita Albuquerque and presented in Gallery 707, which Anait Stevens directed, in the Woman's Building, in Los Angeles. As in *Two Nice Jewish Girls 9–5*, every detail of my personal life was made available for random consumption by any stranger.

The installation was composed of about seventy of my personal journals, each bound in black and numbered with white vinyl letters on the face. The presentation was organized to narrate a psychological story behind Beethoven's *Moonlight* Sonata.

My journals were displayed on sleek floating shelves, which I had built of wood and Plexiglas, that hung suspended on the walls. On the floor were large pillows, where people could sit and read my diaries at their leisure. File cards attached to the shelving at intermittent intervals made comparisons between Beethoven's personal life and my own, as though my perceptions were movements in time for a conceptual sonata.

On opening night, one viewer commented, "Now I know everything about you, but I don't know you." Later I wondered whether laying my personal life bare, as I had learned to do in encounter groups, was really any different from stripping my body bare as Carolee and so many other feminist performance artists were doing then.

On one night of the show, Leonid Hambro performed Beethoven's *Pathétique* in the gallery installation. He sat down at the grand piano the gallery had rented for the occasion and struck the first thundering chords. At that moment, unplanned, all the lights in the building went out. Leonid dramatically completed the performance in the dark.

Mimi Schapiro, who had taken on advising me after Stephan, suggested, as Alex and Steve had a couple of years earlier, that this was finally the time for me to return to New York. Professionally, she was exactly right. Instead, I moved back to San Diego, where I started a modest freelance graphic design business. I returned to Connie Russell's encounter group community, but I saw the same authoritarian abuses emerge that I had struggled to escape elsewhere. It was devolving into a cult. I gradually cut my ties with her and most of her followers, except Earl.

I wish I had questioned myself more deeply about moving back to New York City. In my late twenties, I didn't understand the urgency of

how time slips away from us all. It would take me time to reconsider my practice so that I might incorporate everything I had internalized, but I thought I had all the time in the world to explore intersections among art, relationships, and science. I didn't yet know where to find the audience I'd been advised to find at Carolee's party back in 1967.

I didn't notice that I was beginning to emerge from chaos to be my own model.

The small change in sensitive conditions would be in my relationship to land.

7

Reeducation

In Domenico Gaetano Maria Donizetti's nineteenth-century opera *Lucia di Lammermoor,* a woman is sacrificed on the altar of patriarchal male ego and for the acquisition of land. A woman's life is literally bartered in marriage for her brother's ownership security. Sadly, that remains a common experience internationally, with young girls sold into marriages or prostitution to save the rest of a family from starvation or to expand family fortunes.

Lucia—who, like my aunt, had another love—commits murder and suicide as her only way out of the misery imposed by her brother. She epitomizes how a woman's life might advance a patriarchal agenda, regardless of the personal cost. My aunt might have told me more about that.

When a woman is forced to submit unwillingly, especially in the case of child marriage, her wedding night can become the first in a lifetime of rapes and forced impregnation. My aunt was seventeen when she was forced into marriage. Later, according to my sister, she bragged about having many lovers, perhaps as acts of revenge, or maybe it was just the same assertion of control I recognized in Anaïs Nin.

Lucia's story embodies why early ecofeminists saw parallels between the abuse of women and the abuse of the Earth. Despite the proliferation

of legitimate claims of victimhood from all comers since the last century, women face unique dangers globally that define and are defined by fundamental realities in most women's lives, based on the biology of childbirth and impossible to dismiss.

The exigencies of childbirth and our persistent role in many cultures as chattel property to produce cheap or even free labor and bear children as commodities are related. It is specifically these realities that make for unique associations to the Earth.

Almost any woman must come to terms with these specific biological experiences, unique to our gender, from the onset of menstruation and the possibilities of pregnancy and childbirth. The consequences of primarily male desire and entitlement, often conflated with assumptions of ownership, power, and control, can be expressed as aggression and may escalate to rape or even femicide.

Native peoples have pointed out that the rapes and femicides of their women are specifically about taking ownership of Indigenous lands. Native bodies become the ecocidal stand-ins for that theft.

These realities are interrelated—for example, rape may lead to pregnancy and childbirth. In many cultures, particularly agrarian ones, children are a valued commodity that women's bodies can produce. These values are further mediated in complex ways in most societies, with variations between cultures and in families that many women experience as repressive—for example, restrictions on social participation, dress, and time management.

During the pandemic, much discussion has compared racial and racialized environmental injustice and queer experience to sexism. As an artist interested in physiological determinants, I find these biological distinctions compelling arguments to consider a gender-based definition of ecofeminism that nonetheless includes an analytic model of how to address global oppression and exploitation.

The fact that among a thin global layer of progressive societies women have relative financial autonomy and access to abortion, childcare, and medical support doesn't mitigate the plight of most women internationally or the connections to environmental injustice and ecocide.

Most poor women and many women of color in the First World have experienced discrimination on a historical continuum into the present. In the time of COVID-19, when so many women with young children are sequestered at home, we are all reminded of how fragile women's independence still is and how tied to patriarchal exploitation.

When I got my master's from CalArts, I once more optimistically thought that we were flying past all the constraints on women I had grown up with and that stories like Lucia's and even my aunt's—of women forced into an unwanted teenage marriage—were rapidly vanishing in the rearview mirror. It looked like a high point for U.S. integrity when Richard Nixon resigned in 1974. I thought our messy world might be making progress. The United States Congress was engaged in energy planning, and an international agreement was reached in Oslo to prevent marine pollution. But that year also marked the last sighting of the Japanese sea lion and a devastating oil spill in Chile.

My three years at CalArts had shown me several new points of entry into chaotic systems with art. I had systematically explored a series of performance scores that researched various collaborative configurations and acquainted myself with a number of new technologies, from lasers, graphic cameras, and video to electronic synthesizers, and had thought through some of my relationship to technology. I had learned to use words and space more effectively and investigated whether self-actualization and psychological vulnerability might move the discursive needle to greater interpersonal depth, authenticity, and democracy. It was a good bargain in exchange for eschewing a job when I first met Allan. I wouldn't have anyone to blame but myself if none of that led to a serious academic career. I chose to pursue my practice without a safety net.

Everything I had learned equipped me to analyze where opportunities might arise for equilibrium in or adaptation to complexity by creating new models. But I felt conflicted about abandoning the obvious path forward to professional and financial security, to the New York art world, or even remaining closer to Los Angeles.

Before I graduated in 1974, I had a fateful conversation with Allan in the office of the School of Art, where I was typing a letter to Connie.

He wandered over and asked, "Do you want to teach?"

If I had had any sense at all, I would have replied, "Yes." That was my chance to redeem the opportunity whose door had slammed shut on me at UCSD over the creation of a dance department.

I did not say yes. I suspect I foolishly heard in my mind the stupid mantra of the times: "Great people do; lesser people teach."

"No," I said. "I will support myself with my art."

If Allan had had any sense or compassion at that moment, he would have replied, "That's ridiculously unrealistic. Let me explain the reality of an artist's life to you. You will not always be celebrated and paid for your work, no matter how brilliant you may be, how hard you work, or whom you might know."

Instead, he wandered off, and I continued typing.

In San Diego, I spent most of my time painting. Throughout my career, two questions have recurred: "Why do you want to paint?" and "Why aren't you painting?"

The first questions the formal relevance of the entire discipline in our changing times. The second presumes an artist's only market validation is on the canvas. Neither provokes an answer that is relevant to why I still paint. Painting is contemplative research for me about my observations of the world that produces a mnemonic result.

Painting made me happy. It still does. I love the play of color, surface, and composition, the smell of oil and turpentine, the initial moments of contemplating a pristine surface before making my first mark, and the penetration of white with the first brushstroke. Before I reach my surface to leave a mark, I gather my thoughts about the mark I will make and what it might articulate. I spend a lot of time looking at and memorizing shapes, edges, and colors and considering what mark will best represent what I observed before leaving a mark. I have always known there are many ways to leave a mark.

Eventually, I embraced ancient traditional means, such as egg tempera on wood. I was all too aware of discussions around painting as a commodity that supported the political status quo and how when it became another capitalist vehicle, it supported oppression. I was backped-

aling to see how I might integrate processes that brought me joy into an approach that might contribute to environmental mediation.

I liked working with old materials, feeling that I had history in my hands, grinding my own paints with a glass mortar and pestle, and glazing with oil on linen and wood. I still love the smell of turpentine and linseed oil, and cherish my collection of natural-bristle brushes. I've kept all my brushes since childhood, like old lovers who remain friends. From 1976 until I left San Diego in 1984, in addition to graphic design, I taught in the adult education programs in local colleges and universities and painted portraits to support myself.

One day, I was aimlessly driving up the coast north from San Diego to Del Mar, where Pays was living. By then, I was ready to disengage from Connie's community. I passed Pays on the road and stopped. We picked up our relationship with the best of where we had left off six years earlier, as intellectual equals, passionate partners, and sources of mutual inspiration. That glossed over our conflicts for a while.

We settled into a relatively conventional partnership. For the next six years, we worked and intermittently lived together. We both had a strong interest in city planning and became involved in charettes about the future of Del Mar, where I was able to apply what I had absorbed from my father and learned much more about contemporary urban planning and community input. The most notable project we undertook together was for Scripps, a report to Congress on the fragility of the Southern California Bight, an offshore geological feature. A proposal for oil drilling could have had devastating environmental impacts.

The cover of the report was a the detailed pencil rendering I had done of the underwater terrain of the Bight. The drawing taught me to carefully observe the complex surfaces of the Bight with precision and make a visual connection between that complex fragility and the nature of the rich, interconnected habitats. I was engaged in a process of rendering the heights and depths of the submarine terrain as I contemplated how life variously and interdependently fills in space.

The report represented why I clung to the relationship with Pays despite our conflicts. It was a partnership focused on how land might be

conserved. It echoed and to some extent fulfilled my childhood aspiration to partner in my father's work on land development.

The proposed site for federally supported oil drilling was in Pays's backyard viewscape. The purpose of our report was to inform Congress of the ecological dangers. We delivered our work for publication in 1981, just when Ronald Reagan became president. One of Reagan's first actions was to cancel the nominal cost of printing the report, so the information would never reach Congress. That was the first time I could put my finger on how the Republican Party would sabotage ecosystems to service corporations.

Throughout the next decade, I watched environmental deregulation and its consequences escalate in San Diego County. People said the Mafia was fueling these projects. Watching habitat protections vanish along with the critical scientific education of politicians was alarming. I had already heard from colleagues and friends in the world of science that funding for theoretical research was drying up, unless it could be construed as valuable to business interests.

From 1976 to 1979, I created *Sunsets,* which I had written about in *High Performance.* For the three years I lived with Pays again in Del Mar, I recorded each dawn and sunset in photographs and watercolors, at the moment the sun hit the horizon at sea level, from our backyard, generating a body of work that recorded the viewscape where oil wells were then being proposed off the coast in Del Mar, California.

I thought of the project as a means to capture the many variations of the visually perfect horizon before it might be defiled by oil wells. *Sunsets* was the first time I explored integrating my painting practice with relational and performative modeling. I was watching myself watch differences between what I could see from taking a photograph and what I could capture in paint.

Sunsets was when I first seriously researched ocular perception and spoke to scientists about it. What fascinated me most was the idea that at twilight, the time when I was observing sunsets, the rods and cones in our eyes actually change shape. That is, the means of my perception was unstable, albeit systematic, reflecting on a complex anatomical level the physics of light and time.

Sunsets (1976–1979), black-and-white photograph, Aviva Rahmani, 1977.

When I wrote about *Sunsets* in *High Performance* magazine in 1979, I reasoned that three years was the time it takes to raise a child in the beginning of their life, during which the child's needs would supersede any other demand on my attention. *Sunsets* was a means to test my accountability to something besides myself. I could embrace the prospect of having a child, despite my concerns about overpopulation or nagging worries about my relationship with Pays, or I could continue to explore

the edges of a formal model that was still nascent but that I believed held me accountable for the health of the ocean and the air.

In the article, I announced that my project would record and "save" each sunset before oil wells contaminated the waters, the air, and the wildlife. The project required my daily arbitrary attendance to the ocean at dawn and sunset. That obligation determined an arbitrary schedule for everything else in my life. It both embodied a small window into child rearing and precluded child rearing.

Pays and I had resumed a social life with friends at Scripps, Salk, and UCSD. I fell in with a group of women artists, all wives of famous scientists, such as Odile Crick, Francis's wife; Ursula Bullard, Edward's wife; and Rita Bronowski, Jacob's wife, with whom I would become close friends. Every week we met for figure drawing and then lunch, when the men would often join us. From another circle of friends, whose connections overlapped, I connected with local stables and took up dressage again, renting other people's horses. For a while, my life was stable and happy.

But as *Sunsets* ended, my relationship with Pays ended again, as well. Once more, our fights had become violent.

My mother came to visit and witnessed one outburst from Pays. It ended as it often did—with his yelling at me—but this time it was in front of her.

"Get out of my house!"

Mother urged me to find land and build my own house. All these years later, the memory of that incident still stills my heart, but it was a turning point.

That was when I first began learning something about law, because I had to understand ownership in the contracts I would be signing with banks and real estate agents. It sparked enough of an interest that I took a class from the UCSD Extension law school on copyright, trademark, and patent law, which would serve me well when I came to create *The Blued Trees Symphony.*

I studied architecture in earnest. The book that most inspired my thinking was *The Passive Solar Home,* by Steven Robinson. Building a home separate from where we lived together didn't mean I wanted to

Portrait of the Artist's Mother, egg tempera on wood,
44 × 36 inches, Aviva Rahmani, 1979.

end the relationship, any more than I had intended my injunction to
lead to divorce in 1970, and we did not really end the relationship until
I left California in 1984. I wasn't ready to examine the depth of my dis-
connect between fear and love. My decision was pragmatic. I built the
house because I wanted peace and safety in a studio where I could work
on a larger scale. I was going to extraordinary lengths to negotiate our

conflicts. But when I finally worked on large works, which I could do when I built my own house, I felt drawn into an enchanted dance in the space of the painting, a garden of paint in a painting of a landscape. As usual, all my focus was on the intellectual hunt.

Although I had begun my artistic training as a painter, I had always thought of the beginning of my career as grounded in performance art. I approached painting as I approached dance or dressage, as an engagement of my whole body, spirit, and mind with another existence, whether spatial or living. In figurative work, capturing my experience on a two-dimensional surface required viscerally "feeling" how the parts of a body fit together in my own self and then using my whole body to create an impression of that experience. The movement began in my spine. It flowed from there through my arm to the brush or palette knife, so by the time the hairs of the brush or the metal touched a surface, I could be one with the mark and the connection was completely embodied.

Allan had also begun his career as a painter. A running argument between us was that I wanted to take painting classes at CalArts, even though he had grown contemptuous of most painting. I nagged him for years to teach a painting class anyway. The reason I kept nagging him despite his demurrals was because of what he'd said in his eulogy for Jackson Pollock: "Pollack had acted on the bare canvas. The next step was to act on life." What I wanted to know was what he had learned about the nature of action on a restricted surface from years of acting in unrestricted space. Allan had spent years studying Zen, and many people had come to consider him a Zen master. For me, painting was a comparably meditative, spiritual practice.

After I graduated, when Allan and I were both living in San Diego, he finally taught a small drawing class in the evening at UCSD. We all started each session with the same materials: a sheet of off-white Canson paper, vine charcoal, and a chamois. Each night, he gave us all a simple new nonrepresentational exercise—for example, drawing two lines that met the edges of the paper and intersected. Every time we were pleased with our results, we were to erase the drawing. It was an approach that his own teacher, the painter and renowned educator Hans Hofmann, would

have approved of. But it was also an opportunity to own a moment of sensitivity to initial conditions—between the willingness to surrender an ego investment and the willingness to move on to completion.

As we drew and erased, a beautiful patina of ghost images emerged on our surfaces. Only at the end of each evening were we permitted to complete the drawing without erasure. I enjoyed the class as a performative exercise, and painting as research.

The paradigm I was still pondering was where painting needed to be positioned in a historical trajectory and in my own performative thinking. Many theorists—few of whom were women, particularly among the French philosophers of the last century, such as Guy Debord, who wrote *The Society of the Spectacle* in 1967, or Jacques Rancière—have written about the transition from object-focused work to participatory experience. Logically, I should have found these writers' works to be continuations of my conversations with Marcuse. I looked for inspiration and new ideas, but as with feminists who would later write about ecofeminism, I found nothing new in these texts. I did, however, come to believe in a parity between an artist's approach to artmaking and the approach of the viewer to the artwork.

These works weren't just about seeing the world differently or making models. They were about making sense of my world.

"The approach" had been Jackson Pollock's innovation. But Allan had argued in his 1958 eulogy that we might take the gesture off the canvas to let it emerge more from everyday life. Many artists were exploring the space of approach in the same vein—for example, when Yoko Ono performed her *Cut Piece* in Central Park for the 4th Annual Avant Garde Festival in 1966, one of several versions of her work in which protective covering, in this case a black shroud, was cut away by observers.

I was still trying to puzzle out how to apply what I had learned from my father to what I was seeing and learning about environmental problems around me and how to shape my insights into relationships with others. I wanted to invite my audience into a landscape that might still be stitched back together more than one that had already been paved over for miles.

Late in the summer of 1979, Pays's mother visited us. I was feeling particularly stressed. The night before her arrival, I had been trying to fit in and meet commitments on very little sleep, working, painting, teaching, and building my house in San Marcos. I had bought the land with a swing loan based on records of gross cash flow in my accounts, thanks to my modest design business. Now I was burning the candle at both ends to complete construction and pay back the loan.

Earl supervised the construction. On day he brought me a puppy, who intrepidly followed me up and down the difficult terrain of the property with expressions that alternated between fear before a deep gully and glee when he caught up, endearing himself to me. I named him Bear.

I was also getting my first lessons in ecological restoration. Despite what I had seen of my father's work, I knew nothing about what could go wrong in the construction process. Father's management had been a smooth operation. One day, I returned from teaching and found that Earl had removed most of the topsoil from my site and buried it under my driveway to provide a base for the newly poured concrete. After I got over my shock, I set about learning how to make new soil with composting techniques and create gardens of indigenous plantings.

I read about landscape architecture and thought through how to organize outdoor space to make it discursive with other species. I was picking up where I'd left off in *Synapse Reality*, in search of a restorative model.

Earl helped. He had grown several Torrey pines from seeds, and those saplings became a grove surrounding a contemplative space I thought of as a Medicine Wheel.

During my erstwhile mother-in-law's visit, I had a session in the new house with the photographer Marshall Harrington for an article in *San Diego Magazine*. The session went well. He shot me against a backdrop of a large painting I had been working on of a powerfully built naked woman turning in the saddle atop a fierce-eyed, rearing horse. The painting was hanging between two stained-glass windows that Coryl Crane, Allan Kaprow's new wife, had designed. Despite exhaustion, that day I felt in control of my life.

I was riding a few times a week then. Bear had grown up and always joined me at the stables. I had several favorite horses I could use to take dressage lessons or go trail riding. All the horses I rode had distinct personalities. I felt emotionally attached to each of them. Ligendoso (a name made up by his owner), nicknamed "Liggy," was special: a pure white Andalusian Grey, my lesson horse with my instructor, Ginny Kemp.

One day when someone else was riding Liggy, he reared up in a heart attack and came down dead. I was devastated. He had been part of my animal family as much as any of my dogs. I cried for days over his loss.

I especially loved a small palomino mare I often took trail riding bareback. We would canter across miles of blue hills without a sign of people anywhere. Bear always insisted on leading the way, forcing the mare to collect her canter prodigiously so as not to step on him.

One day, I was scheduled to ride D-Day, the hunt master's horse, but when I went to the stable to get his tack, I missed that his bit had been changed. D-Day's trainer had been gone for a couple of weeks and had worked him hard that morning. Instead of the gentle snaffle we usually used, his bridle had been attached to a more severe bit. I didn't notice.

I first took him into the small ring next to the stable to warm him up on the lunge line. We then headed toward the dressage arena, which required us to pass alongside the edge of a stretch of eastbound open highway. Just as we left the road and were walking into the arena, a large semi drove by and blew his air horn at us. D-Day spooked. That was the last I remember.

What I heard later was that D-Day spun, bucked, and bolted all at the same time. I fell and, without a helmet, cracked my skull open on a rock. I woke in the hospital two weeks later.

Marshall came to visit when I woke and showed me the prints he'd made. He told me, "When I developed the images, that was the same time you were thrown, about four-thirty in the afternoon. In the print, the light from the windows came in and hit the horse's eyes behind you and then the back of your skull, exactly where your skull was fractured in the accident."

When I came out of my coma, semiconscious in the hospital bed, the gold watch my father had given me in Geneva, which I always wore,

was gone. I never recovered it. That wasn't the only thing I lost forever because of that accident.

As I wavered before gaining full consciousness, I told myself, "I can die now, or I can live. I think I will live, because I'm not done yet." This was another point of sensitivity to initial conditions, in a liminal space between an unconscious and a conscious state. I was there because of a cascade of decisions that had begun with my intuitive choice to return to San Diego instead of New York after graduating from CalArts.

What remained undone was putting my thoughts together, all the threads and dots and layers of my thinking, all I still had to express and present that might merge traditional and cutting-edge thinking about making art, and why.

In that semiconscious state, I saw my life and my future differently. It was soon obvious that I had left a significant number of my brain cells behind on the dusty summer rock that had broken open my skull. My thinking was different, more logical, when I woke up. Later, after neurological research, I understood that although swelling might have robbed half my brain of the capacity to think clearly, the other half was quite ready to negotiate strategies with the half that had been injured, compensating for what had been left behind. Just not yet.

The fracture had been on the left side of my brain, causing the right side to swell, which created the greater injury. In colloquial terms, that made the me who woke in the hospital after two weeks a more logical, less intuitive person. Whether or not that idea has any truth, my recovery felt slow and difficult. I couldn't easily call up information that had always been readily available, and I struggled with a pervasive lassitude. Recovery took years.

At the end of the 1970s, before my accident, I had thought I had all the time in the world to work out my premises. My accident woke me to the fact that time might be infinitely flexible, but the arrow of time is fleet and irrevocable. As I awoke, I felt like a different person and newly subject to time. Time was the thread from my previous work that had been expressed in *Sunsets,* and it would frame my future projects.

I was in my midthirties and had to face two basic questions about unfinished business in my life. The first was how I was going to take own-

ership of my intentions in the body of my work on a deeper level. The second was whether I was going to have a child. *Sunsets* hadn't answered that question. Despite my age, the first question seemed more immediate than the second.

But first I faced what felt like a bigger problem, even more consequential than my rape.

When I emerged from the hospital after my accident, the draftsmanship competence I had carefully honed and taken for granted my entire life was gone. I had to relearn how to draw and paint. I had to relearn art history. Art had guided my life for fifteen years, but I had been drawing and painting before I could write. All these skills I had acquired in my life were gone.

I set myself the task of remastering what I had lost and began with draftsmanship. It was terrifying.

As I reached for normalcy after the accident, I found that my mind still worked—just differently and with many holes and gaps. My first exercise was a drypoint print of an exercising dressage horse, based on an extensive series of photographic studies of Harry and Helen Polonitza's dressage horse, Night Train, at Seabreeze Farms, east of Del Mar. I curled up in a corner near a picture window in Pays's house that looked out on the ocean and worked my steel needle on the copper until a printable image developed from detailed sketches.

I struggled for the next several weeks to complete the print and publish a small edition. Even after completing the print, I kept struggling throughout that year and until the following summer to bring back my "touch," to make a mark that seemed gone forever. It wasn't something I discussed with anyone. It was too scary to put into words, because access to those skills was so indelibly intertwined with my identity, whether realized on a surface or in free space.

The summer of 1980, I left my dog, Bear, with a sitter and headed to Italy, desperate to reclaim my technical competence and aesthetic ease. Over a month, I traveled north as I worked on recapturing my painterly skills and understanding of European art history, starting in Tuscany, with time at the Uffizi in Florence, then making my way through Paris and London. I took trains and stared out the windows, sketching the changing

shapes of shifting landscapes. At night I filled in the shapes I had made during the day with watercolors.

Everywhere I went, I visited museum archives and made copies of old masters' drawings. I immersed myself in museum collections, traveling forward in historical time from Giotto and getting permission to copy Dürer prints and Turner sketches as I followed the light from city to city until I reached Scotland.

In Scotland, on the edge of Loch Lomond, I saw the most beautiful purple-green light. As I stared at the hills and water before me, I knew my travels were done. Of all my experiences observing the changing light as I traveled from Florence, Italy, to Loch Lomond, the light in Scotland had impacted me most.

I came home and resumed studio work. I could draw and paint again. But the experience was different. Even as I continued to try to regain my painting competence after my head injury, I still had the second question to answer: whether or not to have a child. It wasn't an easy decision. When the Erlichs's *The Population Bomb* had come out in 1968, I didn't notice what has since been critiqued as "colonial framing." My takeaway was that the consumptive impacts of having children made childbearing immoral. The burden each child born in the West imposes on the Earth seemed unconscionable. But in 1980, my hormones kicked in with their own opinion. I longed for a child.

I had watched the women in my life struggle with pregnancies and parenting. I wasn't certain Pays would stick things out; that had been my psychiatrist's fear before we left New York. I feared the conflicts that might arise between my career and child rearing. I already knew I was prone to depression, and various medications hadn't helped. Medication just made me gain weight. I still wasn't prepared to own the violence in our relationship, let alone connect the dots from that violence to my depression, but I feared trying to raise a child as a single, depressed woman struggling to balance parenting and a career.

My solution to finding an answer, again, was in combining research and artmaking.

Once home from my trip, I wrote as honest a letter as I could about my ambivalence over childbearing and parenting and mailed copies, along

with a couple of black-and-white images that spoke to my apprehensive mind about childbirth and parenting, in twelve-by-nine-inch manila envelopes to about one hundred friends, men and women, mostly in the art world. I asked for their experiences and thoughts about having children. This was when people still penned letters by hand. My own letter was typed.

The letters I got back were all in longhand. I was surprised to learn that different experiences had nothing to do with gender. Differences arose from whether the respondent had access to childcare.

Allan's ex-wife, the photographer Vaughn Rachel, wrote, "You can be a good mother or a good artist. You can't do both equally well. Whichever you choose, you will regret the other for the rest of your life."

Barbara Smith began her letter by saying, "All artists are selfish. You have to be."

This was the beginning of a project I called *Floating Worlds*. When I began it in 1980, it was about childbirth and parenting. By 1982, I was feeling more competent with my painting and drawing again but even more ambivalent about having children. I had read about *ukiyo,* or the "floating world," in James Michener's *The Floating World* (1954), which is about the printmakers of the Edo period in Japan. The city of Edo, present-day Tokyo, had a community of courtesans and prostitutes who serviced the *daimyo* (feudal lords) and their samurai. Their role was to entertain and provide pleasure. In Buddhism, the term *floating world* has a double meaning, conveying both pleasure and suffering. This reflected my abiding expectation that childbirth was less about legacy than it was about being the gateway to household slavery.

For a series of subsequent performances across the country, I copied the letters I had received from my respondents and gave one each to individuals in a small group of performers seated on large pillows dispersed on the floor. Each reader received a letter I thought would be especially evocative for that person, on the basis of what I knew of their lives. The work was performed with variations in many venues in California and on tour in the Midwest. I asked each performer to read the letter out loud without rehearsal, then speak spontaneously to the audience about their reactions to the content and their desires or experiences about having

children. As they spoke, I projected the hundreds of consecutive slides of sunsets and sunrises that I had collected from Pays's yard for *Sunsets* in sequence on one wall to represent the passage of three years—as I stated, the crucial beginning of a child's life. On another wall, I painted from a series of buckets of brilliant watercolor paint to fill in a series, depending on the venue, of from eight to twelve eight-foot-high drawings that had been blueprinted, blowups of the same drawings I had included in my original letter to the artists.

I started the performance by announcing to the audience that I was testing myself. If I could complete the paintings to my satisfaction in the midst of the emotion evoked by the readings, I would know I could successfully raise a child while working in my studio. But I was never satisfied enough with my performance to dare getting pregnant. Perhaps my perfectionism was an excuse.

Later, I mounted two installations, one at San Diego State University (SDSU) and the second at the Long Beach Museum of Art, interpreting my experience. At no time did I realize that the real problems were practical. I feared the absence of affordable child care. I also didn't trust Pays to help and didn't trust myself to make up the difference that society withheld.

If I was looking for more sensitivities to initial conditions where things might have changed, once more in my life, I feared I had failed. I blamed myself first, Pays second. Throughout this time, I believe we wanted the relationship to work, and we wanted to work as a team on ideas we both believed in. Our work on city planning was both for Del Mar, where Pays still lived, and San Marcos, where I was then living.

I was more ambivalent than ever, and the ambivalence I felt in my relationship with Pays was the deciding factor about whether or not to get pregnant, more than any judgments about my artwork or society.

Over the next several years, until I went through menopause, my desire to get pregnant became ever more powerful. After leaving Pays for the last time, I made earnest attempts from time to time to get pregnant with various lovers, setting aside realism. The desire for a child stopped when my hormonal output diminished.

Meanwhile, the work morphed into other installation forms, including a suspended series of thick panels of handmade paper, mounted in a spiral to represent my wave of feelings; a book; and other writings. At SDSU, I mounted the paintings from the performances on the walls and suspended six panels of handmade paper, each six feet by four feet, in the center of the gallery, assembled to represent a breaking wave. The wave was meant to represent how hormones and the imperative to reproduce overcome reason, powerful but as ephemeral as the ghost images I had made in Allan's drawing class.

Toward the end of the project, I had an epiphany.

Nothing particular triggered my epiphany; I could identify no sensitive initial conditions. I was in a parking lot and walking into a market when I suddenly felt that I was seeing my entire life in split screen. I had fragmented my life as cleanly as any housing development might have fragmented a forest. All the veils of denial and compartmentalization I had clung to, routines of my entire life, had accommodated me to violence and abuse in conventional relationships. The veil between realities that enabled my compartmentalization dissolved, revealing a split-screen truth.

On one white screen in my mind, I saw a well-adjusted, pleasant, and privileged life in a traditional partnership. On the other screen, I saw fear, pain, and disappointment on a humiliating and depressing continuum. As I kept walking toward the market's double doors, my mind struggled to make sense of this strange new split-screen movie of my life. As I prepared to enter the store, I looked down to my left. A young boy was overseeing a small cardboard box of tiny kittens, just to the side of the door. He was giving them away.

I went in and completed my shopping as I thought about the fragmentation of my life and the kittens in the box. I vowed, as an act of empathy I had withheld from myself until then, that I would rescue one of those kittens if they were still there when I left. They were. I rescued a tuxedo I would call Blue, for his lovely big blue eyes, and took him back to my car with my groceries. All the way home along empty country roads, Bear's large nose investigated the little ball of fluff in my lap.

At the moment of my epiphany, I felt flooded with every experience of cruelty, unwanted sex, physical or verbal assault, and gaslighting because of my gender that I had ever endured. It was staggering, overwhelming, to experience the sheer volume of hurt. This wasn't a simple adversarial perception. At that moment, I felt I knew every man who had perpetrated abuse and been conditioned to do so by his own experience of abuse.

Besides answering my questions about parenting, I had another idea about what I wanted to do next. I volunteered to create an indoor mural in a shelter called Casa, a facility for abused children. However, I had a lot of loose ends to tie up first.

It was the early 1980s. I was still recovering from my head injury. I was trying to understand what causes and heals violence. I was still contemplating the implications of my conversations with Marcuse before I'd left for CalArts, and I was evading a decision about my relationship with Pays.

I began the new project. I was in touch with and felt somewhat mentored by the Los Angeles Chicano muralist Judy Baca, who had been working with rival gangs to create spectacular murals. For one of her murals, *The Great Wall of Los Angeles,* she employed more than four hundred young people from all over the city. It would become one of the largest outdoor murals in the world. I was tremendously impressed—not only by her monumental work but also by the kindness and generosity of her relationships with the young people who were her crew, some of whom had lived with her.

Years earlier, Pays, Earl, and I had attended the Native American teacher Sun Bear's Medicine Wheels gatherings. I had been as inspired by the ritualized healing ceremonies I participated in as I was by Judy's example. Thinking I was honoring what I had learned, at first I called the new project *The Medicine Wheel Murals.* I thought that contemplating the symbology of the wheel and making art about it would be helpful to the children. The mural took shape as a set of allegorical images designed around the symbols from the wheel about healing and contiguity.

I had not yet encountered the impassioned injunctions from the Native American activist Ward Churchill, railing against cultural appropriation by Anglos. Later, I would encounter other Native Americans who were so incensed by the issue of appropriation that they proclaimed they

would rather their knowledge die with them than be shared with Anglos. Other Native Americans, however, claimed that white women would treat their traditions with respect and could disseminate the wisdom. It was profoundly confusing. As it happened, and reflecting the complexity and emotion behind these questions, Churchill, who self-identifies as part Cherokee in addition to other tribal identities, had his own tribal identity challenged.

Bear always came with me during the work sessions at Casa, as he had once accompanied me to the stables, and the children seemed delighted to play with him. The work we produced was beautiful.

While working on the mural, I was also completing a series of works about male violence. I was beginning to pay deeper attention to how I named my projects and had called this one *Seiche Torque*, a reference to two ideas that seemingly had no connection. One idea was about the small waves that occur during a tsunami. The other was about how metal can twist. Both were about how violence can catalyze and unleash enormously powerful and complex repercussions.

Meanwhile, nothing in my external personal life or relationships had changed. I was a deep, still pool.

I had just been completing two paintings of an old man, ambushed and mugged. When I finished the first study, I learned that while I'd been painting the image, Father had been assaulted in Caracas, suffered a heart attack during a theft, and had been sent back to New York. I flew to New York to visit him in the hospital.

Unlike when I was summoned from Switzerland at fourteen, this time my father's heart attack was real. He looked fragile in his hospital bed. I showed him a picture of one of the paintings I had just finished of a sunlit street attack.

He said, "Yes, that's exactly what it was like."

At a corner of a building, on a sunny afternoon, several young men accosted and beat him, as though they knew that even in his eighties, he might be a tough customer for one young man alone.

The heart attack marked the beginning of my father's decline. My mother had stuck with him, helping him in Venezuela, but as part of his decline, he was having rages, hallmarks of dementia, threatening my

mother. She decided she wouldn't go back to their office in Maracay. We didn't know exactly what was happening in Venezuela before he left for the last time, but he must have become increasingly isolated and vulnerable to relentless graft pressures. He left behind bills, land and financial wealth, and commitments to people. In effect, my family kidnapped him in New York. He would never return to Venezuela. My mother claimed the family turned its back on $100 million to rescue him.

My mother and sister wanted me to stay in New York and help care for Father. My mother had already insisted, over the entire family's objections, on selling the house in Sleepy Hollow for a smaller, more manageable house she would build in White Plains. The sale and her move looked like her declaration of independence.

In 1984, I was putting up an installation for a show in Rochester, New York. It was a large collection of mostly life-size cutout representational figures developed from *Seiche Torque*. Each was painted in oil on Pellon, the light, nontoxic fabric that often backs luxury materials in dressmaking and furniture design, a faint echo of my mother's sewing room. The figures were pinned to the walls of East West Gallery.

Before returning home, I stopped in White Plains for a few days and commuted into New York to visit galleries. The then young and soon-to-be great gallerist Colin de Land (now deceased) of American Fine Arts, located at that time on the Lower East Side of Manhattan, saw slides of the show and wanted me to install the cutouts on the brick walls of his gallery. Somehow, that never happened.

While I was still in Rochester, my mother and sister attended a court hearing to declare Father's incompetence. They felt strongly that I should have left the show before the opening to join and support them. I refused. I foresaw being sucked into a situation where family caretaking would erase my life while I drowned in memories of abuse.

My parents' new house was closer to the company office. Not only had my father become physically frailer, but his rages were increasing. Mother had been reluctant to commit him to a nursing home, but in the end, it was inevitable. He was threatening her, and he still had guns in the house. He was diagnosed. The guns were sold. A new medication kept him calm, and he was taken away.

Mother, at eighty, took over the business. The business in White Plains, where they still owned office buildings and parking lots, was $10 million in debt and on the edge of bankruptcy. The woman who once thought she might find work cooking soup if she divorced Father was about to rescue the family business from bankruptcy.

Her strategy was to get a face-lift and go to the cosmetics counter at Bergdorf Goodman, where she announced she had reached the age when she needed a "spot of color." She got two extra ear piercings and then enlisted me to review contracts with her to figure out what could be sold to avoid bankruptcy.

I returned to San Diego, continued to work with the children in the shelter, and became more emotionally involved with them.

Things started going very wrong in events surrounding the mural. The images evoked strong feelings among some of the children. The woman who had brought me into the project suffered a brain tumor. I hadn't worked closely enough with the rest of the administration, particularly the resident counselor, to ensure adequate support going forward without her. With little notice, the administration announced that the mural would be sandblasted off the walls.

I was stunned and angry, and, along with the children I had worked with, felt blindsided. I pleaded with the administration to save the children's work. The children were equally upset about the news of imminent destruction. I met hostility from the staff that I couldn't understand. I contacted lawyers and the media to try to protect our work, but the people I spoke to feared that the publicity would reflect poorly on the shelter, endangering its support and, ultimately, the children. I argued that destroying the mural, into which the children had put great effort, could be psychologically damaging.

The administration allowed a brief good-bye between me and the children, without Bear. Within a week, they went ahead and destroyed the mural by sandblasting the walls.

In retrospect, I think the cause of my failure was obvious: I simply failed to anticipate or pay attention to warnings from staff of possible conflicts or to adequately weigh other people's concerns. My own emotional boundaries were as fragile as the Pellon I had painted *Seiche Torque* on.

It wasn't the first time I'd made mistakes in important relationships. It wouldn't be the last.

As the early 1980s moved on, my world was turning surreal again. I was too aware of the similarities between the world in George Orwell's book and our new political reality, and I dreaded our future. Ronald Reagan had been reelected president in 1984. Reagan's world seemed positioned to further benefit the privileged by cutting taxes and disenfranchise the needy by cutting support for education. His policies soon merged with the notorious Republican "Southern Strategy" to enlist the support of white supremacists. Heather Cox Richardson would not write her 2020 book *How the South Won the Civil War* for another thirty-five years, but the writing on the wall was already evident.

It was harder for me to read the writing on the wall about the ongoing entanglements of my personal life, written in invisible ink. As I was trying to make sense of Reagan's ascendance, I was still at a point of serious loose ends in my life, as I had felt after the combination of my divorce and the UCSD provost's threat or my horse accident. I was far from resolving my split-screen epiphany and even further from safety.

One evening, the librarian and curator Judy Hoffberg gave a talk at UCSD. She was going to stay with me. But when we walked into my house, we found an ominous display of coiled rope in my living room. Upstairs, all the clothing in my closet had been torn from the hangers.

I reported it to the police. They told me, "Get a gun. No one can get to you fast enough out here where you live. Aim for the heart."

Earl bought me a gun and took me to a shooting range, where I learned to aim and shoot. When I could hit the bull's-eye, I mailed one of my target sheets to my parents. Mother told me it really upset Father, as though as much as he wanted to teach me to fight back when I was a child, it horrified him when, as an adult woman, I finally did.

Times were changing. The dark clouds of evidence and repercussions began slowly and subtly, but as I look back, they were unmistakable. Symbolically, they had begun for me about fifteen years earlier, the day the Disney family cut the endowment to CalArts to one dollar.

In 1986, I finally decided to move back to New York. I set about my transition methodically. My motive was less about the needs of the women

in my family than it was about resolving my emotional loose ends with my father. I rented my San Marcos home and moved to Brooklyn, intending to return to California after my father passed.

In White Plains, my mother had taken complete charge of their business. Her skin doctor told me that she'd had an affair that made her very happy.

By 1987, my father was living in a pleasant nursing home near my mother's new house. Despite her new responsibilities, she visited him daily. I had a loft in Park Slope and drove up with Bear each weekend to visit. My father always seemed elated to greet Bear, and Bear was warm and demonstrative with him. I began a portrait of Father, a thirty-six-by-thirty-six-inch oil painting that was a close-up of his troubled face looking back at me as we discussed his violence.

Portrait of the Artist's Father, oil on linen, 36 × 36 inches, Aviva Rahmani, 1987.

My psychiatrist suggested I visit him more frequently. Despite ambivalence, I resisted what I anticipated could be an emotional vortex for me. I documented our visits in journals and eventually produced a short film shot in Juan Downey's studio by the then-filmmaker and my close friend Anthony Ramos. The text for the film included a seminal exchange I recorded that summer and early fall.

"Your violence hurt me," I told him.

He apologized.

As I painted his portrait, he said, "You are talking to the paint."

For the first time, I felt my father and I were also talking to each other as equals. It was a sad relief. We had taken so long to get there.

The spring of that year, I conceived a new project, which I decided to launch on October 3, 1987, to come to terms with my grief over what I had lost with my father. I carefully planned the new project, *REQUIEM,* intending for it to last for one year, starting on the launch date. My plan was to do 365 meditations, starting the day of the launch. Each day I would spend 366 consecutive minutes meditating in the midst of life. The first day would be 365 minutes of experiencing grief, followed by one minute of experiencing happiness. Each day that relationship would change by one minute, until at the end of the year, I would meditate on only one minute of grief and 365 minutes of happiness.

When I had conceived *REQUIEM,* I wanted to create a model to teach myself to work through grief by limiting my focus on sadness during the grief meditations. I hoped to expand my gratitude for and joy in small events. I intended to sculpt my spirit. I ritualized my research.

I set up a schedule for myself to systematically produce a series of small, medium, and large paintings, documenting my state of mind over time as I made my emotional transitions. I tracked my days in a formatted journal I designed and made pages entitled *Days,* one each of photos and stories describing each day's meditation. I luxuriated in the surfaces and added gold leaf to images. I made a set of drawings for each month and another set for each week.

I was also doing a lot of bodywork to dispel the experiences of abuse from my body. I assembled a set of black-and-white photographic por-

traits of my nude body in profile, furling and unfurling as I sought to open my heart chakra over the course of a year, hoping that time would expand my capacity.

On October 3, the scheduled day of the project launch, which I had designated in June and for which I sent out press releases, Father died. Once more, clairvoyance had struck. Once more, a coincidence of premonition unnerved me. I couldn't have known in June the exact date he would die in October.

REQUIEM was the most meticulously formal structure I had designed up to that point to generate personal change. The change I focused on was in myself, to segue from depression to a state of equanimity. *REQUIEM* allowed me to make a coherent narrative of any remaining conflicts or ambivalences in my relationship with Father.

Father had been rushed to the hospital with heart failure the evening he passed away. I drove in from Brooklyn and first picked up my mother in White Plains. We got lost trying to find the right hospital in the night. When we arrived, he was already gone. I collapsed, sobbing in my sister's arms.

After I disengaged from my sister, I went into his hospital room alone, slipped back the sheet that had been pulled over his head, and took photos of his face in death. The photographs became the subject of a major painting the following year. Two summers later, I completed an eighty-six-by-seventy-six-inch death mask based on the photographs I'd taken.

It took me a couple of years to complete the painting, in a new studio in Maine, as I looked out the windows toward the rocky outcroppings of the harbor where I was living. The painting was so large that close up, it just looked like the rugged marine landscape surrounding my studio. The brushwork only resolved into a human face when the viewer stepped back. Completing and contemplating that painting helped me feel my profound connection with all nature, as I grieved. That painting was the first of decades of paintings of the same vista, divining wisdom from the boundary between land and sea.

That death-mask painting was included in two major solo exhibitions of all that came out of the *REQUIEM* project. I shipped the work from

my studio in Maine to the art galleries at Grossmont College, in El Cajon, California, and at the University of Missouri–St. Louis.

The day after Father died, Mother, Ilana, and I boarded a plane with his body in a shroud. He was buried in Haifa, Israel. His grave site has an excellent view of the sea. He had always prioritized a good view. The main reason he resented leaving the home in Sleepy Hollow was because it had such a fabulous view. The only view from the house my mother built in White Plains was of a beautiful garden she created in her backyard. Now Father had an even more magnificent view than he'd ever enjoyed in life, from the heights of Mount Carmel, overlooking the Mediterranean.

Father's grave site was one of two plots. The second would have been for Mother. But she had done her loyal duty to him her whole life and evidently decided that his death was their expiration date. When her time came close, she asked to be cremated. We eventually sold the second plot. Ilana still has our mother's ashes, though she has quipped that the ashes should have been scattered in front of Neiman Marcus, where she had loved to visit the jewelry counter. She would take a piece of jewelry home with her to consider it, then return it. When I visited the counters of her favorite salesladies after her death, they affectionately recounted how much they had always enjoyed her visits.

Following the burial, my mother, my sister, and I stayed to observe a truncated shivah in the King David Hotel in Jerusalem. My sister and I took walks past the golden stone walls of the city, overhung with brilliant bougainvillea, and took note of what we didn't want to see: the tacit, creeping apartheid between Israelis and Palestinian Arabs, so different from what our father had hoped for so many years ago.

Each day, without fail from the eve of Father's death, I quietly performed my 366 minutes of meditation even if I was with others. Alone each evening in my hotel room, I recorded my thoughts as images and notes, as I had always recorded my life in journals.

Over Mother's objections, Ilana and I took a quick trip to Moscow to visit our cousins, Efraim's daughter, Ludmilla, and her daughter, Katya —all that was left of his line. Mother was beside herself over a trip she deemed very dangerous, so upset that she took a fall on a staircase and

had to be rushed to the hospital. Fortunately, she suffered only bruises, and Ilana and I headed for Russia.

In preparation for our trip, I learned basic Russian, enough to follow conversations and ask essential questions. I was pleased when we encountered strangers and they mistook me for a native Russian. Our cousins took us to all the museums, where I devoured the rare work of the Russian Impressionists and gaped at the gilded chariots, stunning accretions of gold created at a time when the peasants were freezing and starving to death. I stood in Red Square and got a sense of the vast expanse of the country. In our cousins' flat, I took photographs of my second cousin Katya as she played her cello. We returned to Israel and from there returned to New York.

If happiness was the goal of my project, I was most successful at the midpoint of *REQUIEM,* when I was equally balancing grief and happiness. As the project progressed, I learned that psychological researchers thought generosity was good for the immune system. I made greater efforts to be warm and kind to others. In the grief portions of each day's meditation, I took time to mourn every tragedy I knew of in the world—from the *desaparecidos,* casualties of the U.S.-backed Argentine military junta (1976–1983), to the clear-cut forest systems across the planet.

REQUIEM was like previous works of mine in that it was ritualized and systematic; I integrated painting and drawing techniques with performative elements; it had transparent aspects. As in other works, I posed a question: Could I deliberately change my state of mind? At the end of *REQUIEM,* as I considered impending ecological doom in the light of my family history, I came to think about what safety means to people. I was deciding that people often mistake safety for many other circumstances, from silencing whistle-blowers to being generous to people in need.

Early in November 1988, a year after my father's death, *REQUIEM* was complete. I wasn't sure what to do or where to live next. On a Friday evening, I went to bed troubled by my own uncertainty. The next morning, I woke from a dream with direction. In the dream, I went somewhere in northern New England, then to Santa Fe, and then back to New York, where I was finally happy.

A friend, the photographer Joel Greenberg, had a house in the island community of Vinalhaven, Maine. I called him, explained my dream, and told him that I wanted to rent his house because my dream had assured me that would lead to my happiness. He passed me on to a friend of his, a real estate agent. I called the agent, announced that I would arrive the next day on the last ferry, and asked if he could line up something I might rent and perhaps buy.

That same day, a friend called and invited me to take a car trip with her to Santa Fe the following summer. I took that as a sign.

The next day, Sunday, Pam Whidden, my former studio assistant from California, who had been visiting me in Brooklyn, and I woke early and headed for Vinalhaven with Bear. I left Blue home for the overnight trip. The ferry landing was a ten-hour drive from Brooklyn, and we had to make the last boat at three thirty that afternoon. We made it.

When I came off the ferry onto the island, I recognized the same purple-green light I'd seen in Scotland in 1979. I had found my place.

Despite my dream, my plan hadn't been whimsical, spontaneous, or even primarily intuitive. My visit came at the end of three years of research and thinking about where to settle. I had studied the maps of the world to analyze where it would be cool to live but not where the water or other natural features would be contested, as they are in Taos or Santa Fe, New Mexico. In New Mexico, it looked like the Colorado River was stealing water from Mexico. In contrast, Maine had abundant water and apparently stable relationships with Indigenous peoples. On the surface, at the time, the relationship to water in Maine looked reasonable.

In studying maps of places where I might want to live, I was automatically applying what I had learned from my father about how to analyze trends in large landscapes. As a child, I had sat next to him as my family drove through Westchester County to a restaurant where he had done some remodeling and listened carefully as he muttered, "Good place for a development," when we drove by a field. I would note how far we were from a railroad station, a school, a lake, and put two and two together about demographics and correspondences. I read more deeply into island biogeography.

I had finally internalized my transition from the grief of all I'd learned and contemplated about my father's relationship to land. I was coming out on the other side of the looking glass, and a range of new approaches was opening up for me.

My new goal was to muster all my knowledge and insight to make art that might undo some of what my father had done to the Earth. I anticipated joy.

8

Ghost Nets: From White to Green

n February 18, 1989, I began my second visit to Maine. I had decided to move there for six months. It would be a vacation adventure away from the New York art world I knew while I produced new work. I still trusted my intuition. My next art step would provide answers to all my problems, even if it took me over the ecosystem cliff that Roger Revelle had been warning about for decades.

The weather was bad. Bear and my cat, Blue, the tuxedo I'd rescued as a kitten, and I had been driving north for hours in my white 1987 Jeep in a whiteout blizzard. Unlike my first trip, this was just me and the animals. I had left about 8:00 A.M. and had lost track of time. We were the only ones on the road. My tires ate up mile after mile on an empty highway in a pale gray blur punctuated by the darker gray of the occasional semi pulled over on the side of the road. I squinted to see beyond my windshield.

I drove stubbornly forward. Only anxiety kept me from falling asleep at the wheel. I had been ready to leap off a psychic cliff of frustration over environmental threats. Based on what I had watched of Reagan's presidency, we were hurtling toward a disastrous conflation of tyranny and ecocide.

We arrived safely at the Navigator Motel that evening, ten hours after we'd left Park Slope. Pets were welcome. We were across the road from the ferry landing on Main Street.

The only boat to Vinalhaven the next day was scheduled to leave at 7:00 a.m., but it wasn't going to take any cars. I checked out of the motel at 6:15 and drove down the hill. It was still snowing heavily and so windy that all I could see were swathes of white sweeping across the landscape. With misgivings, I left my car and all my worldly belongings in the empty ferry parking lot.

I had just spent the past three years in the wilds of an ungentrified Brooklyn, living across from a meth house. One didn't leave even a paper notebook in a locked car parked on Union Street in Brooklyn in the 1980s, let alone the pile of computers, clothing, and household essentials I abandoned as we stepped on the boat, Bear on a leash and Blue in his crate. The ferry had only one other passenger. As it pulled out of the harbor, I watched bare shapes hinting at land disappear under tones and tints of white and clouds of snow whose boundaries merged into ever more mesmerizing variations on whiteness.

We turned east into the Atlantic Ocean to cross the thirteen miles of open water between the mainland and the island. The swells alarmed me as we rocked violently in the nor'easter gales. It was no more frightening than a hundred other adventures in my life and less worrisome than leaving my car abandoned on the mainland, but this time the danger included my animals. How could I keep us all safe if we capsized? I imagined trying to stay afloat in the icy sea while hugging Bear and Blue before we went down. Waves were breaking over the ferry roof. The entire boat was covered with thick ice.

Blue's crate flew across the cabin floor. As I retrieved it and slid it back onto the seat next to me, I turned to my fellow traveler, a woman who would be my neighbor in another year, and exclaimed, "This is the most exciting thing I've ever done!"

What was so exciting was the unknown, of being in the thick of a journey into a mysterious world of beauty that promised answers to my questions at the end of rainbows. My excitement felt as exhilarating as jumping a fence with a horse. The sense of danger from the very real

storm heightened my conviction that nothing would be the same at the end of my journey. I was stepping off a cliff, with faith that the wings of my intuition would take me someplace irrevocably wonderful.

I settled in a red house on an inlet called Indian Creek and began *Safety,* six months of daily meditations on the meaning and symbolism of safety. I intended to document my thinking about safety and life on this island in text and images. It seemed to be an idyllically safe place to live, but I wondered about how the isolation affected domestic life for the islanders. I had decided to concentrate on the fog, ice, and snow in my backyard on the creek, where the cold made frozen waves. Each day I took one photograph of the shore and wrote comments on an index card about fog as a metaphor for denial and illusions of safety.

I began informing myself about contemporary fishing practices. Since my time in San Diego, I had known of danger on the beautiful seas and how overfishing had emptied the oceans and threatened the viability of its ecosystems. Even as a child, I had guessed that fish have sentience, as biologists would later affirm, and had a visceral understanding of how painful a fishhook might be in any animal's mouth or how frightening net entrapment had to be.

At night on Indian Creek, Bear, Blue, and I huddled under the bed-covers to stay warm. When daylight came, I rose from our warm nest, wrapped myself in a blanket over my robe and nightgown, and went downstairs to feed the wood-burning stove. I then headed back upstairs to dress warmly before all three of us ventured out into the snow to document my impression of fog and safety that day.

Almost daily the ocean-borne heavy gray morning fog rolled in over the ice-slicked rocks and rime-burdened grasses to show me an alternate universe. I noted the edges between rocks and where the waves lapped the shore and circled the grasses, letting them teach me more about the ecotones where microhabitats intersect before freezing in place.

Maine in winter was different from any of the other places I'd lived. Surrounded by ice and snow, life is almost always mystically silent and empty. I made few acquaintances through the winter. I saw people at the one grocery store, at the post office, or at what was called the "new" town

dump, where I took my trash for sorting and recycling, but I had limited exchanges with the people I met.

One morning, while cooking my breakfast oatmeal, I heard a National Public Radio broadcast about ghost nets. These are fishing nets made of invisible, indestructible monofilament wire that break loose from boats and continue fishing in the water. Fishing nets are designed to trap fish, who swim unknowing into them. Fish are caught by their tails or on their gills; the harder they struggle to escape, the tighter the nets trap them, causing them to flail desperately for air and freedom. If the nets are still attached to a boat, the fish are eventually hauled on board to be sold. If the nets have come free, the captured marine animals die miserably and slowly. The narrator explained how often drift nets are lost overboard, how they become indiscriminately lethal for marine life and seabirds and never retrieved. The nets are kilometers wide, functioning like predatory zombies, cruelly and purposelessly harvesting life. The reporter said that these nets caught so much bycatch—fish and birds without commercial food value—that the entire marine ecosystem could collapse.

That was the first I'd heard of any of this. Ghost nets were part of all the other plastic products causing problems, but the scale of their destruction was vast. The metaphor had to form the basis of my next project. I went to the dump, where I could find and retrieve discarded drift nets. I was envisioning the ghost nets as embodiments of every familiar pattern or routine of thinking and acting that was destroying life on this planet. The impact on me was stunning: in the midst of contemplating safety and denial, I considered that the familiar sometimes only obscures real danger. That was true for my grandfather Joshua, who mistook his familiar factory in Białystok for a safe place. We swim into those invisible dangers. They kill us in horrible ways. The ghost nets represented every possible danger to life from familiar patterns and pointless traps: when we think we are safe, we are often only blind to imminent threats.

In the white world of that first Maine winter, I began to weave and reweave a landscape of metaphors while becoming a student of the shoreline. Island time began to stretch like taffy as I imagined that the key to unraveling the puzzle of how to save a threatened world was buried in those metaphors and would be illuminated by what lay under the ice.

When I was close to finishing *Safety* and had been handling and studying the drift nets for a while, I began thinking more deeply about human complexity and denial. Sooner or later, denial strip-mines human joy as much as the nets do marine life. The whole trajectory of destruction seemed enshrouded in the same blind fog I had tried to document in *Safety*. Even before I began my research for *Ghost Nets* in earnest, I foresaw that it would take me well past the six months I had originally planned to stay in Maine.

If anything became really uncomfortable, I assumed I could still easily escape back to New York or head back to my familiar home in San Diego.

I didn't factor in how the beauty of the Maine coast might capture my heart.

But if I stayed, I would never again ride a horse through the blue hills of San Diego County while inhaling the tang of sage and creosote.

Within hours of my decision to commit to the ghost nets metaphor, I began imagining how to apply it to my life. I thought it was my good fortune that had led me to this opportunity to pursue wisdom.

Shortly after I heard the broadcast about ghost nets, the same real estate agent who had found me my rental phoned to say that I might want to see a property that was on the market, even though it was well beyond my price range. A few minutes later, he pulled up in front of my door to pick me up. We drove east and north across the island for a couple of miles, then finally down a long dirt road in fog so heavy that I couldn't see three feet ahead of the car. Our car came to a stop in front of what he explained was a large, abandoned sawmill.

I was already entranced by the pale gray shimmer of fog over the landscape, which muted the sounds of seagulls and waves, so much more intense than my experience of fog at Indian Creek. This site was a doorway into the wild Atlantic. Vinalhaven is thirteen miles out to sea. The fog is different coming off the deep ocean on the eastern shore than it is on the more protected western coast.

We got out of the car and walked forward, deeper into the fog as we headed toward the old building just a few feet beyond the car. My new friend opened the building's door, and we entered an open space that had

once been a sawmill, suffused with the fragrance of spruce boards and seawater. I could hear waves lapping the piers around us. As we climbed up a rickety ladder to the second floor, ocean wind drove between the wooden boards of the exterior walls and licked at my cheeks.

"I'll buy it!" I said.

"You can't afford it!" he replied emphatically.

In a triumphant declaration of hope conquering pragmatism, throwing safety to the winds and sealing my fate, I said, "I don't care. I want it."

All my life, I had been a geographical drifter. Both my parents acquired skills that kept them one step ahead of calamities that swallowed others: the ability to assess a complex situation very quickly, ignore the emotions, and act, the same lesson my father had taught me. I had grown up applying their lessons, but those aren't the skills that assure a safe, happy, stable, or secure personal life.

When I said yes to Maine, it may have seemed impetuous to others. Perhaps I unconsciously imagined that by committing to a life on the island for a time, I was saying no to my parents' history. But I was also acting on what I had learned from them: gamble with life and sort it all out later. I trusted the improbable.

When Pays and I were married, in 1967, my favorite wedding present was a copy of a research paper about the Malaysian Senoi people, who were said to teach their children to retrieve knowledge from their dreams that would serve the cause of peace for the whole tribe. True or not, the metaphor that struck me most powerfully was an account of an admonition to a frightened child who had dreamed of falling: "Fall all the way to the bottom and bring something back." I remembered that wedding gift as I made my decisions about Maine.

Dreams and metaphors were kissing cousins to me; metaphors were the waking clues to answer my questions. This was also where I began to develop what I had learned from *Sunsets*, the rule of the paradox: *Despite urgency, there is time to change.* I recognized the urgent danger to the fishing industry but needed time to connect all the dots. I began with a lesson from one of my earliest performances: "stay wait look listen" until more is revealed.

When I said yes to buying the old sawmill in Maine, I knew that meant I was going to have to sell my home in California. Saying yes meant accepting loss as much as sewing myself a new white future from the loose ends of my past.

When the real estate agent and I returned to the site the next morning, the blue ocean sparkled in bright sunshine, confirming my heart's leap at saying yes. Looking south across the sea toward Matinicus Island, standing back from the water at the deepwater wharf, I imagined I could see forever, looking southwest beyond Matinicus to Spain and Portugal. My agent explained that the site was made land for schooners to deliver quarried granite to the East Coast in the nineteenth and early twentieth centuries. Vinalhaven granite built the New York Public Library and St. John's Cathedral there. At some point, the status of the quarrying site and its wharf declined. It became the town dump. I noted rusting refrigerators and old glass bottles in the barren earth at the shore. But I also saw how light bounced off patches of snow, and I was dazzled by the ice-bound bay before me.

We meticulously walked the property, heading north on the site to a secluded pool, called Oatmeal Quarry for the texture of the granite it had yielded a century ago. As I had as a child in Tarrytown, I noted the dips and heights in the land and the configurations of distant outer islands. I was formulating something about degraded former biological hot spots, places where all the habitat edges should welcome maximum biodiversity but where humans despoil that potential. As I gazed south that morning, inhaling the scents, half conscious, half saturated by the beauty of the light and color, the morning crept into dark spaces between the tree trunks in the stands of boreal forest on islands just east of where we stood. I was eye-drunk and knew I could work there and be visually inspired for the rest of my life.

I wasn't so besotted with beautiful potentials not to clearly see that restoring the site as an unraveling of a metaphorical drift net meant the hard and expensive work of laboriously mending broken bridges between ecotones and ecosystems. As far as I could tell, all those ecotone connections were gone.

Ghost Nets Site 1930. Photograph courtesy of the Vinalhaven Historical Society.

In 1990, the site was a moonscape. I wanted to see what the site would look like if I could "fix" it, manifest a resurrection of those microcosmic ecotone bridges and the macrocosmic bridge between the site and the relatively pristine land of a class A transatlantic migratory seabird fly zone that bounded it to the east and north.

I anticipated years of work to unravel the consequences of disrupted ecosystems and local implications of large landscape fragmentation. I hoped the tasks ahead would transform the ghost nets metaphor from an abstract symbol of death and despair to a model of hope. I thought that sounded like a lot of fun.

I decided to sell my California home. I thought I could buy and restore the former town dump on this remote island, where I hardly knew anyone. It seemed preposterous and yet intriguing and exciting. The relative impossibility of the challenge might crush me. All I had to start with was the metaphor, the site, and my own stolid but irrational belief in my own creative intuition.

The next problem was the purchase. My agent was correct: I couldn't afford it. Luckily, he knew a fisherman who wanted the deepwater wharf.

We struck a deal. The partnership with the fisherman allowed me to afford the purchase and gave him a private place to fish that had once been in his family. My new friendship also helped me begin to understand the life of the island. I had good timing to sell my house in California. My modest investment of $20,000 from my 1979 bank swing loan allowed me to sell high enough in 1990 to afford buying the *Ghost Nets* site in Maine. I bargained the price down from the seller and purchased the *Ghost Nets* site, which would become my primary home for the next twenty years. Soon, *Safety* was behind me. I was part owner of the former town dump on a remote island in the Gulf of Maine and well into *Ghost Nets*.

That summer, when I arrived in Santa Fe, I met Steve Robinson, whose book had inspired the design of my home in San Marcos. He was delighted to meet me, the only person he had met in person who had read and applied the ideas in his book. I was delighted when he agreed to design my house for the new site.

I was pleased with myself and began building. It would take a year and be a "tiny house," less than four hundred square feet, with a footprint of two hundred square feet. I calculated how much wood would be required to build the house and how many trees needed to be planted to replace that wood with a living miniforest of four hundred trees. Then I planted them all. No trees were cut down for the pad or the access. As I have watched the trees grow since then, I have continued to glean insights I could later apply to large landscape contiguity for projects elsewhere.

Before I formally launched my new project, I researched more about drift and ghost nets. Drift nets have a long history in the fishing industry but have only relatively recently been made of plastic. Until the 1950s, drift nets were made of biodegradable materials such as hemp. The mesh was large enough to allow small or younger fish to escape. That changed when net manufacturers created a smaller mesh with monofilament, some nets over fifty kilometers long. The nets are designed to suspend vertically in the water and drift with the tides. They are kept in suspension in the water column by floats and weights.

The nets generated enormous changes in the fisheries. Many more fish could be caught, but with so many noncommercial species and those fish too young or too small composing the bycatch, international fish

populations rapidly began to crash. The estimate in 1994 was that twenty-seven million tons of noncommercial fish were caught as bycatch. At just one location monitored, the nets killed thirty thousand seabirds annually.

The effect of drift nets became such a serious problem that international bans were instituted.

The United States had enacted the Driftnet Impact Monitoring, Assessment, and Control Act in 1987, limiting the length of nets used in U.S. waters to 1.5 nautical miles (1.7 miles, or 2.778 kilometers). The United Nations General Assembly placed a moratorium on the practice of driftnet fishing in 1989. In 1992, the United Nations banned the use of drift nets longer than 2.5 kilometers in international waters.

It was just as these regulations were being implemented that I had come to Vinalhaven, started collecting the discarded nets, and begun *Ghost Nets*.

Retrieving ghost nets from their deadly work has become an ongoing problem worldwide. Many people are familiar with the horrors of the Pacific garbage patch, where wadded-up nets, discarded plastic wrappers, and children's toys create macabre installations with the skeletons of all kinds of animals. The nets aren't the only death machines from the plastics industry; there are secondary killers, stepchildren from the petroleum industries that have caused climate change. Many people have seen images of the dead birds and whales with stomachs full of plastic debris they mistook for food before they died of starvation.

The devastating evidence of damage from the unchecked use of the nets led to a United Nations moratorium. In addition to the relative symbolism of the metaphor to my project *Safety*, the ubiquity of ghost nets seemed consistent with what I already knew about anthropocentric attitudes. Drift-net bycatch wasn't the only problem fish and other marine life were negotiating to survive. In 1995, Rockefeller University estimated that one-seventh of the world's fish consumption was supplied by aquaculture, a practice that harvests wild fish to feed to domesticated animals for human consumption while polluting the ocean with antibiotics and other chemical contaminants. Fish populations are threatened equally by aggressive and wasteful exploitation and by reckless habitat contam-

ination. This damage is just one manifestation of what has come to be known as an extractive, unsustainable economy, gobbling up our world.

Fish have fascinated me ever since because they are indicators of aquatic health. Although not all fisheries are equally responsible for marine environmental degradation, many countries or individual fishermen continue to use drift nets, determined to capture and profit from the last wild stocks, regardless of future costs. As I considered what I was learning, I thought how easily *Safety* had segued to ghost nets, unraveling the practical consequences of denial and indicating how critical regulatory behavior is in the fishing industry and more broadly to maintaining ecotone health.

Those who fish in the Gulf of Maine are known to have tried hard to maintain community self-regulation in order to coordinate their decisions for sustainable and responsible management. Their efforts to find a balance between productive consumption and preserving the resources to sustain that viable economy have had mixed results. This conservative approach to extractions is prevalent in small local communities that depend on what are routinely called ecosystem "services" or "resources." But as has already occurred elsewhere worldwide, even with that consciousness, it may have already been too late for finfish in the Gulf of Maine by the time I began *Ghost Nets*. The fishing industry in Maine had already fished down the food chain by the 1990s, from the immense cod and swordfish recalled in the memory of still-living fisherfolk to the lobsters that dominated the catch at the end of the last century and are now migrating north to escape warming waters.

The Vinalhaven Historical Society has photographs of ten-foot-long cod, suspended and drying in the sun, alongside selfies taken with the descendants of those who had caught such fish—these later-day relatives still fish but catch specimens that have genetically adapted to the predation by growing to only ten inches rather than ten feet. The isolation of the island made it a neat paradigm. It was the site of a rich fishing industry on the cusp of serious transitions and likely collapse.

The field of ecological restoration debates whether restoration is implicitly untenable. What is being restored? Why? To what historical niche?

When I began *Ghost Nets*, I didn't know anything about those debates. All I knew was that the location of the site was in the class A path of migratory seabirds, and coastal fragmentation had severely limited their access to food and rest. I also already knew the peril that the fishing industry faced and the role of wetlands in supporting marine life. The entire *Ghost Nets* project was predicated on the implications of restoring the relatively tiny wetlands systems I came to call "pocket marshes" on the site, which characterize the entire northern half of the coastal Gulf of Maine. This was my first serious and systematic experiment in the primary rule of trigger point theory, that there will always be a small point of intervention to affect healing in large degraded systems.

The Hebrew phrase *tikkun olam* expresses the Kabbalistic idea that our mandate on Earth is to repair what is broken. I thought of that as a housekeeping task. Theologians debate the biblical interpretation of the Hebrew word *radah,* which had been understood to mean "dominion," as in the subjugation of other species. Now, scholars are considering that the word had been used to refer to "caretaking," as of farm animals and crops. I seized on the idea that women were often the household caretakers, at least as much as the men tasked with husbandry.

I'm not sure where I first got the conviction that I could attempt ecological repair. It seemed like the logical extension of everything I had considered since I first watched my father's employees cut down cherished trees.

I had no idea where to start. How could I mend anything broken and get to hope? In 1990, I wasn't a complete neophyte about biological restoration or real estate transactions. I had experimented enough with habitat in San Marcos that I could envision how I might restore the site in Maine to fertile abundance. The risk wasn't in the tasks I foresaw but in whether I could frame the process as the artwork I envisioned and support myself in the process. The first was the really fun part. The second, not so much. That didn't stop me.

I calculated how long the project of restoration would take. Within weeks of making my decision to go forward, I had crafted and sent out a press release announcing that I was launching *Ghost Nets*, a housekeeping project in Maine that would take ten years. Soon, the *New York Post* ran

an article about the project, by Jerry Tallmer. More articles followed, in which I asserted my plan to unravel the implications of the ghost nets metaphor as I worked on restoring the site. I still thought I was somehow going to keep one foot in New York City, so I simultaneously worked out a partnership in Chelsea to share a rent-controlled studio there.

Today, most people know how deeply we have damaged marine ecosystems. In 1990, it was news.

From 1990 to 1994, I learned about commercial fishing from my land partner and, eventually, the friends he introduced me to, who also became friends. The fisherman worked from the deepwater southern toe of the property, using our shared parking area just east of the former sawmill that had become my studio to store his traps in the winter. On summer mornings, he launched his dinghy to row to his boat.

I had a routine. I worked on the land or in my studio. I was usually still painting when the fisherman came in from hauling lobster traps in the afternoon. We could visit and chat for a few minutes about our day. In the evenings, I sketched how I anticipated progress on my restoration plan.

What I learned from my land partner progressively disabused me of any remaining romantic notions I had about life on the sea. From my years with Pays, I already knew how schizophrenic our perceptions of the oceans were—for example, besides overfishing and contamination, phytoplankton, the microscopic organisms that whales feed on, were disappearing.

In time, I learned more harrowing details about the effects of overfishing, the devastating effects of dredging practices from foreign trawlers, and the detrimental effects that ubiquitous chemical contaminants had on marine life—particularly flame retardants from refuse, mercury (from carbon emissions), and eutrophication (nitrogen runoff from factory farms), all contributing to marine collapse and migrating up the food chain to humans, just as the agricultural overuse of freshwater has been a dire threat on land, particularly to the California land ecosystem. This was what my performance *Physical Education* had been about. As time went by, I learned even more about how biologists have found

residual heavy metals, wind-borne pollution from coal-fired plants and other industries in the Midwest, to be a significant problem in trying to reestablish eelgrass habitat.

A few years after purchasing the site and well embarked on *Ghost Nets,* I rendered my sketches in color of relationships between agents of degradation in the complex system of pollutants I knew about in the Gulf of Maine. My map included a lot more that was impacting the ocean besides ghost nets: the loss of phytoplankton and mercury poisoning from built infrastructure, aquaculture, runoff from timbering, and contamination from paper mills. My new knowledge was layered into visualizing how the deepwater Georges Bank area, east of Vinalhaven and considered the most fertile portion of the Gulf, might be accumulating the most intense heavy-metal impacts in the same place where wild swordfish, cod, salmon, and migratory seabirds were negotiating purchase for survival. These threats were also evident from studying GIS maps.

That was how I learned the power of the rule from trigger point theory that layering information will test perception. The obvious story of ecological disaster was appalling.

I didn't need to reference ecofeminist philosophy to recognize the real in the metaphorical implications of how we had turned the mighty womb of the ocean into the human toilet I had represented in *Physical Education.*

In *Ghost Nets,* I collaborated with my environment. I began my restoration work by hiring a backhoe and moving boulders. Over the next ten years, I created several sculptures made of these rocks to engineer solutions that would mitigate erosion in the riparian zone, create microcosms for wildlife, and be a wave-attenuation barrier in the estuary I would restore from the made land at the south end of the site.

I applied my earlier ideas about collaborative interactions in A.R.T. and with ecotones to consider how to proceed—when I planted in the lee of a rock, for example, I could watch seasonal and daily microhabitat change caused by migrating shade and determine growth patterns.

I became friends with a woman on the island who had studied Native American "sweet" medicine, the lore of women, and began weekly study sessions with her.

Bed of Nets, iron bed and drift nets, photograph by Aviva Rahmani, 1991.
Soon after, my new world collapsed.

In 1994, I made two more important friends. One was the bioengineer Wendi Goldsmith, whom I met at a conference and with whom I would complete the restoration of the pocket estuary in 1997. The other was Michele Dionne, who would eventually monitor the success of our restoration work in 2000, confirming our biological "success"—or at least as much success as any restoration can claim—and would donate her research data to me before her death. Each of these friendships taught me what I needed to know about the practical application of biological knowledge.

Ghost Nets had begun with a metaphor that I embodied as an idea model. I assembled some of the drift nets I'd collected on an iron bed in my studio to create *Bed of Nets.* The assemblage became an iconic reminder of all the ways we had gotten in bed with familiar but lethal bad habits. As I studied those entanglements, I thought I would eventually understand and unravel them.

A year after my decision to commit to *Ghost Nets,* I woke in my studio, where I had been living 24/7, holding a thirty-day vigil in preparation

for a traditional Native American Medicine Wheel. I was following the instructions of a Cherokee elder, Grandfather Thunder Cloud. He would arrive in August to launch the project with the wheel. In addition to the vigil, my task before he arrived was to gather twenty-eight round rocks from every part of the island for the ceremony.

I had planned a lot to do that day and was ready to bound from my bed into action. Bear's large black head was resting on my chest, his way of reminding me that it was time for me to get up. He needed to go out. The walls were still just one layer of spruce boards. The welcome fragrance of wood mixed pungently with the sea as I woke, reminding me that I would have to do a lot of repairs on this building if it wasn't going to fall down around my ears one day as I stood at my easel. Finally, I was fully awake and ready to get up to let Bear out.

Nothing happened.

The always reliable message I was sending from mind to limbs for an automatic response was disconnected. I tried several more times. After a great effort and too much time, I was able to roll my head to the right to look into Bear's eyes. The small muscles around his eyes looked worried, baffled, and tense with discomfort. I was worried and baffled, too.

My conscious message to my muscles, "Get up," was having no impact at all on my relationship to gravity or my own physiology.

My body ignored my mind. The willpower and intentionality I had taken for granted my entire life did not lift me from the bedding I had arranged on the floor, where I'd spent the night. They did not lift me one inch from the horizontal. This was worse than my time after my horse accident. No amount of willpower was having any effect on my body. I could not change reality. I could not move. This was a Boolean NOT.

I didn't give up. I tried again, and then again. I continued to try to move my body for two hours.

At first, my response was only puzzlement. As dawn began to pass into midmorning, I slid from confusion into unmitigated panic. Bear and I had a serious problem. My studio had no phone. I didn't expect visitors. I had to solve this problem myself.

What I learned later, after three separate doctors diagnosed my symptoms, was that I had a serious case of chronic fatigue syndrome (CFS). I

had heard of CFS. It would strike others. I felt sorry for them. It sounded terrible. Not me. But it *was* me that morning. That sunny morning was when my life changed forever as dramatically and irrevocably as it had on the day I fractured my skull.

CFS can strike quickly like that, without warning. As with any other aspect of nature, a previously imperceptible event can easily snowball and devastate an entire system before there is a chance to recognize, understand, or mitigate the damage.

No one yet knows what causes CFS, although researchers of the COVID-19 "long-haulers" have noticed similarities between the symptoms. Although the cause or identification of a precipitating event is still unverified, my systemic devastation was clear. CFS would eventually teach me that my own body might embody the same ideas about collapse into chaos and require rules for adaptation that I was analyzing in and applying to a larger world. I had suddenly become the embodiment of what I was researching.

In the early 1990s, CFS was disparaged as a "Yuppie disease," mostly afflicting ambitious women, a contemptuous caution to women to tamp down their dreams and stop imagining themselves flying to any sky. That encouraged ridicule for our "malingering." Odd, that paradox. Ambitious women were to be socially punished if they slacked off, and the same judges would determine that the collapse we experienced was feigned.

Now, of course, we know that people of all ages, races, classes, and genders can be afflicted with CFS. There is a track record of research and funding, albeit few answers. I hope that studying the long-haulers might change that.

Only two things helped me. One was IV gamma globulin infusions, a solution that ended when the United States embarked on perpetual wars (gamma globulin became a hoarded military staple for wounded soldiers). The second was acupuncture.

The latter got me thinking more carefully about the rule from trigger point theory: "There will be a small point of entry into a chaotic system." The philosophy behind acupuncture is that each trigger point connects along meridians to many other systemic points on the body and to elements in nature.

Acupuncture became my most important idea model. I saw parallels between how acupuncture was healing me from CFS and how similar principles could be applied to ecological restoration.

Acupuncture is a system backed by a complex and ancient philosophy, suggesting how to effect serious change from minimal intervention: that judicious attention to a very small point in a very large and degraded system could effect systemic transformation and the balance of forces.

That was later, years away from the morning I accepted that at any moment my body might fail me again, that predictable communications between my brain and the rest of my body might vanish like smoke without warning, even in a crisis, whether or not I was prepared, alone or in the company of others. That realization inspired a great deal more humility, compassion, and patience than I could ever have previously imagined or desired.

After I was diagnosed, one doctor said, "The good news is you won't die. The bad news is there's no cure."

That first sunny morning of the rest of my life, all I knew was that I was having a terrifying experience of helplessness. This wasn't an exciting adventure. It was a chaotic nightmare that no amount of lucid dreaming was going to dispel.

Bear never made a sound as the morning sun slowly moved the shadows of the window sashes across the floor. Bear never left me. He never moved while I couldn't move. I eventually made my body move from prone to upright. I'm not sure how I finally accomplished that. I glanced over my right shoulder, looking out the window at the nearest island to my south, and thought of all my plans for the day. Then I managed to walk down the stairs I had recently built to the front door of my studio and let Bear out.

The month passed until Grandfather Thunder Cloud arrived from New Jersey with his wife and a mutual friend, Paul McMahon, his fire keeper. It was an exceptionally dry summer. Months earlier, Grandfather had predicted healing rain. As they boarded the ferry, the downpour began.

The next several years were problematic. My purchase partnership collapsed. I briefly tried to return to my sixth-floor loft in New York City,

but simple tasks were too physically demanding. Carrying groceries home left me devastated for the rest of the day. Walking Bear was an ordeal, herculean to attempt. The building had an elevator, but it was often unavailable. I returned to Maine and rented my loft. Time passed, but I didn't recover. My New York tenants claimed ownership under a law that said that after three years, they in effect had squatters' rights. I lost the $50,000 of key money I had paid for the lease. I felt far more demoralized and stunned by this failure than I had on the banks of Lake Geneva in 1962.

Back in Maine for the winter, it was torture to try to complete large paintings in small increments of attention. My productivity became glacial. Years passed. Still, a body of work emerged. Each day I learned to celebrate and integrate modest accomplishments—not a forty-eight-inch-by-forty-eight-inch painting but a four-inch-by-four-inch drawing and one walk in the paths I was creating on the site. Sometimes I could do only one or the other, sometimes neither.

Very slowly, I learned to focus my limited energy and personal resources and make myself a trigger point. I looked for tiny changes in my circumstances and began to see them as a CAS.

Meanwhile, there were delights. I studied Chinese ideas about rocks, applied Japanese ideas about stroll paths and views, and applied permaculture ideas about communities. I planted a cover for a hillside of brilliant native blue star flowers, *Amsonia,* a genus of the dogbane family, Apocynaceae. I drank in the stars at night and learned to read the fragrances of changing seasons and weather.

Time became a sonata, as in *Stay Wait Look Listen, My Symphony,* unspooling over long stretches defined by tempos of change and giving me another strategy to regard the data I was studying. The ten years of work were divided into roughly three years each, with musical allusions, each with its own title. Each quadrant of the site was divided into elaborate planting patterns determined by color and permaculture function. I kept four notebooks, each four inches thick, meticulous journals with one page for every plant I tried to grow in the garden. Western ideas about the "bones" of the garden—the paths, trees, rocks, and views—and what I was learning from my Native American teachers about the symbolism of the four winds of change determined how I sculpted the space. Thinking

of this work through the lens of a musical metaphor was conceptual architecture, allowing me to pace myself to the conclusion.

I hoarded stamina for conferences, where I met Native basket weavers. They taught me more about how Indigenous knowledge merged culture and environmental knowledge in relationships between harvesting grasses and wise habitat managing.

As I was learning more about Indigenous culture, I was also reading and hearing their heartbreaking stories of persecution, gruesome atrocities, and disenfranchisement, but I also envied them their millennia-old connections to place. The extent to which their people had protected what they could of their culture and their values, despite the shameful behavior of Anglo-Americans, still awes me.

The first three years created the *Trigger Point Garden,* inspired by what I understood of the Native American Medicine Wheel. That work restored the uplands riparian zone and let me consider how knitting together all the microhabitats and ecotones of the site would contribute to wider resilience. My single most important action during that period was the planting of the four hundred tree saplings in a distinct pattern across the site to replace the wood used in my home. During those years, I meditated on illumination and the color yellow. I simultaneously began restoring the western quadrant, where I meditated on introspection and the color red.

In "before" details documenting the western quadrant of the *Ghost Nets* site in 1990, prior to beginning more systematic restoration work, the absence of resources or shelter for either migrating or local birds was obvious. Neighboring homes to my west and east, with their homogenized expanses of lawn, also told me that creating forage should be my priority—planting or conserving vegetation that could feed them, such as sumac.

On days when my spirits and stamina were higher than usual, I threw caution to the winds and tirelessly gardened, painted in my studio, and photographed everything. I usually paid dearly for those bursts of joy and freedom, with bleak days in bed.

The second phase was *Kind Wind,* which focused on the northern section of the site and watershed restoration. Inspired by Native ideas

about the north winds, this was a time to meditate on justice and the symbolism of whiteness.

The product of the final three years was named *Traffic Dance,* as the restoration of the southern end of the site would finally allow the various habitats to culminate in full correspondence between fresh- and saltwater, the ultimate global edge. During those years, I meditated on innocence. *Traffic Dance* encompassed and culminated in the dramatic bioengineering managed by Wendi, completed in just a few days. Under her supervision, in 1997, we excavated sixteen truckloads of riprap for the estuary. We inserted grasses, mostly spartina, into the daylighted soil. We left a vertical line of demarcation on the slope above the water to observe the distinction between unhindered ecosystem reparation and the work of bioengineering restoration over time.

As we excavated that day, I made a stone line in the newly daylighted soil to indicate the highest storm-surge line I had seen in 1994, which could be compared over time to track sea-level rise. The line also documented where freshwater mixed with seawater for the first time in one hundred years.

As I studied island biogeography, I began to understand more pieces of the trigger point puzzle taking form in my mind. I began to think about how what some restorationists call "nucleation"—creating small sites to lure birds and other small animals to feed, who then disperse seeds—might confirm my thinking about small points of intervention.

The summer of 1991, just before I became sick with CFS, I had fortuitously come into a very modest but timely inheritance from my father. I was land-rich albeit genteel poor. As I found my bearings in my new life, the inheritance saved me from absolute penury or abandoning *Ghost Nets.*

I still felt adrift and often isolated in a community of mostly hardy fisherfolk, with their own social protocols. I was a single woman artist from New York City who spent a lot of time in bed and declined most social invitations. It was even less socially useful that Bear was a large dog who had become fiercely protective of me and our home. Twice, to my horror, he attacked and hurt other dogs before I could control him.

The local grocery store defeated my macrobiotic food plan. The first year, I gained seventy stubborn pounds.

It took me a long time to learn the island community's sometimes harsh lessons, but I did learn. Those lessons boiled down to "Don't rock this boat if you want to be part of this world. You aren't in New York City, and this isn't any old small town. We're fifteen miles out to sea in the North Atlantic."

Off-island friends who knew I was having a hard time suggested that I give up the project and return to New York as I'd originally planned. Instead, I decided to stay and see things through the ten years I had said my project would take.

I had landed in this world as a stranger in a strange land, but I wanted to stay.

I gradually found a wider circle of friends on the island. New routines took hold over time. A desperate will to survive kept me going. Meticulous journaling became routine. The journals were an essential tool to backtrack and find patterns in the days when my energy was at its lowest or those days when my stamina was high. I began to see how drivers in my life, like the beauty of the island and my commitment to the project, were agents in the complex adaptive system I was living in. I had first begun using the journals to care for myself after my horse accident. Now those same systems of careful record keeping taught me what to guard against to avoid collapse. I often failed anyway, but the journals also allowed me to consider reorganizing what I knew.

Eventually, even on the days when my stamina was at its lowest, I was able to marshal the energy to rise from bed and ritually walk the entire stony site along paths that were emerging at the four quadrants of the property—east, south, west, north—while listening intently for the sounds of small animals, to wind and waves as I passed through the topographic dimensions, downhill, uphill, and downhill again as the light shifted. Each traverse of the land took an hour. It was my homage to the bruised land.

Along the way, I moved medium-size rocks to join the large boulders that had been placed by a backhoe to slow down spring streams as

Ghost Nets excavation work, photograph by Ben Magro, 1997.

they rushed to the shore. I planned where more saplings might create more diverse windbreaks and defend more clearly defined microhabitats. Sometimes I painted the boulders that defined the site with silver or blue paint and observed how many years it took for the color to fade.

Starting with my CFS diagnosis, as I came to terms with my new reality, I began wrestling hope from limitation. I was assembling ideas about how to identify a landscape trigger point, but most of my attention was going to basic survival. I was identifying with and feeling empathy for the pioneer plant species I watched on my site, so determined to establish purchase in rock. Most Western science discourages anthropomorphism, but Indigenous peoples and I have found it very useful.

On days when I was bedridden, my sketchy drawings helped me visualize relationships between color, texture, form, and shape for the gardens to paint a living meditative space. I imagined the plant community maturing decades into the future. I drew small schematics of the large landscape outcomes if *Ghost Nets* were to trigger restoration work at a greater scale. How might that work, and why? With a little stamina and determination to concentrate, I inhaled the large environmental science

Restored uplands riparian zone, detail of *Ghost Nets,* Aviva Rahmani, 2021.

tomes on ecological dynamics that I checked out of the local library, the better to understand the processes I was engaging. At mainland conferences, I learned from others and presented my own observations.

At the turn of the century, the soil at *Ghost Nets* was rich and friable. There were other things I cared about.

Bear became old. One winter day, I found him lying in icy water to cool himself. The boyfriend I was living with then carried him tenderly back to the house. The next day, I took Bear to a vet on the mainland. The vet insisted I leave the room to let him administer a sedative. As I backed away, Bear's eyes looked panicky. On the surgery table, we found a large tumor on his liver when he was cut open. It was clear that he could not recover and had to be in considerable pain. We put him down while he was still on the table.

"Some dogs are just special," the vet said.

He was.

When I told my mother he'd died, she said, "He was a good man," and then stopped, laughed, and corrected herself: "dog."

I brought Bear's body home, and my boyfriend and I buried him with some favorite bedding and toys by a large boulder in the west quadrant of my garden, by what I called a "Grandfather Rock." The next day, his neighbor friend, a yellow Lab named Molly, who was also getting on, walked up the hill to visit his grave. We all mourned Bear.

As I wound down *Ghost Nets,* I began to systematically apply what I had learned to other locations. I began *Cities and Oceans of If* (2000–2010), studying one international site after another to discover small trigger points to effect large landscape changes.

Each location I studied had been degraded by human exploitation and extraction, as the *Ghost Nets* site had been. Each allowed me to consider how geological elements might contribute rich edges for hot spots.

At Bergen Belsen, Germany, I teamed with my cousin Arik Ginzburg, an architect, to design a public artwork commemorating the victims there. We couldn't agree on a collaborative approach, so the work was never submitted. But I completed the work, *The Song of the Bones,* transforming the landscape into an aerial image of a bird with a broken neck. The beak pointed to the River Miesse, steps from the camps, whose waters the prisoners were denied, making it a trigger point.

These experiments allowed me to speculate further about the technique of nuclear restoration. As part of a residency at the University of Southern Maine (USM) in 2000, I tracked all the points of connection between buried streams that might be daylighted. In a series of panels

mounted in the City Planning Department, I illustrated where the streams might live again, proposed that humans be the ones contained, and designated corridors as wild areas for large mammals.

The USM residency was one of my first opportunities to drill down into my own methodology. I pored over settlers' diaries at the Portland Historical Society. By comparing maps from different periods, I could locate the buried streams, surmise connections, and determine how they might be daylighted and reconnected. In addition to connecting the vascular system of waterways, I indicated where corridors for wild animals might be established. The design corralled humans in tight cluster communities.

My thinking about regional contiguities at USM culminated in GIS mapping with Irwin Novak, a professor of geology at USM. We found specific vacant lots that could become habitat linkages surrounding Portland's Back Cove Park. I included our work in a one-person show, *If*, at the Center for Maine Contemporary Art, then in Rockport, which extrapolated how restoring contiguity from water systems surrounding the small area around Back Cove could be expanded to provide contiguity all the way to the Mississippi River Basin and beyond.

If was installed close in time to 9/11. 9/11 struck me as a chillingly perfect paradigm for how a strategically identified trigger point could effect global military success.

If was the first of several venues where I created meticulous murals, knowing they would be erased when each show was over. The anticipation of erasure was in itself a performative statement about how casually we destroy habitat, just as water had eventually been flushed down a toilet at the end of *Physical Education* in 1972.

Increasingly, GIS mapping and satellite imagery were reinforcing my intuitions. I traced GIS maps to do a site analysis for *Blue Rocks* at Pleasant River, another site on Vinalhaven, where the U.S. Army Corps of Engineers had long ago installed a narrowed causeway that eliminated tidal flushing. The sketch of the biogeographic layers allowed me to consider ecotones, edges, and interactions for thirty-six acres of degraded wetlands. The causeway was a small point whose restoration might have

a significant impact. I thought I could make the site a perfect test for a regional trigger point.

I painted the boulders around the obstructed causeway with a slurry of mosses, nontoxic ultramarine blue, and buttermilk to draw attention to the location.

This was a far more sophisticated process of investigation than I'd applied to the Southern California Bight. In drawing the Bight, all I did was extrapolate the contours to what I knew about habitat functions. In *Blue Rocks*, I had reality checks from GIS algorithms. This was also a more ambitious version of what I had mapped at USM to extrapolate the consequences of restoring habitat contiguity from Back Cove Park to the Gulf of Mexico.

In both *Ghost Nets* and *Blue Rocks*, I applied my understanding of island biogeographic principles with attention to edge effects to explore the function of ecotones. Studying the topography, it seemed clear that the small site was a crucial connection between edges through the

Blue Rocks After, photograph by Aviva Rahmani, 2004.

center of the island, like arteries connecting two chambers of the island's heart. In addition to GIS, satellite imagery clearly showed that the contours of the land above and below the water surface and between salt- and brackish water provided a wealth of additional habitat edges for biological diversity.

After my launch of *Blue Rocks,* I stepped back to watch the effects of my intervention. Not all the attention was benign. In a short time, however, with work from the Vinalhaven Land Trust, the *Blue Rocks* project helped attract enough attention from the U.S. Department of Agriculture, which invested over $500,000 in expanding the causeway. It became a showcase for fecundity, serving wildlife for the greater region, encouraging my hopes that my theory could work elsewhere.

Early in *Cities and Oceans of If,* I became frustrated with my professional isolation. I still had the tendency to imagine that my life would unspool in my own time and on my own terms, but I started to do things differently.

In 1999, I cofounded the Ecoart Network, a Listserv that began with a seminal panel at the College Art Association in 1999, "Off the Mainstream, Into the Mainstream." One of the themes of the panel was that conventional definitions of environmental art were inadequate to the actual work being done, notably by women who identified as feminists and subscribed to ideas that might be defined as ecofeminist. The Listserv was then, and has remained, invitational.

From the beginning, I argued that one of our tasks was to distinguish between ecoart, land art, and environmental art. I foresaw that as we defined ourselves as a separate genre, we could advance unique arguments for how art could intervene in environmental degradation. Land art had routinely used land sculpturally, at the expense of habitat. Environmental art was about nature but did not embrace agency or interdisciplinary discourse. The genre of art that I was determined to advance proactively engaged with and sought solutions to anthropogenic ecological degradation.

I regarded the Listserv as another way to speculate on trigger point theory in human relationships. I was mindful of Margaret Mead's famous statement that one should never underestimate the power of a small group. The Listserv now numbers over two hundred invited members interna-

tionally who have remained in continuous discourse, giving me the intellectual community I craved and expanding a wide discourse. In 2022, we would produce an anthology of writings on ecoart pedagogy, *Ecoart in Action,* to reach an even broader audience.

In my own work, I was becoming more comfortable with reading the land. By the time I began my dissertation, in the midst of my frustration over governmental inaction about global environmental problems, I was feeling optimistic about the future. My health, or at least my ability to cope, was improving. The obvious goal was to exercise common sense about common good.

I saw how *Ghost Nets* and *Blue Rocks* might provide models to effect change. I thought that everything environmentally salutary could be accomplished. I was confident that with a little more work, a growing collective "we" of wise people would forestall the disaster I'd envisioned beyond a blizzard in 1989.

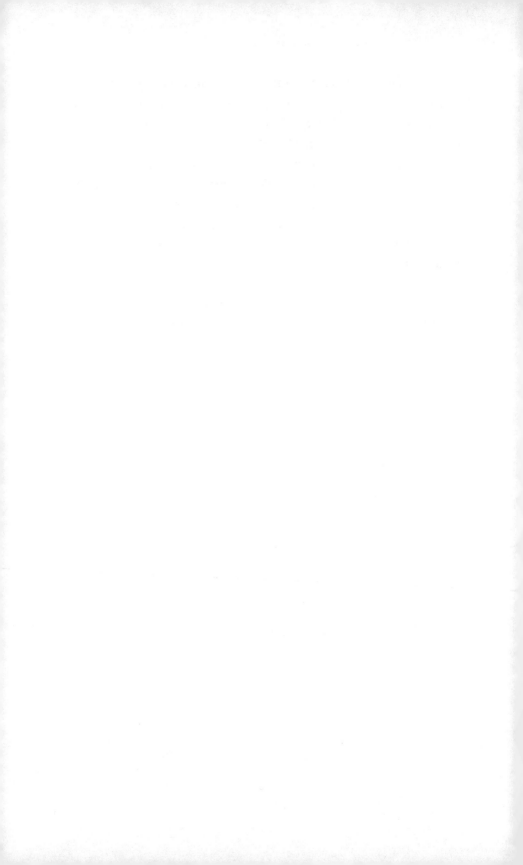

9

Katrina in Zaragoza

My life on the island was changing. At an opening at the Vinal haven Historical Society one winter evening in 1999, I wandered over to the little upright piano where Lucille Roberts, the local church organist, was playing old hymns from an ancient songbook. Like my grandmother Hannah, I've always loved religious music.

I started singing along, reading from the scores. When we finished, she invited me to attend the choir rehearsal that night. I declined.

"I'm Jewish."

"So was Jesus," she said.

I laughed, but I showed up and discovered a whole new island community. When I mentioned to a couple of island friends my discomfort with all the references to Jesus, they laughed merrily.

"Whenever you hear the name Jesus, just substitute the word *love*."

That worked.

Very soon, I realized I couldn't control my voice; it came out as either a bellow or like a squeaking mouse. I had to solve that. Shortly after joining the choir, I finally started the singing lessons I had turned down as a teenager. Soon, I began serious bel canto studies to do my new friends credit. Those studies would later inform my ideas and the score for *The Blued Trees Symphony*.

In the same church, in a reading group organized by the then-minister, Michelle Wiley, I first encountered debates around the words "dominion" and "care" in the Bible. I was impressed by the writings of the Episcopalian theologian Bishop John Shelby Spong. Spong's exegesis of how the translation of biblical terms for care became dominion, further clarified what I already knew about the devastating connection to manifest destiny in the United States, the idea that God entitled (white, Christian) Man to sovereignty over the Earth and other races. In the discussions, I learned that idea hinged on the bias of the monarchist translators of the times for the King James Bible. The Aramaic original of the word "care" referred to husbandry of other life. In effect, the noble priesthood substituted a mandate to serve common good, including other beings with obligation to the monarchy, enshrined in the legal system and exported to other countries. The implication to me was that a single word could be so powerful that it would legitimate destroying countless lives. As with my contemplation of 9/11, that new information brought home to me how small a point of inflection could turn a whole world.

Cities and Oceans of If and the ecoart Listserv were connecting me to a wider international collegial community. Despite the nagging exhaustion I'd come to accept just after watching the disaster of Hurricane Katrina hit Louisiana and drown New Orleans, I headed to Zaragoza, Spain. I was presenting my work with a small group from the ecoart Listserv community for a gathering of scientists, ethicists, engineers, and artists at the 2005 Society for Ecological Restoration (SER) World Conference.

The last time I had been in Spain, it had been Francoist, and I was an innocent. As a teenager in Madrid then, I had thought I would marry a religious count with family estates in northern Spain. When I returned, both my parents had passed away, as well as any mystic glamour that might have lingered for me around Catholicism. Patriarchal family systems, monarchies, tolerance for dictators, bullfighting, and conventional housekeeping for anyone but myself and the planet were no longer part of my life, and there wasn't anyone to answer to for my decisions.

In 2005, Spain had a very liberal government. My taxi driver happily told me Spain had just legalized same-sex marriage.

Memories and conflicts were evoked as I flew into Madrid, the capital of Spain. The drive from Madrid to Zaragoza takes about three hours. Driving through the landscape from the airport and later strolling in Zaragoza, I thought I recognized a rosy golden quality similar to the light that I remembered from my time with Fernando. My distant personal history, so far from my present, was merging with the long and complex history of the region as I brooded on the coastal disaster unfolding back in the United States.

Zaragoza is the capital of Aragon. It is on the Ebro River, a picturesque ancient inland city, close to the rich wetlands of Gallocanta Lake, but it couldn't hold a candle to the architectural beauty of Madrid. I was staying in a small but elegant and comfortable hotel down a cobblestone side street, a short walking distance from the convention center.

In Zaragoza I found many of the Moorish architectural touches, the Mudéjar style, that had enchanted me as I simmered in romance in Madrid so long ago. The Mudéjar style is unique to Spain; it reflects a place that was a cultural hot spot for centuries, a period when Christians, Jews, and Muslims coexisted peacefully, from approximately the twelfth century to the early seventeenth.

My first response to Katrina had been to start speculating about where the trigger point for regional healing might be. New Orleans, unlike Madrid and Zaragoza, was a geomorphic hot spot because of the wetlands systems that surround it. But all three had long been cultural melting pots. At SER, I thought I would be in a professional gathering that was a microcosm of those paradigms of complexity and promise from which a coherent response to Katrina might emerge.

My digression into traditional and politically conservative fairy tales in Spain as a teenager and comparing those memories to the Spain I encountered while I was still absorbing Katrina demonstrated how quickly attitudes about land can dramatically change. Fascism versus restoration. An appropriate response to Katrina was about making choices with major consequences for millions of people.

I came to SER knowing a lot about the causes and the implications of the inundation in New Orleans. I had been attending and presenting

in the SER conferences annually for six years. On this occasion, I was eager to engage with the world-class thinkers attending and draw attention to the insights I thought artmaking could contribute.

Richard Forman was a pioneering landscape ecologist attending SER that year. He had devoted his life to understanding the structural elements of what makes up a landscape. His approach broke up the component elements of the land into a series of patches in functional mosaics. As with most landscape ecologists, his thinking about land was aerially organized. Although he presented his ideas as an on-the-ground engineer would, he segmented landscape into what appeared to be fragments he designated as mosaics. His terminology seemed telling, because a mosaic is made of assembled independent pieces instead of being synchronous with the fluid ecotones that knit habitats.

This conference was going to be special because the Indigenous activist Dennis Martinez had organized a large and diverse contingent of Traditional Ecological Knowledge (TEK) leaders from around the world to present their culturally grounded techniques to preserve and restore ecosystems. A particularly striking presentation from Dennis was on the effectiveness of Indigenous fire-management techniques being adapted by some people in the Southwest's forest service.

When my time came to speak, I presented *Ghost Nets* (1990–2000) and some of the work from *The Cities and Oceans of If.*

The conventional strategies I was hearing and reading about from my SER colleagues who were immersed in academic science often diverged from the views of the Indigenous people who were presenting with Dennis or my own practice. I felt far closer to the Indigenous philosophies and methods I was following. The differences were most evident in the practice of mitigation, promoted by corporations that were despoiling wetlands and the barrier islands that protected them.

Too often, developers in the Gulf of Mexico and elsewhere had been granted permission to build on a wetlands they had destroyed because they promised to create a wetlands facsimile elsewhere. Too often, such wetland mitigations are failures. It is expensive and difficult to replicate the conditions that create an original habitat. Developers want to cut their costs, and regulatory oversight is rarely adequate. Knowing how much

mitigation had taken place in the Gulf of Mexico, I understood how much more fragile the barrier-island systems were now than they might have been before oil production had begun.

The TEK sessions were crammed with hopeful information and new ideas. In other conversations, I learned about subsidence, how oil extractions had lowered the level of land around New Orleans, a process making the coast more vulnerable to inundation in the face of rising sea levels caused by global warming. I understood very well the implications of how the toxins released from the storm assault would interact in the Gulf waters with fertilizers precipitating from and causing eutrophication from uplands factory farms. The fertilizers cause algal blooms resulting in hypoxia, the loss of oxygen. I needed to better understand the lethal loop between fossil fuel extractions in the Gulf and habitat destruction all the way up the Mississippi River and into the Mississippi Watershed.

I recognized Katrina as an environmental catastrophe that required preemptive planning for future storms. It also wasn't only a catastrophe for the Gulf of Mexico; I believed the hurricane was a harbinger of the global destruction caused by anthropogenic activities. My mood went from relaxed to warp speed over the complacency I witnessed over Katrina from some attendees. My adrenaline surged, calling me to act.

I wanted to organize the SER conference officials to make a formal statement to the U.S. government and to alert the media to the scale of, implications of, and solutions to this disaster that ecological restorationists could address. The formidable collective expertise of the attendees could prevent future storm damage if we clearly articulated the causes, our experience, and the solutions. I presumed we could design an adequate containment plan to protect the coastline in the future and plan for the inevitable oil spills that storms such as Katrina released. In the sociopolitical dramas of immediate human impact surrounding Katrina, the consequent spill got less attention. It was a parallel disaster that the wetlands were inundated with eight million gallons of oil, even as the sea drowned the city.

At the conference, I aspired to create a task force to plan for the impacts of continued climate change and future storms in the Gulf of Mexico. I was about to suggest offering the collective expertise of the assembly,

their bread and butter, for charity. That presumption revealed me as naïve as I had ever been as a teenager in Madrid or when I fought my father to save trees. It became apparent that many of the academic, established engineers were already assembling themselves to be well paid to oversee any future strategic planning. I would have no place at that table.

Five years later, there was an even greater insult to the Gulf from the British Petroleum oil spill. The scale of the injury to the Gulf became clear even more quickly than the effects of Katrina. Through negligence and attempts to hide critical data, British Petroleum was responsible for ecocide.

As events unfolded in those five years between Katrina and the BP spill, I went from horror and disbelief to anger and feelings of helplessness, without the slightest clue how to intercede in any decisions that might affect what troubled me or offer a glimmer of realism.

I came to think of New Orleans as a classic example of how ecocide had married white supremacy to corporate fascism in North America. Neglect of the predominantly Black Third Ward after Katrina and the mismanagement of rescue efforts disproportionately affecting Black people trapped in disaster shocked me. The BP spill was the first time I saw the well-lit path between ecocide and genocide that had been previously established in world courts over Agent Orange. It had been common knowledge that the First World had long visited economic colonialism on the Third World, but this neglect was in the U.S. backyard and seemed to recapitulate the casually criminal persistence of nineteenth-century racism. The consequences of patterns of exploiting other nations, including Indigenous peoples, had washed up on the doorstep of the United States and was in our faces. In 2005, the wave came so far inland that even well-to-do white people suffered and had to take notice. In 2010, the horror was all about the animals grotesquely trapped in routine disaster.

What I did not anticipate at SER and profoundly disappointed me was how shallow the dent of awareness would be in business as usual. Somehow, after Katrina, the powers that be managed to ignore the future that was in our collective face, abandoning the citizens of New Orleans and the region.

In New Orleans before Katrina, the islands between land and sea were the same kinds of small outer-island systems I had studied full-time

in all seasons from the *Ghost Nets* site for fifteen years by then. It was obvious how barrier wetlands should have slowed down the storm waves before they reached the coast. It was equally obvious that fragmentation caused by fossil fuel extractions had devastated that protective system.

If Katrina had not been so fierce and the barrier islands had still been intact instead of being diminished by oil extractions, the inhabited mainland might have seen far less devastation. The extractive behaviors of the oil industry had long since infiltrated fragile natural seawalls, dragging the waving sea grasses that had held soil together down to watery graves. The land had long since bowed to the sea. If impoverished humans hadn't been so densely clustered in the path of the storm, the sea might have harmlessly swept in and out, creating new barrier islands, sculpting new edges to the coastline with refreshed wetlands. Instead, almost two thousand people lost their lives, with an estimated $16 billion in damage.

My own history with danger, catastrophe, and drama amplified the already substantial outrage I felt in Zaragoza. I took both disasters, Katrina and the BP spill, personally even though I was personally untouched by the events on the ground. Within minutes of hearing of Katrina, I had reviewed what I knew and identified the most useful experts who would attend our convocation. I imagined that my family history had made me competent in the ways one takes charge in a crisis: the lists of tasks and contacts I had watched my parents assemble; setting aside emotions, particularly any grief over loss or fear for the future. Where I grew up, impossible circumstances were normal, even, at times, a joke, as when my father told the story of the time he had been shot as a boy trying to cross the border to escape the Russian Revolution. The lesson I'd learned from that story was that any crisis should be regarded as an adventure.

Besides negotiating worlds of extremes, my early life with my parents had taught me boldness. Between them, starting in their teen years, my parents had weathered seven wars, including several after I was born.

I had always thought the two greatest tools of change were transparency and community. I had no problem leveraging outrage when either was ignored. All three qualities—transparency, community, and outrage—are resources for activism. I was ready to gather my resources and

passionately fling myself at a solution. I imagined that would be crowd-sourced.

By 2005, I already had a long, checkered history of confronting catastrophe with defiance. My family had taught me to survive catastrophe on the wings of anger. My parents had harnessed their hearts to survive their own histories. I understood that resilience to disaster was about more than endurance. Survival requires proactively identifying danger signals. I had learned how anger can direct logic. I understood that resilience meant making smart decisions, as early as possible, to escape death, like my teenaged mother boarding a train alone but ahead of the Nazis, who'd murdered most of her family. Those skills are logistical.

The danger was apparent for anyone with half a brain. The death threat that Katrina represented was for all the unprotected coastal cities of the Earth, places like New York City, which had been my home for most of my life and which would also be inundated in seven more years by Hurricane Sandy. The BP spill would be a slightly different lesson, but both were about the consequences of fossil fuel use.

I settled on a simple plan at SER. I suggested that we all deliver a formal letter to the government and the media. I hoped the symbolic train I was ready to board in Zaragoza might deliver that letter to someone in power who could save New Orleans.

I knew only a few ways to yell "Fire!" in a theater. In natural ecosystems, however, life has all sorts of ways to announce threat. Biologists have documented trees screaming danger at one another when loggers come through. Some amphibians simply sacrifice a limb to escape a predator.

Those strategies aren't always adequate.

The formal conference reception was scheduled for the evening. We had time to go back to the hotel, have dinner, and change before the reception. In the convention center after the presentations, I had singled out Dennis to help me flesh out what might go into a letter stating how Indigenous knowledge could contribute strategies to help New Orleans. I had been deeply engaged in conversation with the environmental ethicist Holmes Ralston about our moral responsibilities. At dinner alone before the reception, I considered what I had learned, gathered my thoughts,

and decided whom to speak with next. I drafted a letter based on my conversations and made some copies. Then I sketched out aerial views of how conserved and restored barrier islands might slow down future coastal storm surges in the Gulf of Mexico.

After dinner, I walked back to the conference center in the warm evening air. My goal was to explore how we might take this opportunity while we were all together and could effectively respond to the crisis as a community of experts. I thought I could contribute not only my own environmental knowledge but also what my entire career had taught me, what I knew of SER, and the personal skills my family had taught me to convince my colleagues to send that letter.

That evening, I again engaged in urgent conversations with the other participants about subsidence. I made the rounds of the brilliant and powerful scientists attending from all over the world, showing them the draft proposal. The letter was a formal, public statement from SER that would have described how restoring wetlands in the Gulf might protect the coastline and that offered our expertise to accomplish that vision.

Instead of enthusiasm for the initiative, I was dismayed to meet a board of directors demurring over the politics of releasing a formal statement.

Flying home, I felt so frustrated, disappointed, and confused that I left my camera on the plane and never even inquired about it.

Back on the island, over the next month, I watched aerial pictures from the Gulf of Mexico on CNN with increasing alarm. Day by day, inky black oil spread across the Gulf's blue waters. I saw pictures of floating dead people and animals, witnessed the predominantly Black folk who huddled under miserable conditions in a stadium, and heard the excuses and denials of government officials. Their demurrals seemed to echo what I had heard at the SER reception. That was when I understood the visceral implications of being in an arduous race with mortal stakes and inadequate resources. I also understood why the courage I had flung at the powerful men in Zaragoza was ineffectual. I needed something more. Whatever that might be, I was sure that I would discover it and exercise influence.

What I watched over and over on CNN after I returned home to Maine reinforced the fact that climate change had made the storm bigger and the land more vulnerable. As I watched the terrible consequences of an inadequate government response, I thought the first task would be to reduce the impacts of my own behavior. The least I might do was to reduce my own flying to decrease my carbon footprint, a small thing in a larger picture. The big race was between fossil fuel corporations and the rest of the Earth. Reaching the finish line ahead of corporate interests meant breaking free of the strangling noose of fossil fuels, climate crises, shortsighted ecocidal policies, and denial. I felt a personal stake in winning that race and thought that trigger point theory could be our advantage.

I first met Jim White two years after my experience in Zaragoza. Jim was then a professor in the Department of Geological Sciences and the director of the Institute of Arctic and Alpine Research (INSTAAR) at the University of Colorado at Boulder (UCB). He is now the dean of Arts and Sciences at UCB. The curator and writer Lucy Lippard, whom I'd known since CalArts and who had already included me in several shows and books, was living in Galisteo, New Mexico. Lucy contacted me to be part of *Weather Report: Art and Climate Change,* a groundbreaking show on climate change.

Marda Kirn, founding director of EcoArts Connections (EAC) and now, as I am, an affiliate at INSTAAR, initiated *Weather Report* and invited Lucy to curate it for the Boulder Museum of Contemporary Art (BMoCA) and at locations throughout Boulder.

Marda had long known Lucy and Jim. In the fall of 2006, Lucy invited me, and Marda invited Jim, to be one of several collaborating teams inventing projects about climate change for the show. That initiated two working friendships that continue into the present. The work that Jim and I produced, *Trigger Points / Tipping Points,* became an animated film and a series of still prints that premiered at the 2007 Venice Biennale. Our work was also shown in museums and galleries in Cyprus; Ekaterinburg, Russia; Maine; New York City; and Boulder, Colorado, as part of *Weather Report* at BMoCA.

Each still from our work was sourced from Google Earth satellite mapping and manipulated in sharing software with Photoshop as we

spoke and then animated. I went for Technicolor and sardonic texts such as, "Coming attractions: localized regional resource wars," superimposed over an image of Egypt.

I had come a long way since the youthful chagrin of my disappointing experiences trying to work with men from E.A.T. Most of the men I have encountered since have also come a long way.

We were all thrilled when Claire Dederer interviewed Jim and me for a major article in the Sunday Arts & Leisure section of the *New York Times* in the lead-up to the show. In the article, we affirmed our observation that we are "raping the Earth" and said that agreement on this perception had cemented our first commitment to working together.

The film we produced for the BMoCA show, *Trigger Points / Tipping Points,* was just twenty minutes long. It was the product of several months of weekly webcasts between us. The webcasts were a series of conversations we had online and Photoshop productions I assembled as animations—some live, some created between webcasts.

We considered relationships among international deltaic regions in crisis over the impacts of climate change and conflict zones. The three regions we chose to study were Bangladesh, New Orleans, and the Sudan, based on where we anticipated the most serious consequences from cascading relationships between ecological problems.

The composer Joel Chadabe of the Electronic Music Foundation (EMF) invited me to present our work in Stonington, Maine, where he was a summer resident. I'd previously participated in a series of events in New York City for sound and media artists dealing with climate change, which Joel had organized as Ear to the Earth.

The first time I was present for a public showing of *Trigger Points / Tipping Points* was in Stonington, Maine, in 2007. Reaching my audience had been an exercise in time management. It had taken several hours of travel by ferry and car to get from Vinalhaven to Rockland, then north to the Deer Isle Bridge, a suspension bridge that connects the mainland to Little Deer Isle, and from there to Deer Isle via a causeway, then to Stonington, which is located at the southern end of Deer Isle.

After almost twenty years of living full-time on an island almost fifteen miles off the coast of Maine, I was spending more time off the

island. Over the years, I had come to appreciate the rituals of travel to the mainland as a chance to reflect. In the summer, leaving the island meant waking early one month in advance to secure a car reservation by 6:00 A.M. I'd get my car in line fifteen minutes before the departure time on the day of the reservation and follow the guidance of the ferry attendants to maneuver into position on the boat between trucks and other cars. The trip across Penobscot Bay takes about an hour and fifteen minutes, unless there's rough weather, when it might take longer or the ferry might not go at all. That was rarely the case in the summertime. But in winter, it could mean that time-sensitive mainland appointments had to be provisional.

That afternoon, I'd boarded the ferry with my two dogs—Brittany, a Dobie, and Bambi, a Lab mix—on one of those crystal-clear days that makes Maine mythic. While on the ferry, I usually spend my time sitting in my car and listening to Maine National Public Radio as I stare out the window at the shape of the waves, noting the disappearance of and reappearance of land as I let my mind drift. That day, I thought about the work I'd just completed about climate change and would present that evening. I was thinking about the process of collaboration between art and science to solve environmental crises.

I didn't yet have the language, but I knew I was experimenting. Later, I would understand that my experiment was a predictive model. It would take me almost another decade to understand my own thinking about complex adaptive models and the rules that define interactions among disparate agents—for example, climate change, drought, and migration patterns—to fully articulate trigger point theory. In the case of the work I was traveling to Stonington to present, the agents we had considered focused on questions I had about correlations between conflict regions and deltaic systems in Bangladesh, around the Nile, and in New Orleans. What I felt certain about on the boat was that no matter how smart my experiment might be, any prediction was provisional.

After driving off the ferry in Rockland, I dropped my dogs at the vet and turned north for two hours on Route 1, driving the same white Jeep that had brought me to Maine in 1990. I passed miles of boreal forest on either side of the road, keeping my speed to a steady seventy miles per

hour. My view was punctuated by assemblages of massive boulders to my left as my mind kept drifting back to questions that had arisen in the work I was about to share.

The last leg of my trip required passage over the suspension bridge. As I looked down at the water on either side, I felt restrained panic and gritted my teeth. As always when I crossed a bridge, my thoughts turned to an article I'd read decades ago in the *New York Times* that described how most U.S. bridges are so neglected that disaster is always around the corner. Occasionally, I heard about a bridge collapse that validated my fear. As I drove onto the bridge ramp, I clenched my teeth harder than usual, wishing I had my own boat and knew how to operate it. If I'd had one, I could have taken off from my wharf and been at the Stonington docks in ten minutes.

The bridge was barely wide enough for two lanes of traffic. I didn't relax my jaw until I got to the other side. Shortly afterward, I heard a rumor that there had been a problem with the bridge.

As I drove off, I exhaled, made my way via the causeway to Deer Isle, then went south to Stonington, parked, and went to the Opera House, where I prepared to present our film.

That night, not only would I view our film all the way through for the first time alongside my audience; I would view it *with* my audience. I had been editing up to the last minute. My attention had been entirely on assembling and presenting our content. I had been particularly obsessed with our audio. Given the software available for online work at that time, it had been the best we could do, but the quality of both image and audio was woefully below ordinary film standards. The content had been driven by a series of questions, exchanges between Jim and me about the data and visualizations of the answers. Technically, what we did was just a more sophisticated version of scientific illustration, which had supported me in the late 1970s.

During our conversations, my tablet pen had skimmed over continents, discovering potential drought areas as the Himalayas stopped feeding the Ganges and how deeply seawater might flow into Bangladesh, causing the coastline to disappear as the sea level rose. My focus was on seeing how the parts might fit together and how patterns emerged. It

was a very intense process but was not particularly emotional until that evening in Stonington.

Watching with the audience, I was aghast by the probable and imminent future the film portrayed. Our insights stupefied me. The projections we had arrived at and captured on a screen included hundreds of millions of climate refugees flooding Europe; vicious fights over water supplies, particularly in Africa and the Middle East; and the geographic isolation of the Americas in crisis. It was one thing to know this. It was entirely different to see the implications unfold visually.

Suddenly, the viewing was over. We were in the discussion part of the evening, when one might have expected a coolheaded and thoughtful exchange of opinions and observations. My task was to lead my audience through that conversation before we all dispersed for dinner at the various delightful restaurants along the waterfront. There, conversations might continue pleasantly about what the diners knew about global warming and what new information they might have gleaned from our film. Then talk might turn to stories about boats and grandchildren.

When the houselights went up, a genteel elderly gentleman in the audience asked, "What should we do now?"

"We're fucked," I said.

After another couple of heartbeats I added, "Stop having children."

My audience stared back at me, apparently stunned and frozen by my rudeness. After a few more heartbeats, I gazed back at my questioner. His face had fallen. The corners of his mouth had turned down, and his eyes had narrowed. I had to assume that he had grandchildren and was appalled and disapproving.

I have no idea what my audience experienced. I wish I had asked. Did they imagine an endless landscape of children's dead bodies, as I did? Might we have all cried together over our grief, then hugged and discussed how to break the news to others? Might I have mobilized a new army of outraged, elderly WASPs to march on Washington and demand action on climate change? Did they understand, as I did between heartbeats, that events like pandemics would be inevitable without the most drastic and seemingly impossible immediate changes?

I had not satisfied or impressed my audience in Stonington any more than I had impressed officials at SER two years earlier.

It is, after all, much harder to stop having children or using fossil fuels than to organize recycling, but I couldn't see any other answer. I am sure that overconsumption by too many privileged people is one of the consummate drivers of our ecological calamities.

I was frustrated with my own curtness, absolutisms, and failure to gently guide my audience forward. I felt embarrassed by the expressions of frustration before me. My heart was racing. I had forgotten to maintain good posture. Obviously, I had failed in my task, as well as failing Joel and Jim.

I went out to dinner afterward with Joel and a few others. I couldn't stop fretting about my responses.

Joel said, "You needed to tell them what to do."

But, I thought, I had. But I had told them a negative: "Stop having children." They wanted a positive that I didn't have.

Joel said I had to have a solution for people. In retrospect, I could have just walked them through our process and let them come on their own to the same shocking conclusion I was struggling with.

Even if I had had the wherewithal that night to discuss dispassionately what we had all just seen and then to initiate a group hug, share condolences, and encourage a political demonstration, what would that have accomplished?

Still, my encounter with reality had pulled me up short, much like what I'd felt after performing *Perfumed Milk,* about domestic violence. This was a film about global violence and where the trigger points were for that violence. I wasn't ready to apply the rules of trigger point theory to identify a path forward.

At dinner, I managed a lively conversation about opera arias, but I couldn't recover from visualizing future floodwaters sweeping over the homes of hundreds of millions of people in Bangladesh or the stark evidence that climate change was occurring throughout the world. To this day, I live with the reverberations of that future shock, even as that future has overtaken us in the current pandemic.

Jim and I have returned to our revelations ever since for the sheer scale of catastrophic impacts on billions of people and countless other species.

After the *Weather Report* show, Jim and I took a hiatus for a couple of years. During that hiatus, I traveled by train through the Rust Belt to New Orleans and Baton Rouge to experience the effects of climate change directly. My trip culminated at a conference on deltaic systems in Baton Rouge.

In 2009, just as Jim and I started working together again, I decided to begin the Ph.D. program I might have pursued in my twenties. I felt that my confrontation with John Stewart, the UCSD provost, had left me at loose ends. I wanted to test my thinking and ultimately contextualize it with other knowledge, such as physics. The program meant a return to Switzerland, where the low-residency node of the Planetary Collegium was based in Zurich. It was a difficult decision. Financing that I was encouraged to think might materialize did not. The travel sorely tested my capacity to manage my CFS. I was expected to maintain my professional visibility while researching. My topic encompassed environmental sciences, technology, and studio art. I made it harder for myself by embarking on a concurrent degree program in GIS at Lehman College of the City University of New York.

Despite these challenges, I completed my doctoral dissertation, "Trigger Point Theory as Aesthetic Activism," and was awarded a Ph.D. in 2016 from the University of Plymouth, in England.

After my trip to Baton Rouge, with the support of the New York Foundation of the Arts, Jim and I began a series of recorded webcasts, *Gulf to Gulf,* a forum for informal conversations with colleagues on climate change. At Michele Dionne's suggestion, one of her colleagues, the wetlands biologist Dr. Eugene Turner, joined our work. I'd first met Gene in Baton Rouge at that conference on deltaic systems. He was leading governmental monitoring programs on the British Petroleum spill in the Gulf of Mexico.

In 2011, Jim commented that we were in the slow phase of climate change and that by 2012 it would accelerate sharply and geometrically. I absorbed that information as I was completing my last class at Lehman

College for my GIS certificate in 2012, particularly fascinated by a class in biogeography.

That spring, I received a diagnosis of breast cancer. I finished the semester while going through radiation and continued to work on my dissertation, traveling to Zurich to fulfill my requirements. I found the treatments utterly traumatic and evocative of my experiences of rape and abuse. On Facebook, I described my experience as trying to keep my head above water in a torrential river, a stone tumbling end over end, being worn smooth by my efforts to survive my treatment and forestall my death. I felt like my body was an avatar of the Gulf of Mexico.

Week after week, strange men manipulated my naked breasts to position me in miserably uncomfortable machines, where I remained physically imprisoned and helpless under threat of death by cancer if I resisted.

I thought that women and men alike trivialized the extreme pain I experienced—during the needle biopsy, for example. Cancer treatment and ambitious research awkwardly converged. My grade point average dropped at Lehman. I had to retake a class to graduate, which I couldn't do until 2019. I went back into therapy.

The year of my diagnosis, 2012, turned out to be the first of two close encounters with breast cancer. Each time I felt what the French call *boulversé*, tossed upside down like a ball. I knew of only one aunt who had ever had cancer, my mother's very fair-skinned blond sister, a sun worshipper who would have eschewed sunblock and who died of skin cancer. But I had taken hormone-replacement medication, which has been linked to breast cancer, and only this year, I heard from a cousin that Grandmother Hannah had also had breast cancer.

Also in 2012, despite my health, Gene, Jim, and I began a new project, *Fish Story*, to identify a trigger point in the Mississippi River Basin where restoration work could effect healing for the Gulf of Mexico. If we were to address the excess nutrients, called eutrophication, causing oxygen loss, or hypoxia, in the Gulf, where would we start? I asked Gene.

"Iowa," he replied, identifying our trigger point and the first part of my answer to Katrina. Gene was referring to the nitrogen pollution from agribusiness fertilizers coming down the Mississippi and leaving dead zones in seas emptied of animal life. It has been estimated that this

pollution costs between $552 million and $2.4 billion annually in damages to Gulf of Mexico fisheries and for the marine habitat (Lohan 2021).

Our fine-grained *Gulf to Gulf* collaborative analyses broadly layered data to identify where to intervene in which upland conditions that were causing the dead zones of eutrophication in the Gulf of Mexico and land subsidence on its coast. We found a point where the Wolf River meets the Mississippi.

In my small New York apartment, I rolled up the Oriental silk carpet I'd inherited from Mother to unscroll a seventy-foot roll of black paper, on which I painted the Mississippi and its tributaries in silver, feeling like I was wading through the waters of the basin as I delineated them. From rare and delicate papers, I cut out silhouettes of each species of fish going extinct or already extinct. I took it to the 2013 *Memphis Social* show curated by the artist Tom McGlynn.

In Memphis, Gene and I met up for reconnaissance to activate our trigger point by canoeing the waterways of the Wolf River. In the gallery at the Memphis School of Art, I wrapped the black-paper painting around the walls, affixed the fish cutouts to the surface, and wrote "Missing" in silver cursive beneath each ephemeral representation.

The night before the opening, going from fish to trees, I asked Jim to do a quick calculation about how much revegetation would be required to mitigate climate change. Jim mathematically projected how much revegetation would mitigate global warming: 36 percent. Our only caveat was that available land surface wasn't sufficient to enable that plan.

I printed Jim's calculations on the opening night for handouts and left them on a pedestal in the center of my gallery installation. In 2019, Thomas Crowther at ETH Zurich published comparable calculations.

Fish Story identified a specific trigger point where the Wolf River tributary intersected the Mississippi River in the city of Memphis, Tennessee. We produced site-analysis work and developed our conjectures into a restoration proposal. We never realized outcomes from our work. I tried to find partners to effect the restoration we had projected, but the combination of health challenges and lack of financial support ultimately defeated me. Whether or not we contributed to awareness, eventually the site we had identified became a major city project.

I continued my dissertation research. Cancer made my work harder. At no point did CFS leave me, either, but I made my peace with its terms of engagement and bowed to its tutelage, driving me deeper into my work.

I survived. I had no intention of allowing reality to distract, limit, or slow me down. My parents had set me the example of resilience no matter what.

My second encounter with breast cancer was in 2016, as I completed my dissertation, and more serious—much worse and much harder to bounce back from. Like my diagnosis with CFS, each encounter with cancer first set me back and then refocused me. I devoured new information about the microbiology of disease, cytokines, and cancer as I'd once devoured fairy tales and still devour science fiction. I researched how cytokines go somewhat haywire in CFS and a lot haywire in cancer. I began mining my years of interest in physiological perception. I speculated about what the Earth's cytokines might tell us. I gained insight into how crucial the interactive process is to the success of the CAM for trigger point theory that I was fleshing out in my dissertation.

My first bout with cancer had required only radiation. This time, in addition to chemo, I had surgery. Every experience of rejection or humiliation as a woman came back ten times more painfully than I had felt it the first time. Under medical supervision, I fasted for chemotherapy to settle my cytokines. I visualized their choreographed communications between healthy systems in the body as a dance with life energy.

I lost my long hair.

It was a terrible time. I was also facing serious financial problems, with no easy answers. But I kept thinking of Gaia as I completed my dissertation and articulated the rules for trigger point theory.

My questions about human relationships and environmental impacts had evolved. My circle of friends and colleagues was rapidly expanding. I found unexpected allies in my search for insight into cancer and speculated on parallels with the Earth's troubles. I made the conscious decision to discuss my experiences openly on Facebook. I raged for months, writing about how the medical establishment presumes that every woman is financially dependent on a husband and has a supportive family (hardly true). I wrote about how my treatment evoked PTSD, reinforced learned

helplessness, and promoted forced reliance on tenuous evidence from authoritarian experts.

The second bout with cancer devastated my experience of myself as a sexual woman. The profound and very casual depersonalization I experienced during treatment doubled my physical trauma. Breast-cancer protocols, a mastectomy, and the side effects of hormone suppressants pierced the core of my identity as a woman and pervaded every aspect of my experience. I found the medical procedures torturous in the literal sense. Breast cancer in the medical establishment seemed the Grimm brothers' version of a fairy tale: senseless cruelty. The psychological impacts were even more intense than the physiological impacts. I found excellent psychotherapists who specialized in breast-cancer patients and confirmed my perceptions of sexism and dehumanization. I persisted in seeing my personal health as a mirror for larger issues in the wider world. The world is battered but not yet entirely broken, and neither was I.

As I shared my experiences, thoughts, and research with friends on Facebook, their reactions surprised me as much as my diagnosis had. Posts came from men and women. I was railing against the patriarchy, whether represented by men or women—how it reinforces the power of the status quo by gatekeeping competing ideas about how to consider anything that challenges entrenched systems. I ranted that it wasn't enough to fear for our bodies or survive being economically hamstrung. Patriarchy also comes for our minds, just when we need to save the planet. I wasn't alone, and it wasn't just about being a woman.

Over and over in my Facebook threads, as I was experiencing in therapy, I got validation, corroboration, and affirmation for what I felt and witnessed. It was my very first experience of having my insights thoughtfully affirmed in detail. The posts I read expressed admiration for my honesty and perceptiveness. I often got hundreds of responses to a single post from people I respected as well as from utter strangers.

It was the first time I'd stepped back and looked critically at a dynamic I had barely noticed till then; it was so normalized in my life to deny, trivialize, and punish any idea that didn't conform to a status quo. At worst, the people who offended me during my cancer treatments might not have behaved very differently from the way narcissists, competitors, or

misogynists I had encountered before had behaved. When some people put me down, it clearly served their own egos and feelings of inadequacy. The putdowns and dismissals made them feel more powerful even as I was robbed of my own power. Many people who professed love for and concern about me had also had a stake in encouraging my self-doubt and discouraging my self-confidence. Evidently, for many people, witnessing my breast-cancer treatment evoked the same kinds of responses as rape had: none evident. I saw my experience as gender determined. In most cases, silence or even disapproval was simply how everyone behaved in response to a visible woman in trouble with an opinion. But it was more complex than that.

My Facebook exchanges were the first time I turned my attention to self-validation. Writing about cancer treatment revealed for the first time that the psychological dynamic I was experiencing wasn't personal or gendered. It was visceral and systemic. It was also about gaslighting.

For many women, the most egregious example of gaslighting was during the 2016 election. In an editorial titled "Hillary Clinton Was Right to Warn Us," published the day before the 2020 presidential election, Jennifer Senior of the *New York Times* wrote of fictionalized women who prevail over patriarchies versus what occurs in real life: "In real life, such women are often despised precisely *because* they are right."

My reaction for a long time was bitter. I had to accept that the culture I inhabit doesn't just rape bodies; it rapes minds. During the pandemic, it became clear to me that this form of denial was on a continuum.

I have met many men who experienced the same dismissal of their intelligence and originality, usually as young boys—whose bright, curious minds didn't fit a simple mold, who were convinced they were stupid. It colored and determined the entire trajectory of their lives, often leading to antisocial behavior. That was the case with two men I had particularly loved. It is the same patriarchal domination, reifying the white hero, that ends in ecocide. Now I think, how tragic that the price of social stability seems to be destroying the social capital of intelligent nonconformity.

Many of us are as vulnerable to this intellectual violation as we are to physical or sexual assault. Not everyone is violated this way, but enough are.

I began to form a new self-image, an idea about myself that was different from the one I had accepted all my life. I had to ask, Could it be that I had always been a precocious and original thinker but was often surrounded by people who had their own reasons to withhold approval and support?

I had to ask, How many dead Black people floating in the floods in the Third Ward of New Orleans after Katrina had tried to be heard when they raised an alarm about the levees or protested the effects of the oil industry causing subsidence? Many, I think. Saying "We're fucked" in Stonington hadn't scratched the surface of the scale of collateral damage from our culture's failures.

I wonder how many powerful solutions to important problems have been dismissed because they came from outside the status quo. Too many, I suspect.

Breast cancer was a trigger point in my life as much as rape had been. The next years were devoted to toughening up my intellect, gathering academic evidence to test and defend my thinking against skepticism and personal vicissitudes. What often kept me going was sheer stubbornness.

10

The Blued Trees Symphony: Crushing Ecocide

I n 2015, the world witnessed the first salvos of the 2016 presidential election. My attention was on finding a better strategy to change the world with art.

I didn't start with the intention of making art that would stop natural gas infrastructure or confront how natural gas contributed to climate change. I did know from the get-go that I had the second part of my answer to Katrina. It was in the loop between the use of and infrastructure for fossil fuels and using oil derivatives for fertilizers in factory farming agriculture. I layered that with what I had learned from Spong about the power of messaging.

When I began, I was not much wiser about my defiance than I had been at UCSD in 1970 or at SER in 2005, but I knew a whole lot more about collaborative relationships.

A problem with defiance is that it can appear as a somewhat romantic activity even when it expresses a community position, a position of service, innocence, or sacrifice, as a crusade of children, whether led by Joan of Arc or Greta Thunberg. Defiance can be conflated with heroism, seductively and perilously closer to narcissistic egotism than courage. (As twelve-step programs say, "Get off the cross. We need the wood.")

I had reached another end of another rope in 2014, making art that was politely educational about how bad fossil fuels are, how ominous climate change is, and all the reasons we need to behave differently to save life as we know it on Earth and deferentially suggesting what we might do differently. I applied for a Creative Capital grant to be defiant. I don't recall what I actually proposed to do if I got the funding, but my frustration with the culture had never been higher. I explicitly used the word *defiant*. I didn't get the grant. Something better happened.

Shortly after my ineffectual cri de coeur to Creative Capital, the artist Lillian Ball connected me with a small group of antifracking activists who were looking for an artist to work with. They wanted to stop the Constitution natural gas pipelines across northern New York State. They hoped to build on the example of the Demmitt, Alberta, sculptor Peter von Tiesenhausen. Von Tiesenhausen had claimed copyright protection for the top six inches of his ranch. That stopped the corporations, but his legal premise was never tested in the courts.

I met with the activists. They showed me the maps of where corporations intended to destroy large swathes of forest to install pipelines for high-velocity fracked gas.

That was the inception of *The Blued Trees Symphony*, which involved three clear tasks:

1. Assemble a model to predict the outcome of new relationships.
2. Discover our legal trigger point. It would be where copyright law intersected eminent domain law over definitions of *common good* and *ownership*. This would be a heavy lift. No case law had yet set a precedent.
3. Establish the legal parameters within the Visual Artists Rights Act (VARA).

Staring at the Google Earth satellite images where proposed pipelines would be installed in clear-cut corridors, fragmenting the habitat from west to east, I recognized that third task was the second great epiphany of my creative life, without a hint of the DMT I'd taken to hear the music of the city as a young artist.

The Blued Trees Symphony, copyright submissions for registration, Aviva Rahmani with Patrick Reilly. Photo by Robin Scully 2016.

This was where art and intuition intervened. What I saw in the maps wasn't just miles of complex biogeography. What I saw were transformations of the proposed pipeline corridors into musical lines in a treble clef, extending for hundreds of miles across the continent. I could "hear" an enormous and awesome installation of sonified art. Layering these aesthetic approaches increased the work's power to enhance the legal standing in the courts.

When I visualized the potential musical lines, I was envisioning aerial patterns of designated trees to represent the melody. I imagined tree-notes populating one-third-mile measures of a complete aerial score in a contiguous forest system. Conventional garden design refers to rocks, paths, and trees as the garden's "bones." The iterated melody would be the bones of a symphony inflected by biogeographic terrain. The outcome would be a series of geographically determined chord clusters made up of the copyright-protected trees, each marked with a painted sigil of a sine wave from roots to canopy, making them permanent to the ecosystem—tree-notes marching in ascending registers across the score, whose diagonal tracks on the ground across each measure would also impede

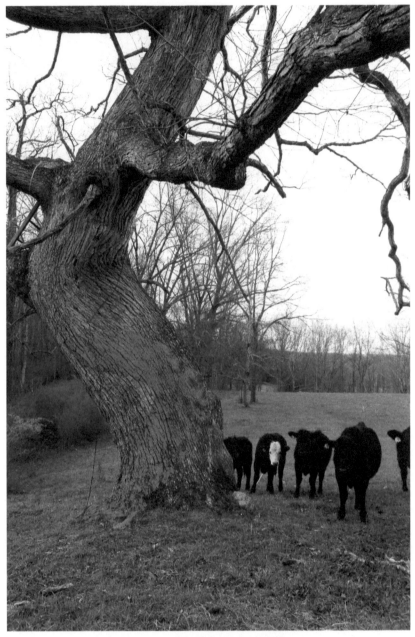

One Tree Note. Photo by Robin Scully 2015.

the advance of heavy machinery. Each tree-note was GPS-located to establish its location in a permanent score on the land and to document that specificity for the copyright office. As I envisioned the score, the location of tree-notes on the ground would be both pragmatic and performable.

The score interpreted the recurrent refrain I had imagined in discontinuous measures connected by the biological ecotones between them. I would transpose the specifics of topology and vegetative cover in the corridors where the pipelines were proposed. The painted trees anchored the musical ornamentation in the score.

The width of each sigil painted with the nontoxic casein of ultramarine pigment and buttermilk on each tree-note corresponded to the girth of each deciduous tree trunk. The height integrated the sigil with the soil, the trees, the watershed, and the art of the whole concept. The brushwork required a bodily relationship with the whole tree. The casein recipe, which I had previously used in *Blue Rocks,* would eventually promote the growth of moss and potentially generate a secondary acoustic environment from life supported by the milk solids, inaudible to human hearing without special equipment. The brilliant hue of the paint shimmered in the light, but its translucence only enhanced the browns and grays of the tree bark and danced with the green leaves. At normal human hearing levels, the tree-notes existed in real time, incorporating local ambient sound into the movements and the sounds of the painters and visitors.

Over five years, *The Blued Trees Symphony* became a work of intercontinental music with threatened forests. The score was aerially conceived. It was created for performance with trees in corridors where forest fragmentation for fossil fuel pipelines was a presumed fait accompli. Each measure of the work was completed at the invitation of a landowner whose property was threatened. Each measure included at least ten tree-notes, extended for one-third of a mile, and was copyrighted. Each deciduous tree was marked with a nontoxic ultramarine blue casein sigil of a vertical sine wave to make a tree-note. Each tree-note in *The Blued Trees Symphony* is a trigger point. Each mark required an intense relationship with each tree, the surface of its bark, and the performing painter.

As I conceptualized the symphony and the implications of copyrighting this relationship between art, forest habitat, and people, I recognized

the same complexity I had seen in marine ecosystems, the importance of aquatic forests, the fishing culture, and my observations from *Fish Story* about relationships between land, water, and industry.

If a spatial correspondence could be observed between spiritual aspirations and definitions of legal ownership, could case law change policy? Could art heal degradation for common good?

The movements of a conventional symphony are based on dance rhythms, corresponding to the rhythms of our heartbeats in various states of calm or excitation. A tarantella is a flirtatious folk dance.

The stately waltz I had learned as a child seemed less appropriate for *The Blued Trees Symphony* than the joyful rhythms of a tarantella did. The playful rhythms of the tarantella were precisely the needed relationship to agents in this complex adaptive model (CAM) paradigm. I thought I was adopting the spirit of Abbie Hoffman's 1967 rain of dollar bills on the New York Stock Exchange. I thought clever play could compete with the bluster of fossil fuel corporations and the threat of ecocide.

Completing each measure was dependent on identifying property in the private hands of resisting landowners whose land had not yet been condemned and then receiving an invitation to go forward. The tree-notes in each measure became the nodes of our musical CAM. Each participating landowner expanded the measures of the symphony.

I speculated about the ecological implications of protecting art with trees in forested systems. It obviously raised issues about common versus public (economic) good and habitat contiguity. It also raised new questions about patriarchy. Habitat contiguity sustains the rhizomatic ecosystems that support clean water and air, mitigate climate change, and protect biodiversity. The metaphorical model is at odds with a political system that concentrates power in the hands of a small number of men rather than disseminating it for the common good.

Even more than in *Ghost Nets, The Blued Trees Symphony* employed transdisciplinary thinking, dissolving boundaries between art, music, science, and law. That approach to artmaking may be the most suitable to the complex uncertainties of our times as well as most antithetical to patriarchal tropes. It is a structurally horizontal and multidimensional

vision of democracy rather than one of simplistic hierarchal verticality. The rigid boundaries of the latter deny adaptive potential to whole systems by closing off the flexibility of political as well as biological ecotones. I believe that is an ecofeminist point of view.

Although a musical score can be copyrighted, there was no legal precedent for asserting that a score embedded in a forest has rights to physical protection, except as one more dimension of the artistry. I was interested in how the cultural location of art might connect to Earth rights.

The originalist legal ideas at the heart of this judicial trigger point developed during the Age of Reason concurrently with ideas about musical harmony. The legal vision for harmony was both literal and abstract, finding expression in the sonata form. Classical sonata form inspired my parameters of time and space for my project but not conventionally.

A classical sonata explores a progression of harmony and disharmony between two musical themes. Themes that develop in time separate into an initial exposition, a midsection development, and then thematic recapitulation. Sound of any kind is delivered to the human ear in envelopes, a term that describes the combination of amplitude and frequency in time, whose shape is described by physics.

I was interested in developing two conceptual themes from arguments about common good and environmental justice. Both themes pivoted on the ecological role of trees in complex systems that include humanity. One theme was a synesthetic conception of musical composition, including engaging other species—in this case, primarily trees—as acoustic collaborators in open-ended envelopes of time. The second theme was the proposition for new case law to protect Earth rights, based on the realignment of ownerships in copyright and eminent domain laws. My goal was to interweave these themes harmonically. I wanted a sonata score that wove together dissonance and consonance, both musically and conceptually.

Some research has shown that absorbing a new acoustic idea, such as hearing music, is an emotional experience requiring discrete measures of time. In a symphony, we hear harmonic ideas unfold in sufficient time, with enough variations in how the information is framed—for example, changing time signatures, keys, or tempos—to allow the understanding of themes that often repeat. I see the sonata form as a yearning for the

reconciliation of extremes expressed as music organized progressively into exposition, development, and recapitulation.

The Blued Trees Symphony divided into movements across time and space. The entire work evolved as five movements—an Overture, a First, Second, and Third Movement, and a Coda—each of which articulated different relationships to time and trees as stand-alone artworks. All the themes were present in the initial Overture. As with the material I assembled for *My Symphony* in 1974, the sonata form in the five movements of *The Blued Trees Symphony* organized my thinking around how art might address a big idea—in this case, how trigger point theory might defy fascism and ecocide.

The First Movement was the painting of measures of tree-notes in the terrestrial forests where we were invited to perform. Participants acted as performers, marking sigils on "sentinel" trees (individual trees whose presence in the larger forest system might be remarkable for a variety of reasons) designated to reiterate the scoring pattern. On the ground, the teams identified the spacing between tree-notes by walking the terrain and counting steps to assemble the spatial pattern that corresponded to the aerial melodic refrain, performing a meditative ritual as they walked the distances. Painters often had to physically embrace each tree to complete the painting three-dimensionally around the trunk of the tree, rather than simply marking two-dimensional signage from paces apart from the tree. That made participants literally "tree huggers."

The documentation of tree-notes with GPS and photography was the record of hundreds of individually performed, crowd-sourced, painted, kinetic, moving parts of one sonified biogeographic sculpture. On the ground, each measure required intimate, synesthetic relationships with each tree and its surfaces. At every stage, we all engaged with conventional and social media, widening our experiences into a public event. I reveled in having created a structure that was only completely realized when I relinquished control and trusted the universe.

The first movement of a classical symphony is often presented as a recapitulation of sonata form, beginning briskly, entering a largo (slow) phase, continuing with vigor in subsequent movements, and closing with a vibrant flourish. In the First Movement of *The Blued Trees Symphony,*

the emotional tension I intended to express as **yearning** for harmony with nature was represented by an iterated musical refrain. The iterations stepped through moods and variations determined by topography. The result was that the habitat of each new site of painting a measure determined and resolved dissonance differently in each movement. The painted measures with trees of the ongoing First Movement of this symphony began briskly with joyful optimism about beauty and justice. It proceeds now, as the measures continue to be painted, with a slow determination to bear witness to ecocide: the forests consoling us before they suffer death.

The Second Movement was based on my own unpublished research comparing the Newtown Creek Superfund site to the potential impact of natural gas pipelines in New York State. If fossil fuel production could be developed with impunity, the entire region would be in danger of becoming a massive Superfund site. The Second Movement was completed at an agitated tempo (agitato) during a two-month residency at the International Studio and Curatorial Program (ISCP), near the Newtown Creek Superfund site, in Brooklyn, New York, supported by the National Endowment for the Arts (NEA).

The Brooklyn site had no healthy trees. The thematic discourse was between the transposition of data points and local traffic sounds. Everything seemed mediated by fear. The audio mix became part of a performance that made comparisons between the fossil fuel contamination at the Newtown Creek Superfund site and patterns of natural gas pipeline infrastructure spreading across North America. A conclusive performance was accompanied by mapping projections that juxtaposed the natural gas infrastructure plans for New York State to current conditions at Newtown Creek. It foretold a story of how the entire state, and possibly the entire continent, could become a toxic site if fossil fuel development expanded with impunity.

The in-progress Third Movement has tracked the legal progress of the theory. I see this movement as a narrative about heroic lawyers systematically challenging ruthless corporations. A libretto in progress includes text from case law and the subsequent mock-trial climax, which I hope may become an opera. The tempo has been very slow (largo).

The Coda was developed as a discursive chorale in response to the 2016 presidential election. The layered vocalizations of the melody recorded with my singing teacher, the coloratura Debra Vanderlinde, and me created a refrain for the iterated measure. That was interspersed with a narration by the actor Dean Temple of legal conclusions about free speech and ownership from other cases. The sound composer Maile Colbert assembled the parts and created an acoustic veil from the interior sounds of trees.

Classically, the coda in a symphony is fast (presto). In the *Blued Trees* composition, the Coda was composed under the urgent pressure of and framed by the 2016 U.S. election, but the actual tempo of the completed work was largo, slow and deliberative. In the days before the election, I was trying to force my thoughts into the music I was composing.

I spent election night at the home of the art writer Suzi Gablik, sketching her portrait as we listened to the results. If the coda of a symphony must represent a dramatic finale that recapitulates what came before, the 2016 election results were a dirge for environmental justice in the subsequent years of that administration.

Music conceptualizes landscape contiguity for me in patterns that correspond not only to scoring but also to historical events. After beginning *The Blued Trees Symphony*, I studied music theory for two challenging semesters at Juilliard to refine my thinking about how Western musical form can contain passion. My experiments with conflating arcane and arguably white-supremacist musical rules with the rules of law drew on considering the historical context of the evolution of those rules. Rules of harmony, counterpoint, and dissonance were semiotic inspirations that became containers in my mind to abstract emotional events in time.

In a conventional symphony, a seated audience has a continuous but bounded acoustic experience contained in a defined window of time. The parameters maximize an emotional experience that builds to a crescendo and resolves to harmonic catharsis in the denouement. In *The Blued Trees Symphony*, time and tempo in the unfinished movements continue to develop and mutate. These musical parameters are as rhizomatically shaped by my experience of the realities of environmental hope and crushing

disaster as by the biology of habitat, although they are also bounded by my experiences as a white woman artist.

The acoustic ecology of *The Blued Trees Symphony* (captured sound on-site) was integrated into subsequent indoor phases of the project. The First Movement continued to expand in measures at additional sites in New York State, Virginia, West Virginia, and Saskatoon (Canada) and with individual trees (as a Greek chorus) painted in Washington State, Florida, and Louisiana.

At each location, one person—usually another artist—took responsibility to organize a team of painters-performers. Near Blacksburg, Virginia, the artist Robin Scully personally supervised the painting of over two hundred trees. The captured sound of birds at a single tree from one measure of the First Movement contributed to subsequent variations, particularly in gallery exhibitions, as at the Perspective Gallery at Virginia Tech and the KRICT gallery in Daejeon, South Korea.

When I had conceived of the "solution" to the pipeline problem, I was applying my rules for trigger point theory: considering time, metaphor, layering, play, a small point of emergence, and critical disruption to design something that could leverage how the agents might interact over a long period. I was being my own version of Maxwell's demon, reorganizing data, while relying heavily for my strategic design for reorganization on the Boolean logic I had learned as I studied for my GIS certificate in 2012.

Organizing the performative aspects of the work around movement, music, and terrain in a simple score for participants was a playful way to invigorate communities' commitment to save their forests, creating experiences that were both joyous and contemplative but undergirded with a very pragmatic legal premise.

If I find peace in a forest I own
And someone wants to profit from destroying my forest,
Then I must find a rule to resist that destruction
And find others with whom to join forces.
If I fail with the first rule,
Then I must discover another strategic rule to preserve my forest.

Giving up is *not* an option.

Yes, the process is often difficult, frustrating, and lengthy.

Boolean theory forms the basis for any complex adaptive model. The CAM I started to investigate as *The Blued Trees Symphony* progressed was conjunctive. The rules were predicated on Boolean logic. The intention was to apply the rules to a CAM for creating a knowledge space.

The heart of my theoretical approach was that harmony comes *with* the other—including other species, other ways of thinking, other rules to approach information. In that approach, I was fulfilling the ideals behind my research into relationships in 1971. The philosophical source of my motivation was the dialogic world Martin Buber described in his writings, particularly *I and Thou.* In the landscape of the world his writings painted, I saw a blue city where the spirit of art filled a sacred home—a home where our intuition might someday teach our better natures to live in a resilient future.

Trigger point theory was a conceptual project, triage for environmental catastrophe. Many of the circumstances I tried to address with trigger point theory before *The Blued Trees Symphony* were the consequences of fragmentation, which disconnects the ecotones and their species that protect a healthy ecosystem. In that narrow sense, I was echoing Carolyn Merchant's disquiet with the Age of Reason as a source of disconnect from nature. In a broader sense, I was challenging hierarchal ideas about ownership from the King James Bible.

The Blued Trees Symphony was conceived to protect forest contiguity. I foresaw contiguity as the essential agent to preserve water quality and reduce habitat fragmentation at large landscape scales before irrevocable damage occurred. Functionally, forest contiguity has to be a regional, even continental project to succeed in protecting watersheds. I had seen that need for contiguity as an ecological opportunity that conflated with a musical concept, to create a score out of biogeography.

Our Overture was painted on the 2015 summer solstice in Peekskill, New York. The day before painting, I flew south to New York from Maine and took the train to Woodstock, where I stayed with our project manager, Linda Leeds, and her partner, the photographer Jack Baran.

The night before we performed, it started raining heavily. To the rhythm of the rain, Linda; Nancy Vann, the head of Reynolds Hills properties, who had invited our painting; and I pored over the maps at Nancy's house while the filmmaker Denise Petrizzo documented our work.

The next day, a group of about fifteen of us, of all ages and genders, worked in a slowly abating downpour to identify the spacing for each tree in relation to the others and then paint the sine waves on them, the width of each sigil calculated to the width of each trunk. We made a forest marked with a blue that reminded me later of the Safed of my imagination, securing a representation of the spirit of the art to be defended. The paint was brilliant against the muted grays and brown of the tree trunks. The glimpses of blue among the green, gray, and brown of the land created our surreal stage. The smell of buttermilk in the casein mingled with forest fragrances.

I watched a group of Earth Guardians, young activists reaching up as high as they could to make the sine-wave sigil connect roots to canopies. The weather eventually cleared, leaving behind a sky as brilliantly blue as the paint.

A reporter from Vice came to the Overture. The footage never streamed on its channel, but over the next several years, almost one hundred articles, films, and interviews spread the word about the *Blued Trees* strategy: how copyrighting an artwork that makes music out of biogeographic relationships on private land might contest eminent domain takings to expand fossil fuel infrastructures.

One year into the project, I had cancer for the second time. During chemo and surgery, I was completely debilitated. Afterward, the hormone-suppressant medication I had to take for five years made me gain weight and increased my already-substantial anxiety. I had no partner, but friends consoled me.

I continued to find paths to keep working.

The conceptual tension of my counterpoint in *The Blued Trees Symphony* circled around the lyric complexity of interspecies interdependence versus anthropocentrism—that is, the music of life, the cytokines of the universe. As the project evolved, I tried to imagine how this thematic

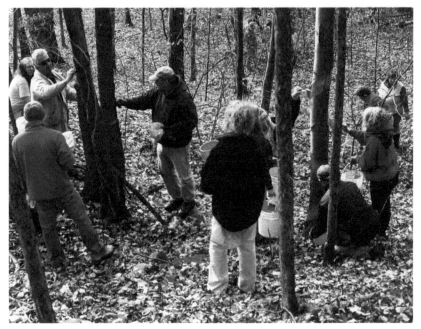

Painting Tree-notes. Photo by Jack Baran, 2015.

discourse was comparable to the cytokines coursing through my body, negotiating cancer and communicating with all my systems.

It felt paradoxical that while I was dealing with cancer, *The Blued Trees Symphony* got more interest and support than any of my previous work had.

I kept imagining my experiences with cancer as I had with CFS during *Ghost Nets*: as provocative reflections of our planetary experiences, disjunctive, exhausted, and vulnerable. I sought metaphors and analogies to let me distance myself and find new narratives to make sense of life-threatening events. I felt that ecocide was clawing at my body as I resisted surrender.

In therapy, I said I feel "naked, crawling forward on broken glass, under a blistering sun."

My defiant reflexes kicked in. I continued headlong.

I was entranced at each measure as we painted the translucent paint on the bark surface of each tree-note. As if I were painting on linen, I loaded my brush with the deeply pigment-saturated paint, scraped some

of the liquid off the edge of the white bucket we carried from tree-note to tree-note so that it wouldn't run, and then made the first mark on the surface, wondering as I did at the beauty of translucent pigment color over the bark color.

As we walked through the woodlands to choose the tree-notes and after the painting was complete, the appearance and disappearance of mediating painters and the blue sigil magically echoed a memory of the long-ago passage of A.R.T. performers I had watched moving slowly through a grove of eucalyptus trees in eastern San Diego.

In making my decisions about how to proceed with the first trigger point locations for the project and launching the CAM, I had noted that Peekskill is biogeographically sensitive, evidenced in studies of on-the-ground habitat conditions that have a bearing on common good, such as the availability of clean water. As part of the rich and richly sensitive Hudson River estuary, it has an abundance of edge systems. The projected Spectra Energy Corporation pipeline path for volatile fracked gas would pass within feet of an aging nuclear facility at Indian Point, within thirty miles of New York City, alongside the Hudson River and near an entry point to the Atlantic Ocean.

I felt regret that I didn't adequately research Peekskill's demographics. How equipped were residents to resist a powerful corporation whose activities might endanger their lives? Anthropogenic degradation routinely manifests as environmental injustice, imposing toxic conditions on vulnerable communities. I was coordinating from Vinalhaven and my stamina is always limited, but could I have done more?

The Blued Trees Symphony was copyrighted as three-dimensional art under VARA in the fall of 2015. VARA protects the rights of permanent art of recognized stature but not site-specific, transient, or activist art. It also doesn't yet recognize ecoart as a separate genre. Nonetheless, copyright was granted. I got the notification just before we were also notified that the corporation intended to proceed with destruction, and I immediately sent Spectra a cease-and-desist notice.

Pipeline construction proceeded in November 2015. Spectra would destroy the Overture of the symphony within days, before I could get a stop-work injunction.

On a clear fall day, I took the train to Peekskill and then a taxi to the site where Spectra was cutting down the *Blued Trees*. I walked the terrain, taking pictures and bearing witness. The scene was heart-stopping. I felt far more defeated by what I witnessed than I had when I defied my father as a child. I cried as I recalled deer and butterflies I'd seen pass through the now-devastated habitat we had painted just five months earlier. I mourned each tree, marked or not. Surely even the trees that had not been painted mourned the loss of their companions.

I asked one backhoe operator if he had any remorse.

"No," he said.

It was a job.

The destruction went quickly.

As I stood at the edge of the tree massacre, despite my grief, I realized that this was where this story started, not where it ended. Spectra's response merited an expanded discourse. Shortly afterward, I began my residency with ISCP in Brooklyn to study the Newtown Creek Superfund site and began the Second Movement of the symphony.

In March 2018, the hundreds of painted trees from the First Movement remained untouched in Virginia and West Virginia. The next month, just before the mock trial, gas companies ignored the rights of property owners and warnings from scientists and began indiscriminately cutting down trees on private lands, despite ongoing protests, to make way for their pipelines. Some landowners resorted to "tree sitting" to protect their trees. Park rangers were called in to deny the sitters food and water. Heavy machinery came in despite the owners' efforts to halt the destruction in the courts. All legal constraints were swept aside with impunity.

Robin Scully had alerted me to the massacre of the trees. I traveled to Virginia to bear witness.

I took a long chain of trains and buses to get to Blacksburg. I stayed at Robin's that night, and in the morning, we walked the site. Trees had been clear-cut in every direction. Apparently, the *Blued Trees* were the first felled and most targeted. I was numb as we walked through the devastation. Afterward, we met with several of the landowners and reviewed the political manipulations that had once again made Virginia a sacrifice zone in a long history of abuse. I returned to New York in a fog of grief.

Cutting the trees had occurred with the support of local officials. Shortly after beginning excavations, companies were forced to suspend work because severe erosion threatened local communities. The erosion was caused by the clear-cutting to install the pipelines, as commenters had warned the Federal Energy Regulatory Commission (FERC), a board of corporate appointees that oversees natural gas pipelines.

The persistent possibility of a test case in court was a crucial and potentially interesting performance event, and a proposal to support that plan was a finalist for a Franklin Furnace emerging artist grant in 2016. Although I was ultimately deemed too emerged to qualify (too old and established in my career), I appreciated the interest. My most substantial fellowship came from A Blade of Grass (ABOG).

Despite meticulously preparing the legal arguments to defend *The Blued Trees Symphony,* trying to find a lawyer to protect the project proved difficult, particularly in the vindictively conservative legal atmosphere of the Trump administration. It was frustrating that I couldn't enlist a pro bono copyright lawyer to take our fight to the next step. Lawyers realistically feared the potential for legal and economic harassments and retaliations from corporate legal teams if judges deemed their arguments "frivolous." Corporate power seemed to have been unleashed, and impunity appeared to be the order of the day.

But in 2018, as part of my fellowship and in partnership, spear-headed by at ABOG's director Deborah Fischer, who worked with Jan Cohen-Cruz to coordinate a cast, in collaboration with the copyright lawyer Gale Elston. Gale assembled the legal people and briefs. She was assistedd by her colleague Steven Honigsman and with other participating activists, we launched a mock trial to test the premises as a matter of legal record.

Just when I was feeling most frustrated, several important women came to my rescue. The most instrumental of those was Deborah Fisher, who mobilized ABOG resources.

"What do you need?" Deborah asked.

"I need a court trial to establish the legal precedent for new case law."

"A Blade of Grass could do a mock trial."

ABOG produced a spectacular mock trial of the legal theory. The legal theory of the project had evolved in conversations with several lawyers, including the copyright lawyers Patrick Reilly, Gale Elston, and Jonathan Reichman; individuals at the New York Volunteer Lawyers for the Arts; and the environmental lawyer Marcia Cleveland, as well as in discussions after my appearances on panels at various universities.

Technically, the goal of the mock trial was to press for an expanded legal definition of *sculpture* that might include ecoart. Registering copyright for *The Blued Trees Symphony* had challenged the limits of VARA. In my successful registration of copyright in the fall of 2015, I was asserting protection for this ecoart project under VARA.

In preparation for a court case, my priority was to establish standing for the genre. I also wanted to establish how the legal theory linked and paralleled copyright and eminent domain laws to advance case law on ecocide and nonhuman rights, my ultimate response to the semiotic triumph in the King James Bible.

Eminent domain is part of real estate law, intended to secure lands for public works that benefit the commons. Ironically, conservative judges have found that law has been perverted in recent years for corporate projects that not only offer little benefit to the commons but also pose environmental threats to communities and at the personal expense of private landowners.

Copyright law developed in Europe, enacted first in England to protect the rights of authors and inventors. The United States adopted a copyright law in 1790. France initiated the concept of the "moral rights of art," which other countries have since adopted, to distinguish between economic and aesthetic intentions. The *droit à l'intégrité* acknowledges the author's right to protect a work from alteration, mutilation, and excessive criticism without permission. The term *integrity* in copyright law has been associated with decidedly noncommercial language, such as "soul, honor, transformative properties," and the "personality" of the artist, which goes beyond what subsequent authors have referred to as the physical embodiment of the "spirit of the art." Also, ironically, in light of current debates over economic ownership and copyright law, French

jurists' original goal was to contest the monarchy's absolute power over the culture.

Originalism presumes that the exact text of the law as first written requires absolute adherence. The originalist intention of eminent domain law, which developed as part of the 1804 French Napoleonic Code, was to protect the "sacred home."

When we devised the legal strategy, I speculated that those ideas might gain traction with conservative judges, who are often deeply invested in originalism.

My process of integrating elements from various art forms with legal policies and environmental science was a matter of layering rules and relationships. In 2009, before I began my dissertation work, I had attended the 15th Conference of the Parties (COP) for the Intergovernmental Panel on Climate Change (IPCC) in Copenhagen as an official observer for the University of Colorado at Boulder, thanks to Jim White. The event began inspirationally and ended in such a colossal failure that it rivals the devastation of the Trump administration's response to COVID-19. In the first case, it was the consequence of the panicky interference of fossil fuel hegemonies; in the second, those same hegemonies, as the historian Heather Cox Richardson has noted, had made common cause with oligarchic white supremacists.

But in 2015, I presumed the United States was still immutably governed by the rule of law. My intention was to create direct, practical engagement with the forests that protect watersheds and the legal rights that protect those systems. Before the 2016 U.S. presidential election, I was certain we could develop the legal theory and bring the premises to trial.

When the copyright registration was confirmed, it had positioned the project to contest eminent domain takings of private property and preserve forest contiguity. After the election, our prospects in the courtroom looked grimmer as the administration began packing the courts with legal proxies. The apparent rise of oligarchic fascism made navigating the U.S. judicial system that much more difficult.

The COP 15 had been the setting for my first workshops on trigger point theory, with activists in Copenhagen. The goal there was to

experiment with how an art-based strategy might serve to resist climate change. My takeaway from COP 15 was that if there is to be change, it will not come from governance. It will come from the ground up. *The Blued Trees Symphony* was literally from the roots up.

Data showed that natural gas infrastructure was already killing many thousands of the trees that might otherwise mitigate climate change and protect water systems. The Union of Concerned Scientists provided additional details about the damage from methane gas leaking from the pipelines. The producer/director Josh Fox modeled how to draw attention to the deleterious impacts of fracked natural gas in his film *Gasland*, released in 2010.

Nonetheless, private land has continued to be condemned and taken under the auspices of eminent domain law, under a current, novel definition of *public good*. The ecological cost of using fossil fuels dramatically outweighs any short-term corporate profits. That cost overlaps the interests of the whole culture by threatening communities.

Under VARA, the copyright issues go into the somewhat murky legal territory of "fair use," permitting others to source an original work for inspiration so long as the physical manifestation isn't tampered with.

Eminent domain law and copyright law intersect as a matter of public good as well as common good. Both eminent domain and copyright laws go to definitions of *property*, with deep historical roots in ideas about politics and philosophy that emerged in the Age of Reason. The intellectual paradox of the Age of Reason that fascinates me is in the simultaneous explosion of ideas about musical harmony and human rights even as slavery and other forms of oppression spread. Yet in the twentieth century, artists such as Robert Henri and Wassily Kandinsky and, later, the writer Susan Sontag began referring to these inherent qualities as not only a manifestation of integrity but the very "spirit of art."

That liminal legal space that von Tiesenhausen pioneered and I am still exploring is also where transdisciplinary work of all kinds might live: in the boundaries and ecotones where one or more disciplines dissolve, to reemerge with a new set of adaptive relationships. This is where ecoart can thrive.

As Carolyn Merchant pointed out in her 1980 book *The Death of Nature: Women, Ecology and the Scientific Revolution,* the fragmentation of disciplines and the natural world that emerged with the Age of Enlightenment had a mighty commitment to the same fragmentation and compartmentalization that reinforces racism, sexism, and patriarchal tropes. Merchant articulated what I had been experiencing and thinking about. To my mind, the tropes she described were, and still are, based in white-supremacist ideas about entitlement and impunity that are inextricable from colonial and extractivist entitlements. These fragmentations have no inherent logic that I can see except divisions of labor that serve capitalism to privilege a narrow demographic of beneficiaries. The more labor is divided, the easier it is for people in power to control populations. That model would hardly seem to serve the environmental challenges of the Anthropocene or support future biological life on Earth.

Should the liminal space between originalist conservative ideas about protecting "the sacred home" and "protecting the integrity of art" be recognized, it would force a discourse around whom policies of public and common good serve.

In talks, publications, installations, and other discourse, in Korea, China, the United Kingdom, Japan, and multiple venues in the United States, I have tried to advance provocative legal premises about ecoart. The stature of the project, critical to prevail in the courts, continues to rise as it evolves internationally as a symphony, an opera, a series of gallery installations, interviews, and writings by me and others.

The expansion of the project that had the greatest effect on me was the shortest in time and didn't involve any impact I might have had on a site. In the summer of 2018, at the invitation of Dr. Changwoo Ahn of George Mason University and funded by the National Science Foundation, a cohort that had engaged in the ecodialogue in Zaragoza attended a conference in Beijing to present our work. I presented trigger point theory and *The Blued Trees Symphony.*

After the Beijing conference, I traveled to Inner Mongolia, where I spent several days absorbing the phenomenal culture of the horse tribes. I saw a habitat devastated by climate change and Chinese extractions for

rare minerals. I saw how the people are trying to create a tourism industry and the vast concrete ghost cities the Chinese had built, inhabited by no one. I saw horses trying to survive on dry grass during the season when they needed to fatten up to live through the harsh winters. I rode a horse with no name through the desert.

I visited the Gobi Desert, where I watched workers pulling out struggling patches of colonizing grass so tourists could slide down hills of pure sand. I listened to my guide, Mongolian herself, disparage the tribes as "lazy." We drove by endless hills of monoculture trees being planted by lone workers, one at a time. I attended a spectacular horse opera depicting Mongolian mythology and history, which included a performance by young people straddling several horses at a time at full gallop to represent triumphant battles and whole herds of horses lying down in the sand to represent defeat.

I came home from China profoundly troubled by understanding how habitat devastation links across continents and by how modern "progress" is annihilating ancient cultures. My experience of Inner Mongolia broadened and deepened my thinking about how complex cultural patterns are being fragmented as much as the landscape mosaics that support them are, dying both from the edges and the cores, as much a manifestation of ecocide as Katrina or the BP spill, ecocide at a global scale.

Ecocide is a cultural idea, based on anthropological understanding of how communities thrive or collapse. We face planetary ecocide for a number of reasons, including climate change, overpopulation, loss of biodiversity, and habitat fragmentation, all arguably the consequences of the appropriation of just one word, *care,* by powers without regard for common good.

Jared Diamond's controversial writings popularized the concept of ecosuicide, which he proposed as the reason for the collapse of civilization on Easter Island. In fact, his premise has been contested, in arguments that the collapse was actually another European genocide caused by slave trading and diseases brought to the islanders. But *ecosuicide* is a valuable term for how dominant cultures have been perpetrators of these calamities. Jurists have been trying to unravel the painful confluence of genocide, ecocide, ecosuicide, and impunity for decades, with minimal

and incremental progress. Progress might depend on challenging how the manipulation of one word, which Spong called a sin, created the continuing religious entanglement in English law on which U.S. law is based.

Arthur Galston first presented ecocide as a crime for litigation at the Conference on War and National Responsibility in 1970, conflating it with genocide and the effects of Agent Orange in Vietnam. Ideas about ecocide gained legal traction after Galston's pronouncement. As the discourse evolved, interest from artists engaged with environmental issues accelerated, contributing to the rise of ecoart.

While I was beginning my dissertation work in 2010, considering the failure of governance and appalled by the denouement of COP 15, the UK environmental lawyer Polly Higgins was moving the legal discourse about ecocide forward. It was Higgins who proposed an amendment linking ecocide and genocide to the Rome Statute at the United Nations, which had established an International Criminal Court. Her amendment was argued in a mock trial in the UK Supreme Court.

Her legal theory helped pave the way for the children's suit initiated by Earthjustice against the United States of America. The children's suit went to the United Nations under a section of international law on "the rights of the child," on the grounds that support for fossil fuels had endangered their future. Greta Thunberg joined the suit to voice the necessity defense: that the imminent danger posed by fossil fuels to the entire Earth and future generations takes precedence over corporate profits. The basis for asserting that precedence is in the interdependence between public and common good. (Higgins's goal before she passed away of cancer in 2019 had been to litigate before the United Nations in the Hague on behalf of Earth rights.)

The advance of international arguments for the "rights of nature" has been framed as a cultural shift. The legal implications will be a global determination.

A mock trial such as the one Higgins initiated or the one initiated in 2018 with ABOG for *The Blued Trees Symphony* could still encourage future litigation.

The Blued Trees Symphony strategy was intended to be culture jamming—turning one cultural trope into another to effect the opposite

purpose for which it was intended. It reminded me of my performance *Stealing* in Allan Kaprow's class, as a structure that raised awareness of assumptions about trust. *The Blued Trees Symphony* turned conventional socioeconomic models and conservative legal assumptions around to serve an environmental and ecoart agenda as classic legal activism.

Since the legal theory we were advancing had no case law to support it, *The Blued Trees Symphony* was campaigning for a new category under VARA compatible with Earth rights. In 2020, the artist Eliza Evans launched *All the Way to Hell,* giving away mineral rights on her land to protect it from fracking. In all three cases, those of Evans, Higgins, and me, as well as in the case of von Tiesenhausen, we were all exploring new legal boundaries between ownership and place, legal manifestations of ecotone adaptation.

The copyright lawyer Gale Elston choreographed the mock trial for *The Blued Trees Symphony.* It took place on June 18, 2018, slightly more than three years after the project launch, at the Cardozo School of Law in New York City. Elston wrote and coordinated scripted briefs. She obtained participating lawyers and the judge and worked with Jan Cohen-Cruz of ABOG, who enlisted actors for some roles. Elston and others in her practice structured the trial, prepared arguments, briefs, and recruited Judge April Newbauer of the Bronx Supreme Court to adjudicate and the attorneys to perform pro bono.

I knew it would be raining the evening of the trial. Rain always triggers a CFS relapse for me. But I rented an elegant dark-blue dress. My hair had grown out gray since chemo, but I had it styled and booked a professional makeup artist for the event and ABOG's documentation by RAVA films. Erik McGregor, who had previously documented the performance of the *Blued Trees* Overture and the massacre afterward, shot stills. The courtroom was packed with colleagues and friends.

Elston and Steven Honigman represented me and *The Blued Trees Symphony* as plaintiffs arguing against the defendant, a hypothetical natural gas corporation. The jury delivered a verdict to defend the trees. Judge Newbauer rendered her judgment for a temporary injunction, and the transcript was recorded for later use.

As with Higgins's mock trial in the UK Supreme Court, lawyers argued the legal theory based on the testimony of witnesses, with real evidence, and a real judge rendered judgment. The difference between Higgins's legal theory of ecocide and the theory advanced to protect *The Blued Trees Symphony* was the role of presenting a new genre of art in a definition of ecoart entangled with originalist legal theories.

Newbauer ruled for a temporary injunction, with the proviso of advising counsel to seek resolution. As with the thematic binary of the sonata form, the ruling for a cease-and-desist injunction against the corporation had a twofold significance.

First, establishing art-world standing to merit protection became crucial as a means to emphasize the ongoing task of continuing to advance the legal grounds for the work. Newbauer explicitly stated that she made her decision largely on the basis of testimony from the art critic Ben Davis, who affirmed the significance (legal standing) of the work in a wider art-world discourse. As I had anticipated, establishing art-world standing to merit protection was crucial to Newbauer's decision. Davis positioned the artwork in the avant-garde of discourse advancing the role of law and nature in contemporary art. The mock trial provided a legal road map for legal experts bent on winning these cases in an real trial.

Second, Neubauer's injunction aligned with the philosopher of science Karl Popper's assertion about scientific theorems: if a counterargument might be imagined but a preponderance of evidence implies that a theory *could* be true, that can be the basis to accept the theory. In this case, Judge Neubauer's injunction, albeit temporary, left the door open for further adjudication on the basis of evidence.

I considered the trial to be a milestone in the project, an invitation to position the work for protection in a real courtroom and advance the legal theory.

The mock trial had moments of aesthetic levity and whimsy despite its gravitas. I had Robin Scully bring the cut remains of a painted tree from the Virginia site of a tree massacre into the courtroom, and a "tree translator" interpreted the song of the trees. *Blued Trees* music was piped into the courtroom and translated as testimony by the actor Toya Lillard.

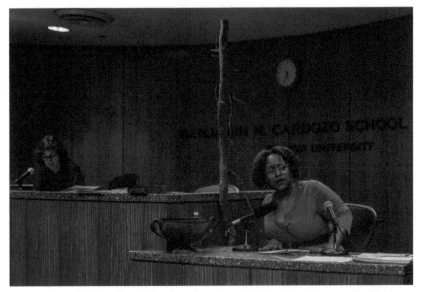

Listening to the Tree. Toya Lillard performing, with April Newbauer adjudicating.
Photograph by Erik McGregor, 2018.

Globally, ecocide, Earth rights, redefining common good, and water protection are broadening struggles. At this writing, a number of related activist protest cases against natural gas pipelines, including the Standing Rock case, are wending their way through U.S. courtrooms.

After the trial, I could hardly stand, due to exhaustion. ABOG had prepared a gracious reception, but I stayed for only a short time. I joined a small group of colleagues at a restaurant across the street.

Fictional legal dramas often imply a one-to-one relationship between theory and outcome. But the judicial system grinds slowly. The legal world depends on numerous litigatory experiences. In prosecuting ecocide or protecting *The Blued Trees Symphony,* case law might build to a conclusion over many more decades than our species may have to avert ecosuicide. But many legal options remain to be explored.

While I had been working on my dissertation, lawyers across the world had begun filing amicus briefs against major corporations such as Shell, Chevron, Chiquita, and the World Bank to protect "Earth rights" from ecocide. Meanwhile, natural gas corporations continued to argue

for expansion across the North American continent, claiming that profits and jobs from fracking gas and installing pipelines would benefit local economies for the "public good." Since Higgins's mock trial, the conflict between intransigent extractive corporations and those clamoring for environmental rights has increased, creating another counterpoint at a public level to parallel my themes in *The Blued Trees Symphony*.

The Cuban activist artist Tania Bruguera refers to her own increasing engagement and that of other artists in policy matters to effect change as "artivism." Artivists' work can cover a broad spectrum, as in the work of the late German artist Joseph Beuys, who was one of the founders of the Green Party in Germany and who established the genre of social sculpture to describe engaging with governmental policies as art. In the UK, Liberate Tate, Platform, and Art Not Oil, inspired by the devastating *Deepwater Horizon* 2010 spill in the Gulf of Mexico, began a campaign in 2016 for the Tate Modern museum's divestment from British Petroleum. These coalitions staged events and photo ops to enlist mainstream sentiment. Media-friendly images, such as pouring oil over a naked body in the Turbine Hall, advanced the public dialogue over fossil fuels, and their campaign achieved the success of disengaging the Tate from BP in 2017.

Across the Atlantic, the Standing Rock Water Protectors in North Dakota gained comparable international attention before Donald Trump's election. Trump was an investor in Spectra Energy, which the people at both Standing Rock and *The Blued Trees Symphony* sought to resist. Indigenous groups such as the Standing Rock Water Protectors often lead the fight against environmental injustice as their communities struggle to adapt to environmental calamity.

Who or what has rights has led to arguments for nonhuman entities. The relevance to *The Blues Trees Symphony* is in the recognition of the "common good" value in the integrity of other species, which challenges narrow definitions of commodified ownership and public good. A series of recent habeas corpus briefs to protect chimpanzees failed to prevail in the courts but did raise salient questions. Geomorphic features such as the Whanganui River in New Zealand and the Ganges and Yamuna

Rivers in India are receiving legal protection. These precedents signal a shift in global consciousness.

In the case of *The Blued Trees Symphony,* rather than copyright the forests endangered by natural gas pipelines, we had copyrighted relationships among human teams, the art, and the trees in a habitat. In writings and interviews, as with Brian Droitcour in Eleanor Heartney's 2020 *Art in America* article, I had been careful to refer to the work as *with* the trees, rather than *on* them. The preposition makes a critical distinction between presuming consumptive ownership and situating the artwork as an equal partner in an interdependent ecosystem.

Confirmation bias might be the trapdoor for any observation that leads to action. Dispassion is hard work. My trigger point rule that layering information tests perception assumes that mindfulness requires self-discipline. History is perception in retrospect, and we say that those who don't learn from history are bound to repeat it.

One way to consider history is as the organization of events in time. History organizes those events into a narrative. In physics, time is nonlinear, demanding that we consider events in relation to one another rather than as a string of direct causes and effects. Physics interprets events according to the effects that emerge from proximity, rather than through analytic interpretation of the connections. The preceding text described some histories of music and law that inflect my spatial and ontological perception. In turn, how I consider my own perceptions determines my choices. The history that trolls me is the resurgence of the same fascist values that Mother escaped.

The progress of change presents differently in art (including music), science, and law. Humans long for paths forward to adapt effectively to radical, complex change. Considering events in reverse, by studying history, often illuminates the future. In that sense, it is closer to physics.

The relevance to *The Blued Trees Symphony* is that CAM strategies may cumulatively represent an approach to climate justice that is as complex as the problem. I located *The Blued Trees Symphony* at continental and local scales simultaneously, in pragmatic legal discourse and in an

emergent understanding of how we might live sustainably with other species: "Think globally, act locally."

Generally, the idea from quantum mechanics about the power of small anomalies to effect dramatic change is central to trigger point theory. Biologically, species do not survive overpopulation and overuse of resources. Politically, the rule of the commons tells us we need rules. The question is, Which rules bring us closer to common good? Behind my six rules for trigger point theory are two more presumptive and implicit rules: the imperatives of empathy and transparency.

This writing presumes that art can help effect common good. In the case of trigger point theory and *The Blued Trees Symphony*, I could observe many points of convergence and layering by studying satellite photography and doing follow-up research—for example, the status of the Indian Point nuclear facility in Peekskill or the incidence and consequence of methane leaks from natural gas pipelines.

I was gambling on something that went against generations of hard-science dogma that disputes the value of empirical knowledge, particularly if at all subjective and even more so from a woman, an artist. That dogma only piqued my interest in dismantling and reorganizing systems that lead to ecosuicide.

The rules I identified can be implemented in random order or individually. Applying them together might yield the most powerful results. They can be broken down for closer examination.

First, the rule of the paradox of urgency is that there is time to change. Physics tells us that time is flexible and multivariant. Perception emerges from a range of elements in staggered time. But for progressives after the 2016 election, time was torture. Significant systemic change can be inspired in a heartbeat but not necessarily permanently, as we have seen with the COVID-19 pandemic. People accepted lockdown for a relatively short time, and then they didn't. Even in urgent situations, permanent change takes time because the emotional acceptance of change takes time and memories linger.

In music, the organization of tempos in time manipulates emotion. Law is also a continually evolving process of parsing justice in time. The

trick in life now is to accept the frustrating reality of urgency while sustaining the self-discipline of systematic and methodical work on problem solving, no matter how long that takes.

In *The Blued Trees Symphony,* my sense of urgency culminated when the Spectra Energy Corporation destroyed the trees of the Peekskill Overture. That inspired me to develop a long-term strategy for the project, to position it to affect public opinion over time. Musically, I defined the way forward as movements over spans of years in staggered relationships.

The First Movement of the project was performed at each site as a measure painted. That created contiguity across vast landscapes with trees as well as musical continuity to emphasize habitat contiguity. The Second Movement was composed for Newtown Creek, a toxic site, to analyze the prevalence of heavy metals such as mercury. The Third Movement, determined by the legal trajectory, is yet to be completed. It might be developed as a stand-alone opera project or remain unfinished, as justice sometimes does remain. The Coda was produced as a brief event for the weeks before the 2016 U.S. presidential election, iterated in a variety of forms for live and recorded performance. It was performed at the opening for my show at the Perspective Gallery days before the election. The text about justice and my apprehensive mood made it feel like an elegy.

The night of the election, as Suzi and I listened to the results, our spirits fell. Soon, it was time for me to leave. As I walked to the door, Suzi called out, "What do we do now?"

She was asking a rhetorical question.

My approach to my project for the next four years was determined by a conception of history as a number of delimited events not only strung together but also overlapping in time, with the capacity to study each event in relation to all the others, such as resistance to ecocide, toxic contamination, and political manipulation. After the destruction in Peekskill, I had to accept that I'd come too late to the party to stop the home wrecking. After the election, I had to accept the possibility of total defeat for the future that I and so many others had worked to rescue from disaster.

I had to make an even long-term plan. By 2020, I felt that the country was a mob of Russian dolls overcoming courts of public opinion and en-

vironmental policy. But public opinion changes with discourse. Discourse depends on education and trust.

The second rule of trigger point theory is that play will teach. Using a game to devise strategy is a time-honored military exercise. This is a familiar idea from many thinkers, as in John Dewey's writings on art and education and in the work of Georg Wilhelm Friedrich Hegel, as well as in science fiction texts, in contemporary game theory, or among Montessori educators. Many of these writers conflate embodiment with a free-ranging mind.

Learning through play means something deeper to me than taking a pleasant walk. A singing teacher at the Metropolitan Opera demanded that his soloists run around the theater as they sang their arias, to be sure they could cope with performance stress while integrating their craft with another kind of experience.

The very nature of transdisciplinarity plays in the liminal sphere between ideas. Play has allowed me to see where copyright and eminent domain might eventually overlap and define a new area for potential case law about ownership. *The Blued Trees Symphony* became my lodestone to find my way out of the nightmare of living in a country tilting toward oligarchic totalitarianism while the planet went to hell in a handbasket.

The third rule is that large chaotic systems have small points of entry. Self-organization can occur at multiple points. The legal overlap I had seen between copyright, eminent domain, and Earth rights to protect a work of ecoart, and considering how that overlap might define another way to think about artmaking and community organization, brought me to consider the whole world as my spiritual burden. The simple point of entry to manage that burden is empathy. The emergence of a new legal ecotone between copyright and eminent domain laws looked as if it might establish a new paradigm. Successful intervention depended on proposing the new category for VARA protection, of art in collaboration with trees and other species, permanently fixed in the habitat ecosystem of the land on which it is composed, integrated with empathy for other species.

Ecotones between systems are what transdisciplinarians like the physicist Basarab Nicolescu term the *in between*, the "space between," which

can open up to greater possibilities. In this case, my hunch was that the space between ownership and empathy might house a serious argument for Earth rights, affirming our collective ownership of the sacred home of the planet and the spirit of art in our relationships with all the species of the Earth.

The fourth rule is that we will see critical, unexpected, and opportunistic disruptions in sensitive initial conditions. The challenge is to notice the small anomalies in an otherwise predictable system that would be critical agents of change before the emergence of self-organization. Von Tiesenhausen's bold assertion of copyright power was an example of disruption. Spectra's destruction of the *Blued Trees* was also a disruption. Rather than discouraging me, the act of corporate vandalism and the tragic loss of forested habitat triggered my reflex of defiance and the continued expansion of the project. Grief was my disruption.

The fifth rule is that metaphors can be idea models for art to intervene in degradation. Trees are living metaphors for systemic interdependence. Ghost nets are what we tangle ourselves up in. Maxwell's demon reorganizes what we know. Rape destroys. The acoustic metaphors heard in a classical symphony present as a complex discourse between musical elements and instruments experienced in time. In habitats, contiguity negotiates comparable levels of complexity. That complexity achieves a harmonious balance that permits resilience.

Recent research about the complex systems of roots and fungi has revolutionized our perceptions of forest systems. Yellow fungal mycorrhizae constitute systems of communication between the layers of a forest, raising all kinds of questions about what thought might be. As with forest and water systems, that web of vegetative metaphors warns us to heed systemic contiguities and ecotone relationships.

In law, justice is achieved through the accumulation of many complex discourses rendered in individual instances of case law, comparable to forest communications. Justice is won in this aggregation. In every case, time is determinative and assumes metaphorical qualities. Even as the Trump administration consolidated power, people were talking about how forests self-organize.

The sixth rule, that layering information will test our perception of approaches to complex problems, wasn't just about data during the four years I was developing the ideas behind *The Blued Trees Symphony*. Layering data, as in GIS, can facilitate conclusive connections. Ecological disasters interact and cause cascades of secondary effects. Habitat fragmentation, as noted earlier, is not only a threat to watersheds and a source of loss of biodiversity but also a cause of new viral infections across species, contributing to imbalances that threaten human life. Personal events live on in all kinds of ways. Feelings and memories create confirmation bias that manifests in tragic ways, including irrational fears of the other.

In the book *Doomsday Dreams*, Eleanor Heartney identifies the disharmony of present events as an apocalyptic state of mind driving some artists to envision a "New Jerusalem." I don't know if I see a New Jerusalem, but I definitely see hope, if a narrow beam of light filtered through trees and illuminating a sometimes dimly lit pathway into the future is hope.

Scientific mapping, discussions with legal experts, the knowledge of local communities, and the recognition of the critical biological importance of individual trees and forest contiguity contextualized *The Blued Trees Symphony*. That data-layering approach to ecological design was rooted in my own previous work and inspiration from the seminal landscape architect Ian McHarg. The difference in *The Blued Tree Symphony* was that my layering went beyond assembling material data and ecological systems to include music, law, and my personal experiences to see where each might reinforce the others. The layer that came to my attention most forcefully as I seemed to exhaust my legal avenues and we drew closer to the 2020 election was hearing how many people were calling for environmental justice and Earth rights.

When *The Blued Trees Symphony* first began, I had once again been at my wit's end to stop climate change, but I thought I had a legal tiger by the tail to force the courts to align themselves with Earth rights. The project layered in all my previous research and drew on all my training

and experience. I felt invincible. I hoped that *The Blued Trees Symphony* would offer an expanded discursive knowledge space for common good.

As the hostile new administration set out to undo any good that environmentalists had ever accomplished, I felt very vulnerable. Five years after inception, while trying to develop a new measure in Minnesota, I felt sobered by the tactics our opposition was willing to resort to in defense of the economic status quo and humbled by my own limits.

Legally, I had multiple motives for a test case. Besides establishing ecoart as a distinct genre with copyright protection, culture jamming eminent domain law, and protecting the waters and contiguous forests that humans depend on to survive climate crises, the umbrella goal remained to win the case in the court of public opinion.

The phrase *spirit of art* implies a special, reverent relationship to art as a key element of human culture. That assertion of cultural rights agrees with findings from the IPCC that cultural aspirations, often entwined with spiritual values, must be given equal consideration as economic well-being while the human community attempts to resolve climate change and its secondary effects, such as zoonosis.

When I began *The Blued Trees Symphony,* I had three goals:

1. To perform with trees across miles of forests. This goal exceeded my original ambitions. Measures were performed from Washington State to Saskatoon, Canada, and from Baton Rouge to Florida, Virginia, West Virginia, and several points in New York State.

2. To legally advance ecoart as a new genre protected by VARA.

3. To suggest an alternative narrative to ecosuicide.

It seems self-evident to me that corporations have run roughshod over justice and due process in recent years to privilege a putative definition of *public good* over *common good*.

The songs of the trees have not been silenced, but they *have been* muted.

Science and the judicial system typically work more slowly than art or music to produce significant results, but all are pillars of civilization.

The Blued Trees Symphony may still inspire suits that avert apocalyptic ecosuicide.

This project provoked public conversation around *where* the spirit of art resides (as protected by copyright law), whether common good might be aligned with public good, and *what* is public good (as enshrined in conservative eminent domain real estate law).

I have argued for *The Blued Trees Symphony* as a case study in new strategies to attain resilient environmental policies. I described the context from which trigger point theory emerged as a CAM and the rules to apply that theory to environmental problems. This project suggests replacing arbitrary boundaries and rules with a *Blued Trees* CAM in which our vulnerability and interdependence with other life, such as trees, is protected. A transdisciplinary, synesthetic vantage may better equip us to counteract ecosuicide.

Trees inhabit a web of life torn apart by greed. In corridors slated for sacrifice, sentinel trees still sing arias in complex forest systems. Tree songs can still be heard from the measures that remain intact. Songs still echo in the memories of people who knew tree martyrs.

Suzi's question has haunted me since 2016. "What are we going to do now?"

In *The Blued Trees Symphony,* I dreamed a world that might survive climate change. It would be a sunlit world of complex communications and justice. Law would be based on common good, not capitalist patriarchies. I imagined that by proceeding from a transdisciplinary, synesthetic vantage, we might be better equipped to counteract ecosuicide by seeing where ownership meets Earth rights and cultural survival.

What I hadn't dreamed into the future or calculated into my original analysis in 2015 was the extent of devastation that would proceed from the results of the 2016 presidential election. I couldn't begin to imagine that.

11

Time

B y the time you, my reader, have this book in hand, world events
will have gotten much more threatening and conflicted or better
in some ways—or both, depending on global political willingness.
The pandemic has been a crash course in injustice for any of us who
have lived with entitlement and privilege. Links between religion, ecocide,
racism, patriarchy, sexism, speciesism, classism, and capitalism now seem
self-evident. They are all connected, and all are profoundly antithetical
to the common good. How could any of us have missed the clarion calls
for attention? But what hubris for me to assert that art offers a path out
of this disaster!

When you have this book in hand (or on-screen), I will have had
the time to figure out my future. I will have found a way to continue to
survive in New York City or will have moved back to Maine or somehow
have found the funding to do both. The economy and the environment
will or will not have gone into free fall for the whole planet and all its
citizens, human and nonhuman alike.

I wanted to contribute to a better future, no matter what happens.
If you have walked with me on this path, perhaps I have succeeded in
pointing out stories and concepts that were moving, inspiring, informa-
tive, intriguing, entertaining, useful, or all of these. In the time you have

given to read this book, you have had time to reflect on how relevant to you the trigger point theory complex adaptive model I propose may be.

Writing this book didn't stop my artmaking.

In *Hunt for the Lost*, the small point of entry that I intended to playfully provoke critical thinking without judgment about was the installation of signage and the assemblage of painted branches. The sensitive ecological conditions from which *Hunt for the Lost* emerged was the collapse of rational national discourse. The paradox I observed as I wrote the prompts for the signage was that learning to think critically, which is at the heart of liberal education and can take a lifetime, had taken a backseat to urgent factions clamoring for precedence. The metaphor I applied was a scavenger hunt. My goal was to disrupt familiar patterns of thought around charged issues.

Each week, new prompts for the *Hunt* were suggested on social media—such as *Lost Forests*, which turned out to be very popular, or *Lost Courage*, which got no responses. Responses were posted on a website (www.huntforthelost.org). Appropriating the metaphor of a game was a device to tell a story. The "winner" of the game wasn't an individual. The winner was the lost agent that got the most responses: *Lost Wings* was the runner-up, second only to *Lost Forests*.

Lost Wings

Wings are gone.
The wings once flew to the moon.
The moon is an uncertain destination.
The moon lives inside every human.
Wings carry dreams to the moon.
Without the flight of wings, the moon will die.
We can find wings inside our own minds.
Without the flight of dreams carried by wings to the moon,
We will die, too.
The moon will die in our own minds first.
We cannot save the moon without the wings of dreams.
If you find at least one wing of a dream, you might save the moon,
And yourself.

I designed the work to mimic conventional political yard and window signs. Posts for each prompt went on social media platforms, on the project website, and into weekly eblasts to my followers. The signs were installed at multiple sites on Governors Island after my studio reopened, to create a trail of conceptual bread crumbs. Several were placed on the lawn outside the public bathrooms located in the LMCC building, so people would have to pass them as they went to use the facilities when they got off or on the ferry.

After the first lockdown, at the height of summer, park workers had told me that at weekly foot traffic past the signs still averaged sixteen thousand people a week. Before the pandemic, that might have been the daily tally. The signs remained up until ten days after the election, by which time the island had closed for the year and I was preparing to leave my studio. My LMCC residency had ended.

In the island's Lavender Field, across from the landing for the Brooklyn ferry, I painted and installed an assemblage of fifteen twenty-foot-long branches with the same nontoxic casein of ultramarine blue and buttermilk I had used for *The Blued Trees Symphony* and *Blue Rocks.* When the signage came down, the assemblage would disappear soon after. Marisa DeDominicis and I planned to make the branches into *Blue Art Mulch.* We planned to auction off the mulch to support Earth Matter, which had become one of my sponsoring organizations, making the dead wood into materials for new life in someone's garden.

Before the election, it seemed that words such as *empathy* or a phrase like *law and order* sometimes triggered passionately narrow, shallow, and judgmental reactions among constituents, with tragic consequences.

"Languaging" the prompts was a semiotic experiment. I wanted to use words to invite people into an alternate world, where speculations might generate the dispassionate discourse I yearned for before the election. The trigger point rule "play will teach" applied at every turn to ensure that this process might be fun and intriguing, building muscle for more complex thinking.

Besides *Hunt for the Lost,* I made smaller experiments, as with a signature screen image that made my face blend into a background image of water and ducks for Zooms. I wondered, as we all sank into isolation,

whether we were blending into a global environmental event that erased all individuality. The photographer Grace Roselli did a portrait of my self-portrait effect for her own project.

I coedited the book on ecoart pedagogy *Ecoart in Action: Activities, Case Studies, and Provocations for Classrooms and Communities*. It had evolved from the Ecoart Network and been my dream goal for the ecoart community since 2005 to reach a broader audience.

In Photoshop and PowerPoint presentations, I experimented with a series of maquettes based on one of my last studio projects, a thirty-foot-long ink drawing of the praying-hands motif on translucent Japanese paper. Yearning for deliverance from our pandemic catastrophe was the message.

As I sequestered, I tracked the science on COVID-19, watched the seams unravel between communities of inequity, and tried to imagine the world that might receive this book in what began to seem like a very faraway future. The vistas I imagined were set on a grand stage for a global tragicomic opera set to a score that nature composed, with an incoherent and indecent libretto sung by distracted politicians in counterpoint with others of all kinds.

The pandemic collapsed our experience of time. In that collapse, I thought a new landscape of hope might emerge like an island thrusting up from the sea after a seismic event. In February 2020, most of us had taken the relative stability of our interdependence with soil, air, water, and the animals of complex habitats for granted. Humans proliferated without limit. We disregarded the integrity of habitat systems, the lives of other species, and, during COVID-19, even one another's lives. Those entitled impulses to expand, consuming the land and its living residents of habitats where humans were once rare, have implicated us all in eco-cide. If I had any doubt about the extent of human culpability, at least in the First World, the pandemic uncovered systemic collusions, from autocratic governments, avaricious fossil fuel corporations, entrenched patriarchies, and white supremacy.

I still imagine hope in the crucible of honesty. Many more of us can now choose to see clearly the scale, depth, and breadth of terrible things that the status quo has hidden.

I continue to see the pandemic as a spectacle, replete with the clash of metaphorical cymbals and the blare of Klaxons. In the United States, hope turned to despair as right-wing politicians figured out how to game the system to further enrich themselves, consolidate fascist power, and ignore suffering and death. We will not know for a while if empathy is a mirage. But the research I did for my dissertation implied to me that we might simply rearrange the agents by having some empathy for the effects of our behaviors.

As I write, researchers are projecting not only that the virus will be with us for up to two years but that it is the leading edge of waves of zoonosis caused by many of the factors identified by the Club of Rome in the 1970s and neglected in favor of unlimited "progress." Perhaps this might be an occasion to rethink things.

Since the Club of Rome was established, some researchers have considered how many sectors of culture might contribute valuable insights, represented by individuals who might eventually be deemed "expert witnesses" in a court of law. I think art and artists should have also been expert witnesses there.

Technology rules. Technology is the cause. Technology flattens the world. It complexifies the world. It oversimplifies things. The lockdown halted time even as the arrow of time sped on Zoom's wings into projections of what our future as a species and civilization might be. Accepting humility and sadness changes nothing that concerns me in the greater world, but it mitigates rage and enhances wisdom. In the night, my mind eludes sleep, as thoughts race forward in time on a blinding trajectory in the wake of the impact of this global virus with ideas I fear might escape before morning.

As I wrote from the midst of the COVID-19 disaster in New York City, I was no less horrified by what I witnessed and no more adequate to protect anyone from threat or uncertainty than I had been after Hurricane Katrina. We had more opportunities in 2005 than we have today for wise precautionary ecological choices and to prevent disaster. Humanity seems to routinely choose going forward into the future blindly. I am no different. During the lockdown, despair often brought me to my knees.

At those times, I stared blankly at a white wall. But I have written this book because in spite of my dystopia, I am a true believer.

At least into my forties, I had that recurrent image of a white and empty place, probably my memory of how I was incubated. Once again, I recall Mother's sewing room as I survey my personal landscape.

Mother died just before I installed a major project at the Hudson River Museum in 2003. The show was *Imaging the River*, curated by Amy Lipton, with whom I had often worked. My work was called *Through a Glass Darkly*. The reference was to a verse from the King James Bible, 1 Cor. 13:12: "For now we see through a glass, darkly; but then face to face: now I know in part; but then shall I know even as also I am known."

A series of occluded views out the museum windows, to the gray-blue river waters below, inspired my installation. I painted a grid of landscapes in a style reminiscent of the Hudson River School of the nineteenth century. The painters of the Hudson River School had set out to celebrate the river and ended in defacing it by attracting industrialists who befouled it. The installation had two parts, one indoors and one outside in the parking lot. In the parking lot, I mounted a sign that read, "HERE LIES A FORESTED STREAM. ONCE, IT FED THE HUDSON WITH CLEAN WATER." Internationally, the ecotones and tributaries of many rivers have been paved over for development.

Our sensitivities to others in this COVID-19 time often seem paved over even as we collectively face death. In 2003, I vainly hoped my signage might inspire some landowners to daylight some of those tributary streams to feed the Hudson. As far as I know, it did not. In 2020, besides needing many black swans, we have many opportunities to daylight ecological hope. As with the *Ghost Nets* estuary, the tributaries to many waterways can still be daylighted.

In March 2020, when I began writing this book on the Upper West Side of New York City, my previous rages over environmental negligence were nothing to the incandescent white-hot rage that coexisted with black depression for me during most of the pandemic. But the truth was, a lot of my anger was selfish. I felt enormously betrayed and put upon.

When the lockdown first began, my reaction was supercilious: "I told you so."

In Greek mythology, the god Apollo admired Cassandra and gave her the gift of true prophecy. But when she refused to have his child or just turned down his advances, he cursed her. Her fate was to never be believed. I saw myself as a Cassandra or an elderly Joan of Arc, futilely screaming in the wilderness: "The sky is falling! Climate change and over-population will lead to zoonosis and cause escalating pandemics!"

My pleas for attention joined an unheard chorus with legions of scientists, activists, and many others who had also been staring at the writing on the wall till we were all cross-eyed and our hair, on fire, had long ago singed our scalps. Aspiration, divination, faith in fairy tales, modeling— these are all human efforts to control horrific futures that may remain intractable.

My frustration peaked even as I kept venting over the helplessness I defied. That was when I began furiously working on this book, imagining that I might articulate or portray something to arrest future tragedies. But as I worked, I had to face my limits in time, stamina, insight, wisdom, and, above all, power. Even as I pounded away at my keyboard, I daily accepted ever more loss with each account of needlessly mounting casualties. Daily, I felt ever more horror as what seemed like a lack of thoughtful planning kept leading to ever more grief, reflecting ever more stupidity and, finally, death. Eventually, I leveled off in my rage and just kept typing. But every time a right-wing politician got on public media to trivialize the crisis, I drowned out their voice with invective mantras.

In the spring of 2020, I felt that I had found myself in the patriarchal world of my youth, which I had imagined I had escaped and transcended. The overriding message from the U.S. president and his supporters was that resistance against the privileged white male domination of the world is futile. But I was unwilling to be a good student of learned helplessness or even oversimplification.

My apartment is at least four times the size of my mother's sewing retreat was and is far larger than the monstrous cages that immigrant children have been forced into. It is ten steps in one direction and thirty steps

in another. What is identical is the reality that my life is circumscribed. No dinner parties. No dates. No way to consider the future. What is totally different is that most of the world now is sharing my confinement.

As I manage the pathway between the furniture of my bedroom and access to my nominal kitchen and pathetically small bathroom, I dwell on why I don't think this globally communal experience of injustice is going to be an anomaly.

It seems to me that anyone with half a brain should see that this is the first time that most humans on the entire planet have been simultaneously experiencing the catch-up consequences of centuries of environmental neglect. As most of us try our best to cope with radical uncertainty, it is glaringly obvious that an entitled and privileged few feel and often are excluded from misery even as they, as a class, are often responsible for causing incalculable misery for the rest of the world. Equally, vast numbers of people of color and particularly poor women of color have been experiencing a special misery throughout our society: caring for the more privileged and enduring risk even as their charges blithely squander dwindling resources.

Hurricanes Katrina and Sandy didn't appreciably change Americans' behavior. The fires in Australia haven't stopped those who profit from coal mining. The drivers of an economic system that relies on cruelty toward most people who labor at low wages and on the extraction of foundational resources, resulting in the fragmentation of forests and the pollution of air and water, continue to accelerate.

Ian Dunlop is a former oilman from Australia whom I met at a United Nations event in 2010. Dunlop did the math about all the possible impacts on human life from the use of fossil fuels, from the flooding due to sea-level rise to pandemics, and predicted that without emergency interventions on a global scale, the human population would drop from eleven to two billion people by 2030, although the United Nations thinks we will be just shy of eleven billion by 2100. During a *Gulf to Gulf* public webcast on Vimeo, Jim White and I reviewed and confirmed Dunlop's math. Therefore, I was not—could not have been—surprised by COVID-19, any more than by the causes and effects of climate refugees whose plight became obvious in *Trigger Points / Tipping Points*.

In casual conversations since about Dunlop's predictions for 2030, I've been asked two questions, both of which depend on future events. First, where will I go that's safe to live out my remaining years? Second, what can I hope to accomplish with my work if all might vanish in a handful of years?

The first question is harder than the second. I located the *Ghost Nets* site thirty years ago as a refugium to ride out my lifetime while being a laboratory for trigger point theory. It still is that laboratory. Just as the pandemic emerged, Josh Franco from the Smithsonian Archives of American Art contacted me to be a repository of my papers. So the accounts of how I got to my thinking and practice will have a home in another kind of refugium even after I'm gone.

Refugia is a biogeographic term to describe places where remnant populations of species might survive biological catastrophe. I am still thinking about refugia and where they might be. Thirty years ago, like the grasshopper who lives for summer instead of the methodical ant, I did not plan to grow old alone with uncertain financial means. Vinalhaven seemed like a fine refugium then because it was geographically positioned for safety. The Atlantic Ocean makes it the ultimate gated community. But that's also the island's vulnerability. In 1990, I couldn't envision living with cancer in a remote place as I grew old and possibly poor. Where I might live now will depend less on geography than on how time visits age on everyone.

I have other realistic fears. I fear sea-level rise and its impact on all coastal communities.

A far larger new worry is the worldwide resurrection of fascism, with its implications for global justice. The seduction of fairy-tale narratives of simple solutions is profound, powerful, and tenacious. Jane Austen's world may not be so far from Margaret Atwood's in *The Handmaid's Tale*. Fascism and totalitarianism are the siblings of extractive patriarchies. I would defend the personal narrative I have recounted here as a reflection of ecofeminist resistance in many people's lives to the abuse of power. Addictions, some forms of religion, and strongman politics have always offered tantalizing fairy tales of safety to the unhappy and defeated. Now is no different. I understand all too well.

The goal of totalitarianism is economic prosperity for a few regardless of the cost to the many. It is not a *with* system of government. Eventually the bill for short-term prosperity for a few tends to come due, with interest, for the many. Neither fascism nor totalitarianism represents a civil society that fosters much art, let alone science. What is civilization without art or science? I believe people yearn for civilization as much as freedom.

The strongman of this hour is the golem who will inevitably manifest Dunlop's statistics: Trump, Bolsonaro, or Putin. Strongmen in reality are as seductive as the supermen and superwomen of fairy tales.

I'm not a super anything. Even if theory as a systems change might save the world, mine is based in a belief in the power of art, which, no matter how powerful, is still just candlelight in the dark.

It wasn't until I was in my forties that I learned the fate of my maternal grandparents. At the end of World War II, my maternal grandmother, Hannah, had overcome her deference and pride to beg my mother, then married in Palestine, to send her parents funds to escape before it was too late. But Father was a violent man who had intimidated her into silence. She confided her failure to me.

My maternal grandfather, Joshua, had embraced his own fairy tale of assimilation in Poland. He was a patriarch, modeled on strongmen. Joshua was a tall, handsome, blond man with an impressive mustache, proud of his attractive family but, like my own father and then my husband, with his violent temper. His last name wasn't typically Jewish. He was pleased to find a public monument to a general who shared his surname, Zoltoc. Joshua's delusion of safety doomed both my grandparents.

Białystok had become a hub of Jewish resistance against the Nazis. Joshua greeted the Nazis with a gun at his front door and shot them dead. Then he shot his wife, Hannah, and then himself.

By the time I heard Mother's story, I had long settled into my own lifelong patterns of defiance, inveterate risk taking, persistent denial of the implications of my family's violent past, and my own occasionally dangerous or frightening experiences that made for an exciting but profoundly unstable life. Then, I embraced a family heritage of resistance to

tyranny. Now, I simply yearn for my own impossible fairy tales of safety even as I face the real political vistas unfolding before us.

When my sister, Ilana, read my account of the story of our grandparents, she scoffed, "Where would a Jew have found a gun then?"

When I did my research, I learned that Białystok had been a center of Jewish resistance.

Still, I continue to consider. Could trigger point theory have saved my grandparents? Did Joshua have a small window in time when he might have reconsidered his own stubborn defiance and saved himself and Hannah before the Nazi grip tightened around Poland and before Mother chose silence? Probably. Joshua's choice nags me. It was eighty years ago, and my grandparents' bones have long since joined Bear's, Shiva's, Natasha's, and Duke's in the dust of history.

But I still wish I could know, at what moment did the arrow of my grandparents' time break midflight when Joshua missed his trigger point?

What remains is my own measure of awe and sadness that my mother lived alone with these choices for about forty years. I don't recall having had any words of response after she told me.

Fascism rages and flourishes across the globe now, reputedly fueled by Russian political ambitions and entrenched oligarchic messaging. But it is just as likely a Malthusian answer to human foolishness. Now, that dark shadow of historical persecution and murder haunts me.

Several of my father's stories were about defying anti-Semitism. In one that sticks in my mind, a friend who was an officer in the Royal Canadian Mounted Police invited my father to their Officers Club. As they entered, my father's friend turned to him and said, "No Jew has ever entered this building."

Father replied, "Good. Then I'm the first."

Before I transferred to NYU from Parsons, I had applied to Sarah Lawrence College, which would have been my first choice because of its renowned theater department. At my application interview, the interviewer remarked, "We already have so many students like you." Did she mean they had a Jewish quota? It never occurred to me to ask. How many young Black women might have heard the same offhand comment if they got as far as an interview? Anyway, I was rejected.

The older I get, the more empathy I have for my own imperfect humanity. I have come to respect my father's complexities and accept his inadequacies and their effects on my life as I have tried to reorganize the data in his lessons about land. He taught me the meaning and value of defiance in life and taught me when it is insufficient. This is not the passive resistance of Gandhi's *satyagraha.* I want to seize the keys to the alternative kingdom, where armies of black swans live in harmony with common good.

Any human life is replete with trigger points. Turn right or left on a path. Marry this person or another. Leave under threat or stay in a place you love. Art is the same: choose this color or another, that venue or another. I can't guarantee that trigger point theory can reliably predict the future. It only suggests how we might observe what we know in a different way and how those observations could lead to insights into the probable outcomes of future complex relationships.

There's the possibility that for all my research and contemplation, I have it all wrong.

Except, not really. Saying that trigger point theory is based in a belief in art is disingenuous. It came out of *Ghost Nets,* out of the conviction and then the qualified proof that art could repair a degraded world from a series of experimental tests—in Bergen-Belsen; Pleasant River, Maine; Memphis, Tennessee; and so on for the *Cities and Oceans of If.* When corroboration didn't come fast enough for me—because, really, monitoring restoration takes much longer than reestablishing key species—I went after the law. Law is glacial but maybe faster than restoration. That still wasn't fast enough for me, so then it came to ordinary conversation in *Hunt for the Lost.* What is needed now is for others to test my premises.

If we track the loss of fish species, for example, in the Mississippi Water Basin, we might identify where targeted restoration work might intervene in habitat loss from hypoxia in the Gulf of Mexico. If we study hydrologic changes in deltaic systems from global warming, we can own our responsibility for waves of climate refugees. If we observe probable cascades, we might reconsider the point where we open the Arctic. If we consider convergences between Earth rights and ownership, we see where

judicial reform might better align with common good. Guided by trigger point theory, I found insights from my practice before they appeared in science journals or were discussed in the media. In each case, small points of emergence predicted outcomes. Timeliness can be everything. Without discounting the work of science to verify facts, art can be prescient.

When I set myself the task to implement *Hunt for the Lost* before the U.S. presidential election, I believed the election would be a historic trigger point. Was the work I produced compelling enough to reach anyone whose vote might have mattered? Did I find the best venue to open the widest-possible discourse? I can't know.

The ecofeminist analysis about land that I understood in the 1980s conflated ecocide and racism with capitalist extractions. Marcuse's lectures made clear that communism as Karl Marx had imagined it had never been realized. Communism was an ideal that was a cousin to democracy; neither was ever fully realized. The question I continue to ask despite every challenge is, "What are the agents we need to consider in relationship to one another that might point us to a resilient future for all peoples, all species that inhabit the Earth?" It seems to me we have to consider a lot more than we used to think we had to include in our CAMs.

Discrimination is a reality that my Black friends know much more profoundly than I, with far more devastating personal and economic consequences as they resist learned helplessness. The flood of stories, ghastly events, and historical information since George Floyd's murder has made that glaringly obvious. It has been brought painfully home that a Black person's skin color announces that person's social and economic vulnerability and determines cultural access before they speak a word. I had long known of environmental injustice, but redlining, for example—the practice of barring Black families from real estate purchases, probably in all the neighborhoods I knew as a child—was new and appalling information.

Owning land is a toehold on financial security for most people, at least in the United States. But other relationships to land are possible, as so many Indigenous cultures have tried to teach us. Many of us have learned a great deal about land ownership, tribal identities, power, and inclusive culture during the pandemic.

The answer to the second, easier question in response to Dunlop's grim prediction—What might I still accomplish?—is that I am working for the human refugia of the future, those places where remnants of civilization, knowledge, and art might be trigger points to slowly help our species rebuild from the devastation we insist on wreaking.

Of the rules I identified to apply trigger point theory to how agents interact in relationship, in instances of environmental degradation, the rule about time has given me the most pause. Is it truly always possible to take time in an urgent situation? Even as whole species and peoples vanish forever? Is, as Daniel Kahneman warned of fast thinking, the danger of intuition that a spontaneous and intuitive lurch could endanger hope for the world?

I spent my whole life trying to puzzle out illogical things until I came up with trigger point theory. The impossible task I set myself in March 2020 was to look into the impenetrable future by sifting through the past to project possibilities. I write in the present to be read in that future.

Prophesizing isn't an avocation that leads to security even for the best seers. Cassandra's life as a seer did not go well. Ajax raped her. King Agamemnon made her his sex slave—well, they called it "concubine," a mistress or wife without status. It amounted to more rape. Then she was murdered with Agamemnon. Cassandra was "right," but her status as the daughter of King Priam and a high priestess and her foresight or divination availed her nothing. I am neither a high priestess nor—no matter that my father might have been a man of power or that he called me his princess—the daughter of a king or a princess in reality or in any fairy tale.

No matter how long I live or how competent my skills, I can no more guarantee that anything I do can determine our future than I can force-feed the *Gulf to Gulf* webcast on Dunlop's work to the billions of people at risk from ecocide. Making art is an act of Zen faith.

I met the Nobel laureate Wangari Maathai, who initiated the Green Belt reforestation movement in Kenya in 1977, at a conference where she was presenting. She told a story of a great forest fire. As all the big animals fled, the elephants and lions, one tiny hummingbird flew back

toward the fire with one drop of water in her beak. When the big animals all laughed at her and asked her what she hoped to accomplish with one drop of water, she replied, "It's all I can do."

The point of Maathai's parable wasn't about how realistic adding one drop of water from a hummingbird's mouth en route to a forest fire could be. It was about faith and willingness to do what you believe in, that it could be the trigger point. Maathai's drop of water was an initiative that planted fifty-one million trees in Kenya, one tiny sapling at a time. In an installation for the 2005 show *Groundworks,* curated by Grant Kester in the Regina Gouger Miller Gallery at Carnegie Mellon University, I showed references to as many artists and organizations as I could think of working on ecological restoration, with images from the sites I had studied for *Cities and Oceans of If.* I called it *Hummingbirds in Situ.*

Learned helplessness is blinding and toxic and requires great energy and time to inculcate and perpetuate. Defiance might not have been the most efficient skill to carry me safely through the rest of my life, but when I watched the effects, even when I felt I had paid a steep price, I learned that even in the face of violent danger, I am never helpless.

Where then, I ask myself, could trigger point theory divine hope for humanity in our present? How could it make a dent anywhere in this cascade of catastrophes? For trees? For cats and dogs and panthers and lobsters and finfish? For ordinary Americans of any color? I have offered a set of skills to sort out unpalatable complexity so we might make better choices. But have I ever made sane choices for myself? Were my mother's choices any more or less sane than Grandmother Hannah's, Joshua's, or my own? Can anyone make a sane choice in a chaotic moment?

Perhaps a more precise question is, Would we be *willing* to share the Earth *with* other life? In any CAS, it is the *with* of interaction that determines outcomes, that mobilizes willingness when hope is scarce.

Where are Wangari Maathai's hummingbirds when we need them? In the 1960s, I convinced Pays about the necessity of going to demonstrations by arguing, "We each need to be one more body protesting the war." Hope is a relative concept. Hope for what? For whom? Stripped of dispassion and hope, nothing is left but passionate willingness. Angela

Davis has spoken to the necessity to sustain passion, regardless of what is said or done, until the moment of opportunity for action arrives. We never know when that moment might come, but we can be prepared.

While writing this book, I was included in *ecofeminism(s),* a wildly successful group show, curated by Monika Fabijanska, that opened early in June 2020 at the Thomas Erben Gallery in Chelsea. Making the show a brick-and-mortar event was a courageous choice. Few businesses had reopened. Even fewer commercial galleries braved conditions in the city to open for in-person visits. To choose ecofeminism as the theme for a commercial gallery at that political moment in the United States was a strong statement. In the many reviews, over and over, writers referred to the affirmation of what art and art galleries are supposed to be: harbingers of where the culture must go. I was moved to have *Physical Education* (1973) chosen for the show. It was not only the oldest work in the exhibit but affirmed the consistency of my vision as an artist across my lifetime; one writer phrased the tragedy I presciently represented as "flushing the ocean down the toilet." The show heartened me as much as stopping pipelines had. The success of the show emerged from the same art-world system that often valorizes big toys for rich adult kids. But the curator, gallerist, and writers culture jammed the system and sent a broad message to society of many hands clapping to make the sound of one.

This text has turned on metaphors. Rape was the most emotional metaphor. Ghost nets were the most painful metaphor. A symphony was the most joyful.

Maxwell's demon is the most hopeful metaphorical model for serious change that I know: promising that reorganizing data can change everything by creating new relationships. We need to look at the elements we might reorganize with fresh eyes and assume the possibility that what is familiar is not the entire story. That is a discursive process in which the introduction of additional stakeholders could impact results. Can we agree that art can be the demon, the black swan that changes how we consider data, the story, the vista, even the community?

What is notable about Maxwell's demon is not only the demonstration that imposing a rule for order expends energy and therefore increases entropy in a closed system but also that the very existence of the demon is a black swan, an anomaly whose emergence defies expectations or quantification. I have proposed that art is Maxwell's demon. Once we have conceded the possibility of a wider path, a bigger story, would data, events, relationships, and outcomes manifest differently, even, more easily? Unlike Maxwell's demon, our present is theoretically occurring in an open system, except I would argue that we live in a lethal patriarchy that makes the present another closed system.

This book was never intended to be abstract. I want an army of black swans and hummingbirds, assertions of the clairvoyance of hope despite despair.

The effect of listening to Mother Nature's silent musical score during lockdown was to arrest my personal sense of time despite a state of urgent global emergency. Recovery from COVID-19 will require many black swans to lead us back from the brink of systems collapse to sustainable self-organization. *When* is the qualification on all history, but *how* is what determines justice and beauty.

If some economists don't expect a full recovery from the consequences of the pandemic until 2028, that would be only two years from Dunlap's prediction of a drastic population drop in 2030. There are already reports of starvation and homelessness. I have heard speculation that 90 percent of cultural institutions will permanently close their doors. And if the United States sinks into fascism, all bets are off.

My task is to keep flying toward the fire with one drop of water. I have joined others flying into a strange, flaming landscape seeking promises in flames. If there's a paradox between negotiating urgency and time for change, sometimes I still find myself waltzing alone as I try to hear the meter and rhythm of the music. At other times, I know I am part of a global community that thinks alike and is dancing a tarantella together. Both are true.

Hunt for the Lost felt like a culmination of my experience of this seminal political time, the silent music I waltzed to, discourse as dance. Could I

segue from waltzing with authority to dancing a tarantella with the future while making the sound of one hand clapping? The waltz and the tarantella are both courtship dances for couples in communities—one for the court, the other for the peasants. Either way, I think we all need to learn new dances.

The *Hunt* wasn't my last work at LMCC before I left.

Seizing time by making art affirms my reservoir of hope in the face of despair for our species. I need hope that isn't just about me. I must not forget that none of us is dancing alone.

When this book is published, you will know more about how this story will end than I can predict now no matter how diligently I apply the rules of trigger point theory. Everything is subjunctive and conditional. We will still have to survive a world of complexity and chaos. Can the lions of rage and entitlement lie down with the lambs of empathy and democracy?

Let me be clear. I am not trying to assert causation or even what variables indicate causation for trigger point theory.

The agents we are all considering are probably more similar than not. The point of view I have presented is different from accepting hierarchies, patriarchies, fairy tales, learned helplessness, or competitive attitudes that end in winner-take-all outcomes and leave out almost everyone and everything else. I have proposed rules to observe nodal relationships between agents in a CAM and to discern small points of emergence. I have referenced those points with many similes and metaphors—ecotones, trigger points from acupuncture, black swans, hummingbirds, Maxwell's demon, a drop of water, clapping hands, a dance, a symphony, or a path—and contrasted them to rape, entangled ghost nets, and the environmental fragmentation that causes zoonosis. I imagine a world of happily dancing cytokines making everyone joyous, peaceful, and free. Symbolically and practically, conserving ecotones that sustain habitat contiguity may be the most critical metaphor of all, even more than Maxwell's demon. Or maybe the pandemic is the ultimate metaphor.

The pandemic has given me a window of time to tell this story about discovering a path and to polish it in this period of uncertainty in isolation. Trigger point theory is an artwork, a drop of hope flying in the

face of despair, in defiance against apocalyptic probabilities, dysfunction, and division, a complex adaptive model for the ecological crises ahead, a vision of what art could contribute to change, the ephemeral sound of one hand clapping.

Might this account help you divine your own path through chaos to hope? To engage in a big campaign to end ecosuicide? That would be the bigger story. These are sensitive initial conditions in time.

There will be another time. Meanwhile, if you can, put your hands in the Earth or embrace a tree and listen for the music of emergence.

Epilogue

have asserted that transdisciplinary strategies might help us divine our way out of a chaos most radically manifesting as ecocide. As with applying Boolean conjunctions and prepositions to considering the dynamics of Maxwell's demon, the rules of applying trigger point theory all exist in a state of complex relationships in a hypothetical world whose openness seems to make the ever-increasing uncertainty of our lives almost impossible to embrace. Without fairy tales, this process is hard work, although joy along the way is very helpful.

Trigger point theory is a methodology to divine hope from chaos. Other artworks I've discussed make up a string of intuitive knowledge nodes: escape, recovery, physics, ecological restoration, empathy, fish as indicator species, ownership, forest contiguity, legal theory around Earth rights, cultural first responders, and ordinary conversations about extraordinary matters, such as morality and snow. And then there are dreams and life events.

Let's take a cursory look at some correlations between the two projects that establish my greatest claims for trigger point theory.

Ghost Nets	The Blued Trees Symphony	Correlations
Vision of a series of ecotone relationships in a large landscape system.	Vision of the relationships between ownership of goods, intellectual ideas, and land.	Breaking down the perceived elements of an in between of knowledge spaces.
A performative process that used language to change perceptions about time and ecological relationships. It resulted in different conditions on the ground.	A series of legal steps to establish a theory of ownership. It culminated in a mock trial, which established an injunction to present the legal theory for other lawyers to explore.	A series of recognizable events that changed possibilities on the ground.
The imposition of poetic metaphors on a pragmatic process of changing a barren landscape to a rich habitat.	The organization of actions with legal implications around spatial and musical ideas drawn from classical music theory.	Reorganizing practical processes with ecological and social implications around aesthetic structures.
An internalized experience of time.	An externalized experience of time.	A formal recognition of the inevitable power of time in the experience of change.
A point of planned loss of control as the regenerative process took on its own trajectory.	A recognition that opportunities for establishing case law were dependent on many other factors, such as the political atmosphere or public opinion.	A willingness to negotiate with factors that were beyond my control as central elements in the performative process.

The goal of this book is to provide a reliable road map to solutions to intractable problems, but the road map isn't linear or simple. Still, I think this road map could bring us to emergent anomalies, bread crumbs to resilient self-organization through the agonizing multiple states of chaos we are experiencing now.

When COVID-19 infected the human world and a series of global lockdowns came next, many people embraced the ensuing pause. Not everyone paused. Not everyone could pause. Now there needs to be a reckoning.

In 2020, I saw a different kind of violence to resist than I saw in the 1960s. But the lessons from power are the same: Succumb to despair. Resistance is futile. Power confers impunity.

I can't control expressions of self-centeredness or cruelty, whether individual or from powers that be who refuse to pause and learn or listen, instead leveraging the pandemic crisis for their own needs, not even, at times, in myself. But powerlessness is not the same as helplessness. As long as people of conscience can support one another, resist cruelty, and celebrate life, we are not helpless.

Resistance is always necessary. In the wake of the pandemic and in the face of right-wing indifference to suffering, I am equally unnerved. I feel caught in a vise between the urgency of suffering and the time history requires for systemic change. I can't get images of disaster and misery out of my head. I understand the roles of empathy and discourse, the perils of defiance. Outrage never left me any more than CFS did. But time tempered my passion.

My Native American friends remind me that any path forward must be grounded in my heart, where joy still lives. That joy might be the small point of intervention, the drop of water that could change everything.

When I began my art practice, while I was first contemplating broad questions about global ecosystems and injustice, when I was learning how to collaborate with others, those beyond my circle were also coming to terms with big ideas. In 1968, the Club of Rome assembled in Italy as a group of academics, government heads, diplomats, and business leaders concerned with the problems facing humankind. A monograph titled *The*

Predicament of Mankind was published on behalf of the club in 1970. It identified a list, albeit incomplete, of eight factors, which included poverty, faith in institutions, urban sprawl, and economic disruptions. The document led to a 1972 report prepared by Donella Meadows et al., *The Limits to Growth,* which analyzed MIT modeling for what the global environment could sustain but never led to actual change, let alone accountability for consequences of inaction or continued extractions.

• • •

I think prosecution for ecocide might be the next trigger point and gaining mainstream interest. I think seeing common good triumph over institutionalized ecocide might give me joy.

• • •

Consider your joy. How might you creatively engage in collaboration with multiple complex worlds, peoples? Layer metaphors. Discern where hope emerges from the ecotones of chaos and act. Dream your own fairy tale of common good into reality. Carpe diem. Whatever our future may bring, may you treasure and perhaps carry your drop of water to our forest fire.

Acknowledgments

This book would not have been possible without the editorial wisdom of numerous people, including my amazing publisher, Lynne Elizabeth, with help from Abigail Grimminger and the incredible New Village Press team; the support of my sister, Ilana Adler; the contributions of a voice from my past, A. O. Black, who knew Connie Russell; the friendship of Dennis Broe; Paul Cronin's knowledge of CalArts history; the gallerist and artist Elaine Crossman, who knows the island ways; the generosity of the ecoart community, legions of Facebook friends, and my cousin Karen Frayn; the indefatigable editorial professionalism of Ellen Clair Lamb, Marina LaPalma, Amy Sherman, and Howard Lovy; the assistance of my tolerant studio assistant, Daisy Morton; my colleague the art historian Robert Shane; my project manager, Felicity Stone; and my intern, Elia Emery Min. And yes, I did need all those people.

Bibliography

Acheson, James, and Roy Gardner. "Fishing Failure and Success in the Gulf of Maine: Lobster and Groundfish Management." *Maritime Studies* 3, no. 8 (2014). https://doi.org/10.1186/2212-9790-13-8.

Arendt, Hannah. *The Origins of Totalitarianism.* New York: Harcourt, 1968.

Bernholz, Peter. "Art and Science in Totalitarian Regimes and Mature Ideocracies." In *Totalitarianism, Terrorism and Supreme Values: History and Theory,* 97–115. Cham, Switzerland: Springer, 2017.

Boole, George. *An Investigation of the Laws of Thought.* 1854. Reprint, Buffalo: Prometheus Books, 2003.

Buber, Martin. *I and Thou.* New York: Clydesdale, 2020.

Calhoun, Ada. *St. Marks Is Dead: The Many Lives of America's Hippest Street.* New York: Norton, 2015.

Campbell, Courtney S. "Eschatological Passage: Death as Progress in the Latter-day Saints' Tradition." *Ultimate Reality and Meaning* 25, no. 3 (2002): 185–202.

Chan, Steve. "Explaining War Termination: A Boolean Analysis of Causes." *Journal of Peace Research* 40, no. 1 (2003): 49–66. https://doi.org/10.1177/0022343303040001205.

Churchill, Ward. *Indians Are Us? Culture and Genocide in Native North America.* Monroe, ME: Common Courage, 1994.

Cilliers, Paul. "Rules and Complex Systems." *Emergence: Complexity and Organization* 2, no. 3 (2000): 40–50. https://doi.org/10.emerg/10.17357.7ebe3f25 7be831cef34e80a1ff65dd36.

Costanza, Robert. "Ecological Economics: Reintegrating the Study of Humans and Nature." *Ecological Applications* 6, no. 4 (1996): 978–90. https://doi .org/10.2307/2269581.

Costanza, Robert, John H. Cumberland, Herman Daly, Robert Goodland, Richard B. Norgaard, Ida Kubiszewiski, and Carol Franco. *An Introduction to Ecological Economics.* 2d ed. Boca Raton, FL: CRC, 2014.

Costanza, Robert, Ralph D'Arge, Rudolf de Groot, et al. "The Value of the World's Ecosystem Services and Natural Capital." *Nature* 387 (1997): 253–60. https://doi.org/10.1038/387253a0.

Czech, Brian. *Supply Shock: Economic Growth at the Crossroads and the Steady State Solution.* Gabriola Island, BC: New Society, 2013.

Daly, Herman E. *Steady-State Economics.* Washington, DC: Island, 1991.

Debord, Guy. *The Society of the Spectacle.* Detroit: Black and Red, 2002.

DeLaure, Marilyn, and Moritz Fink, eds. *Culture Jamming: Activism and the Art of Cultural Resistance.* New York: New York University Press, 2017.

Dentan, Robert K. "Lucidity, Sex, and Horror in Senoi Dreamwork." In *Conscious Mind, Sleeping Brain: Perspectives on Lucid Dreaming,* edited by Jayne Gackenbach and Stephen LaBerge, 37–63. Boston: Springer, 1988.

Dewey, John, et al. *Art and Education: A Collection of Essays.* Merion, PA: Barnes Foundation, 1978.

Diamond, Jared. *Collapse: How Societies Choose to Fail or Succeed.* New York: Penguin, 2014.

Dicken, Thomas. "Visions of Reality and Meaning in the Thought of John Berger." *Ultimate Reality and Meaning* 25, no. 3 (2002): 168–84.

Duncan, Laramie E., Bryna N. Cooper, and Hanyang Shen. "Robust Findings from 25 Years of PTSD Genetics Research." *Current Psychiatry Reports* 20, no. 12 (2018): art. 115. https://doi.org/10.1007/s11920-018-0980-1.

DuVernay, Ava. "The Herald." *Vanity Fair,* September 2020.

Ebringer, Alan. "The Scientific Method of Sir Karl Popper." In *Rheumatoid Arthritis and "Proteus,"* 191–200. London: Springer, 2012.

Ecocide Law. "Relevant International Crime History." Accessed 8-10-2021 https://ecocidelaw.com/.

Elliot, Robert. *Faking Nature: The Ethics of Environmental Restoration.* New York: Routledge, 1997.

Erlich, Paul. Erlich, Anne. "*The Population Bomb*," Ballantine Books, 1968.

Falk, Donald A., Margaret A. Palmer, and Joy B. Zedler, eds. *Foundations of Restoration Ecology*. Washington, DC: Island, 2016.

Fiske, Edward B. "Reagan Record in Education: Mixed Results." *New York Times,* November 14, 1982. http://www.nytimes.com/1982/11/14/education /reagan-record-in-education-mixed-results.html.

Flora, K. "Surrealism and Madness." *Psychiatriki* 28, no. 4 (2017): 360–66. https://doi.org/10.22365/jpsych.2017.284.360.

Forman, Richard T. T., and Michel Godron. *Landscape Ecology*. New York: Wiley, 1986.

Fryd, Vivian. *Against Our Will: Sexual Trauma in American Art since 1970*. University Park: Pennsylvania State University Press, 2019.

Geffen, Amara, Ann Rosenthal, Chris Fremantle and Aviva Rahmani. *Ecoart in Action; Activities, Case Studies, and Provocations for Classrooms and Communities*. New Village Press, 2022.Glasner, Eli, and Benjamin Weiss. "Sensitive Dependence on Initial Conditions." *Nonlinearity* 6 (1993): 1067–75.

Haase, Donald, ed. *Fairy Tales and Feminism: New Approaches*. Detroit: Wayne State University Press, 2004.

Heartney, Eleanor. *Doomsday Dreams: The Apocalyptic Imagination in Contemporary Art*. New York: Silver Hollow, 2019.

———. "How the Ecological Art Practices of Today Were Born in 1970's Feminism." *Art in America,* May 2020.

Henderson, Lynne. "Law's Patriarchy." 1991. http://scholars.law.univ.edu/fac pub/876.

Higgins, Polly. *Eradicating Ecocide: Laws and Governance to Prevent the Destruction of Our Planet*. London: Shepheard-Walwyn. 2010.

Hilborn, Robert C. "Sea Gulls, Butterflies, and Grasshoppers: A Brief History of the Butterfly Effect in Nonlinear Dynamics." *American Journal of Physics* 72, no. 4 (2004): 425–27. https://doi.org/10.1119/1.1636492.

Ibish, Hussein. "A 'Catastrophe' That Defines Palestinian Identity." *Atlantic,* May 14, 2018. https://www.theatlantic.com/international/archive/2018/05 /the-meaning-of-nakba-israel-palestine-1948-gaza/560294/.

Jaya, Bajaj. "Art, Copyright, and Activism: Could the Intersection of Environmental Art and Copyright Law Provide a New Avenue for Activists to Protest Various Forms of Exploitation?" *Northwestern Journal of Technology and Intellectual Property* 15, no. 1 (Spring 2017): 53–71. Kahneman, Daniel. *Fast and Slow Thinking*. Farrar, Straus and Giroux 2011.

Kaprow, Allan. "The Legacy of Jackson Pollock." *ARTnews,* October 1958.

Kelley, Peter. "Herbert Blau Remembered as Teacher, History-Making Theater Pioneer." *UW News,* May 8, 2013. https://www.washington.edu/news/2013/05/08/herbert-blau-remembered-as-teacher-history-making-theater-pioneer/.

Kimmerer, Robin Wall. *Braiding Sweetgrass: Indigenous Wisdom, Scientific Knowledge and the Teachings of Plants.* Minneapolis: Milkweed Editions, 2012.

Kosarkova, Alice, Klara Malinakova, Zuzana Koncalova, Peter Tavel, and Jitse P. van Dijk. "Childhood Trauma Is Associated with the Spirituality of Non-Religious Respondents." *International Journal of Environmental Research and Public Health* 17, no. 4 (2020). https://doi.org/10.3390/ijerph17041268. Kuhn, Thomas. *The Structure of Scientific Revolutions.* University of Chicago Press, 1962.

Lakoff, George, and Mark Johnson. *Metaphors We Live By.* Chicago: University of Chicago Press, 1981.

Lewison, Rebecca L., Larry B. Crowder, Andrew J. Read, and Sloan A. Freeman. "Understanding Impacts of Fisheries Bycatch on Marine Megafauna." *Trends in Ecology and Evolution* 19, no. 11 (2004): 598–604.

Lindgren, Tim. "Ecocide, Genocide and the Disregard of Alternative Life-Systems." *International Journal of Human Rights* 22, no. 4 (2018): 525–49. https://doi.org/10.1080/13642987.2017.1397631.

Lohan, Tara. "Scientists Find New Way to Reduce Marine 'Dead Zones.'" *Salon,* September 26, 2021. https://www.salon.com/2021/09/26/scientists-find-new-way-to-reduce-marine-dead-zones/.

Longfellow, Henry Wadsworth. *The Song of Hiawatha,* 1855.

Lynas, Mark. "The Myth of Easter Island's Ecocide." November 2011. https://www.marklynas.org/2011/09/the-myth-of-easter-islands-ecocide/.

Malthus, Thomas Robert. *An Essay on the Principle of Population.* New Haven, CT: Yale University Press, 2018.

Marcuse, Herbert. *Eros and Civilization: A Philosophical Inquiry into Freud.* Boston: Beacon, 1955.

Maruyama, Koji, Franco Nori, and Vlatko Vedral. "The Physics of Maxwell's Demon and Information." *Reviews of Modern Physics* 81, no. 1 (January 2009): 1–23. https://arxiv.org/pdf/0707.3400.pdf.

McHarg, Ian. *Design with Nature.* New York: Wiley, 1992.

McLuhan, Marshall. *The Medium Is the Message: An Inventory of Effects.* New York: Random House, 1967.

Meadows, Dennis, Meadows, Donella, Randers, Jergen, Behrens III, William W. *The Limits to Growth.* New York Universe Books. 1972.

Merchant, Carolyn. *The Death of Nature: Women, Ecology and the Scientific Revolution.* San Francisco: Harper and Row, 1980.

Michener, James. *The Floating Worlds.* The University of Hawaii Press, 1954.

Nicolescu, Basarab. *Manifesto of Transdisciplinarity.* Albany: SUNY Press, 2002.

Nin, Anaïs. *The Diary of Anaïs Nin.* New York: Harcourt Brace Jovanovich, 1966.

Peeler, Calvin D. "From the Providence of Kings to Copyrighted Things (And French Moral Rights)." *Indiana International and Comparative Law Review* 9, no. 2 (1999): 423–56. https://mckinneylaw.iu.edu/iiclr/pdf.

Penhollow, Mark E., Paul G. Jensen, and Leslie A. Zucker. *Wildlife and Habitat Conservation Framework: An Approach for Conserving Biodiversity in the Hudson River Estuary Corridor.* Ithaca, NY: New York State Department of Environmental Conservation, 2006. https://www.dec.ny.gov.

Popper, Karl R. *Conjectures and Refutations.* London: Routledge and Kegan Paul, 1963.

Princenthal, Nancy. *Unspeakable Acts: Women, Art, and Sexual Violence in the 1970s.* New York: Thames Hudson, 2019.

Rahmani, Aviva. "*The Blued Trees Symphony* as Transdisciplinary Mediation for Environmental Policy." *Media+Environment,* July 2021. https://doi.org /10.1525/001c.25256.

———. *From Fish Story to Blued Trees: Fixing Disaster.* Filmed 2020 for *Gulf to Gulf.* https://vimeo.com/433744703.

———. "Hunt for the Lost." 2020. http://www.huntforthelost.org.

———. *Invasive Species, Pervasive Changes.* Filmed 2014 for *Gulf to Gulf.* https: //vimeo.com/102149231.

———. "Mapping Trigger Point Theory as Aesthetic Activism." *Parsons Journal for Information Mapping* 4 (Winter 2012): 1–9.

———. *Mirrors.* Filmed 2016. https://vimeo.com/189830093.

———. "The Music of the Trees: *The Blued Trees* Symphony and Opera as Environmental Research and Legal Activism." *Leonardo Music Journal* 29 (2019): 1–2.

———. "Practical Ecofeminism." In *Blaze: Discourse on Art, Women and Feminism*, edited by Karen Frostig and Kathy A Halamka. Newcastle, UK: Cambridge Scholars, 2007.

———. *Trigger Points/Tipping Points*. Filmed 2020. https://vimeo.com/5296 1095.

Revelle, Roger. *Energy and Climate*. Washington, DC: National Academies Press, 1977.

Richardson, Heather Cox. *How the South Won the Civil War: Oligarchy, Democracy, and the Continuing Fight for the Soul of America*. New York: Oxford University Press, 2020.

Robinson, Steve. *The Energy Efficient Home*. Plume Books, 1978.

Schäfer, Thomas, Jörg Fachner, and Mario Smukalla. "Changes in the Representation of Space and Time While Listening to Music." *Frontiers in Psychology* 4 (2013). https://doi.org/10.3389/fpsyg.2013.00508.

Seitz, William C. *The Responsive Eye*. New York: Museum of Modern Art, New York, 1965. https://www.moma.org/.

Senior, Jennifer. "Hillary Clinton Was Right to Warn Us." *New York Times*, November 2, 2020. https://www.nytimes.com/2020/11/02/opinion/hillary -clinton-biden-trump.html.

Simard, Suzanne. *Finding the Mother Tree*. New York: Knopf, 2021.

Sky News. "A Million Tonnes of 'Lethal' Ghost Gear Left in the Seas Each Year, WWF Report Claims." October 20, 2020. https://news.sky.com.

Sontag, Susan. *Styles of Radical Will*. New York: Picador, 1969.

Spong, John Shelby. *The Sins of Scripture: Exposing the Bible's Texts of Hate to Reveal the God of Love*. San Francisco: Harper, 2006

Steinem, Gloria. "Gloria Steinem on Patriarchy and Power in *The Handmaid's Tale*: How Margaret Atwood's Classic Shows the Significance of Reproductive Freedom." Early Bird Books, May 9, 2015. https://earlybirdbooks .com/gloria-steinem-on-the-handmaids-tale.

Stohr, Greg. "Supreme Court Refuses to Curb Government Power to Take Land." Bloomberg News, July 2, 2021. https://www.bloomberg.com/news /articles/2021-07-02/supreme-court-refuses-to-reconsider-kelo-eminent -domain-ruling.

Sturgis, Sue. "The Katrina Oil Spill Disaster: A Harbinger for the Atlantic Coast?" Facing South, August 2015. https://www.facingsouth.org/2015/08 /the-katrina-oil-spill-disaster.

Tjaden, Patricia, and Nancy Thoennes. *Full Report of the Prevalence, Incidence, and Consequences of Violence against Women: Findings from the National Violence against Women Survey.* Washington, DC: U.S. Department of Justice, 2000.

Union of Concerned Scientists. "Environmental Impacts of Natural Gas." June 19, 2014. https://www.ucsusa.org/.

United Nations Department of Economic and Social Affairs News. "Growing at a Slower Pace, World Population Is Expected to Reach 9.7 Billion in 2050 and Could Peak at Nearly 11 Billion around 2100." United Nations, 2019. https://www.un.org/development/desa/en/news/population/world -population-prospects-2019.html.

von Bertalanffy, Ludwig. *General Systems Theory: Foundations, Development, Applications.* New York: George Braziller, 1968.

Zaki, Jamil. *The War for Kindness: Building Empathy in a Fractured World.* New York: Crown, 2019.

About the Author

Aviva Rahmani lives in Maine and Manhattan with her cat, Bliss. She has published and exhibited internationally, including at the 2007 Venice Biennale, but avoids flying. Rahmani has been an affiliate at the Institute for Arctic and Alpine Research at Colorado University at Boulder since 2010. For her project *Blued Trees* (2015–present), part of *Gulf to Gulf* (2009–present), a New York Foundation for the Arts–sponsored project on changing climate change with art, she was awarded numerous fellowships, including ones from the NYFA and A Blade of Grass.